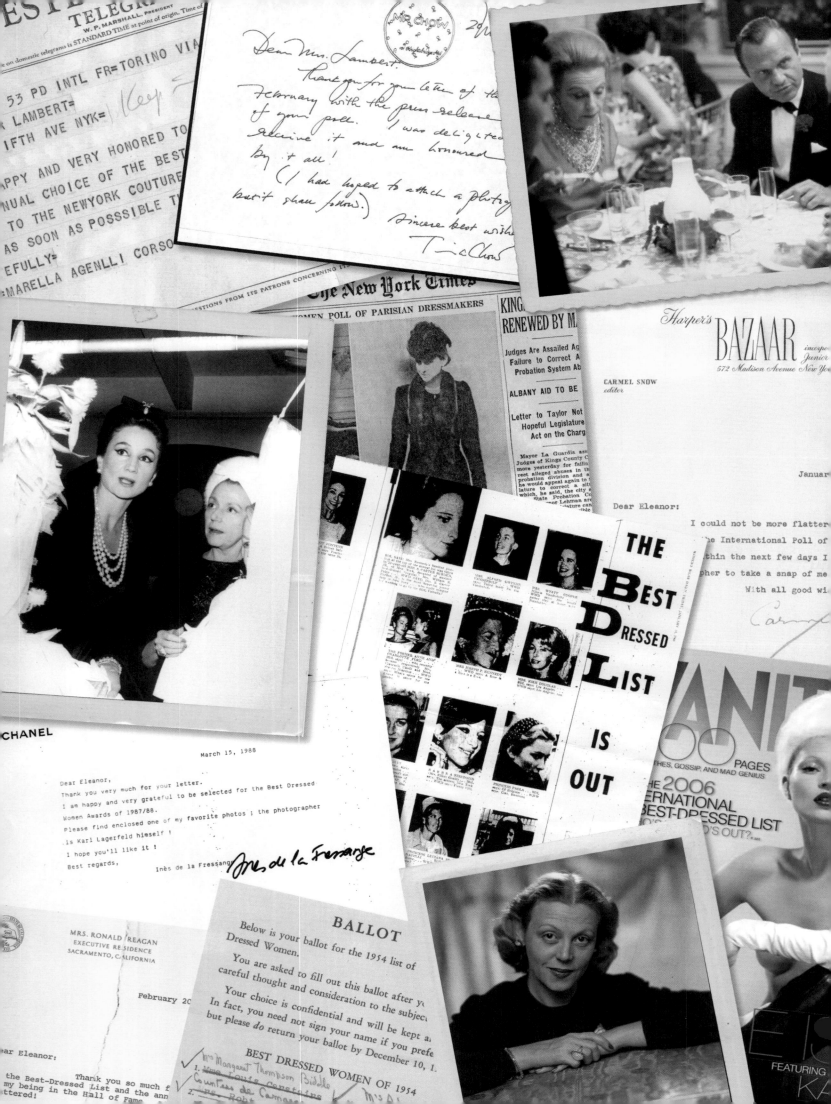

WP. MARSHALL, PRESIDENT

TELEGRAM

Time of

on domestic telegrams is STANDARD TIME at point of origin. Time of

53 PD INTL FR=TORINO VIA
LAMBERT=
FIFTH AVE NYK=

HAPPY AND VERY HONORED TO
NUAL CHOICE OF THE BEST
TO THE NEWYORK COUTURE
AS SOON AS POSSSIBLE TI
EFULLY=
=MARELLA AGENLLI CORSO

MR CHOW

Dear Mrs. Lambert,
Thank you for your letter of the
February with the press release
of your poll. I was delighted
receive it and am honoured
by it all!
(I had hoped to attach a photograph
but it shall follow.)
Sincere best wishes
Tina Chow

The New York Times

WOMEN POLL OF PARISIAN DRESSMAKERS

KING
RENEWED BY M

Judges Are Assailed Ag
Failure to Correct A
Probation System Ab

ALBANY AID TO BE

Letter to Taylor Not
Hopeful Legislature
Act on the Charg

Mayor La Guardia ass
Judges of Kings County C
more strongly for failing
rect alleged abuses in t
probation division and
he would appeal again to t
lature to correct a sit
which, he said, the city
State Probation Co
nor Lehman are

Harper's BAZAAR incorpor
Junior
572 Madison Avenue New Yor

CARMEL SNOW
editor

Januar

Dear Eleanor:

I could not be more flatter
the International Poll of
thin the next few days I
pher to take a snap of me
With all good wi

Carmel

THE
BEST
DRESSED
LIST
IS
OUT

VANITY
PAGES
THES, GOSSIP, AND MAD GENIUS
THE 2006
INTERNATIONAL
BEST-DRESSED LIST
O'S IN, WHO'S OUT?...

CHANEL

March 15, 1988

Dear Eleanor,
Thank you very much for your letter.
I am happy and very grateful to be selected for the Best Dressed
Women Awards of 1987/88.
Please find enclosed one of my favorite photos ; the photographer
is Karl Lagerfeld himself !
I hope you'll like it !
Best regards,
Inès de la Fressange

MRS. RONALD REAGAN
EXECUTIVE RESIDENCE
SACRAMENTO, CALIFORNIA

February 20

ear Eleanor:
Thank you so much f
my being in the Best-Dressed List and the ann
ttered!

BALLOT

Below is your ballot for the 1954 list of
Dressed Women.

You are asked to fill out this ballot after y
careful thought and consideration to the subjec

Your choice is confidential and will be kept a
In fact, you need not sign your name if you prefe
but please do return your ballot by December 10, 1.

BEST DRESSED WOMEN OF 1954

1. Mrs Margaret Thompson Biddle
Countess de Camaso
2. Inès Robt

FEATURING

# *The*
## *International*
# BEST-DRESSED
# LIST

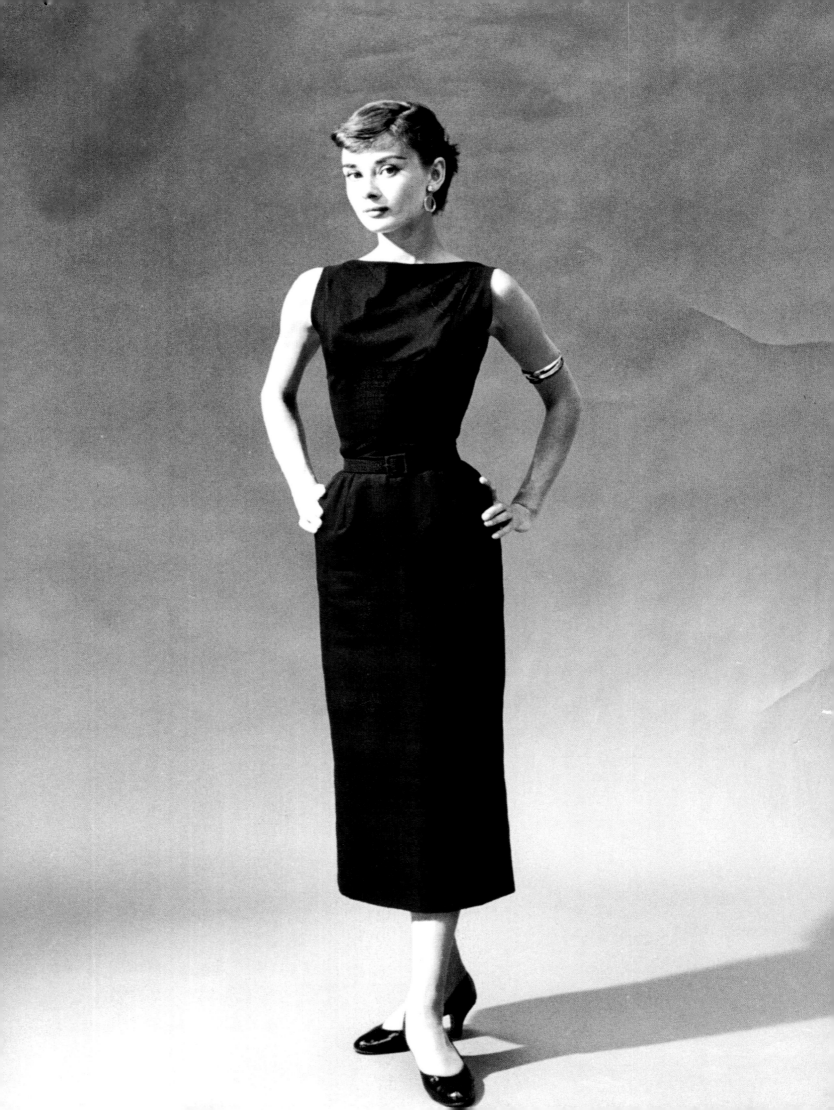

# The International BEST-DRESSED LIST

## The Official Story

The I.B.D.L.

"A Permanent Record of Excellence."
—Eleanor Lambert

Est. 1940

## Amy Fine Collins

Introduction by GRAYDON CARTER
Foreword by CAROLINA HERRERA

RIZZOLI
NEW YORK

New York  Paris  London  Milan

# Contents

PRECEDING SPREAD: **AUDREY HEPBURN,** circa 1952, by George Karger. Audrey was voted onto the List five times before ascending to the Hall of Fame in 1961.
RIGHT: Actress and singer **JANELLE MONÁE** leaving the Mark Hotel in New York, en route to the Metropolitan Museum's Costume Institute gala, celebrating "Heavenly Bodies: Fashion and the Catholic Imagination," May 7, 2018. Janelle wears an ensemble by Marc Jacobs, left, with husband Charly Defrancesco, right. "My black and white is meant to honor my working-class parents," Monáe said.

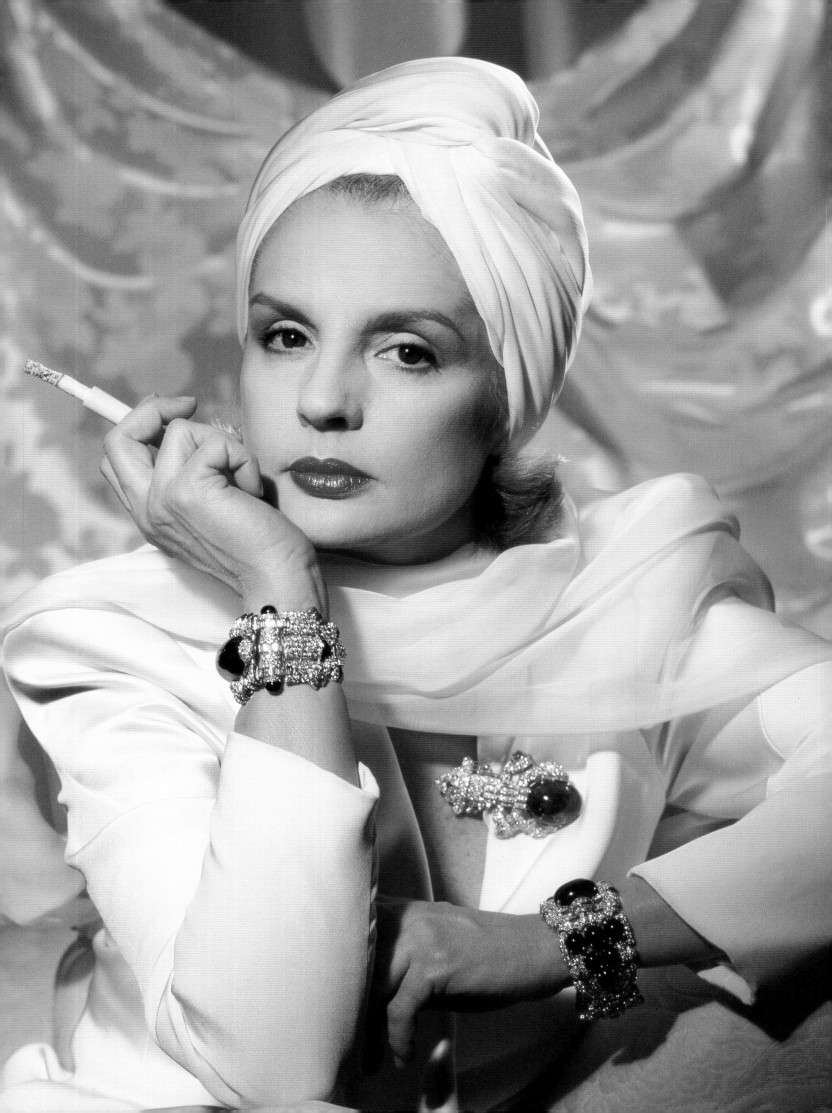

# Foreword

by **CAROLINA HERRERA**

*I* am often asked what it means to be "best-dressed." As the members of the List portrayed on these pages show us, best-dressed is not so much about what you wear as how you wear it. Best-dressed is also not about wealth or following a fashion trend, but about how you move, think, and live in your clothes day-to-day, ideally with a sense of humor.

The impressions that linger most indelibly from this book are, for me, certain incidental details that reveal personality and character: the Begum Aga Khan delicately touching her gloved hand to her hat; Marina, Duchess of Kent, tentatively finding her footing as she descends a staircase; Babe Paley cradling her chin; Audrey Hepburn gazing at Grace Kelly, who mirrors her friend's arched pose; Jacqueline de Ribes extending her long legs languorously on the deck of the *Creole*; Diana Ross happily propelling her arms skyward. In other words, these women's fascinating attitudes and gestures, with elegance, make even more of a statement than the clothes on their backs. This principle, of course, applies to life as well as to pictures. A beautiful dress is always a pleasure to wear and a delight to look at. But it is the quality of our thoughts and of our actions and of how we live—not just of our clothes—that distinguishes well-dressed from Best-Dressed.

Before Amy Fine Collins worked exclusively for *Vanity Fair,* she had been style editor at both *House & Garden* and *Harper's Bazaar.* She was also the muse of Geoffrey Beene. She has written or contributed to numerous books and has won, for her seriousness, the respect and admiration of the fashion world. Both personally and with this book, Amy carries into the future the standards of elegance that Eleanor Lambert established for the International Best-Dressed List so many years ago.

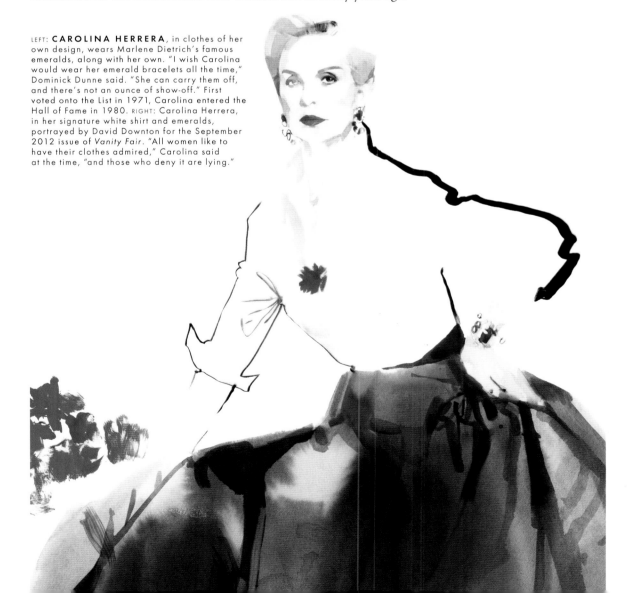

LEFT: **CAROLINA HERRERA**, in clothes of her own design, wears Marlene Dietrich's famous emeralds, along with her own. "I wish Carolina would wear her emerald bracelets all the time," Dominick Dunne said. "She can carry them off, and there's not an ounce of show-off." First voted onto the List in 1971, Carolina entered the Hall of Fame in 1980. RIGHT: Carolina Herrera, in her signature white shirt and emeralds, portrayed by David Downton for the September 2012 issue of *Vanity Fair.* "All women like to have their clothes admired," Carolina said at the time, "and those who deny it are lying."

**AMY FINE COLLINS** portrayed by
Marc-Antoine Coulon at home in a
Christian Lacroix dress, Marina B earrings,
and Manolo Blahnik satin pumps, 2015.

# Preface

---

*"It is my gift to fashion."*

—ELEANOR LAMBERT,
*on the International Best-Dressed List*

---

Eleanor Lambert and I met when she was representing, among dozens of other posh clients, the venerable decorating firm of Parish-Hadley. Sister Parish and Albert Hadley planned to publish a book about their work, and Eleanor proposed that they engage Valentine (Nicholas) Lawford to write the text. But Nicholas—a former diplomat and the photographer Horst's longtime partner—by that point preferred painting to writing, so he offered me up to Eleanor in his stead.

A neophyte at *Vanity Fair* who had befriended Nicholas and Horst while profiling them for the magazine, I was a little intimidated by the situation into which I had been thrust. At the initial meeting, in the stately Parish-Hadley offices, I sat across a table from the two dowager arbiters of taste, Sister and Eleanor. Though Sister was perhaps the more celebrated of the imposing pair, she was not the one to whom I was most drawn. More mesmerizing to me was the exotically attired, warmer-blooded Eleanor, a totemic presence in her wide-brimmed, cardinal-red hat, with vivid matching lips, nails, pantsuit, and cane. She guided me into the elevator with her, invited me into her black town car, and swept me straight into her life.

Eleanor, it turned out, was my neighbor, so I began frequenting her apartment. She would have me to tea on Sundays, and when my daughter was old enough, she was invited, too. Eleanor would spoil her with cups of thick hot chocolate, melted down from the confectionery tributes she received regularly from doting clients and fawning International Best-Dressed List hopefuls. Though her housekeeper, Belén, was usually on duty, Eleanor would prepare the treacly brew herself on her gargantuan, antiquated stove. Eleanor was often bent over that enormous gas-burning apparatus, mixing up a batch of her famous chili con carne for supper guests or stirring her signature red-pepper sauce, which she would ladle into Ball jars every year for Christmas gifts.

During that time I was also very close to Geoffrey Beene—I was his muse (or "a-muse," as he put it). Eleanor and Mr. Beene were cut, as it were, from the same cloth. They shared matching points of view

about fashion and the country of their birth. Eleanor, an Indiana-born product of the prairie, tirelessly championed American designers, and among them she favored those with a distinctly artistic and original twist. Both Mr. Beene and Eleanor liked the fact that I had trained, before taking a detour into glossy-magazine journalism, to become an art historian. Eleanor herself had studied at the Art Institute of Chicago to be a sculptor and represented artists before she became a fashion publicist. Consequently, she had an exacting, sometimes irascible, eye for form, volume, texture, composition, proportion, quality, and craftsmanship. But Eleanor did not take me under her wing just because she found in me a like-minded, aesthetically informed protégée. Eleanor was a press agent, after all, and I was press.

Before long, Eleanor invited me to join her synod-like International Best-Dressed List committee, which oversaw and edited the results of the annual International Best-Dressed Poll. Back then we usually convened in March, a group of maybe 20 seasoned observers assembled for the day in her Fifth Avenue living room, overlooking the Central Park Reservoir. When we broke for our buffet lunch—typically tea sandwiches, salad, macaroni and cheese, ham, chicken potpie—catered by Mortimer's, the very social restaurant at Lexington Avenue and 74th Street, I would savor the eclectic setting even more than the food. I coveted the dazzling Étienne Drian mirrored screen that dominated the southeast corner of her salon, and on the way to her bathroom I would walk down a picture-filled corridor, whose walls, like those of her bedroom, were upholstered in surplus striped mattress ticking, a present from Mr. Beene.

Sitting on the I.B.D.L. committee was a heady experience. Surrounding me were some of the era's most sophisticated personalities from society, media, and fashion. It was there, among Eleanor's needlepointed chairs, Noguchi portrait bust, absinthe-green sofa, and Alex Katz landscape, that I encountered the debonair Jerry Zipkin, Nancy Reagan's consort, about whom *Women's Wear Daily*'s John Fairchild coined the word "walker." I became acquainted with Lynn Wyatt, Betsy Kaiser, Anne Slater, Nan Kempner, and Lyn Revson—all long-standing I.B.D.L. Hall of Famers. The chain-smoking, opinionated Kenneth Jay Lane, another omnipresent arbiter, was so attached to Eleanor that he called her "Mummy." One year, Kenny and Reinaldo Herrera, with whom he sometimes sparred about potential List honorees, asked me peremptorily to leave the room. Later, to my relief, I discovered that this was a ruse contrived to discuss my candidacy in my absence. They sanctioned my election first, in 1994, to the Fashion Professionals category, and in 1996 dispatched me to the Hall of Fame.

As she advanced into her 90s, Eleanor began to hatch various schemes for the posthumous survival of

LEFT: portrait of **ELEANOR LAMBERT** from Eleanor's archives, circa 1930s. Photograph by Eisenstaedt/pix. Inscribed on the back by an unknown hand are the words "EL—fresh spring flower in bloom." ABOVE: **ELEANOR LAMBERT** with **AMY FINE COLLINS** at the memorial party for Horst at the Lotos Club, New York, January 27, 2000. Eleanor wears a pantsuit by Léon Paule Couture of Beverly Hills, Verdura earrings, Belgian loafers, and Parallel Red Estée Lauder lipstick. Amy wears a Geoffrey Beene dress, Verdura bracelets, and Manolo Blahnik "Orientalia" mules. Bobby Short played the piano during the event.

*Eleanor Lambert* Ltd.
*245 East Fifty-eighth Street, Suite 18A, New York 10022*
*Telephone: (212) 754-9045    Telefax: (212) 826-2834*

Dear Amy

The Best Dressed ballots will be in the mail before January 20 and I would like to have the committee meeting on Wednesday, February 10 at my house, 1060 Fifth Avenue, 11A. We traditionally begin at 11:00 a.m. with the men's list, break for a buffet lunch at 12:30 and continue the discussion and finalizing of the women's list about 2:00 p.m.

Is this plan convenient for you and may we count on you to be with us? It's of the utmost importance to have your help in everyway possible. Thank you.

Affectionately,

Eleanor Lambert

her List. Ultimately, she wrote a letter bequeathing the International Best-Dressed List to Graydon Carter, Reinaldo, Aimée Bell, and myself. All of us had served multiple terms on her committee and all were at the time working for *Vanity Fair*. Three of us had been elevated to the Hall of Fame. Eleanor specifically stated in her letter that the List would belong to the four of us, not to *Vanity Fair*, and that she did not want the List ever to wind up the property of a fashion magazine. We accepted Eleanor's remarkable gift and celebrated the passing of the baton with a lunch at La Caravelle. We are grateful to Eleanor, our Godmother of Fashion.

Much of my working life these days is dedicated to the List. Eleanor's grandson, Moses, a photographer and filmmaker, remains a friend. And, thanks to Moses, and the 2004 Christie's auction of his grandmother's belongings, many of Eleanor's objects have found their way into my own home. Her porcelain-flower chandelier, which used to illuminate the hallway between her bedroom and bathroom, hangs in my daughter's bedroom. Her fanciful Marcel Vertès panels depicting an artist and her model, from the same location, now adorn my dining room. Her round, tiered end tables that used to flank her living-room sofa—one with its glass top still cracked—are well-used fixtures in my library. The glamorous Drian folding screen (originally the property of Mrs. Marshall Field) sold at Christie's for what seemed at the time an unattainable price. I now regret that I did not empty my wallet for it. Over the long haul, I would not have missed the money. But I do, very much, miss Eleanor—my mentor, friend, and benefactor, from whose I.B.D.L. archives much of this book derives and in whose memory I dedicate this book.

*A note on the organization of the book: Photographs of members of the International Best-Dressed List appear in the chapter devoted to the decade during which they were first elected. As a rule, the photographs illustrating each chapter were taken during the decade of an individual's initial naming to the List, although, inevitably, there are some exceptions. Occasionally, an individual shows up in more than one chapter, usually because that person is pictured with a first-time winner from the designated decade. Especially before the establishment of the Hall of Fame in 1958, numerous individuals appeared on the List multiple times, across more than one decade. For a comprehensive directory of who appeared on the List year by year, and in which category, please see pages 264-73.*

# Introduction

*by* GRAYDON CARTER

*I*n 1988, I was in my office at *Spy* magazine, in the Puck Building, on the northern edge of SoHo. I was about to turn 39, and I worked in a sea of younger editors, assistants, and interns who were all about half my age. To them, I was a dusty antiquity. I wasn't as slim as I had been at 30—I wasn't as slim as I had been at 38. There were flecks of gray here and there in my hair. And I was tired. Starting a new magazine—or a new anything for that matter—is exhausting and the hours and the exhilaration were beginning to take their toll. I felt like Nick Nolte in that arrest photo. I was talking across a dividing wall to my partner Kurt Andersen when the phone rang. It was Susan Morrison, our deputy editor. She was on holiday in Europe, and in those days long-distance calls were not made lightly, or cheaply. Susan was a bit heated. She was speaking quickly, and the line was scratchy. I couldn't quite make out what she was talking about. The words "Herald Tribune" and "best-dressed" came over the line. And then the connection cleared. "You're on the International Best-Dressed List!" she shouted. "How do you know that?," I asked. "Because," she replied, "I just read it in the *Herald Tribune*!"

I have to say that, when I hung up the phone, I was suddenly in a better mood. I felt rejuvenated. I didn't tell anyone at the office. I thought I'd wait until Susan returned. But there was a lightness in my step, a sweep in my jacket, that hadn't been there before. It was the only list I think I'd ever been on. Or at least the only good list. And I care about clothes. I didn't have a lot of them back then, but I bought the best things I could afford and wore them until they were frayed. And then wore them some more. My philosophy was that great tailoring can disguise, or at least mitigate, the imperfections of the physique and metabolism we are given. Furthermore, we took pains to dress up at *Spy*. The magazine was something of a revolutionary new voice, and I always felt that we would have more authority if we looked as if we weren't shouting from the ramparts. I was embarrassed at how happy the inclusion on this List had made me. At the same time, I wasn't sure what the List was. I knew that there was a Mr. Blackwell who produced a camp annual roster of the 10 worst-dressed women. So I knew it couldn't be that—or at least I hoped not.

As I was to discover, the International Best-Dressed List was then almost a half-century old. And it was something to be named to it. The List had been cooked up by Eleanor Lambert before the U.S. entered World War II as a way of drumming up interest in American fashion at a time when the European houses

struggled. Eleanor was as canny a public-relations shaman as you were apt to find in those days. Like so many people who make their mark in New York, she was not from the city. She had grown up in Indiana and, after a stop in Chicago, wound up in the New York art scene of the 20s. In time she began representing artists (including Isamu Noguchi) and even museums (including the Whitney, then just opening). Eleanor gravitated to fashion, and as one looks back, it can fairly be argued that she probably did more for the

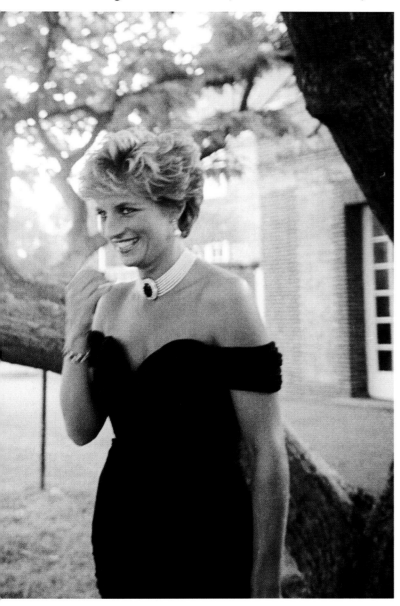

American clothing industry than any other single individual. She created the Costume Institute, Fashion Week, the Council of Fashion Designers of America, the Coty Awards, and the International Best-Dressed List.

Eleanor came into my life about a decade after I had gone on the Best-Dressed List. I was by then at *Vanity Fair,* and she invited me, along with three colleagues from the magazine, to join the committee that selected, after reviewing the poll results, who would be on the List. Those three colleagues were Reinaldo Herrera (a contributing editor and, not incidentally, the husband of designer Carolina Herrera), Aimée Bell (who had been my assistant at *Spy* and who was now my deputy at *Vanity Fair*), and Amy Fine Collins (rail-thin fashion icon, *V.F.* special correspondent, and the author of this estimable volume). We would gather with the other committee members at Eleanor's apartment, on 87th Street and Fifth Avenue, with its tree-height view looking out over the Central Park Reservoir. Tea sandwiches were served. As were names, reputations, and decisions. I'd mention the other committee members, but we had all taken an oath of secrecy. This was a policy to protect us not only from the wrath of those not included on the List but also from Eleanor herself, who wanted the meetings to be held in complete secrecy. She always had the look of someone who, when angered, could burn toast from across the room.

Eleanor became close to my three colleagues, and a year before her death in 2003, she gave the List to the four of us. I am largely a decorative figure in this glamorous enterprise. The legacy of Eleanor's vision—and the integrity of the List—rests fully on the shoulders of my three compadres. The International Best-Dressed List tells you a lot about where we've been over the past 80 years, and we hope that it will continue to provide an historical record. Looking back to the 1988 List, I feel that I was in company far above my station. President George Bush (the dad, not the son) was included that year. So were three dashing men of my later acquaintance: John F. Kennedy (the son, not the dad), Bryan Ferry, and Steve Martin. My guess is that, even if they might have publicly pooh-poohed their inclusion on Eleanor's List, privately they were tickled. I know I was.

PREHISTORY

# The 1930s

## Post-DEPRESSION-ERA *Glamour*

The five-times-married **MONA WILLIAMS** (later Countess von Bismarck), whom Cecil Beaton revered as a "chef d'oeuvre" from "another world" and whom Cole Porter praised in song, photographed by Horst in 1936. Mona wears a broadtail hat and matching coat, embellished with two hammered-gold Suzanne Belperron brooches.

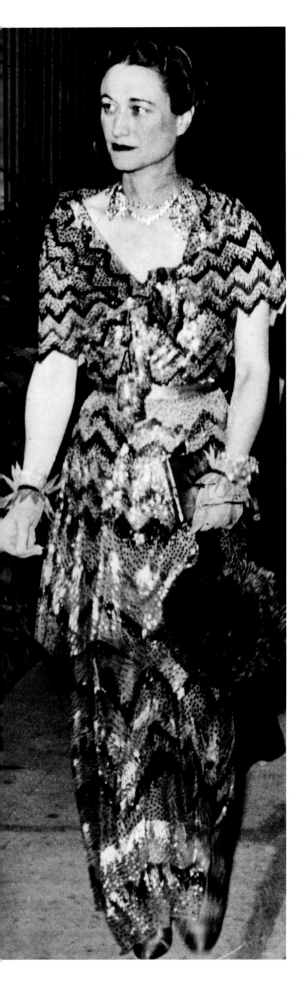

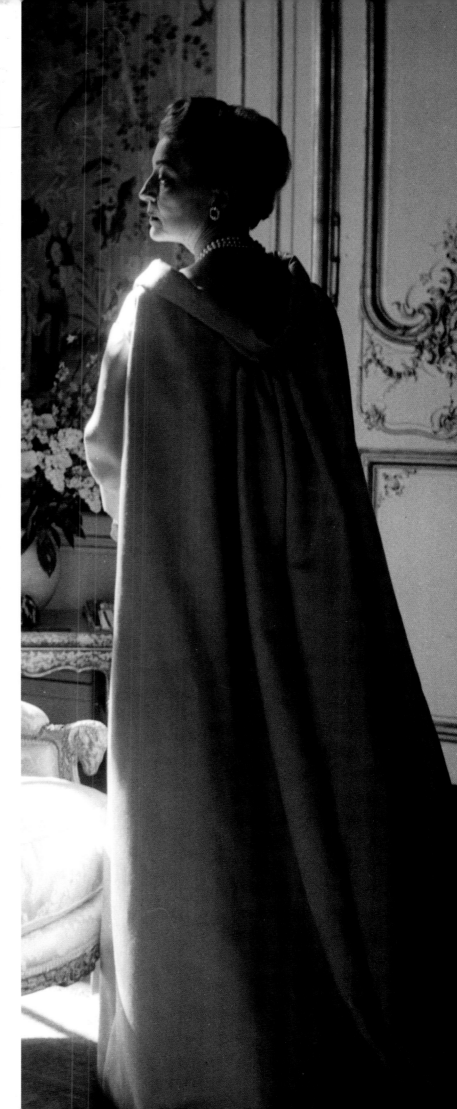

# *"Good clothes open all doors."*

## —THOMAS FULLER

### (1608-1661)

FACING PAGE, FAR LEFT: the **DUCHESS OF WINDSOR** (formerly Wallis Warfield of Baltimore) in Paris, 1937. TOP: Woolworth heiress **BARBARA HUTTON**, the original "poor little rich girl," in costume as "The Spirit of Adventure," Madison Square Garden, May 1932. BOTTOM, RIGHT: **ELIZABETH, THE QUEEN MOTHER**, seated between herms at Buckingham Palace, 1939. Photo by Cecil Beaton. BOTTOM, LEFT: the 21-year-old tobacco heiress **DORIS DUKE** at Bailey's Beach, Newport, Rhode Island, 1934. THIS PAGE, ABOVE: **KATHRYN "KITTY" MILLER**, left, with William Rhinelander Stewart and his wife, **JANET RHINELANDER STEWART**, in New York at opening night of the Maxwell Anderson play *Candle in the Wind*, October 1941. Fashion editor Baron Nicolas de Gunzburg believed that Diana Vreeland knew "one-tenth as much about clothes" as Kitty Miller did. RIGHT: **MONA WILLIAMS BISMARCK** in a peony-pink Balenciaga, at her apartment in the historic 17th-century Hôtel Lambert, Paris, photographed by Cecil Beaton. Mona was immortalized by Truman Capote as Kate McCloud in his notorious roman à clef, *Answered Prayers*.

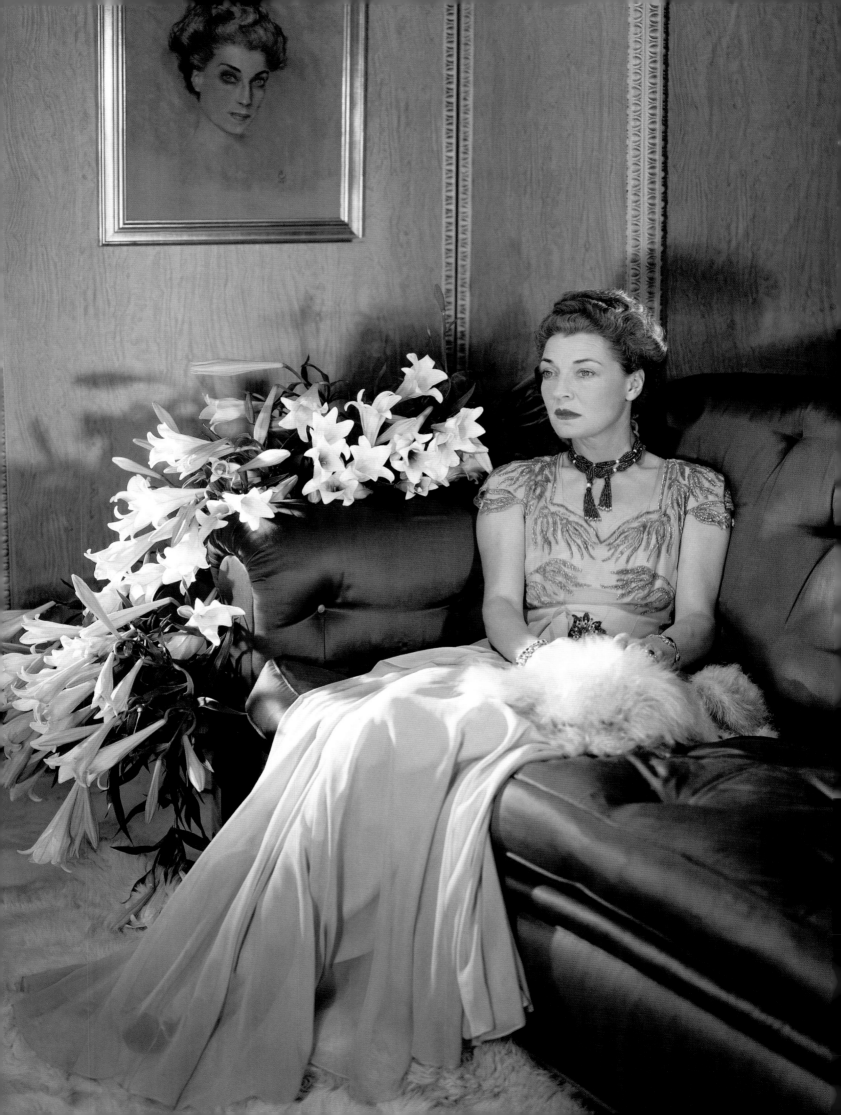

# *The* Dress Institute *and the* Couture Group

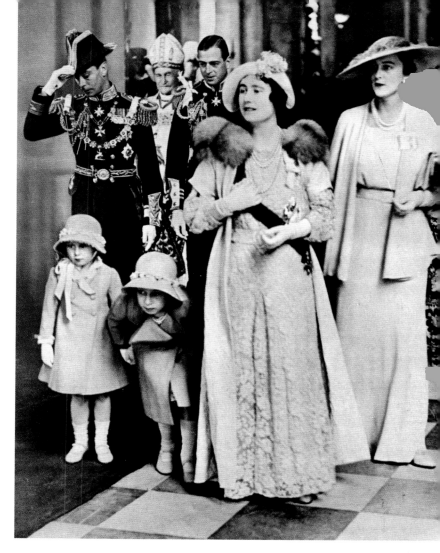

In 1939—while Germany was invading Poland and women and children were being evacuated from London—Seventh Avenue's captains of industry were panicking about selling dresses. In an unprecedented maneuver, labor unions and manufacturers banded together to form the Dress Institute, with propaganda as their mission. Strategic billboards, created by the J. Walter Thompson advertising agency, sprang up across the country targeting the female consumer. The boldest sign hectored, AREN'T YOU ASHAMED YOU ONLY HAVE ONE DRESS—ONE DRESS BEULAH? In spite of the looming war, dress sales soared. But Dorothy Shaver of Lord & Taylor, Adam Gimbel of Saks Fifth Avenue, Andrew Goodman of Bergdorf Goodman, Henri Bendel of the eponymous store, and William Holmes of Bonwit Teller were appalled. They demanded that the Dress Institute switch to more tasteful promotional tactics, and they insisted on publicity sorceress Eleanor Lambert for the job.

---

## *The* Paris Dressmakers' Poll

Lambert devised two ingenious, resilient mechanisms to advance the Dress Institute's cause. One of them was Press Week—the direct antecedent of today's biannual New York fashion shows. The second apparatus was more subtle, but equally effective. Starting in the 1920s, and continuing into the 30s, unsigned Associated Press or United Press wire-service stories, datelined Paris, had appeared at the end of each year, conveying the results of the "Paris Dressmakers' Best-Dressed Women Poll." (Mainbocher, Edward Molyneux, Jeanne Lanvin, Madeleine Vionnet, Lucien Lelong, and Coco Chanel were, depending on the year, among those canvassed.) At a time when the world was still reeling from the Depression, the anonymous columnists relished printing the fabulous sums–from $10,000 to $50,000–that such often cited incarnations of chic as Elsie de Wolfe and Mrs. Cole (Linda) Porter supposedly poured per annum into their wardrobes. Fashion, these women's-page correspondents recognized, was a competitive sport, with winners, losers, and high-stakes players, and their readers liked

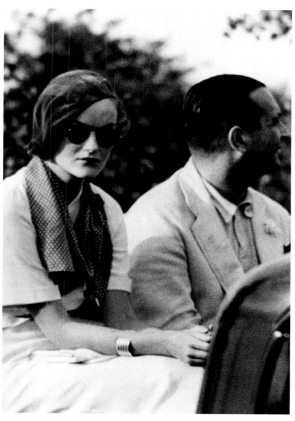

LEFT: **MONA WILLIAMS** next to her portrait by Henri de Bach, photographed by Horst, 1941. *Vogue* reported in 1936 that her "dressing is high art" and that her blue-white hair and aquamarine eyes were "New York phenomena." TOP: **ELIZABETH, THE QUEEN MOTHER,** accompanied by her daughters, **PRINCESSES MARGARET** and **ELIZABETH,** and her sister-in-law, **MARINA, DUCHESS OF KENT,** during the Silver Jubilee of her father-in-law, King George V, May 1935. Marina was criticized for wearing a face-obscuring cartwheel hat for the occasion. ABOVE: **DORIS DUKE,** at the Meadowbrook Club, Old Westbury, New York, 1934.

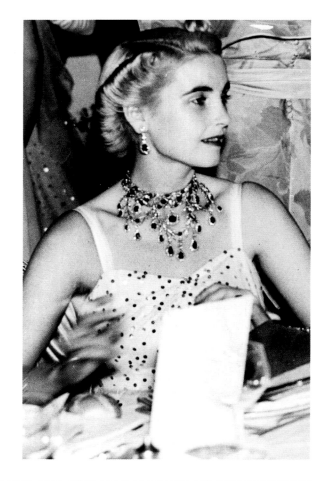

keeping score. A meticulous archivist, Lambert filed away clippings pertaining to the Paris Dressmakers' Poll. Of particular interest to her was the fact that so many Americans appeared alongside the Continental swells, and that the scale of a winner's fortune did not necessarily correlate with her Poll ranking. "I had always watched it," Lambert confessed in the 1970s, "because it was a piece of social history." It is likely that by at least 1933 the Dressmakers' Poll had secretly passed into the hands of Mainbocher, the Chicago-reared, Paris-based couturier renowned for designing Baltimore divorcée Wallis Simpson's startlingly simple "Wallis blue" silk gown for her 1937 marriage to the Duke of Windsor. Accentuating Simpson's boyish frame and deep blue eyes, the narrow, long-sleeved frock (which had been dyed 67 times to achieve the correct shade) was the most copied dress of a generation. "Main" had such a deft touch that it was said that he possessed the skill not only to transform a woman into a lady but also to make it appear as if her mother had been one, too. "Ladies who wear Mainbocher suits," his *vendeuse* said, "never sweat." In 1967, Mainbocher divulged that he had covertly transformed the Poll into "a publicity stunt for my Paris house," orchestrated "by the *directrice* of my salon with the aid of a helpful journalist. Naturally, the top awards went to my own clients with a few others sprinkled in for verisimilitude. We did not take it all seriously at the time, but others did; indeed, it was a sensation, and it eventually passed out of our hands altogether. Since then, there has been a stupendous escalation of the original idea."

## *The* Last Paris Poll

*The New York Times* published the last of Mainbocher's Polls out of a still-unoccupied Paris on January 29, 1940, under the headline BRITISH DUCHESSES ARE BEST DRESSED. Illustrated with photos of the victors, the story continued: "The Duchesses of Windsor and Kent today wrested the title of world's best dressed woman away from Mme. Anténor Patiño, the 'Tin Princess' whose husband is heir to one of the world's biggest fortunes....A new challenger, Mrs. James H. Cromwell, the former Doris Duke, appeared in the list in fourth place.... The war has failed to dim feminine enthusiasm for pretty dresses or to affect good taste, and the French dressmakers polled in the annual championship of style concluded that, war or no war, women are better dressed today than at any time in history since Cleopatra charmed Antony." The remaining "champions of style" were: **5. The Begum Aga Khan.** The Imam's third and

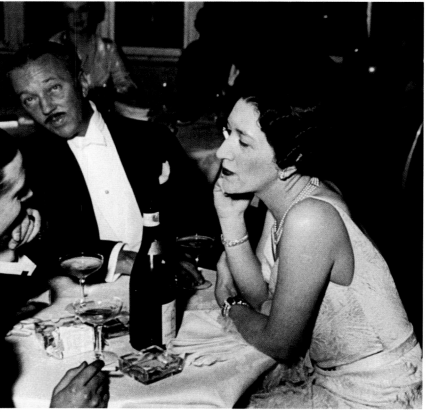

TOP: the 25-year-old **BARBARA HUTTON** at the Grosvenor House Hotel, Mayfair, London, May 30, 1938. One year earlier, she had built a 35-room London residence, Winfield House, which she later donated to the U.S. government. BOTTOM: **KITTY MILLER,** daughter of art-collecting financier Jules Bache, with William Rhinelander Stewart at the St. Regis Hotel, New York, 1936. RIGHT: the seven-times-married **BARBARA HUTTON** and her poodle watch a tennis match at the Everglades Club, in Palm Beach, January 18, 1940.

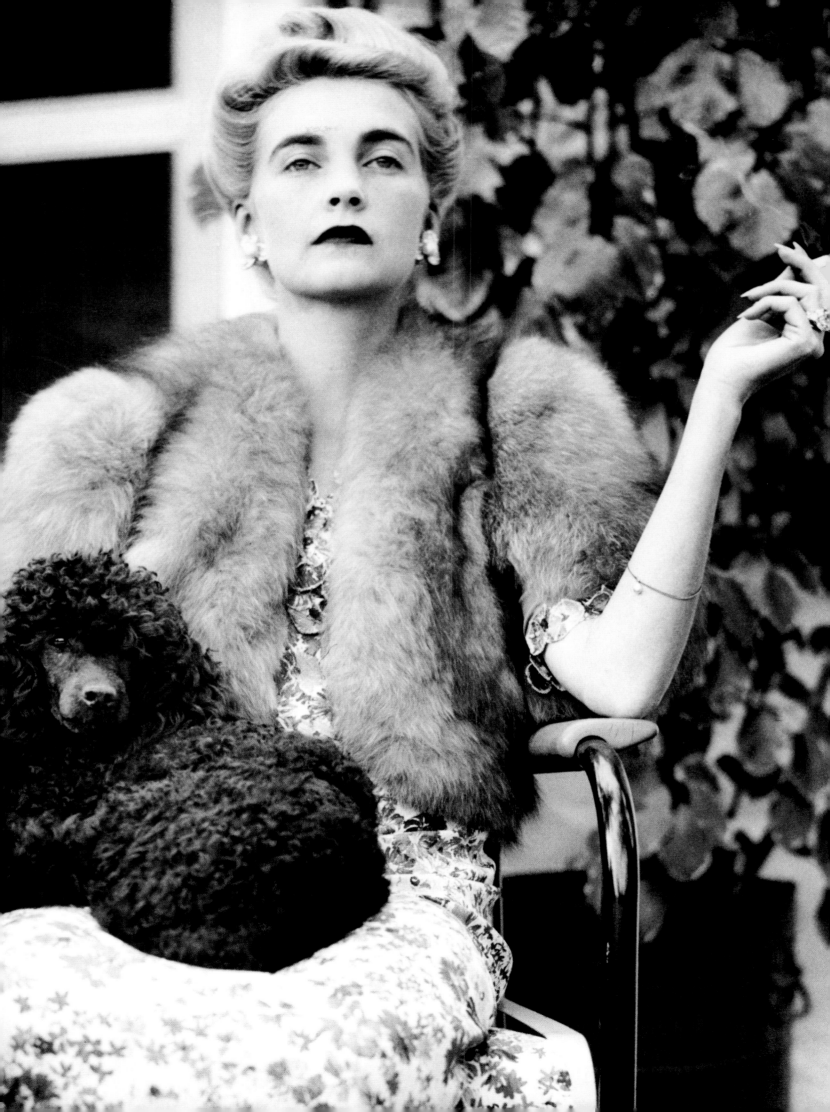

penultimate wife, former Parisian dress-shop keeper
Andrée Joséphine Carron.

**6. Mrs. Gilbert Miller.** Kathryn "Kitty," the
imposing, brittle wife of the prolific Broadway
producer and the daughter of art-collecting Wall
Street banker Jules Bache. "She has unfailing taste,"
decorator Billy Baldwin said, "based on knowledge
and experience, not on caprice."

**7. Baroness Eugène de Rothschild.** International
glamour figure and friend of the Duchess of Windsor.
The former Kitty Wolff, she had previously been
married to Dr. Spotswood, a Philadelphia dentist, and
to an Austrian aristocrat, Count Schoenborn. It was
to Baron Eugène de Rothschild's house near Vienna
that the Duke of Windsor fled for three months
immediately after announcing his abdication in 1936.

**8. Mrs. Harrison Williams.** Born Mona Strader, she
was the hypnotically beautiful daughter of a Kentucky
horse breeder and noteworthy not only for her style but
also for her succession of rich or titled husbands. Mr.
Williams, the "Utilities King," was her third, and, at the
time, the richest man in America, with a net worth of
$680 million. Deified as "a rock crystal goddess" and
"a chef d'oeuvre" by Cecil Beaton, Mona was also
immortalized by Cole Porter in his 1936 song *Ridin'
High*, fictionalized by Truman Capote in *Answered
Prayers,* and lampooned by *Town & Country* in a 1938
poem on the occasion of her slip from the Poll's No. 1
spot. Her eerily enormous eyes, said Salvador Dalí,
who painted her, "seem to capture whatever light there
is in the room." In the 1944 Bette Davis film *Mrs.
Skeffington*, the deluded title character tells herself,
"You are Venus and Mrs. Harrison Williams combined."
When Mr. Williams was under investigation for financial
malfeasance, the first question posed to him was
"Is it true that your wife ordered 75 sweaters from
Schiaparelli?" The normally prickly *Herald Tribune*
fashion expert Eugenia Sheppard said that Mona's
turnouts were so superb "nobody can ever describe
what she wears." Foremost a Balenciaga client (she
took to her bed when he announced his retirement),
Mona popularized the vogue for charm bracelets,
aquamarines, halter necks, tulle skirts, ice-white
hair, rhinestone-buckled patent pumps, black
dresses instead of suits for day, and white velvet
carpets, the better to display it all.

**9. Barbara Haugwitz-Reventlow.** The original "poor
little rich girl," she was the seven-times-married
Woolworth heiress Barbara Hutton, reputed in her
day to have ordered an entire Lanvin collection at a
cost of a million dollars. According to a Cole Porter
lyric from 1936, "Countess Barbara Hutton has a
Rolls-Royce built for each gown." Hutton, a law
unto herself, occasionally wore a tiara in the daytime.

**10. Queen Elizabeth.** (The Queen Mother—clearly, a
Mainbocher red herring).

**MARINA, DUCHESS OF KENT,** leaves her house at 3 Belgrave Square to
attend the coronation of her brother-in-law, King George VI, May 1937. Her husband,
the Duke of Kent, walks ahead of her, in naval uniform. A great-granddaughter of
Czar Alexander II, Marina, while exiled in Paris, modeled for Molyneux, who went on
to design the duchess's dress for her 1934 royal wedding. Cecil Beaton noted that
Marina had "more Parisian dress sense than any other member of the English royal family."

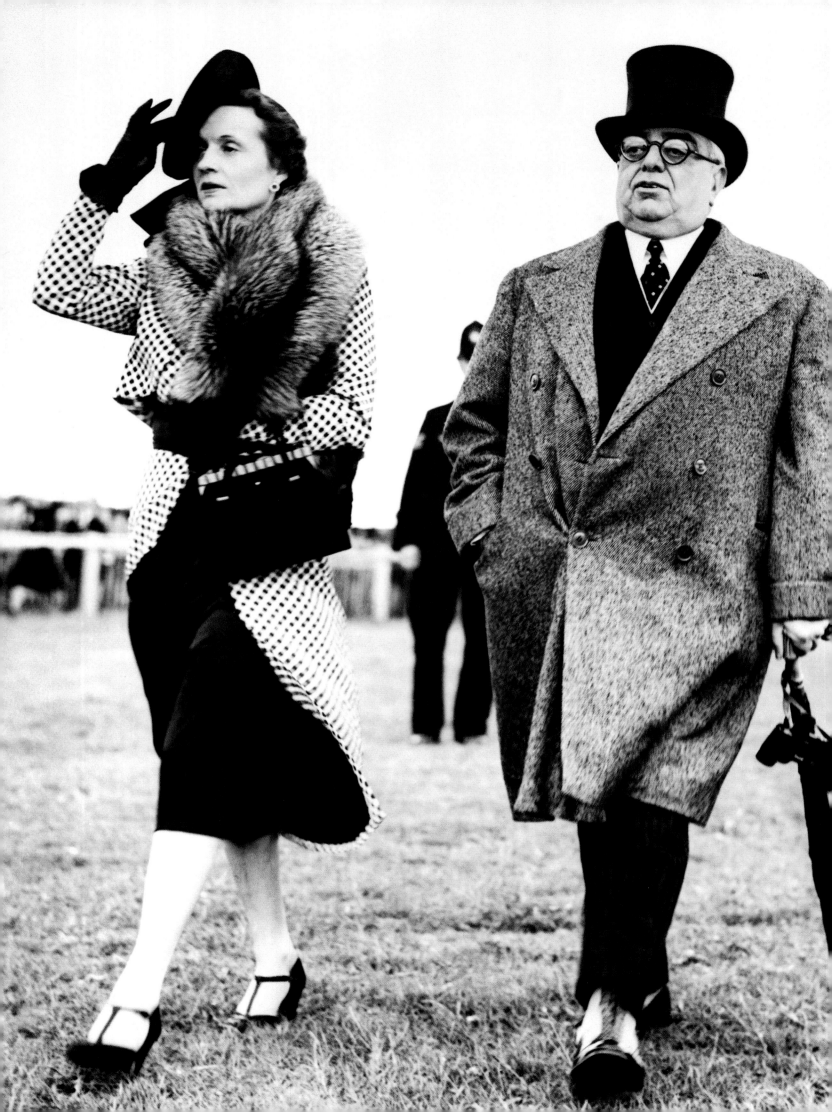

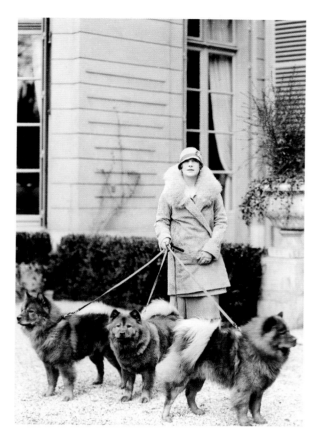

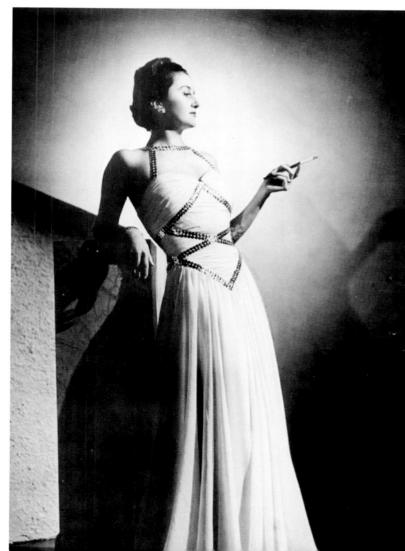

LEFT: The **BEGUM** (left) and **AGA KHAN** at Epsom, England, June 3, 1939. Formerly Andrée Joséphine Carron, a Parisian dress-shop owner, she was the Imam's third and penultimate wife. ABOVE: **BARONESS EUGÈNE DE ROTHSCHILD,** the former Kitty Wolff, of Philadelphia, with her family of Chow Chows in the garden of her Paris house. In June of the same year that she was named to the last Paris Dressmakers' Poll, Paris fell to the Nazis, and Kitty and her husband were among ten thousand Jews rescued at that time by the heroic Portuguese diplomat Aristides de Sousa Mendes. RIGHT: **MARÍA CRISTINA PATIÑO** in Mainbocher, 1939. Born a Borbón in Madrid, she was the third Duchess of Dúrcal and the first wife of Antenor Patiño, heir to a Bolivian tin fortune. Photo by Constantin Joffé.

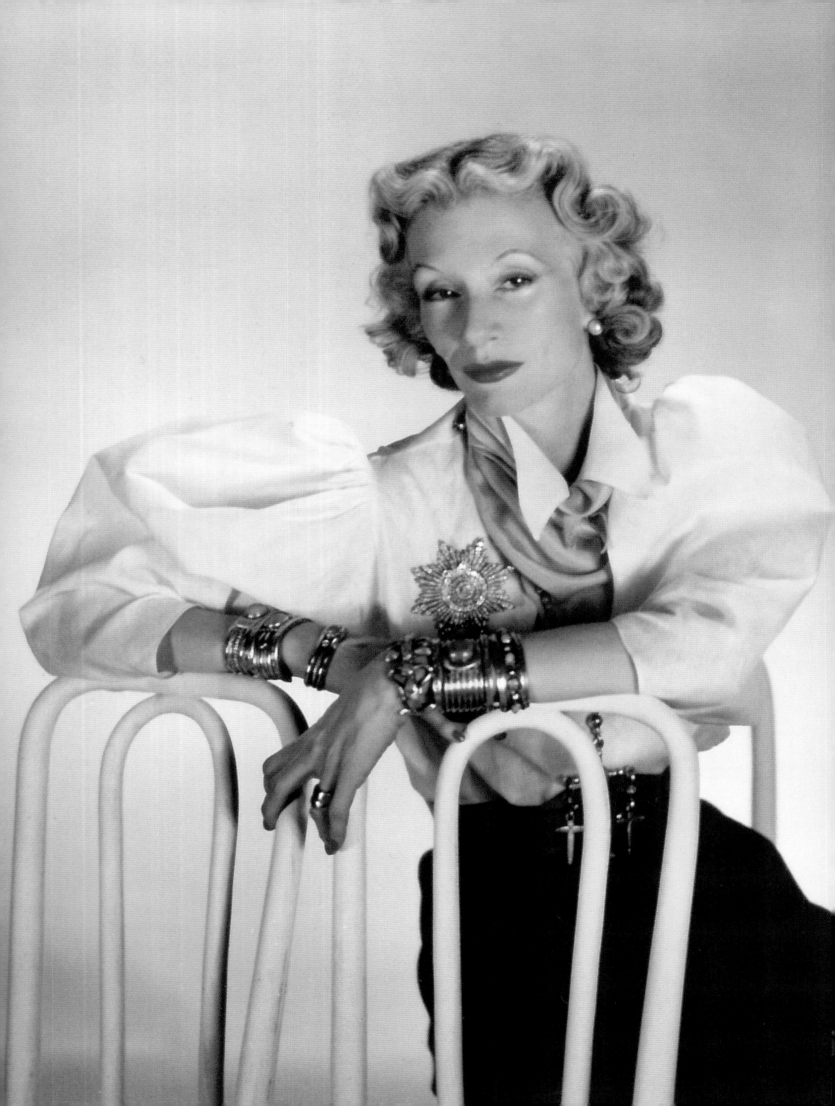

# The 1940s

## From FRIVOLITY to SOBRIETY

### Eleanor Takes Charge

Standard Oil heiress **MILLICENT ROGERS**, an aesthete, Cecil Beaton noted, "of remarkable originality" and "highly civilized tastes."
Photographed by Louise Dahl-Wolfe, circa 1948, Rogers wears a Valentina blouse with Native American jewelry, which she collected.
Rogers moved to Taos, New Mexico, and became an advocate for the rights of indigenous peoples.

# THE
# LISTS

*The honorees on the Lists opening each chapter were initially voted onto
the International Best-Dressed List during that decade to which
the chapter is devoted. The names are arranged in alphabetical order.
If a photograph of an honoree appears in that chapter, or in another, the name is
printed in gold. For a chronological List of every person elected, and in
which category, please see the "The Complete Lists," starting on page 264.*

NEAR RIGHT: MGM's fast-talking **ROSALIND RUSSELL,** 1948—"ultimately," designer James Galanos said, "*the chic one in film.*"
TOP: **MILLICENT ROGERS** by the beach, circa 1940. BOTTOM, LEFT: French-born soprano **LILY PONS**—who made New York's
Metropolitan Opera her home base—just before her 50th birthday, 1948. For decades the diminutive coloratura was
opera's most glamorous personality. Pons expanded her audience through radio broadcasts and Hollywood films and was
awarded a Légion d'Honneur in 1938. BOTTOM, RIGHT: debutante turned Hollywood star **GENE TIERNEY,** 1940.

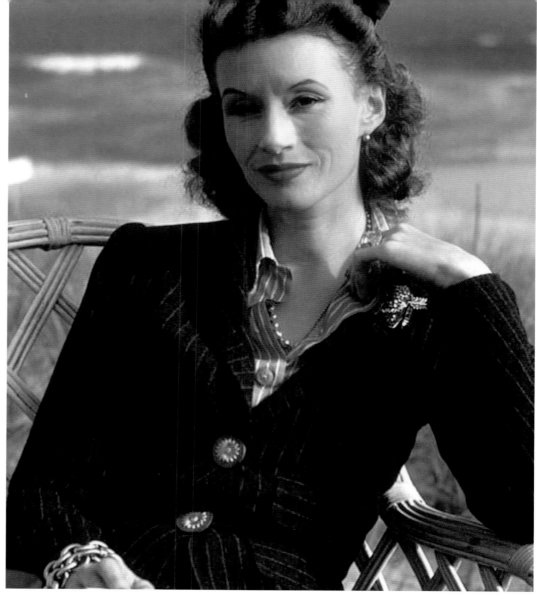
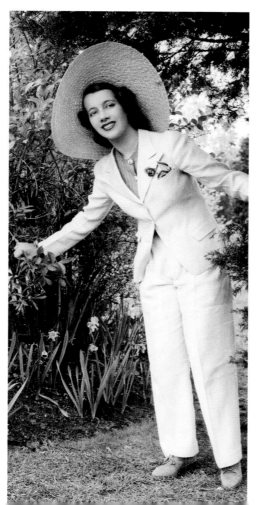
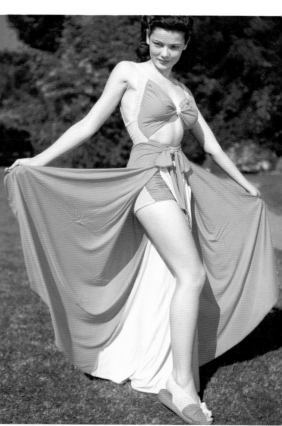

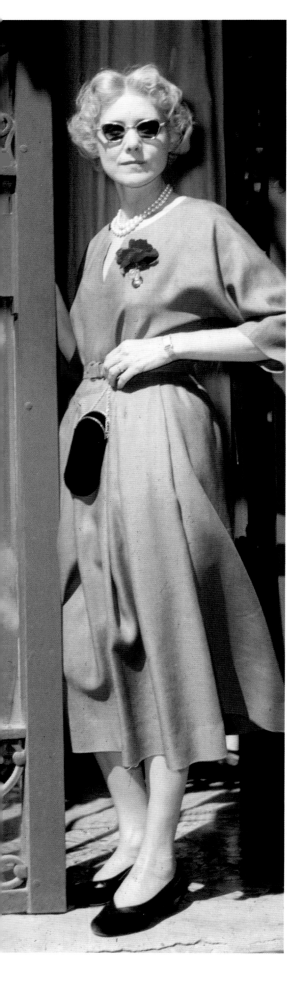

# THE LIST

HÉLÈNE ARPELS

ADELE ASTAIRE

MME. CHIANG KAI-SHEK (SOONG MEI-LING)

INA CLAIRE

LEONORA CORBETT

MRS. ANDRÉ EMBIRICOS (BEATRICE AMMIDON)

MME. FELIPE A. ESPIL (COURTNEY LETTS BORDEN)

MAXIME DE LA FALAISE

LYNN FONTANNE

THELMA FOY

JANET GAYNOR

SOPHIE GIMBEL

NANCY "SLIM" HAWKS (LATER HAYWARD, KEITH)

AUSTINE "BOOTSIE" HEARST

MRS. RODMAN ARTURO DE HEEREN (AIMÉE LOPES DE SOTOMAIOR)

LOUISE HOPKINS (LATER GATES)

BARBARA HUTTON

H.R.H. MARINA, DUCHESS OF KENT

MRS. S. KENT LEGARE (MINNIE ZIMMERMAN)

MRS. HOWARD LINN (LUCY MCCORMICK BLAIR)

THE HON. CLARE BOOTHE LUCE

MARY MARTIN

KATHRYN "KITTY" MILLER

MRS. ROBERT W. MILLER (ELIZABETH JANE FOLGER)

BARBARA "BABE" MORTIMER (LATER PALEY)

MRS. ORSON MUNN (CARRIE NUNDER)

DOROTHY HART PALEY (LATER HIRSHON)

PRINCESS NATALIA PALEY

MURIEL "MOLLY" PHIPPS

LILY PONS

MILLICENT ROGERS

ROSALIND RUSSELL

MRS. ROBERT SARNOFF (ESME O'BRIEN)

MRS. THOMAS SHEVLIN (LORRAINE ARNOLD ROWAN)

MRS. ROBERT SHERWOOD (MADELINE HURLOCK)

JANET RHINELANDER STEWART

GLADYS SWARTHOUT

MARGARET "PEGGY" TALBOTT

MRS. LAWRENCE TIBBETT (JANE "JENNIE" MARSTON BURGARD)

GENE TIERNEY

VALENTINA

MRS. ALFRED G. VANDERBILT (JEAN HARVEY)

MONA WILLIAMS (LATER BISMARCK)

THE DUCHESS OF WINDSOR

FAR LEFT: *Vanity Fair* editor, U.S. congresswoman, and ambassador to Italy **CLARE BOOTHE LUCE,** wearing her signature brooch of a crystal vase holding a flower. TOP, LEFT: the ill-fated **MARGARET "PEGGY" TALBOTT** in sidesaddle habit. TOP, RIGHT: the flawless **BARBARA "BABE" CUSHING MORTIMER PALEY,** society paragon and former *Vogue* editor, in a John-Frederic shantung-silk suit inspired by American folk portraits, 1941. BOTTOM: a Cecil Beaton portrait of **PRINCESS NATALIA PALEY,** the morganatic daughter of the Grand Duke Paul of Russia, uncle of Czar Nicholas II. Natalia married couturier Lucien Lelong in Paris, acted in Hollywood, and worked for Mainbocher in New York.

> *"A creation wrought by human nature*
> *is of subtler human interest,*
> *of finer fascination, than one nature*
> *alone has evolved."*
>
> —TRUMAN CAPOTE

---

## *The* First List

Astutely presaging that war would terminate the Paris Poll—when the city fell to the Nazis in June 1940, most couture houses went dark—Lambert requisitioned the P.R. tool for the Dress Institute. "I was desperate," Lambert later explained, "reaching for anything that might help." She figured at the very least she would "carry the torch" for Paris "until they could pick it up again." To ensure that her List would reappear on schedule, Lambert, in the late fall of 1940, mailed out 50 mimeographed ballots to fashion savants: milliners Mr. John and Lilly Daché; designers Sophie Gimbel, Jo Copeland, and Valentina; the design staff of Bergdorf Goodman; retail executives; and the fashion editors at *Vogue, Harper's Bazaar,* the news syndicates, and the New York papers. She tabulated their votes and circulated the outcome as a Dress Institute press release, which *The New York Times* printed near-verbatim.

"Mrs. Williams Tops Best-Dressed List," the paper declared on Friday, December 27, 1940, on page 17, adjacent to a "Books of the *Times*" feature discussing Somerset Maugham. "The selection just announced," the article stated in paragraph two, "was for many years compiled in Paris, but was taken over this Winter for the first time by the key designers, fashion authorities and members of the fashion press in New York, as the world's new style center."

In one swift stroke, Lambert had not only redrawn the map of fashion with Manhattan as its capital but also composed a roll call as all-American as the nation's armed forces. "America is a huge country full of well-dressed women," Lambert stated in her Dress Institute press release, a *coup de grâce* for the old-world Poll. "The Paris designers spoke for Paris alone, while we must speak for the world."

Following Mona Williams's lead were:

*2. Mrs. Ronald Balcom.* Millicent Rogers, the haute bohemian, physically frail Standard Oil heiress with a penchant for folkloric and historical clothing mixed with (or designed by) Mainbocher, Schiaparelli, Valentina, and Charles James. In 1949, Rogers donated 24 rare examples of James's work to the Brooklyn Museum. "With her face like a lotus flower and her figure like a Chinese statuette," Cecil Beaton wrote, the flamboyant Rogers "saw to it that anyone who observed her should never forget the occasion."

*3. Mrs. Thomas Shevlin.* Lorraine Arnold Rowan McAdoo. The Pasadena-born wife of a sportsman, eight years her junior, she herself was the daughter of an L.A. real-estate developer and stepdaughter of an Italian prince. "Colorful and erudite and bright and humorous," according to Aileen Mehle, Lorraine had left her investment-banker husband, Robert McAdoo, for Shevlin—who had, among many other properties, a plantation in Kenya. Mona Williams had introduced the couple to each other. Subsequently, the sleek brunette wed Senator John Sherman Cooper of Kentucky. Mr. Shevlin's later spouse, Durie, was rumored to have been J.F.K.'s secret first wife.

---

**NANCY "SLIM" HAWKS KEITH** by Horst, 1949. Celebrated for her sporty style, Slim, married at the time to director Howard Hawks, wears a short wool Pauline Trigère coat. Though the Californian vaunted her own "talent for individuality" in dress, Slim said she was "nothing but amused" when she was elected to the List. She claimed that, for her, the accolade was akin to winning the title of "Miss Butterfat Week in Wisconsin."

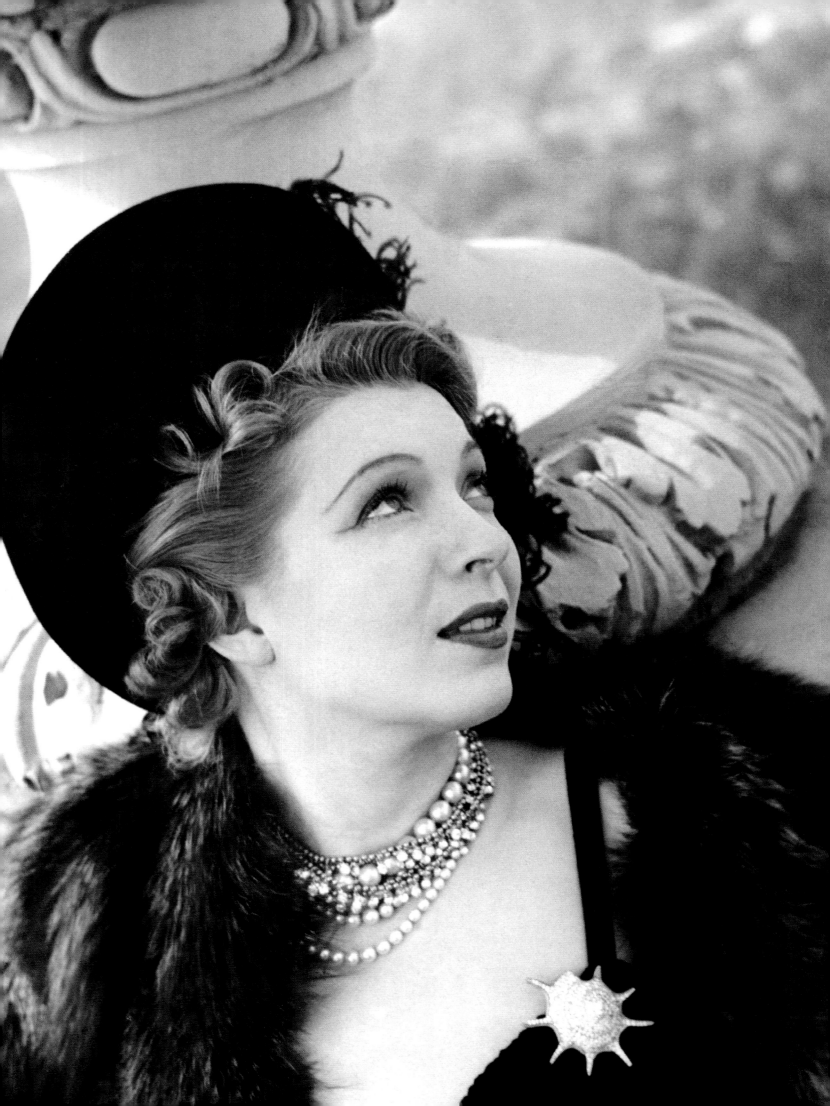

**4. Mrs. Thelma Foy.** The uncannily soigné daughter of automotive tycoon Walter P. Chrysler, Thelma was capable of buying out a designer's entire collection—although Lambert maintained that her reputation for lavishness was exaggerated. One year, her husband, Byron Foy, implored Lambert to omit his wife. "His finances were being investigated in Washington," Lambert recalled, "and he said, 'I don't want people to think that my wife spends a lot on her clothes.'" For milliner and photographer Bill Cunningham, Thelma was "the most chic woman in New York," with Dior ball gowns so spectacular they could make any other dress "look like a rag." Upon her 1957 death, 132 pieces of her clothing entered the Metropolitan Museum of Art's collection, and, as *The Ladies' Home Journal* noted the following year, "there was, of course, no machine stitch anywhere."

**5. Countess Haugwitz-Reventlow.** Barbara Hutton.

**6. Mrs. William Paley.** Dorothy, the CBS founder's first wife. A sophisticated beauty, Dorothy was previously married to a Hearst scion, and, after divorcing Paley, she wed the stockbroker Walter Hirshon. An avid patron of the arts and an education advocate, she worked briefly as a columnist for *Harper's Bazaar*.

**7. Mrs. Howard Linn.** The former Lucy Blair McCormick, she was a Paris-dressed Chicago hostess, interior decorator, and champion sidesaddle horsewoman. No stranger to publicity, she shilled for Simmons mattress ads in the 1920s. Late in life, she donated 150 couture pieces to the Chicago History Museum.

**8. Gladys Swarthout.** A glamorous mezzo-soprano from the Ozarks, she became a beloved star of opera, film, and radio.

**9. Ina Claire.** Sophisticated comedienne commended by Cecil Beaton for bringing "real clothes" to the stage. When she was re-elected by the Poll a few years later, the actress told *Time*, "I decline absolutely," while posing in front of her closet.

**10. Mrs. Gilbert Miller.**

**11. Mrs. Lawrence Tibbett.** Jane "Jennie" Marston Burgard, a banker's daughter and the wife of the baritone entertainer (her third husband).

**12. Lynn Fontanne.** Stage actress who co-starred in clever comedies of manners with her longtime husband, Alfred Lunt. Celebrated in verse by the otherwise acerbic Dorothy Parker, she favored ethereal draped and floating looks by Valentina.

**13. Mrs. S. Kent Legare.** Formerly Minnie Elizabeth Zimmerman, of St. Matthews, South Carolina, she was a leading hostess of Washington, D.C. Often dressed in Paris couture from Francevramant, she had married into an old Charleston family with a history of serving in presidential Cabinets.

**14. Mrs. Harold Talbott.** Born Margaret "Peggy" Thayer on the Main Line, she was the big-game hunting, equestrienne deb daughter of a *Titanic* survivor. Married to a sometimes shady aeronautics pioneer and U.S. Air Force secretary, she later threw herself from the 12th story of her Fifth Avenue apartment building.

**15. Mrs. Rhinelander Stewart.** Formerly Janet Newbold, she was a witty hostess and society beauty, idolized for her severe, center-parted, marcel-waved white hair and her austere habit of rarely spending more than $20 on a dress. A costly garment, she reasoned, might detract from the otherworldly perfection of her oval face. When Minnie Cushing was divorcing Vincent Astor, she suggested he replace her with Janet. Astor proposed to Janet, saying he was ill and hadn't much longer to live, so she would shortly inherit millions. Janet replied, "What if you do live?" (Astor instead married Brooke Russell, a future I.B.D.L. Hall of Famer.)

Interestingly, the new List's selections seem to have been guided not only by the America First proclivities of Lambert and her 50 voters but also by the biases of the tyrannical society columnist Maury Paul, the first "Cholly Knickerbocker"—who, like Eleanor's husband Seymour Berkson, toiled for Hearst's INS newspaper syndicate. Coiner of the term "café society," Paul fawned over Janet Stewart and more or less invented the phenomenon of Mona Williams. On the other hand, he loathed Elsie de Wolfe, who never made it onto a Lambert List.

Possibly irritated by the Windsors' pro-appeasement politics or, more likely, by the despotic Mainbocher's refusal to participate as a voter, Lambert made certain by means of her press release that the world knew that the designer's most famous client had received only a paltry two votes—a fact that the *Times* gleefully printed in the subhead to its story.

# *The* War

Though it was unveiled on December 30, 1941, just three weeks after the bombing of Pearl Harbor, Lambert's second Dress Institute List was not buried by breaking war news (Hong Kong and Borneo surrendering to the Japanese, rubber rationing instituted). Among the newcomers tapped by voters were

---

INA CLAIRE by Toni Frissell. A stage and film actress,
Ina was best known for starring in the comedies of
S. N. Behrman. Here she wears a black velvet
evening halo hat from Bergdorf Goodman.

Mrs. Stanley Mortimer, the exquisite *Vogue* editor, born Barbara "Babe" Cushing, and Mrs. Rodman Arturo de Heeren, a jet-haired Brazilian beauty. Born Aimée Lopes de Sotomaior, magnificently bejeweled, and previously linked to both a South American dictator and a British tycoon, de Heeren personified Nancy Mitford's conviction that the *ne plus ultra* of chic was a South American dressed in Paris couture.

Less of a hothouse choice was the wisecracking MGM clotheshorse Rosalind Russell, whose *Design for Scandal* had just been released. She became the first working Hollywood star to climb onto the List—causing Kitty Miller to snipe to *Time*, "I laughed when I saw Roz Russell's name." Perhaps in retribution, Miller, whom Maury Paul reviled as an insupportable snob, never appeared on the List again. (In 1965, however, Lambert redressed this neglect by quietly placing her in the Hall of Fame—prompting Miller to grouse, possibly disingenuously, that her husband "asked Eleanor to take my name off it, but it still remains.")

America's entry into the war was acknowledged only obliquely in Lambert's 1941 List, by the inclusion of retired silent-film slapstick siren Madeline Hurlock, whose husband, playwright Robert Sherwood, had become overseas director of Franklin Roosevelt's Office of War Information.

---

## *1942-44*
# Best Dressed *in* Wartime

Perhaps out of respect for the American troops surging in Guadalcanal and North Africa (and maybe acknowledging the new L-85 regulation of such feminine staples as nylons and pleats), the List was halted in 1942. In 1943, eager to resume operation, Lambert advised her 50 voters—now including Norman Norell and manufacturer Maurice Rentner—that "after two years of wartime shortages, restrictions, and psychological conflicts in fashion, the press is very much interested in a new type of best dressed women list, 'Best Dressed Women in Wartime.'" As the Allies bombed Germany round the clock, Lambert implored her group to consider women who had responded to the worldwide conflict with "good taste and ingenuity." Lambert proposed as an exemplar Mrs. Cornelius (Lorraine) Dresselhuys, an asbestos heiress and diplomat's wife who had exchanged "overdressing" for "simplicity." Before the war, the *Queen Mary* would follow her to London with two Rolls-Royces, 52 trunks of shoes, furs, and dresses, and 30 gallons of American water, just for shampooing her flaxen bob.

Though Mrs. Dresselhuys failed to impress the voters with her wartime economies, other, more topically political figures made the cut. Former *Vanity Fair* editor Clare Boothe Luce, then a Connecticut congresswoman, tied with the Duchess of Windsor for first place. Luce had dutifully traded in such frothy extravagances as the diamond-embellished ermine bed jacket in which she had written her play *The Women* for sober navy suits, adorned with a red rose in a miniature crystal vase instead of a showy brooch. (Her wardrobe re-adjustment did not, however, prevent President Roosevelt from dismissing Luce as "a sharp-tongued glamour girl of 40.") In any case, Luce had finally fulfilled a request made years earlier by her second husband, Time-Life founder Henry Luce, that she return from a trip to Paris the best-dressed woman in America.

Another war-related winner was Mrs. Harry Hopkins (née Louise Macy), wife of President Roosevelt's closest adviser. Before her marriage, she had been a Hattie Carnegie model and a mistress of Jock Whitney, who magnanimously showered her with rubies. Yet precious-metal shortages only made Louise more resourceful with her jewelry acquisitions. When Harry had his decayed teeth extracted and replaced with false ones, Louise brought her husband's gold fillings to Fulco di Verdura to turn into earrings. In a similar spirit, Mona Williams (No. 4 in 1943) reset her aquamarine jewelry in the form of bombing airplanes.

Extending the List for the first time to personalities of the Eastern Hemisphere, Lambert praised Mme. Chiang Kai-shek, ranking No. 6 in 1943, for her keen "perception of the part which dressing beautifully plays in wartime morale." The Dress Institute's accolade had capped off what had been a banner year for the wife of the future dictator of Taiwan. In February, she had addressed Congress—only the second woman ever to do so—to rally support for her husband's anti-Mao Nationalist Party. In March, *Time* had showcased her on its cover. And in November—alongside Roosevelt, Churchill, and her husband the Generalissimo—she had helped forge Asia's future at the historic Cairo Conference. Though she wore native qípáos throughout her travels, Mme. Chiang Kai-shek demurred that "the only thing Oriental about me is my face."

---

**MME. CHIANG KAI-SHEK** with Winston Churchill in Cairo, Egypt, where they conferred with President Franklin Roosevelt and Generalissimo Chiang Kai-shek about military actions against Japan, November 1943. The Wellesley-educated Mme. Chiang Kai-shek wears a traditional Chinese qípáo mixed with Western accessories.

36

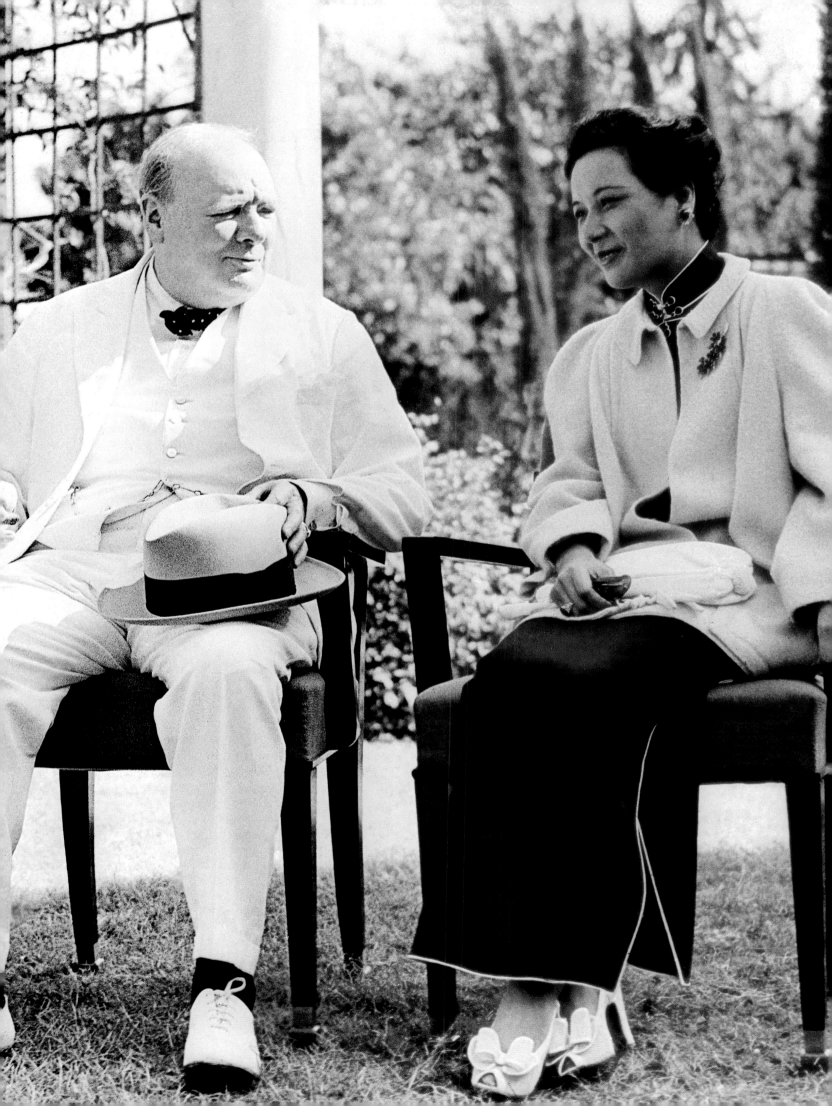

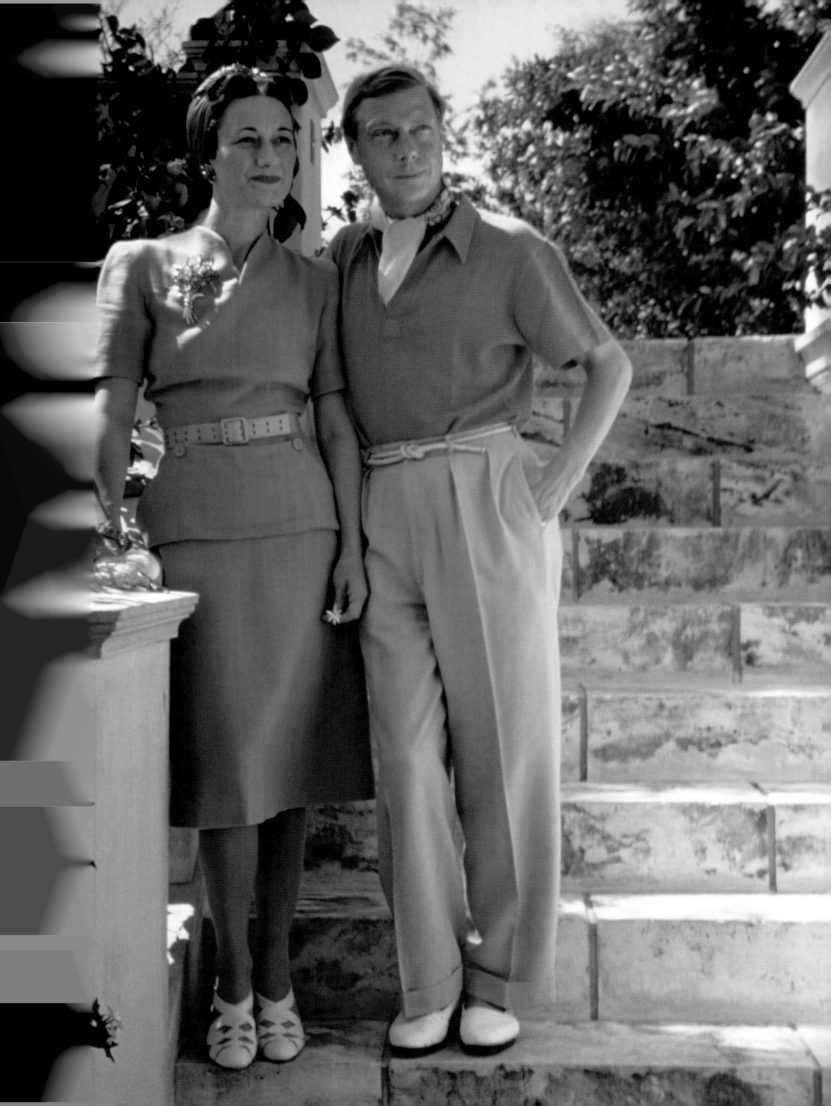

## Postwar, *1945-47*
# Return *to* Normalcy *and the* Duchess's Jewels

In 1945, the List's restoration of the Duchess of Windsor—who had nearly vanished the previous year—to a top spot signaled for Lambert, "a swing back toward normal interest in fashion." Accordingly, Lambert led the following year's press release, dated December 27, 1946, with a newsflash: "Though the Duchess of Windsor lost her jewels, she has regained her title of best dressed woman in the world." Two months before, the Duke and Duchess of Windsor had visited the Earl and Countess of Dudley with a convoy of three army trucks, piled with dozens of their trunks (the Duchess purchased more than 100 dresses a year) and one special case overflowing with the Duchess's fabled jewels. Early the next morning, the case was discovered, opened and nearly empty, on the Dudleys' golf course. The Dudleys told police they believed the Duchess had "deserved" the theft as she had not bothered to avail herself of their safes. With the crime unsolved and insurance money on the way, the Windsors sailed for New York. Her presence in town and the sensational scuttlebutt about the heist seem to have earned the Duchess sympathy votes from Lambert's team.

But in the Dress Institute's patriotic lineup of 1946, it was not in fact the Duchess but the outdoorsy Slim Hawks who led the pack. Her director husband, Howard Hawks, had earlier that year opened *The Big Sleep,* starring the sultry Lauren Bacall, whom Slim had discovered on *Harper's Bazaar*'s cover. It was on the rangy Slim that the starlet based her own man-tailored, sporty look. "I have a tall, skinny frame that clothes look well on," Hawks remarked. "Seriously, just say that I'm a great believer in simplicity in clothes." (A dozen years later, after her name had vanished from the List permanently, Slim Hawks claimed, "I thought it was silly then and I do now. Making the list doesn't require brains or skill. I was very pleased when my name dropped out.")

Lambert, for whatever reason, couldn't resist teasing Clare Boothe Luce, who had withdrawn from her 1946 re-election race and had plummeted to 10th place on the List, by joking that the retiring congress-woman's "slip is showing." Meanwhile, the newly divorced Babe Mortimer appeared as No. 3—six slots ahead of Dorothy Paley, whose berth in a matter of months she would usurp as the wife of CBS founder William S. Paley. Lambert never ceased to admire how the willowy American-born, American-married, and American-dressed Babe, between husbands, "earned her own living" and remained, without hats and with minimal jewelry, "best dressed on nothing a year."

# *1948:* Fashion Professionals

In 1947, Lambert noted that four women who had attracted enough votes to be placed in the top 10 had to be disqualified because "it was decided by authorities of the Dress Institute that their affiliation with fashion designing made them ineligible." Participating in the fashion industry's postwar recovery period, Lambert decided to remedy the situation by improvising a supplementary "sister list," "Best-Dressed Fashion Professionals," for 1948. On it were the dramatic, Kiev-born Valentina, whose financier husband, George Schlee, was reportedly Greta Garbo's lover; Sophie Gimbel, a.k.a. Sophie of Saks, prolific proponent of the low, decorative neck-line and wife of the store's president; British-born, six-foot-tall aristocratic beauty Maxime de la Falaise, then a designer at Paquin; and the hauntingly glamorous White Russian, Mrs. John C. Wilson. Born Princess Natalia Paley, she was a morganatic first cousin to the last czar, a mannequin, an actress, and, implausibly, a lover of Jean Cocteau. Married to Noël Coward's producer and lover, Natalia Paley worked at the time of her naming to the List as a *directrice* for Mainbocher, who during the war had relocated his Paris fashion house to 6 East 57th Street. Also gracing the new 1948 group were two screen-goddess wives of Hollywood costume designers, Janet Gaynor and Gene Tierney, spouses of MGM's Adrian and Paramount's Oleg Cassini, respectively.

Though 1948 was a good year for designers, it was, Lambert acknowledged, "a bad year for the Republican party." Harry Truman, the incumbent, had just blindsided Thomas E. Dewey, the Democrats had regained control of both Houses, and "the beauteous ex-Congresswoman and playwright" Clare Boothe Luce, after a five-year streak, dropped off the List entirely. As it turned out, it was she, not Truman, who (to use Luce's words from her Philadelphia Republican convention address) was the "gone goose."

---

The **DUKE OF WINDSOR** with the **DUCHESS OF WINDSOR,** wearing an ensemble in her trademark blue, which matched her periwinkle eyes. The Duchess, for whom the Duke abdicated the British throne, famously said that, though she could never be the most beautiful woman in the world, she could be the chicest.

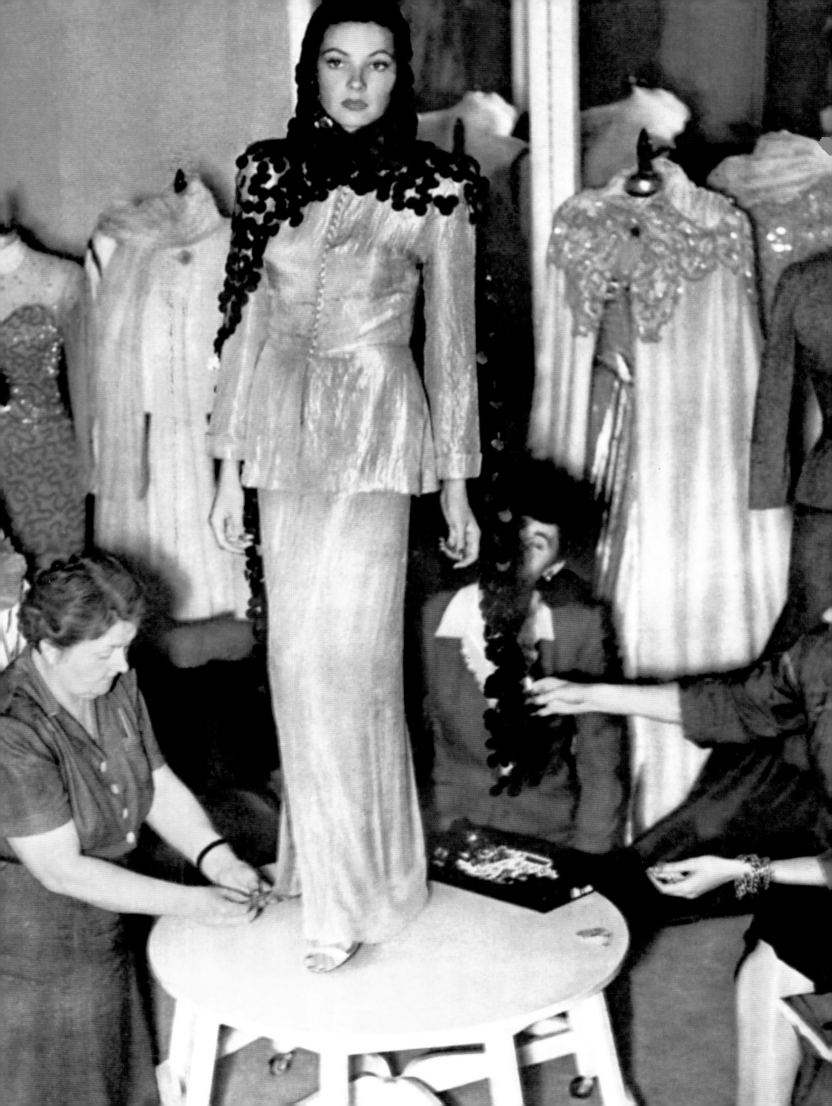

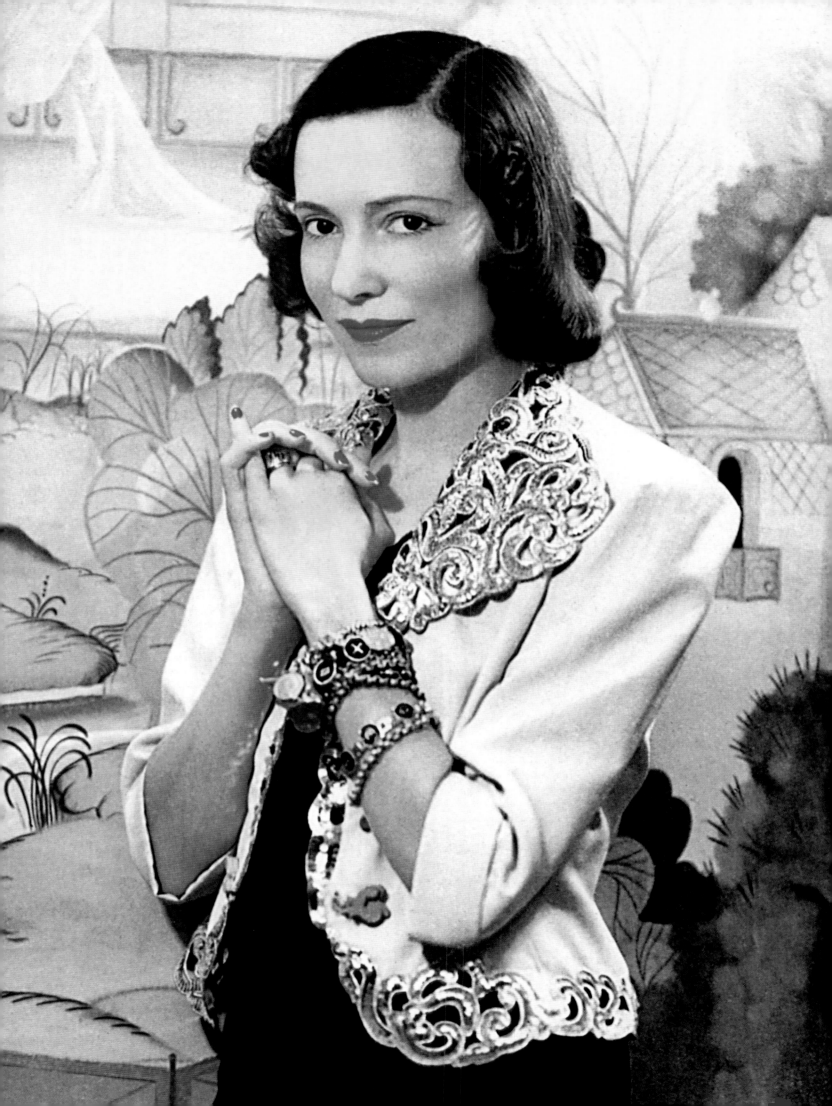

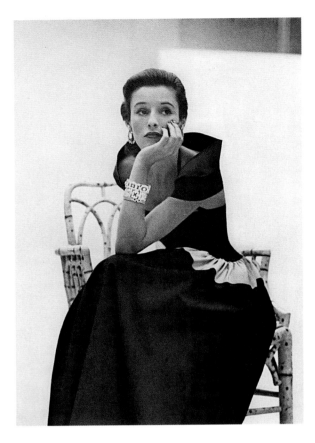

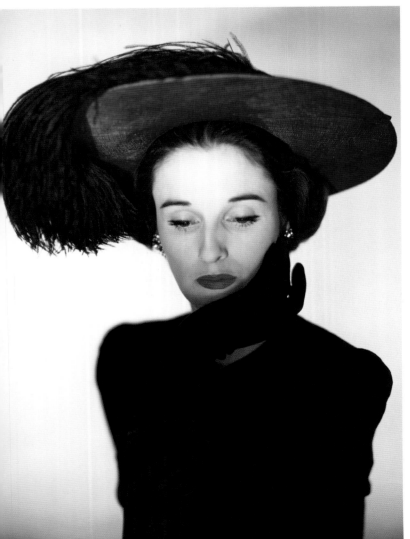

PRECEDING SPREAD, LEFT: **GENE TIERNEY** was among the first to arrive on the List in the Fashion Professionals category, as she had been married to Oleg Cassini, then a costume designer for Paramount Pictures. Here, Tierney is fitted by designer Bonnie Cashin in a dress of lamé, velvet, and sequins, for her lead role in Otto Preminger's 1944 masterpiece, *Laura*. RIGHT: **ADELE ASTAIRE**, Fred Astaire's older sister and dancing partner, photographed by Madame Yevonde. Adele retired from show business to marry Charles Cavendish, a British lord. By the time she was named to the List, Adele was remarried to the American banker and C.I.A. assistant director Kingman Douglass. Adele was known not only for her breezy style but also for her very salty tongue.

LEFT: **BABE CUSHING MORTIMER PALEY**, photographed by Erwin Blumenfeld, 1947. *Vogue* remarked that she "has a special talent for wearing clothes." Blumenfeld waxed more ecstatic: "The shape of her face is as attenuated as an El Greco. She has the most luminous skin imaginable and only Velasquez could paint her coloring on canvas. She has the greatness, the poise, and the dignity of one of those *grandes dames* whom Balzac described in his *Comédie Humaine*." ABOVE: Babe in a taffeta dress and diamonds, photographed by John Rawlings, 1946. Daughter of a prominent Boston brain surgeon, she was one of the three famously "fabulous Cushing sisters," known for their looks and their advantageous marriages. Babe's face had been reconstructed after a car crash, a misfortune that paradoxically added to her beauty. RIGHT: Babe, who patronized American more than French designers, photographed by Horst in a matte-rayon dress by Traina-Norell, 1946. Eleanor Lambert later called her "the super-dresser of our time." About Babe, Truman Capote wrote, "She had only one flaw. She was perfect. Otherwise she was perfect."

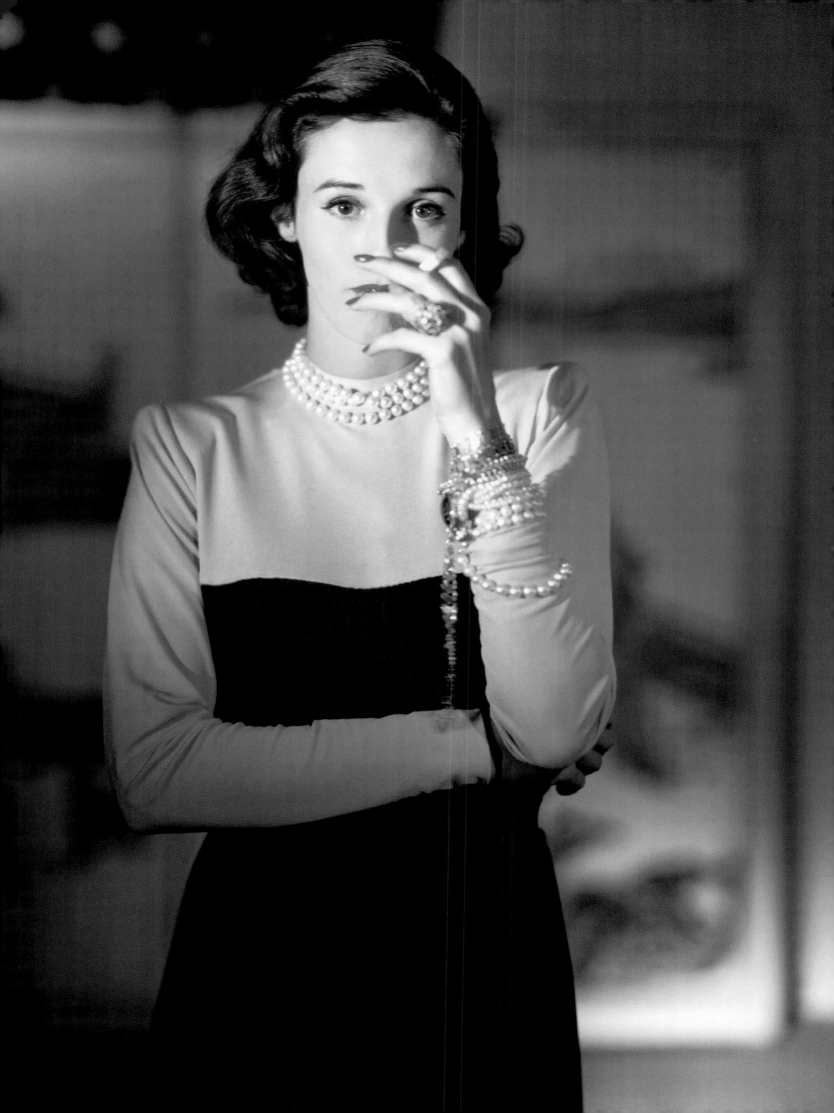

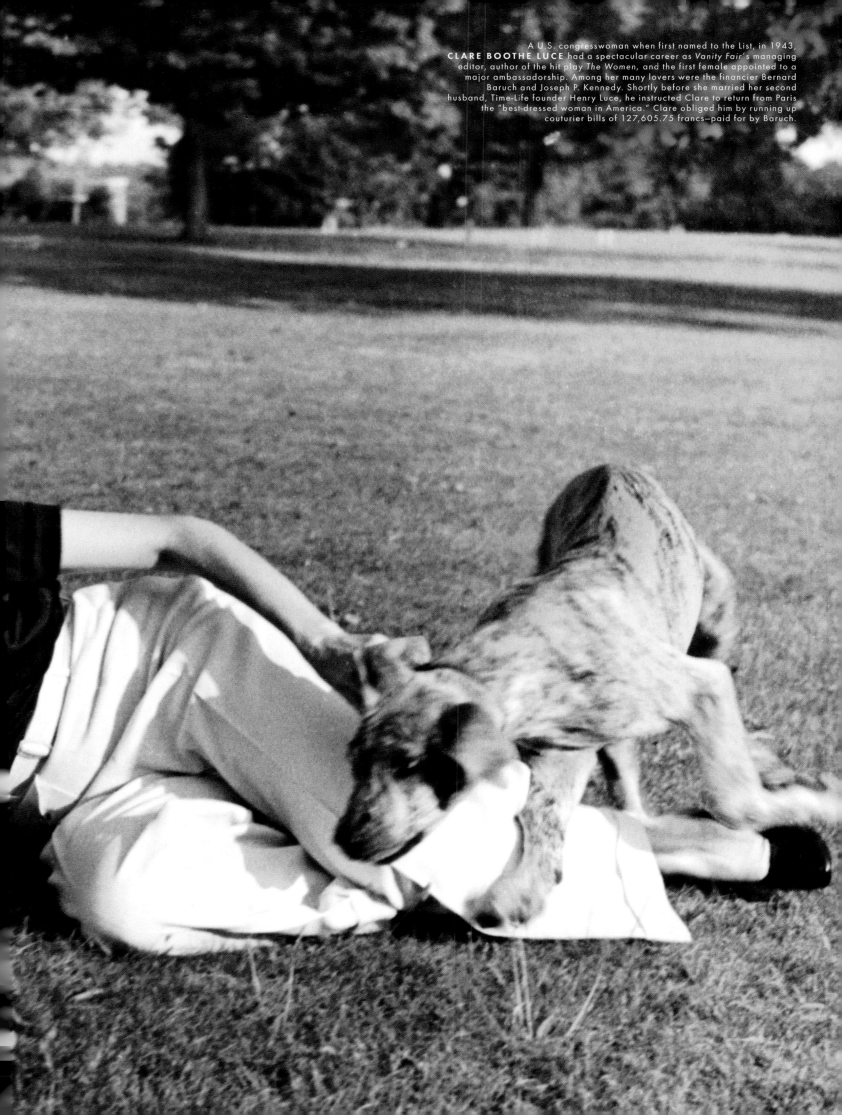

A U.S. congresswoman when first named to the List, in 1943, **CLARE BOOTHE LUCE** had a spectacular career as *Vanity Fair*'s managing editor, author of the hit play *The Women*, and the first female appointed to a major ambassadorship. Among her many lovers were the financier Bernard Baruch and Joseph P. Kennedy. Shortly before she married her second husband, Time-Life founder Henry Luce, he instructed Clare to return from Paris the "best-dressed woman in America." Clare obliged him by running up couturier bills of 127,605.75 francs—paid for by Baruch.

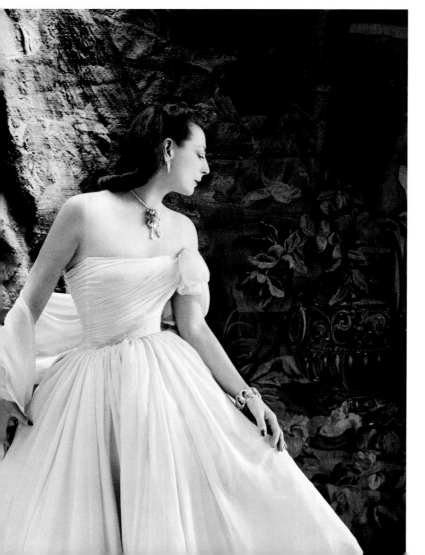

LEFT: Chrysler heiress **THELMA FOY,** photographed by Cecil Beaton in an absinthe-yellow chiffon Castillo dress, worn over a crinoline, 1948. *Vogue* extolled Thelma for her "fractional waist," "superb shoulders," and "celebrated flair for clothes." An avid client of Christian Dior, she donated much of her wardrobe to the Metropolitan Museum, where her strapless 1949 silk-and-plastic "Junon" Dior ball gown is one of the Costume Institute's most frequently exhibited items. ABOVE: **JANET RHINELANDER STEWART,** daughter of a newspaper executive, by Irving Penn, 1948. A "charter member of café society," according to columnist Cleveland Amory, Janet wears a pale-blue chiffon Castillo dress. Stewart's afternoon salons in Manhattan were legendary, as was, to quote *Vogue,* her "cool, blonde, and appealingly fragile" beauty, a counterpoint to her biting wit. RIGHT: **JANET RHINELANDER STEWART** photographed by Horst for *Vogue,* 1940, in the same Lanvin dress she wore as a debutante in the 1920s.

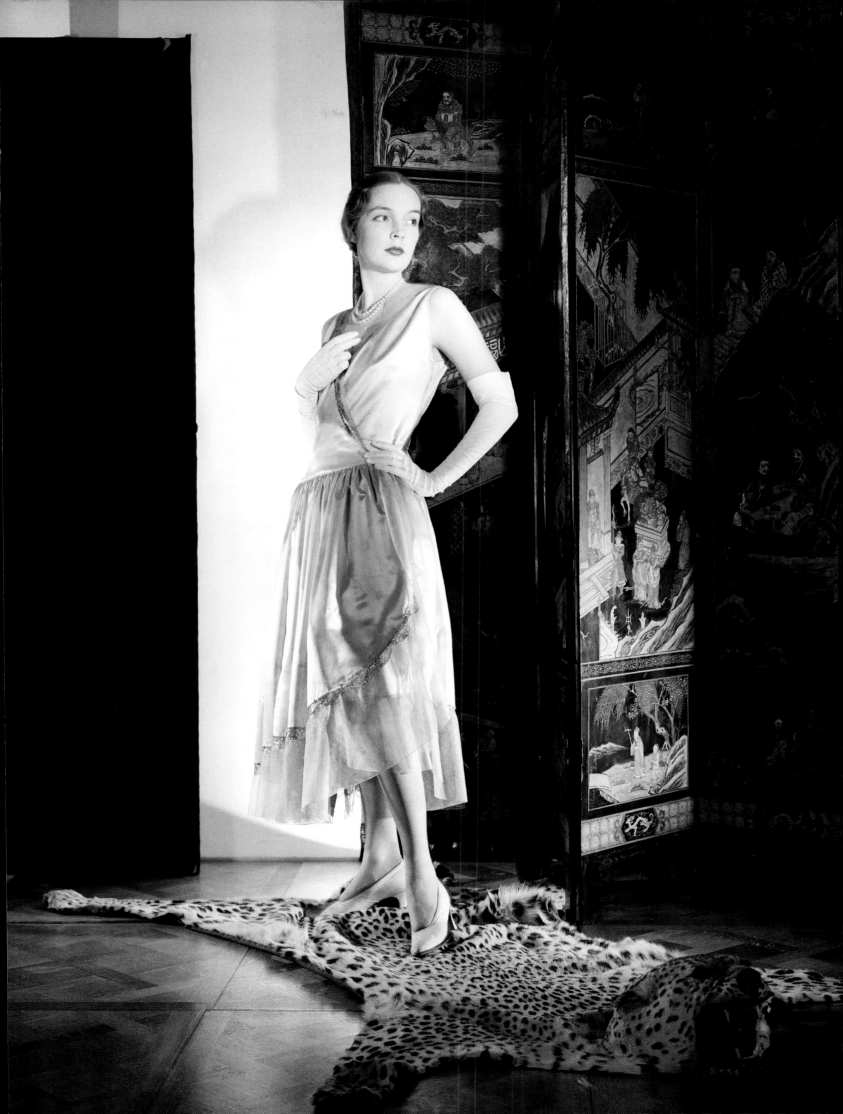

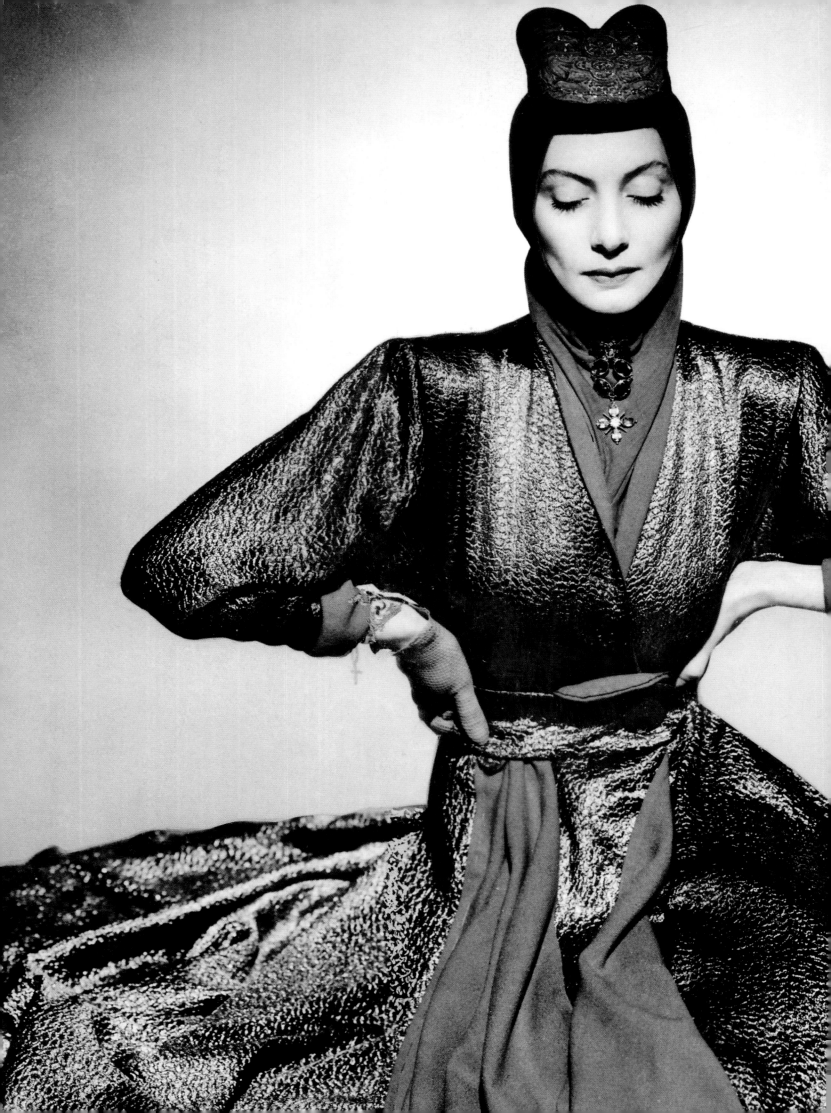

LEFT: the Russian-born couturière **VALENTINA** was married to financier George Schlee, reputed to be Greta Garbo's lover. All three lived in the same New York City building. TOP: Valentina, 1943. A former actress, Valentina said about her style, "I am theatre." Convinced of her powers of transformation, she declared that her East 67th Street shop was "a clinic where I treat my patients for bad taste." ABOVE: in a 1948 photograph by Horst, Valentina wears red gloves the same color as her antique Russian ruby necklace. Horst recalled that her "outlandish" designs "were not practical" but her sense of "fantasy was amusing and brave."

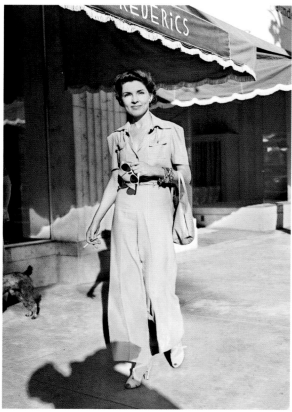

TOP, LEFT: **JANET GAYNOR,** the first actress to win an Academy Award, for *A Star Is Born.* As she was the wife of Adrian, the former head of MGM's costume department, Gaynor was named to the first Fashion Professionals List. She was a partner in her husband's dress-design business. BOTTOM, LEFT: **DOROTHY HART HEARST PALEY HIRSHON** on Worth Avenue in Palm Beach, December 13, 1939. Married to the CBS founder William S. Paley at the time of her naming to the List, Dorothy helped him build his outstanding art collection. Matisse was among the artists who depicted Dorothy. RIGHT: **MAXIME DE LA FALAISE** in Florence, 1952. Daughter of portraitist Oswald Birley and wife first of Count Alain de la Falaise and then of museum curator John McKendry, the six-foot-tall Maxime worked as a codebreaker during World War II and as a model and a designer for Paquin and Schiaparelli. Cecil Beaton considered Maxime, who later became a food columnist for *Vogue,* "the only truly chic Englishwoman." Her daughter Loulou, Yves Saint Laurent's muse and accessories designer, and her granddaughter, Lucie, a model, were both later named to the List.

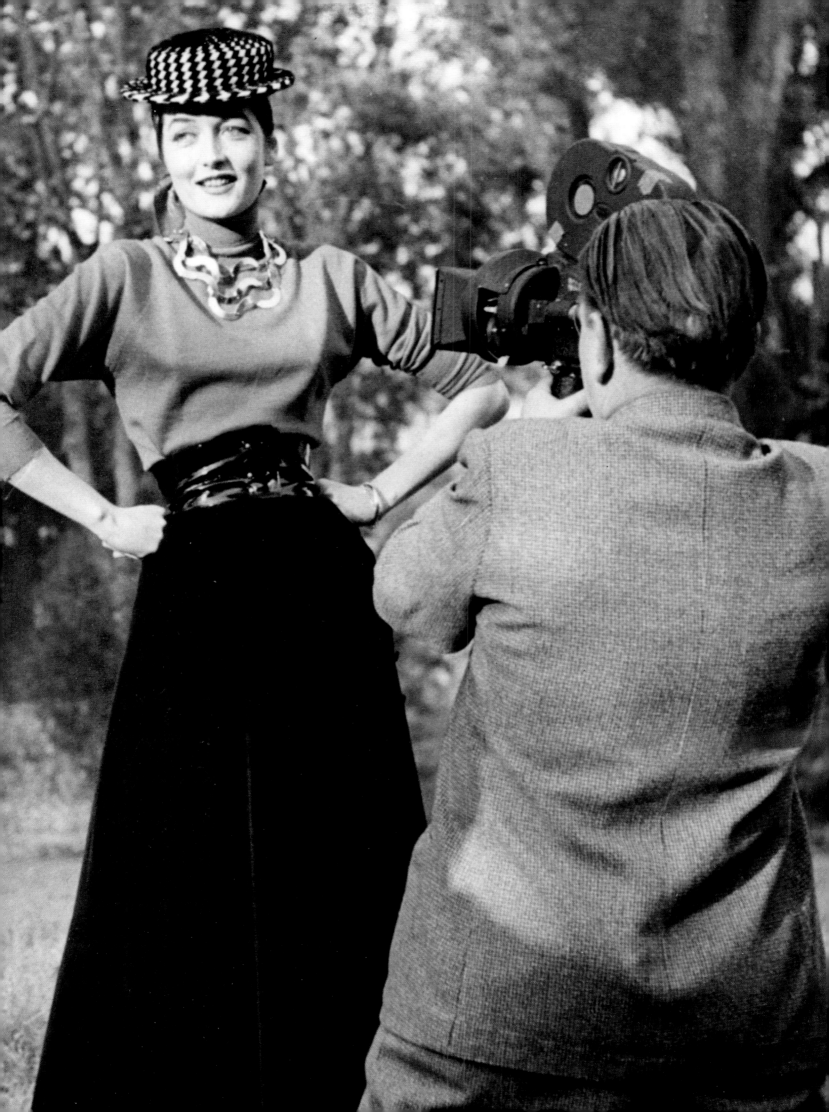

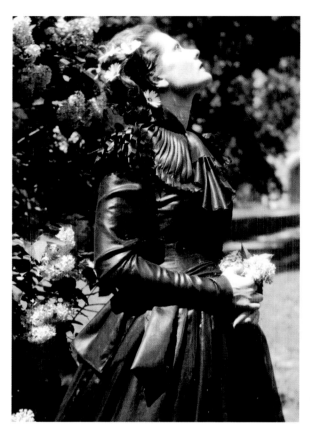

ABOVE AND RIGHT: **PRINCESS NATALIA PALEY,**
photographed by Cecil Beaton, who likened her ethereal,
tragic appearance to a Piero della Francesca painting.
She seemed, according to her friend the Prince de
Faucigny-Lucinge, "to be in exile on this earth." Like many
Russian refugees, she found a home in the fashion worlds
of Paris and New York. Her waifish beauty and cataclysmic
family history (she was a Romanov) attracted unlikely male
partners, including the ballet dancer Serge Lifar and
Jean Cocteau. In America, Natalia married theatrical
producer John C. Wilson, the lover of Noël Coward, and
entered into a long liaison with writer Erich Maria Remarque.
Among the stranger moments in her episodic life was her
cameo in the cultish, gender-bending Katharine Hepburn–
Cary Grant vehicle *Sylvia Scarlett,* directed by George Cukor
for RKO in 1935 and one of the decade's major flops.

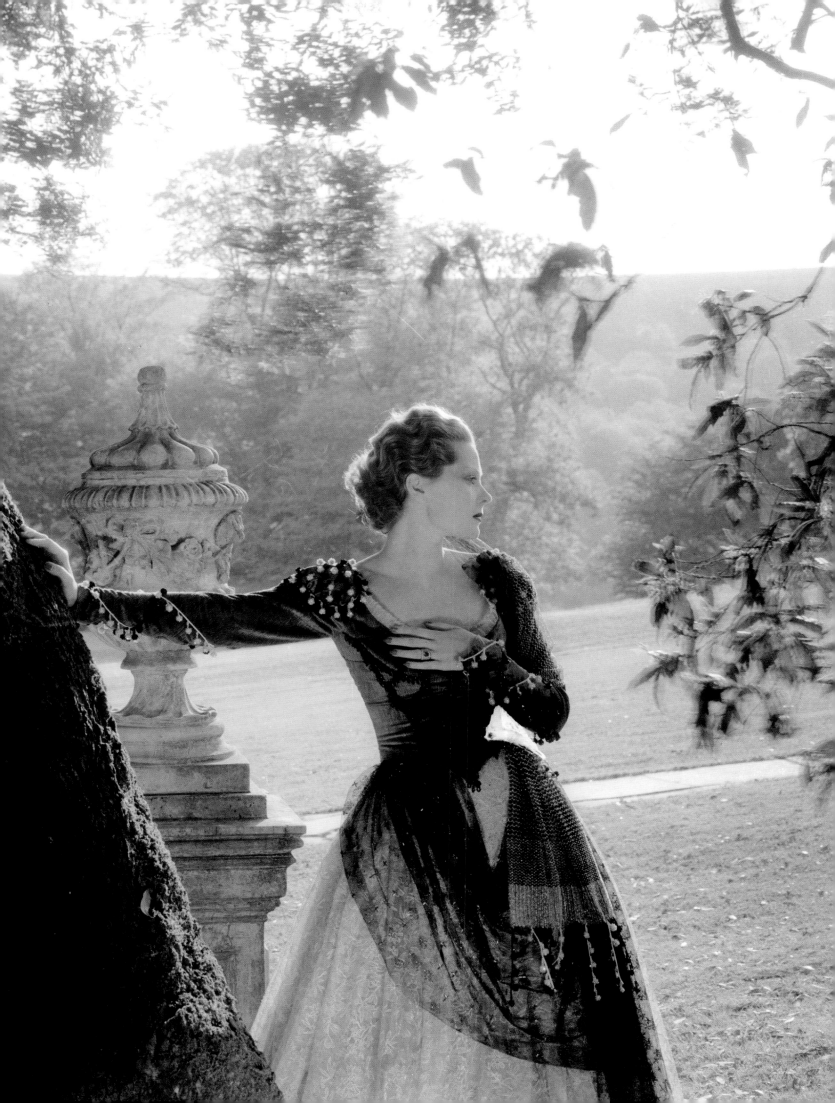

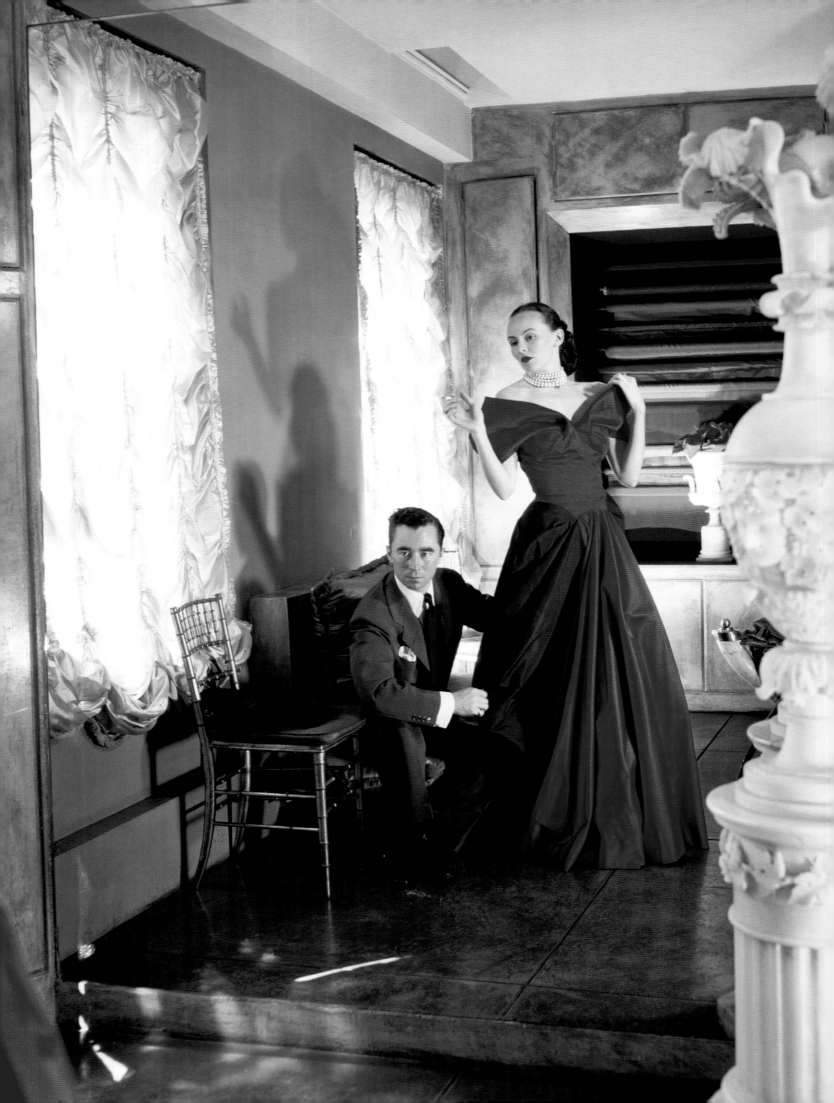

# The 1950s

## From AUSTERITY to LUXURY

**AUSTINE HEARST** worked as a newspaper columnist before marrying the chairman of the Hearst media empire. Here, the New York–based couturier Charles James fits her in his studio. Eleanor Lambert noted that Austine launched "many trends through her adventuresome clothes sense." Wearing James's sculptural tours de force, she said, felt like "magic. Everyone turns when I sweep into the room, the gentlemen in admiration, the ladies in envy."

# THE LIST

MARELLA AGNELLI

PRINCESS ALEXANDRA OF KENT

MME. HERVÉ ALPHAND (NICOLE MERENDA BUNAU-VARILLA)

HÉLÈNE ARPELS

BETTINA BALLARD

CONSUELO VANDERBILT BALSAN

MRS. THOMAS BANCROFT JR. (MARGARET BEDFORD)

MONA BISMARCK (FORMERLY WILLIAMS)

MME. HENRI BONNET (HELLÉ ZERVOUDAKI)

MRS. DAVID BRUCE (EVANGELINE BELL)

MARGARET CASE

GABRIELLE "COCO" CHANEL

CLAUDETTE COLBERT

SYBIL CONNOLLY

COUNTESS UBERTO CORTI (BORN DUCHESS MITA COLONNA DI CESARÒ)

CONSUELO CRESPI

MARLENE DIETRICH

PHYLLIS DIGBY MORTON

IRENE DUNNE

MRS. DWIGHT D. EISENHOWER (MARY "MAMIE" DOUD)

H.M. QUEEN ELIZABETH II OF GREAT BRITAIN AND NORTHERN IRELAND

MRS. ANDRÉ EMBIRICOS (BEATRICE AMMIDON)

FAYE EMERSON

MRS. HECTOR ESCOBOSA (JOAN RAISBECK)

DONNA SIMONETTA FABIANI

GENEVIÈVE FATH

ANNE FOGARTY

MRS. HENRY FORD II (ANNE MCDONNELL)

PRINCESS IRÈNE GALITZINE

JANET GAYNOR

QUEEN FREDERIKA OF GREECE

SOPHIE GIMBEL

MRS. ANDREW GOODMAN (NENA MANACH)

C. Z. GUEST

GLORIA GUINNESS

ENID HAUPT

NANCY "SLIM" HAYWARD (FORMERLY HAWKS, LATER KEITH)

AUSTINE "BOOTSIE" HEARST

AUDREY HEPBURN

OVETA CULP HOBBY

TOP, LEFT: **GRACE KELLY** on the deck of the S.S. *Constitution*, on her way to marry Prince Rainier of Monaco, April 1956. Eleanor Lambert helped Grace choose her wedding trousseau. TOP, RIGHT: Broadway's versatile **MARY MARTIN** in Mainbocher during the run of the comedy *Kind Sir,* photographed by Horst, 1953. Martin first appeared on the list in 1949. FAR RIGHT: **HÉLÈNE ARPELS,** wife of jeweler Louis Arpels, and later, a designer of opulent shoes, in a slate-gray jersey dress, Maximilian coat, and Lilly Daché hat, photographed by John Rawlings. The five-foot-nine Arpels was, Eleanor Lambert said, "an inspiration for such couturiers as Jacques Griffe and Castillo." BOTTOM: the Vicomtesse **JACQUELINE DE RIBES** at home in Paris in Christian Dior, then designed by Yves Saint Laurent, 1959. Yves likened her to "an ivory unicorn."

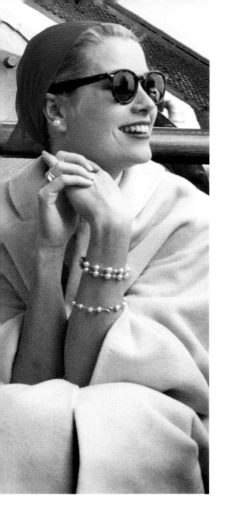

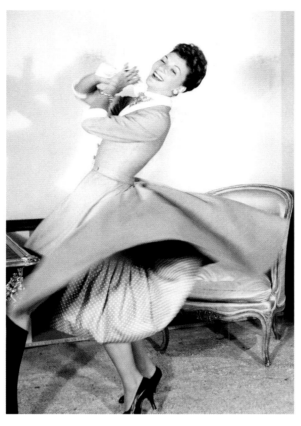

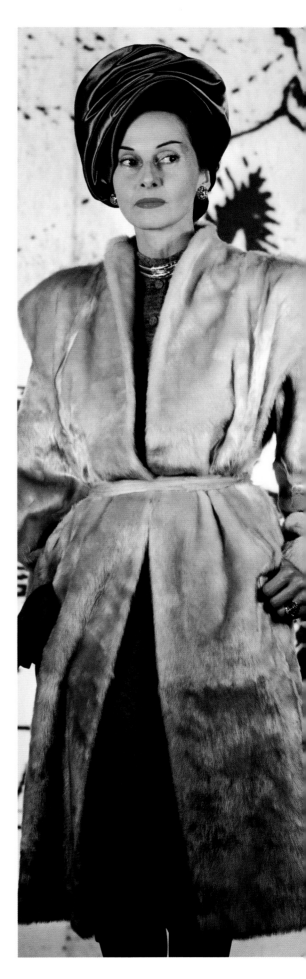

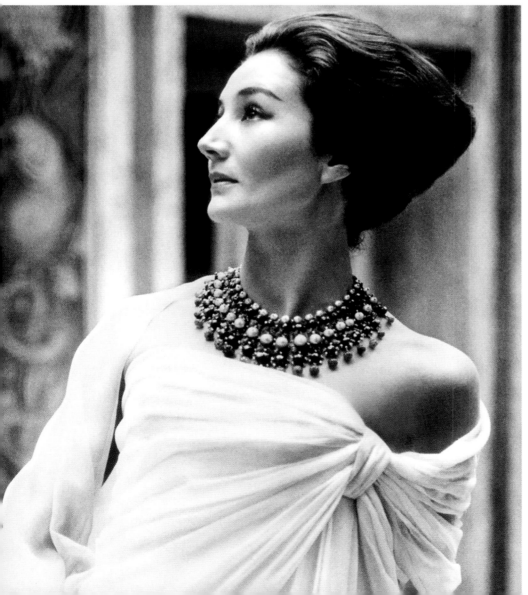

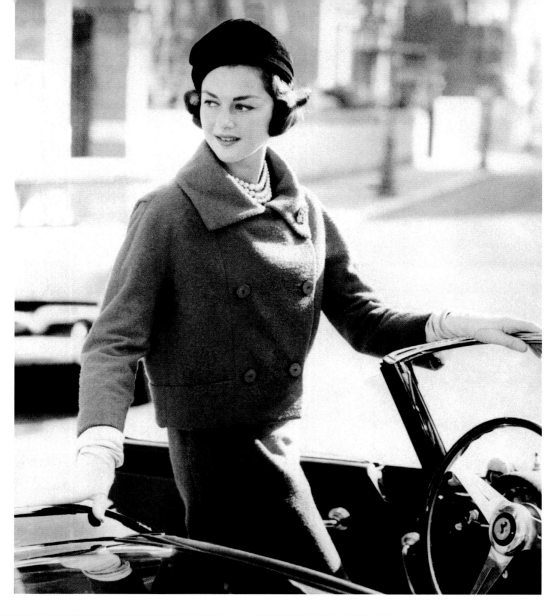

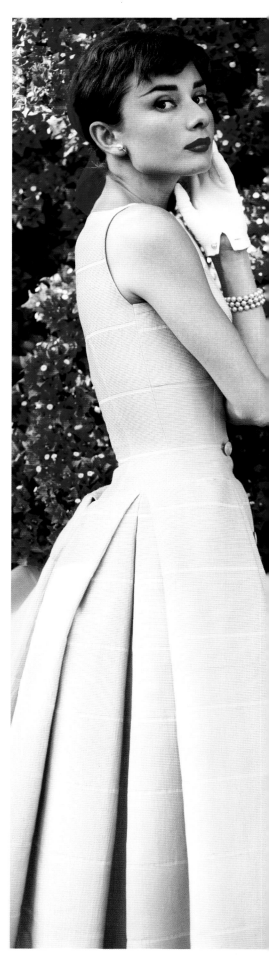

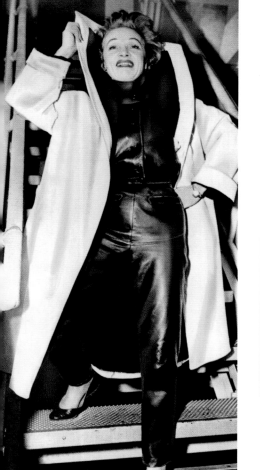

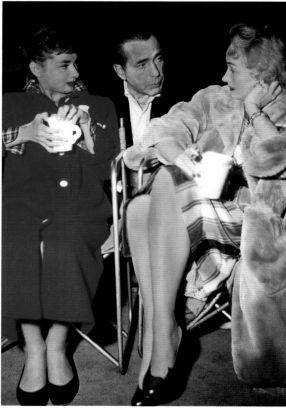

MRS. WALTER HOVING (PAULINE VANDERVOORT ROGERS)

GRACE KELLY

KAY KENDALL

DUCHESS OF KENT (MARINA)

MME. ARTURO LÓPEZ-WILLSHAW (PATRICIA LÓPEZ-HUICI)

CLARE BOOTHE LUCE

JEAN MACARTHUR

MRS. LEON MANDEL (CAROLA PANERAI)

MRS. LAWRENCE MARCUS (SHELBY)

MRS. STANLEY MARCUS (MARY CANTRELL)

H.R.H. PRINCESS MARGARET OF GREAT BRITAIN AND NORTHERN IRELAND

MARY MARTIN

MRS. TOM MAY (ANITA KEILER)

MRS. GEORGE MCGHEE (CECILIA DEGOLYER)

CATHERINE MCMANUS

DINA MERRILL

PHYLLIS DIGBY MORTON

MRS. ORSON MUNN (CARRIE NUNDER)

MERLE OBERON

MRS. WILLIAM O'DWYER (ELIZABETH SIMPSON)

BARBARA "BABE" PALEY (FORMERLY MORTIMER)

PRINCESS NATALIA PALEY

COUNTESS OF QUINTANILLA (ALINE GRIFFITH)

VICOMTESSE JACQUELINE DE RIBES

ROSALIND RUSSELL

MRS. JOHN BARRY RYAN III (DORINDA "D. D." DIXON

MRS. WALTHER MOREIRA SALLES (ELIZINHA)

VALENTINA

MRS. EARL E. T. SMITH (FLORENCE PRITCHETT CANNING)

CARMEL SNOW

GERALDINE STUTZ

GLORIA SWANSON

MARGARET "PEGGY" TALBOTT

GENE TIERNEY

PAULINE TRIGÈRE

MRS. ALFRED G. VANDERBILT (JEAN HARVEY)

DIANA VREELAND

THE DUCHESS OF WINDSOR

MRS. NORMAN K. WINSTON (ROSITA HALFPENNY)

---

TOP: the American-born Italian countess **CONSUELO CRESPI**, a former model and fashion editor, in a red Capucci suit and a Ferrari, circa 1958. NEAR LEFT: **AUDREY HEPBURN** photographed by Norman Parkinson in Italy, where the actress was filming *War and Peace,* 1955. BOTTOM, RIGHT: **MARLENE DIETRICH** visiting **AUDREY HEPBURN** and Humphrey Bogart on the set of *Sabrina,* the film that sparked the decades-long friendship and collaboration between the Belgium-born gamine and the blue-blooded couturier Hubert de Givenchy, 1954. About her own famous legs, Dietrich reportedly said, "They really aren't that good. I just know how to use them." BOTTOM, LEFT: **MARLENE DIETRICH,** whose "indestructible glamour" Eleanor Lambert praised, arrives in New York, dressed in leather, 1954. "Marlene wasn't sexy," Horst remembered, "but she projected sex."

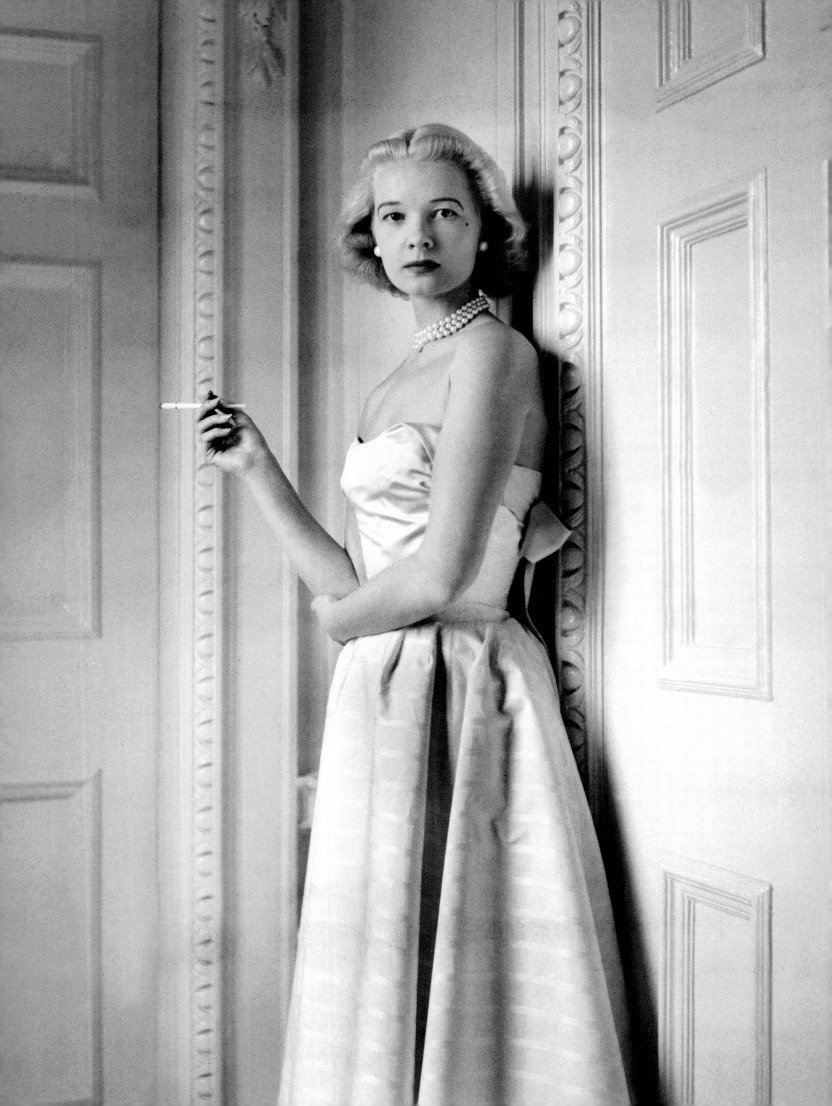

*"I . . . have always had such admiration for those enviable creatures who were best dressed."*

—AUDREY HEPBURN
*in a letter to Eleanor Lambert dated May 10, 1957*

———

# *The* Almighty List *and* Its Detractors

In the boom years of the 50s, Lambert's power was uncontested. Her pool of voters burgeoned from 50 to 3,000, and she conscripted a smaller international advisory board (including decorator Valerian Rybar and London designer Digby Morton) to compile a directory of nominees for consideration, which she now enclosed with her annual Dress Institute ballots. "Just to be a nominee thrills many ambitious women," observed *New York Herald Tribune* fashion editor Eugenia Sheppard. Anticipation of the List's annual announcement, the *New York Journal-American*'s Inez Robb reported, now had "the social set palpitating from its padless shoulders to its pointed toes" (the feminine uniform of that moment). Lambert's wartime Dress Institute P.R. contrivance had in a single decade matured into, a Texas fashion editor wrote, "one of the most important women's page stories all year."

And God help any newspaperwoman who dared to break Lambert's sacrosanct release date, even by one day, as Louella Parsons, Hearst's omnipotent Hollywood columnist, did late in 1951. Top-heavy with marquee names—a Dior-addicted Marlene Dietrich, whose languid glamour Lambert called "indestructible"; Irene Dunne; Gene Tierney; Gloria Swanson; and Janet Gaynor—the release that year proved more of a temptation than Parsons could resist. "I was dizzy," Parsons simpered to Lambert in a note dated January 8, 1952. "Please apologize to anyone I offended, with the exception of rival newspapers. That doesn't hurt me."

But there was such a frantic scramble for the Best-Dressed scoop that Lambert found herself regularly rebuking uncooperative journalists. An overzealous *Rocky Mountain News* columnist jumped the gun in 1953, the *Daily Mail* violated the embargo in 1954, and the *Houston Press* ignored the hold-for-release in 1956. When an exasperated Lambert wasn't battling rogue reporters, she was beating back spurious imitators. In her files are a heated 1954 exchange with the Federal Trade Commission about a dubious entity called the Fashion Academy, which was issuing best-dressed awards in exchange for money, and a condescending correspondence with an *Atlanta Constitution* editor, who hoped her town could generate a copycat list.

Lambert also routinely sparred with skeptics, especially those employed by newspapers that disseminated the List. In 1953, a Toronto editor complained about the List's dearth of Canadians. ("There was not a single vote cast for any Canadian lady," Lambert retorted. "Either by a Canadian editor or any other person.") In 1954 the *New York Post*'s Leonard Lyons questioned the Dress Institute's claim of authenticity for the List when its authority had been granted by neither "royal appointment" nor congressional decree. The leftist French paper *Combat,* noting the paucity of Parisians, haughtily estimated that the List "does not count for much. It is only a little local game." And *The Worcester Telegram* preached on its editorial page, "Taken all in all, we trust our women readers will agree with us that the list … is balderdash…. Let the Institute name the ten women who dress best on three or four $30 dresses…. That would be a list of real merit." Even *The New York Times*'s women's news editor, Elizabeth Penrose Howkins, adopted a similar position. "The simple fact is," she reprimanded Lambert, "that the world is too big … to make any such list."

Lambert's response to Howkins is unknown, but she preserved in her files her letter to *The Worcester Telegram,* which the paper ran in full. "The term 'best dressed' has become a symbol of good taste in dress," Lambert argued, "as descriptive and worthy as the honor awarded annually to writers by the Pulitzer Prize committee, the Hollywood Academy, or any other body which tries to set recognizable standards and milestones of progress for an art or an industry." Besides, she added elsewhere, it "sets up … a viewpoint for looking at this moment in history." Yet she herself admitted in the *Journal-American* that, "viewed in the cold light of census-taking, the title 'best-dressed' is obviously more romantic than scientific."

Lambert might have also stated in her own defense that the List in the 50s did make some accommodations

———

C. Z. GUEST, in a Hattie Carnegie dress of white Italian piqué, featuring a pink satin plastron tied in the back with three satin bows, by Cecil Beaton, 1952. Eleanor Lambert introduced the sportive Guest to Mainbocher, in whom the ardent gardener and equestrienne found the ideal interpreter of her understated, patrician American style.

63

to the mainstream sensibilities of the period. The rarefied Mona Williams's disappearance in 1951 came, an INS correspondent stated melodramatically, "as a catastrophic shock." (The "rock crystal goddess" had been receding from the limelight to her castle in Capri.) Swept into the No. 10 spot with the 1952 election of Dwight Eisenhower, the cozier and ampler Mamie, 57, initiated the List's long tradition of electing First Ladies. Lambert justified this one-time inclusion by commending Mrs. Eisenhower's "years of training as an army wife," which "taught her the value of a dollar" and a "lack of snobbery about labels." Mamie's "round, off-the-shoulder necklines," "full skirts," and "small hats" became standard issue for respectable matrons nationwide throughout the decade. But Mrs. Eisenhower was not the first World War II hero's wife to find her way onto the List—that distinction belongs to General Douglas MacArthur's spouse, Jean, a southern-belle heiress sentimentally voted in just a few months after her husband's ignominious recall in 1951 from Korea.

Another Eisenhower administration Listee was the Valentina-wearing, violet-eyed Texan dynamo Oveta Culp Hobby—like Mamie (with whom she tied)—at 50 "a late starter," Lambert noted. On *Time* magazine's cover the year she won, Hobby wrote Lambert when she learned the news, "I won't go so far as to say I hate this!" In her capacity as the nation's first secretary of health, education, and welfare, Hobby—previously director of the Women's Army Corps—approved both the polio vaccine and millions of citizens for Social Security benefits. But as far as some participants were concerned, the List still had not conformed sufficiently to the era's Everywoman outlook. Lambert conscientiously related in her 1953 press release that one prominent, dissenting fashion editor had filled out all 10 blanks on her ballot with the name "Mrs. Jane Doe, the average American woman."

## British Royals

At the other end of the spectrum from Mrs. Doe (but probably equally beloved by Americans), the British royal family invaded the List during the 50s, a direct result of the attention lavished upon them by the 1952 coronation of Queen Elizabeth II. Her sister, Princess Margaret Rose, preceded the Queen onto the List in 1953, joining her aunt by marriage, the Greek-born Marina, Duchess of Kent. While in exile in Paris in her youth, Kent had earned her living as a Molyneux mannequin and had helped couturier Jean Dessès get his start. Lambert admired the Duchess of Kent for initiating a trend for pairing an ordinary white shirt with a "significant pearl necklace." In spite of her grand ancestry (she was a Greek royal princess), she shopped, Lambert stated, for "off-the-peg" "ready-mades" at London's "budget-priced stores," including Liberty. After a decorous wait of a few years, Queen Elizabeth, aged 32, was admitted to the 1957 List. Lambert respectfully praised the young monarch's "impeccable sports clothes" and her "ability to wear formal clothes in a youthful, extremely pretty way." (When skeptics criticized Lambert for including "that dowdy woman with the dinky handbag," she retorted that the Queen's frumpy shoes and midget purse were to prevent her from fidgeting and rummaging—"and the whole definition of being well dressed is being dressed to suit your life!") All three bluebloods kept uncomfortable company on the List with their despised in-law, the Duchess of Windsor, who reigned supreme there—she was cited a record 17 times—as she never could over her husband's empire.

## Nubile Icons *and* Living Landmarks

By the mid-50s, Lambert's elastic apparatus had advanced well into the modern age, as several of fashion's most evergreen icons, some youthful and others already legendary, began to file onto the List. C. Z. Guest surfaced in 1952, aged 32, with kudos for her "super-distilled blend of debutante and sophisticate," and her "childishly slender figure," invariably displayed in the same columnar manner, regardless of the prevailing silhouette. (The athletic Guest declared the fussy designs of Dior "too difficult to dance in.") Lambert, who also credited Guest with reviving chinchilla, introduced her to Mainbocher—a match that proved to be as mutually inspiring as the enduring one he still enjoyed with the Duchess of Windsor. (Guest set in motion a mania for his lasting invention, the jeweled cardigan.) "My style," Guest recalled, "was his style." As dressed by Mainbocher, Guest was so understated—she thought nothing of wearing the same

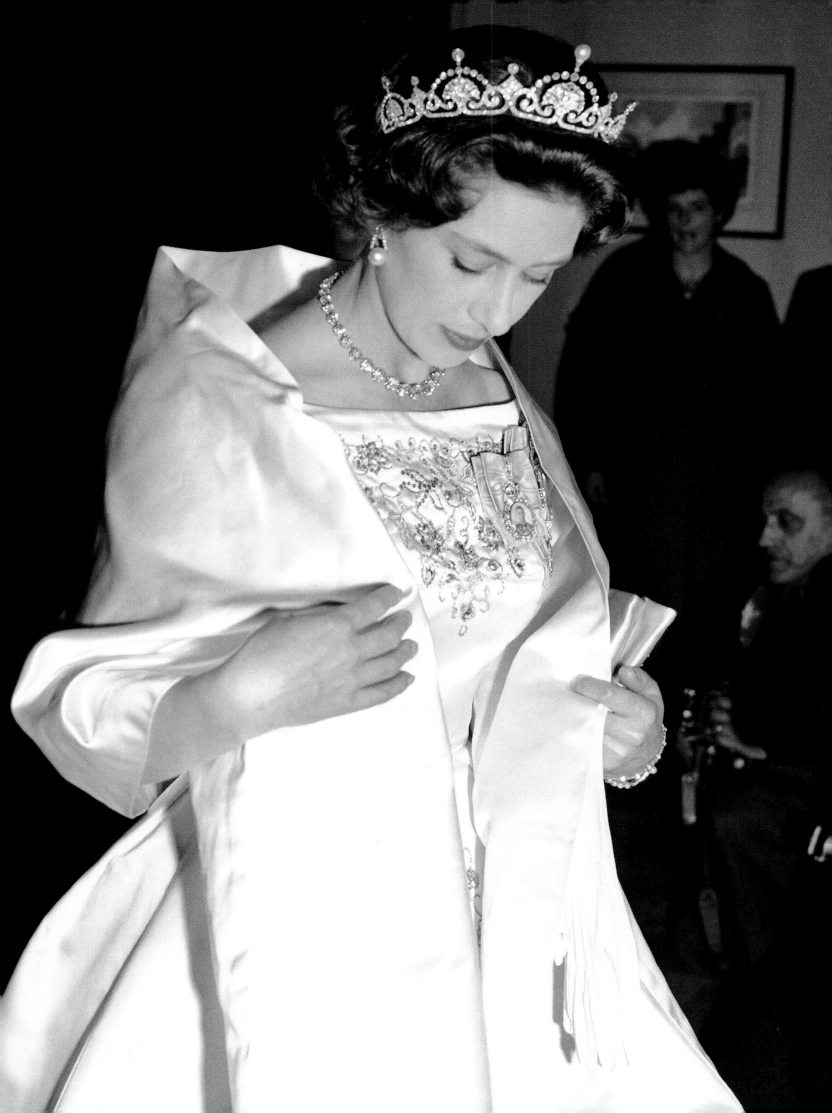

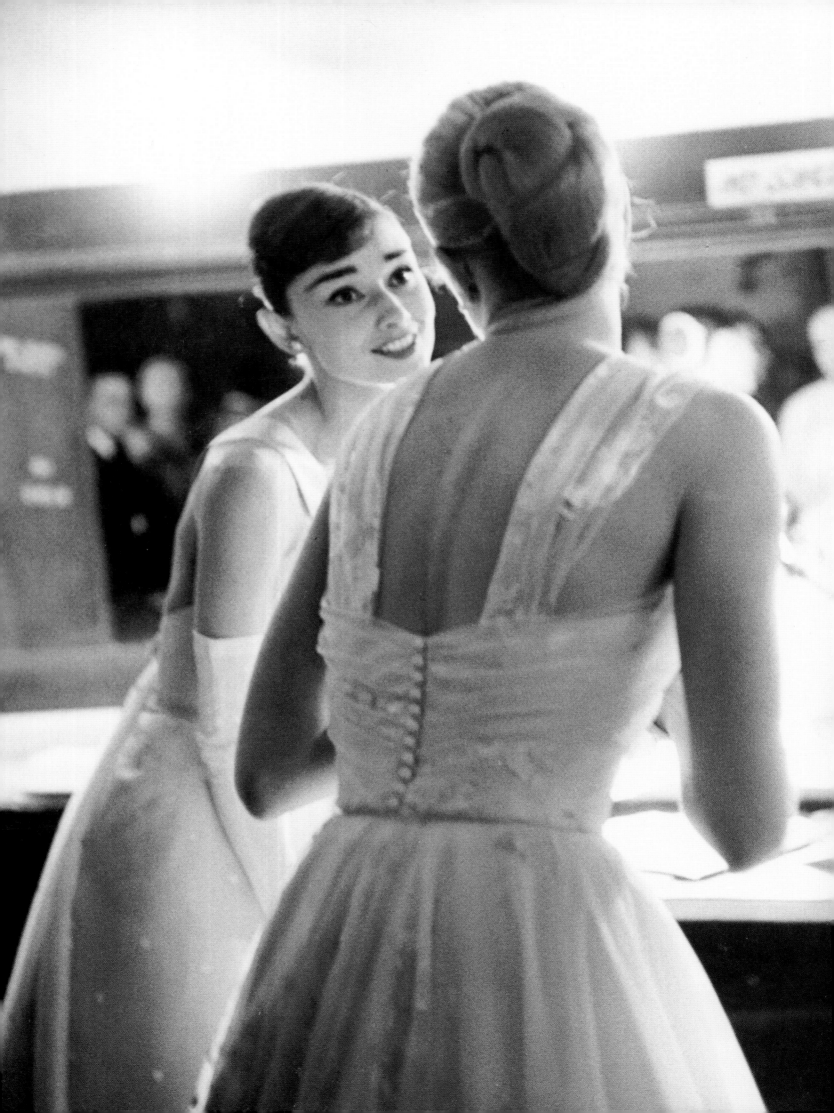

suit for a decade and was responsible, Eugenia Sheppard wrote, for the "'little nothing' dress trend"—she was mistaken in Spain for her own maid. "Clothes don't wear out," Guest reasoned, "if you hang them up."

Diana Vreeland, who had been toiling behind the scenes at *Harper's Bazaar* since 1936 and had been a List voter for nearly as long, premiered in 1954 as a Fashion Professional. Her 67-year-old boss, Carmel Snow—to correct what might have appeared to have been an act of insubordination—was slipped in the following year. For the *grande dame* of fashion magazines—she had been editor in chief of *Bazaar* for 22 years—it must have seemed like an interminable wait; Snow immediately wrote to Lambert, "I could not be more flattered."

Yet by mid-decade, "young women," Lambert observed, were beginning to "outnumber the hardy perennials." The dewy beauties sweeping "the ranks of the world's best-dressed women," Lambert remarked, "conclusively cancels the old style maxim that a woman doesn't learn to dress well until she is 35 or over." Nubile film star Grace Kelly, barely 23, tied for first place in 1955 with List paragon Babe Paley. Fresh from her Oscar win for *The Country Girl,* Kelly was attracting as much admiration, Lambert said, for her "calm immaculate clothes" as her "acting ability." Even during her first pregnancy, in 1956—while the baby boom was at its peak—Kelly (as Princess Grace of Monaco) maintained her standing on the List. Sheppard reverently ascribed to Princess Grace "the fad for short white gloves and the briefcase handbag," now known, of course, as the Kelly bag—which she had used, while gestating baby Caroline, to deflect attention from her swelling waistline.

Kelly cleared the way for fellow model-like newcomer Audrey Hepburn, 25, whom Lambert considered "a fashion natural who can wear anything and make it look right." Tying for fifth place in 1956 with veteran vixen Marlene Dietrich, Hepburn, who had just portrayed Natasha in Paramount's *War and Peace,* was the sprightly force behind "bunchy sweaters," "childish hats," and the "gamine hairdo," Lambert observed. And she had facilitated the acceptance of "the young, highly original designs of the French couturier Givenchy." From location in Mexico with her husband, Mel Ferrer, who was shooting *The Sun Also Rises* for Twentieth Century Fox, Hepburn wrote Lambert what amounts to the most gracious letter conserved in the fashion publicist's files. "I must tell you that not in my wildest dreams did I ever think this could happen to me," Hepburn marveled. "But I had always followed the annual best dressed list with eager wonderment. I have always been more than ordinarily interested in fashion as such and have always had so much admiration for those enviable creatures who were 'best dressed.'"

Joining Hepburn as a first-time Listee the same year was the sphinx-like Vicomtesse Jacqueline de Ribes. "Another Givenchy fan," the distinctive de Ribes, Lambert wrote, was "scarcely out of her teens and already one of the most imitated members of the chic international set of Paris." With her "exaggeratedly slanting eyes," masses of dark hair, and fearless embrace of inventive fashion, sometimes of her own design, de Ribes provoked her baffled father-in-law to describe her as a "cross between a Russian princess and a girl of the Folies-Bergère." Against her family's wishes, the Vicomtesse ghost-designed for Cassini and Pucci (who called the reedy six-footer "Giraffina") and posed for Richard Avedon. The photographer's 1955 cameo-like profile portrait, with the impossibly long neck, hyperbolically almond eyes, conspicuously hooked nose, and improbably thick braid, was published in *Life* and in Avedon's anthology *Observations,* with text by Truman Capote, in which he famously compared I.B.D.L.-ers de Ribes, Babe Paley, Marella Agnelli, and Gloria Vanderbilt to "a gathering of swans." In his *Life* encomium for the Vicomtesse de Ribes, Avedon judged her dominant feature "perfect," adding, "I feel sorry for near-beauties with small noses."

A less publicly celebrated fashion trailblazer was Rosita Winston (No. 11 in 1957), the part-Cherokee wife of international real-estate titan Norman K. Winston and arch-nemesis of Kitty Miller. An early proponent of Christian Dior's New Look (she even ordered Diors for her husband's lover, the Princesse de Polignac), the adventuresome Winston started a rage for fur coats with pelts sewn horizontally, and spearheaded the American acceptance of Balenciaga's esoteric 1957 "sack" silhouette. (At the 1958 Campaign Conference for Democratic Women, Adlai Stevenson disparaged Balenciaga's waistless shift as "Khrushchev's greatest triumph—it spreads discontent, unrest, hostility, and antagonism.")

Then, also in 1957—forgiven for her war crimes and rebounding after a 14-year career hiatus—Coco Chanel, aged 74, materialized at the head of the revived Fashion Professionals List. Having collected a Neiman Marcus award in Dallas, Chanel had just spent a few days in New York at the Waldorf Towers in September—her second and final visit to America. (Lambert admired the couturière but said "her hands were like claws when she touched you.") Remarkably, Chanel was not the List's most senior member in the 1950s. Two years earlier Consuelo Vanderbilt Balsan had been voted on at 78, a nostalgic, overdue addition probably inspired by the publication of her best-selling memoir, *The Glitter and the Gold.* When she learned the news, Balsan immediately wrote Lambert from her white-pilastered home, at 319 El Vedado Road, in Palm Beach, to thank her "for the honor you and the Couture Group New York Dress Institute have done me."

# *The* Hall *of* Fame

In spite of these fresh additions to the List, with each passing year, the record stuck repetitively on certain predictable names. By 1957 the Duchess of Windsor had been honored 17 times, Mona Williams 11, and the much younger Babe Paley 15. A rumored purchase by the idolized Paley of an item such as a Maximilian squirrel coat would set off a frenzy of imitative acquisition. When she allowed her brunette hair to fade to gray, nonchalantly tied a silk scarf around the handle of her purse, lined a coat in fur, or offhandedly left a top button of that coat open, thousands duplicated the move. Paley at one point asked Lambert to delete her from the List, as she was besieged with requests for her hand-me-downs. She also told Lambert she feared her impressionable daughter would mistake dressing well for a talent. Lambert replied to Paley, "Not to worry. It *is* a talent." For her part, the Duchess of Windsor—in New York every year in the late fall—held sales of her old clothes in Suite 28-A of the Waldorf Astoria. A bargain-hunter would not necessarily find a Balenciaga or Chanel among her castoffs. "Balenciaga is such a trying man," the Duchess complained. "He makes one pull everything on over the head. It is ruinous to the hair." She in fact directed Balenciaga's fitter to make whatever dresses she bought there "look more like Mainbocher." And Chanel was just "too much. A chain here, a ruffle there."

The Duchess pointed out the List's redundancies to the *Herald Tribune*'s Eugenia Sheppard. Younger women needed more of a presence, the Duchess believed, to "inspire them to be more careful about their hats and shoes." Likewise, Florence Pritchett Smith, former fashion editor of the *New York Journal-American* and wife of Eisenhower's ambassador to Cuba, urged Lambert in a 1957 letter to consider composing a separate list for what Sheppard called "riper talent." Sheppard huddled with Lambert about the situation. The pair decided, at first half-jokingly, to "shake up the line up," as *Life* phrased it, by establishing a Hall of Fame—an Elysian field for the List's most frequently named and most exalted clotheshorses. It would entitle the anointed few "to be described as best-dressed forever after," Sheppard wrote.

At the end of 1958, Lambert simultaneously fired off eight Western Union telegrams to congratulate her first Hall of Fame inductees. "I have the honor to inform you that you have been designated to the newly created Fashion Hall of Fame of the International Best-Dressed Poll conducted annually by Couture Group New York Dress Institute in permanent recognition of your distinguished taste in dress without ostentation or extravagance. Announcement will be made January 5, meanwhile confidential."

Lambert's "eight women of unchallenged style leadership" and "faultless taste in dress" eternally "placed above the annual competition" were:

**The Duchess of Windsor.**

**Countess Mona von Bismarck** (formerly Williams). Since her previous appearance on the List, she had married her confidant Eddy von Bismarck, the aristocratic, gay secretary of her late husband. Von Bismarck was Mona's fourth, and penultimate husband.

**Claudette Colbert.** A Sophie's of Saks regular, she knew how to elongate her short neck with an abbreviated sable cape and accentuate her saucer eyes with a back-of-the-head hat. At the moment of her induction, the Oscar winner was starring on Broadway in *The Marriage Go Round,* for which she was dressed by Castillo.

**Babe Paley.**

**Queen Elizabeth II.**

**Mme. Jacques Balsan.** The former Consuelo Vanderbilt humbly replied to Lambert that it was an "undeserved award." With her "now white hair" crowned by "pale satin toques," Balsan, Lambert felt, had become "an elegant fashion individualist in her later years."

**Mary Martin.** The Texas-born Broadway star (*Peter Pan, Sound of Music*), admired for her "famously beautiful back," made a point of showing it off, even in long-sleeved dresses. A fan of "dog-collar necklaces" to accentuate a long neck, Martin called herself a "Mainbocher makeover," as she wore his clothes nearly exclusively on and off the stage and TV screen.

**Irene Dunne.** A devotee of Dior and the Catholic Church, the Academy Award–nominated stage and film actress had been appointed in 1957 by Eisenhower as a delegate to the U.N.

Though she privately wrote ingratiating telegrams to Lambert, the Duchess of Windsor publicly still feigned a snobbish annoyance at her long run on the List. "How could such a list be anything but phony when most of the judges seldom see me?" the Duchess inquired. Yet she also had confided to Kitty Miller, "I can't afford to let down. The Public Eye is always on me." As for Lambert, she later confessed that she had never been a fan of the Duchess's style. She "always," Lambert said, "wanted the latest thing from head to toe."

---

GABRIELLE "COCO" CHANEL at home. The couturière arrived on the List at age 74, after her return from exile in Switzerland, to which the French had banished her for collaborating with the Nazis. She owed the success of her comeback to America; the French had found her démodé.

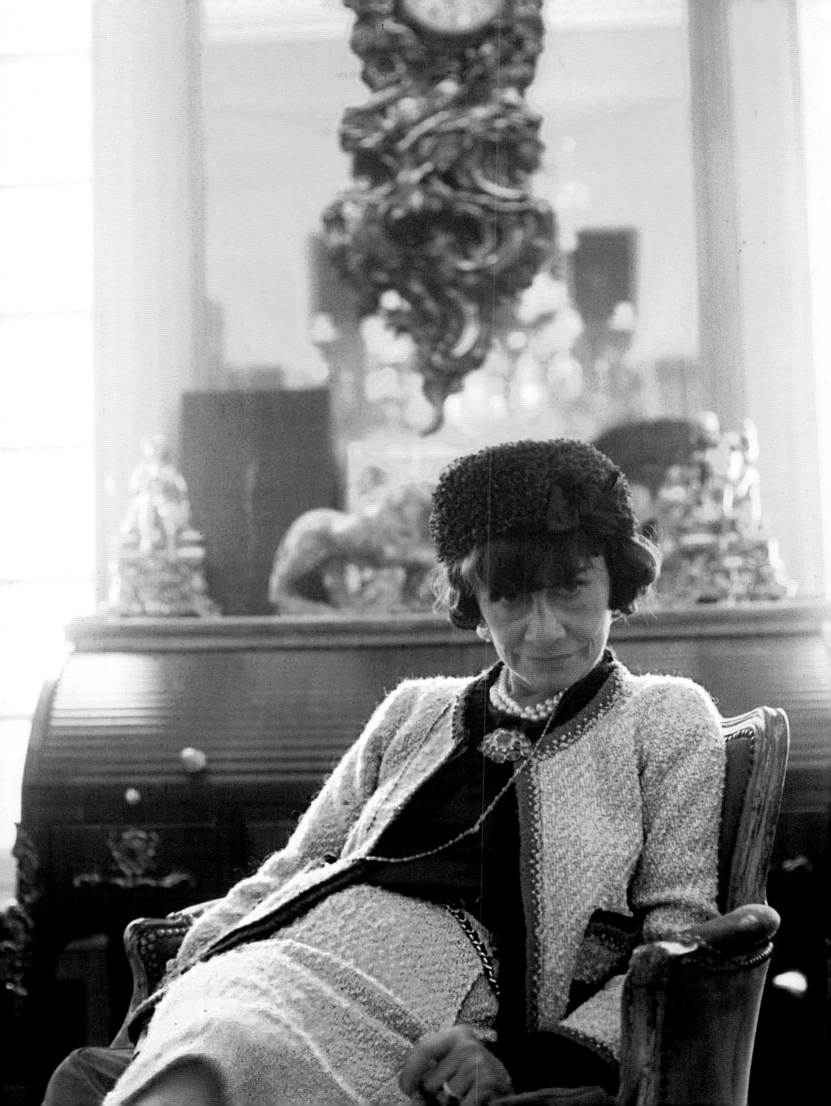

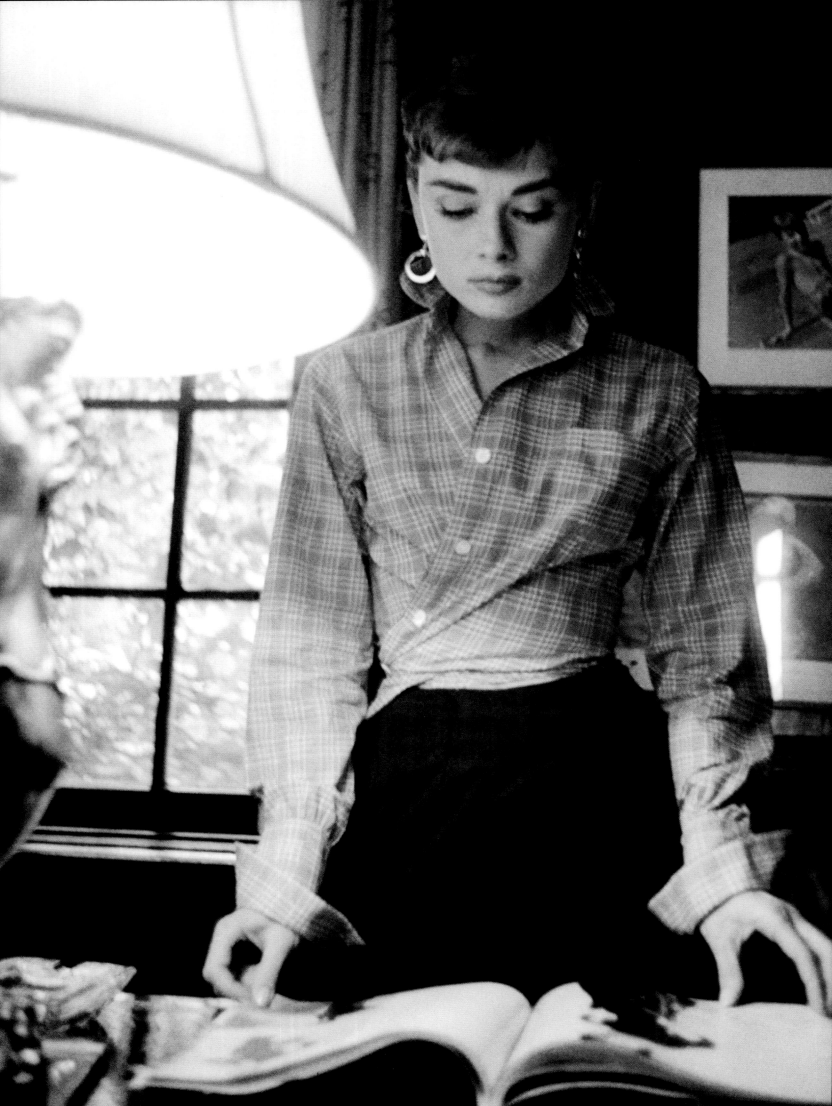

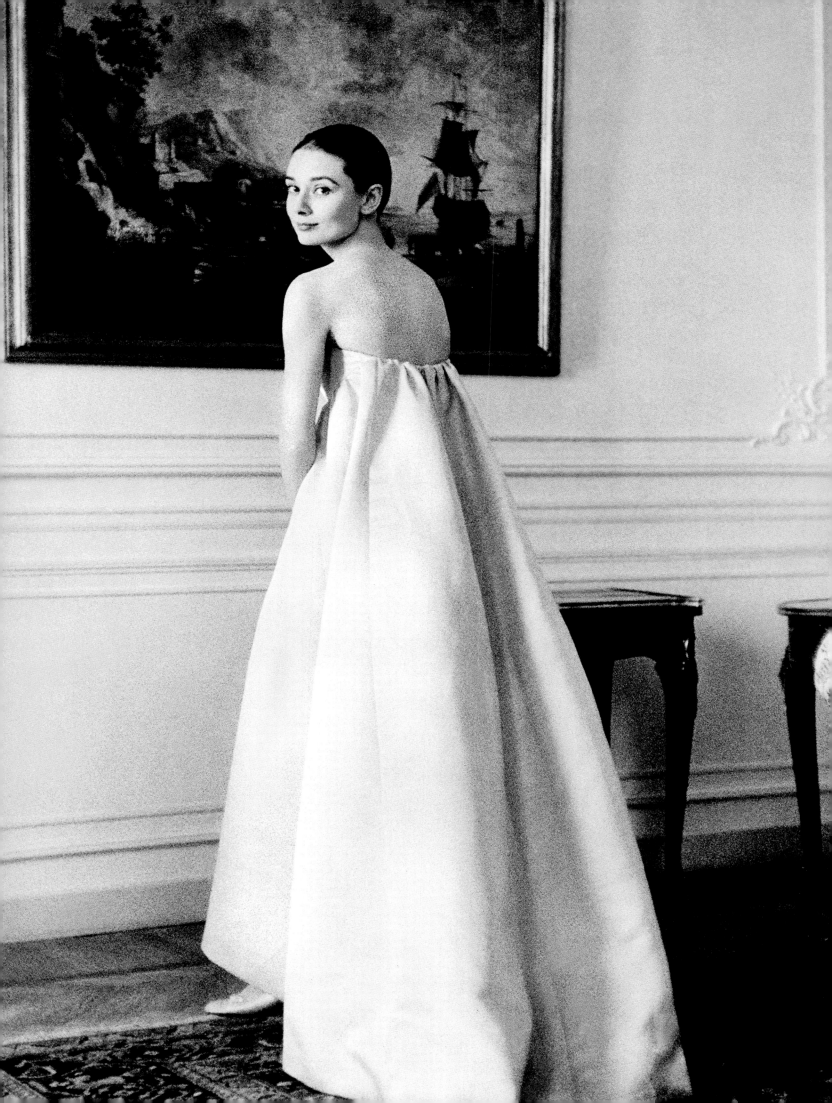

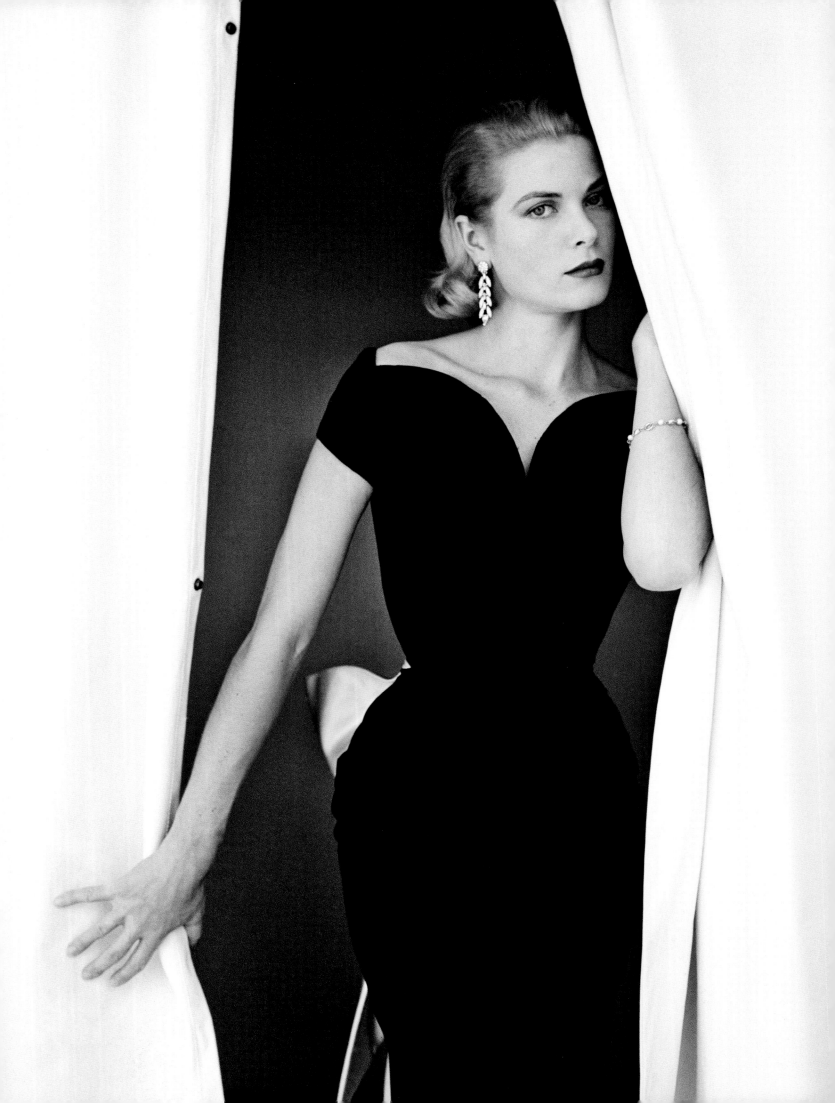

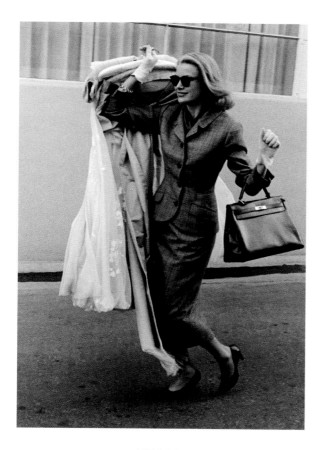

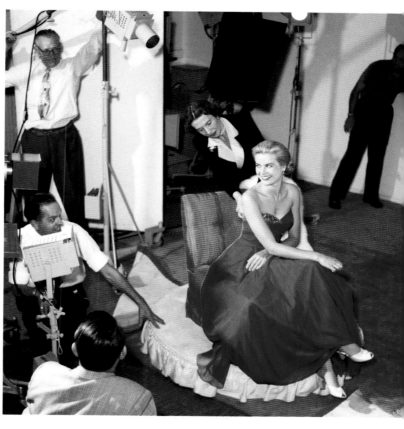

PRECEDING SPREAD, LEFT: **AUDREY HEPBURN** on location for
*Sabrina*, at Paramount president Barney Balaban's Long Island
estate, 1954. Hepburn told a journalist on the set, "Clothes are
positively a passion with me. I love them to the point where
it is practically a vice." RIGHT: Audrey in the Givenchy dress she
wore to the premiere of *The Nun's Story*, 1959. Givenchy said
of his muse, "Audrey always added a twist, something piquant,
amusing, to the clothes." Before she met Givenchy, the
actress recalled, she had "never even seen an haute
couture dress, much less worn one."

LEFT: **GRACE KELLY** by Howell Conant, her favorite
photographer. Conant said he "trusted" her beauty, as it
wasn't artificially "built from clothes and makeup." Here she
parts the curtains at the Hollywood Hills home she was renting
from Gayelord Hauser, nutritionist to the stars. TOP, LEFT: Kelly,
carrying her eponymous handbag, leaving Hollywood in 1956,
to marry Prince Rainier of Monaco. "I just buy clothes when
they take my eye," Kelly said, "and I wear them for years."
TOP, RIGHT: Grace Kelly, in an MGM studio publicity shot, 1954.
Kelly's background as a model trained her how to show to
advantage what Alfred Hitchcock termed her "sexual elegance."
RIGHT: Grace Kelly on the threshold of the hair-and-makeup
room at MGM studios, Los Angeles, 1955, by Howell Conant.

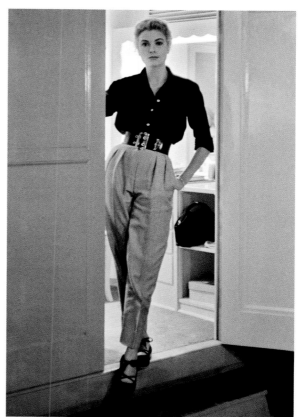

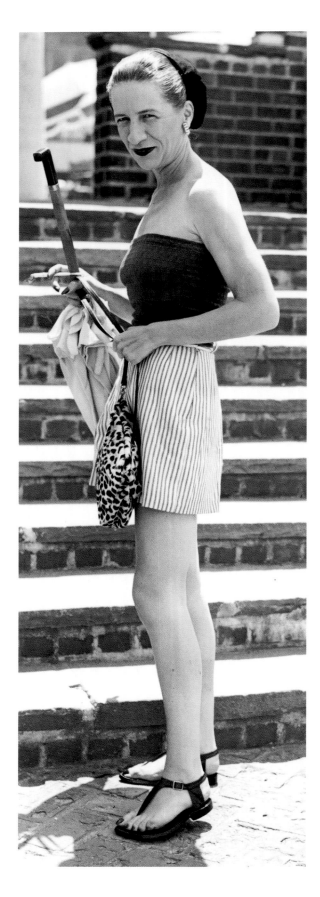

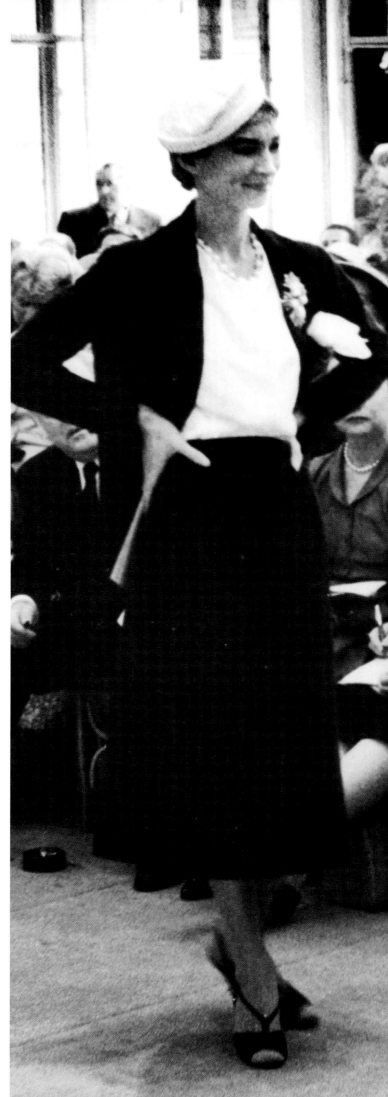

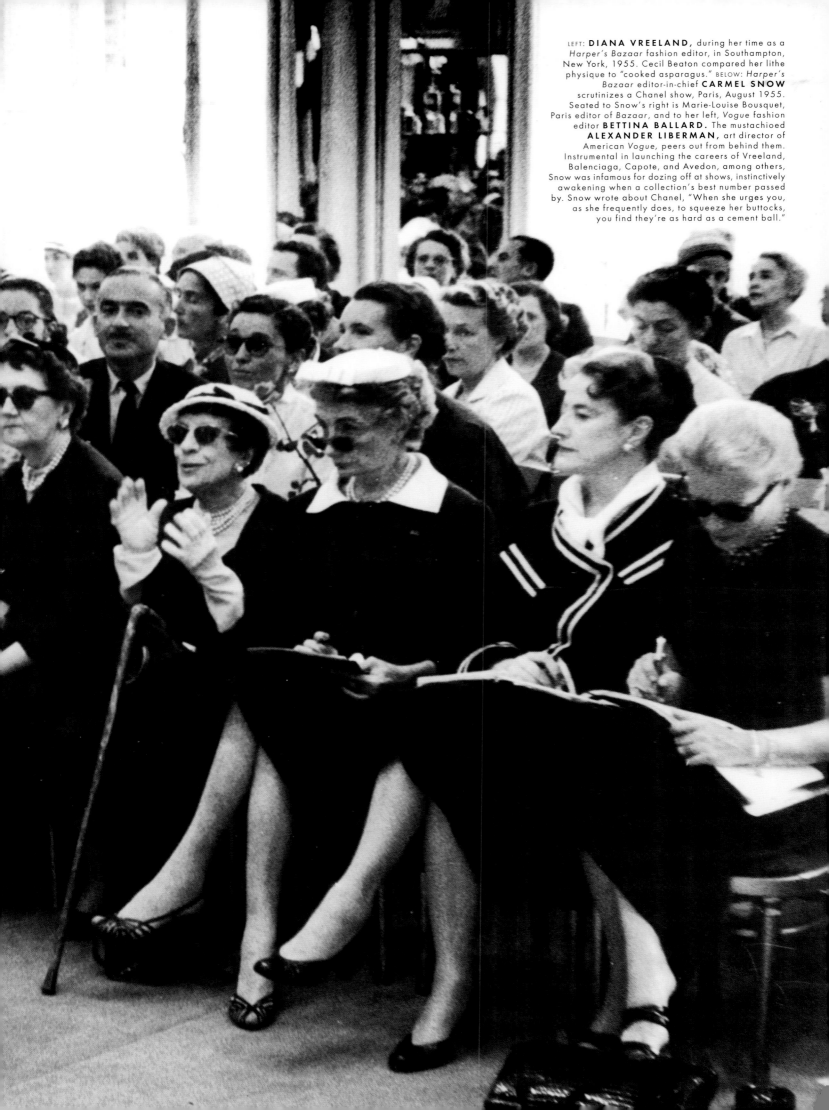

LEFT: **DIANA VREELAND,** during her time as a *Harper's Bazaar* fashion editor, in Southampton, New York, 1955. Cecil Beaton compared her lithe physique to "cooked asparagus." BELOW: *Harper's Bazaar* editor-in-chief **CARMEL SNOW** scrutinizes a Chanel show, Paris, August 1955. Seated to Snow's right is Marie-Louise Bousquet, Paris editor of *Bazaar*, and to her left, *Vogue* fashion editor **BETTINA BALLARD.** The mustachioed **ALEXANDER LIBERMAN,** art director of American *Vogue,* peers out from behind them. Instrumental in launching the careers of Vreeland, Balenciaga, Capote, and Avedon, among others, Snow was infamous for dozing off at shows, instinctively awakening when a collection's best number passed by. Snow wrote about Chanel, "When she urges you, as she frequently does, to squeeze her buttocks, you find they're as hard as a cement ball."

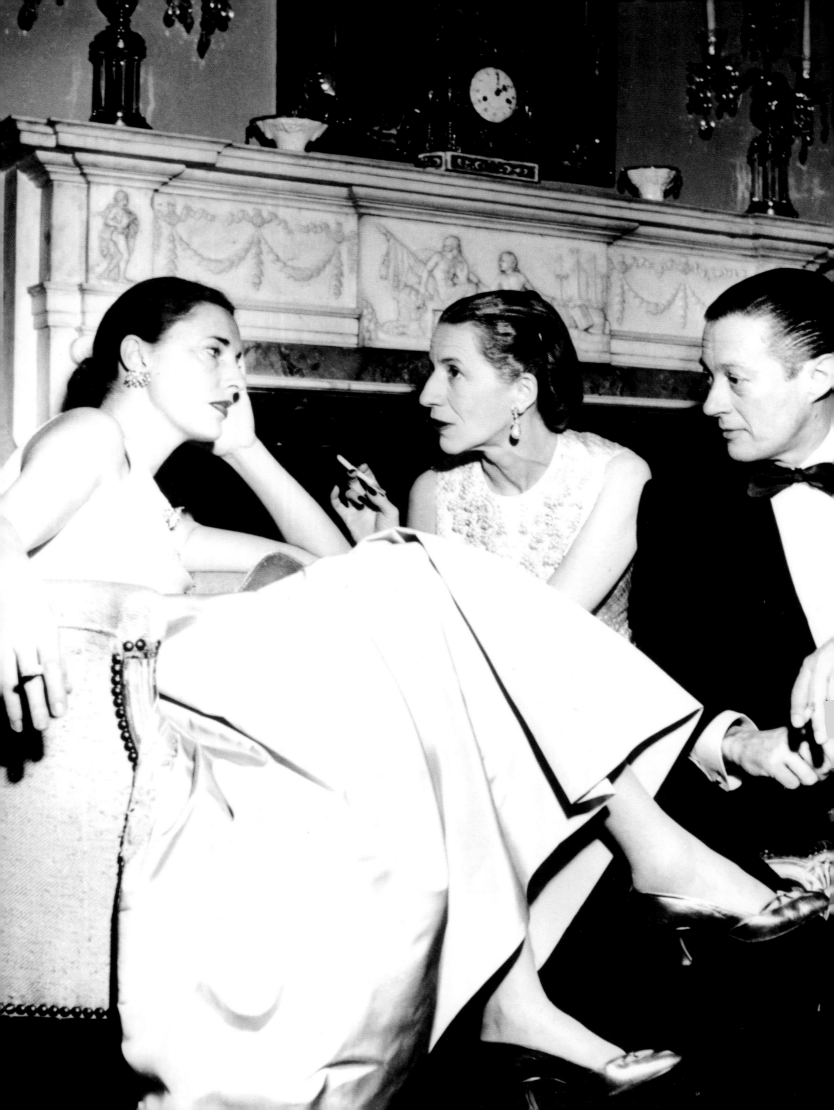

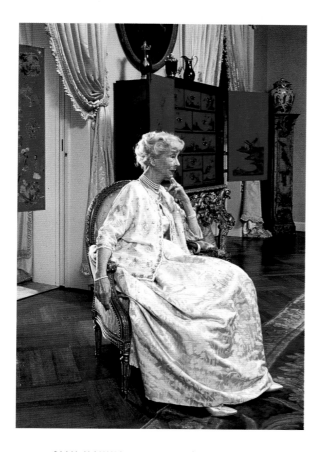

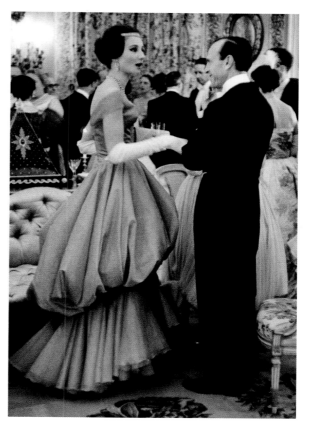

LEFT: **SLIM HAWKS** conversing with **DIANA VREELAND,** then a *Bazaar* editor, and her husband, Reed Vreeland, at Kitty Miller's Park Avenue apartment, New Year's Eve, 1952. Slim discovered Lauren Bacall on a *Bazaar* cover and, with her director spouse, Howard Hawks, remade the teenage model in her own tailored image. TOP, LEFT: **CONSUELO VANDERBILT BALSAN** by Toni Frissell. Forced as a teenager to marry the Duke of Marlborough, Consuelo later wed aviation pioneer Jacques Balsan. In her time a suffragette, social worker, and patron of many charities, at age 78 she was singled out by Eleanor Lambert as "an elegant fashion individualist." TOP, RIGHT: Vicomtesse **JACQUELINE DE RIBES,** in a flame organza Dessès dress, speaking to Miguel Carcaño at the Château de Groussay, Carlos de Beistegui's house outside Paris, March 18, 1957. The party celebrated the opening of de Beistegui's private theater, where Comédie-Française actors performed a new play by Marcel Achard. RIGHT: **GENEVIÈVE FATH,** widow of couturier Jacques Fath, posing on a tête-à-tête, 1955. Always his best model, Geneviève inherited the business from her husband and continued making well-received collections for the label. Shortly before his 1954 death, *The New York Times* praised Fath for "his magic with color, his way of making women both beautiful and smart."

FOLLOWING SPREAD: **JACQUELINE DE RIBES** aboard Stavros Niarchos's yacht, *La Créole,* 1956. De Ribes is wearing Pucci, for whom she ghost-designed for two seasons. Emilio Pucci accurately predicted that she could become a serious designer in her own right.

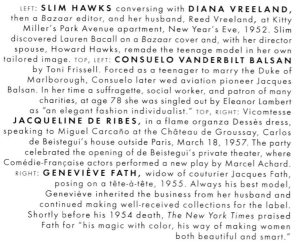

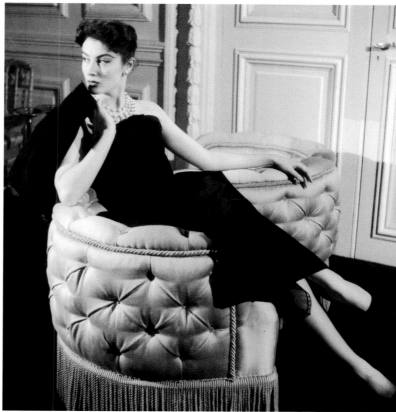

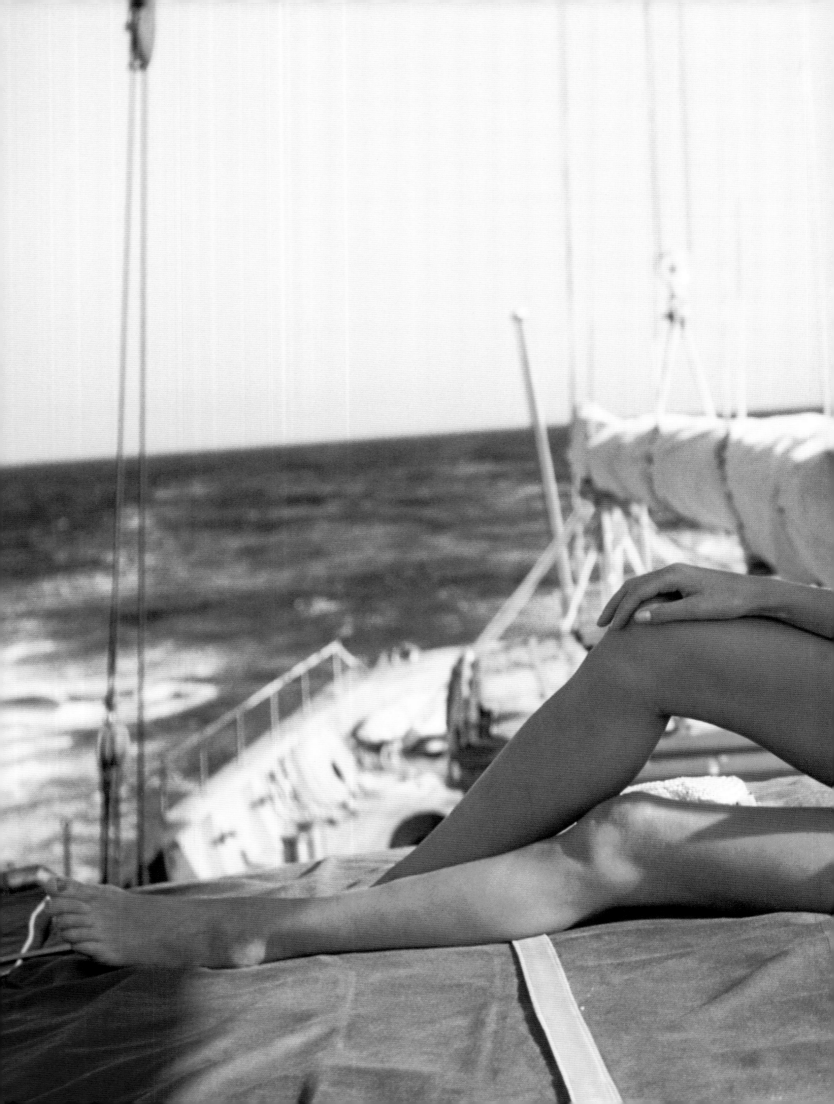

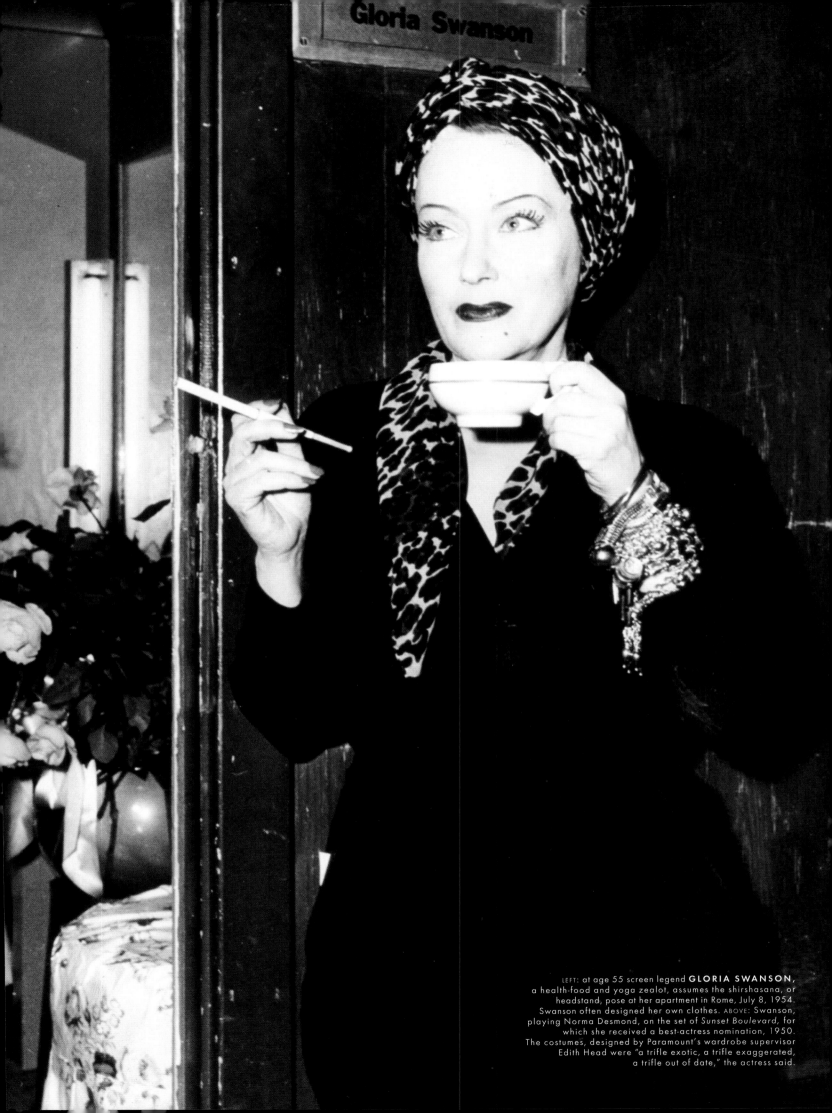

Gloria Swanson

LEFT: at age 55 screen legend **GLORIA SWANSON**, a health-food and yoga zealot, assumes the shirshasana, or headstand, pose at her apartment in Rome, July 8, 1954. Swanson often designed her own clothes. ABOVE: Swanson, playing Norma Desmond, on the set of *Sunset Boulevard*, for which she received a best-actress nomination, 1950. The costumes, designed by Paramount's wardrobe supervisor Edith Head were "a trifle exotic, a trifle exaggerated, a trifle out of date," the actress said.

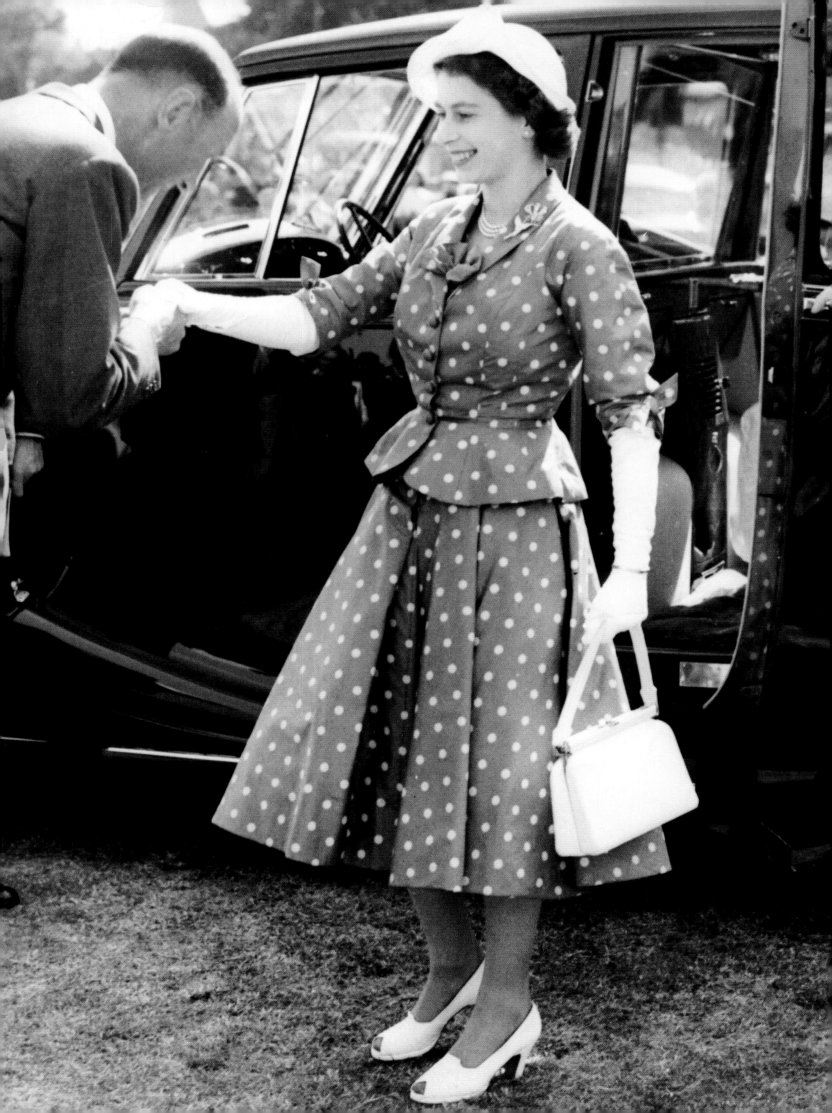

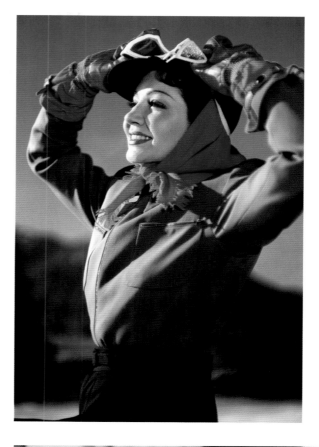

LEFT: **QUEEN ELIZABETH II,** aged 26, arriving for the first day of the Royal Windsor Horse Show, in the Home Park of Windsor Castle, July 24, 1952, one year before her coronation and just five months after the death of her father, George VI, whom she succeeded to the throne. RIGHT: **CLAUDETTE COLBERT** in Sun Valley, Idaho, displaying her left profile, the only one she allowed to be photographed. A perfectionist, the Oscar winner expertly elongated her neck with dressmaking tricks. She taught the designer Adolfo to make a collar "so she would not look buried in a blouse," he said. BELOW, RIGHT: **JEAN MacARTHUR,** a Tennessee banker's daughter, attends ceremonies to mark the founding of the Korean Republic, August 1948. Her husband, General Douglas MacArthur, was the commander of the U.N. forces there until 1951, when he was recalled by President Truman. BELOW, LEFT: **OVETA CULP HOBBY,** the silver-haired, violet-eyed former director of the Women's Army Corps. "Even in her WAC uniform she had her own air of distinction," Eleanor Lambert said. Later, Eisenhower appointed Hobby, a Valentina client, the first secretary of health, education, and welfare and advised her to run in the 1960 presidential election (she chose not to run).

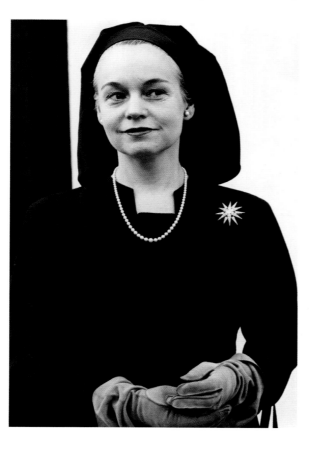

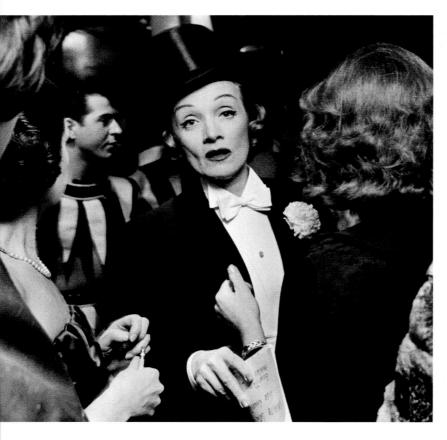

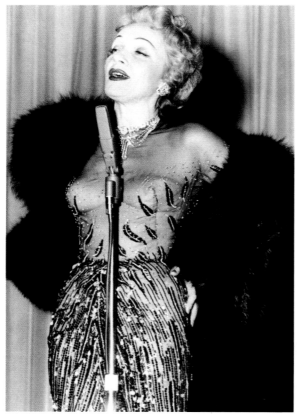

LEFT, TOP: **MARLENE DIETRICH** photographed in 1959 at the April in Paris Ball, at the Waldorf Astoria hotel, New York. The men's formal evening attire had been a trademark look for Dietrich since her first Hollywood film, Morocco, 1930. "I can't wear women's trousers," she explained.

LEFT, BOTTOM: Marlene's first nightclub act, December 18, 1953, at the Sahara Club, Las Vegas. After playing cabaret singers, Dietrich decided to become one, at 51. Her racy beaded silk soufflé dress is by Hollywood costume designer Jean Louis. "People come not to see me," Dietrich said, "but to look at me."

RIGHT: The eternal movie goddess and humanitarian arrives at the Hollywood Egyptian Theater, November 21, 1955, for the film premiere of Oklahoma! "I dress for the image," Dietrich said. "Not for myself, not for the public, not for fashion, not for men. If I dressed for myself I wouldn't bother at all."

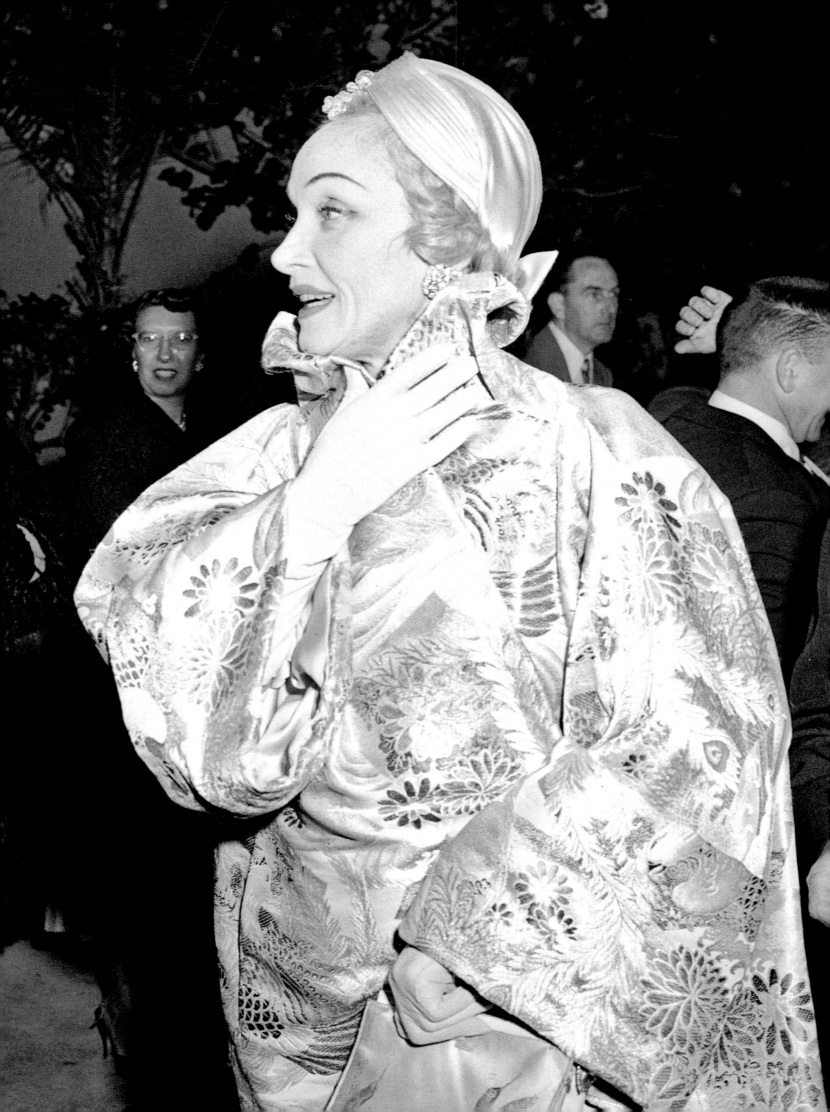

# The 1960s

## BEAUTIFUL PEOPLE
### *and*
## ELEGANT REBELS

**VERUSCHKA** by Horst, 1966. She wears Arnold Scaasi dinner pajamas with Bernardo sandals.
Beside her is a Marisol sculpture, *Untitled*, 1965–66. The six-foot-one German countess, model, actress, and artist, who was incarcerated
as a child by the Gestapo, said, "No million dollars is worth giving up my freedom of expression."

THE HON. DEAN ACHESON

GIANNI AGNELLI

MARELLA AGNELLI

SRA. UMBERTO AGNELLI (ANTONELLA PIAGGIO)

PRINCESS ALEXANDRA OF KENT

MME. HERVÉ ALPHAND (NICOLE MERENDA BUNAU-VARILLA)

ADOLPHUS ANDREWS

HÉLÈNE ARPELS

FRED ASTAIRE

LAUREN BACALL

CECIL BEATON

HARRY BELAFONTE

MME. AHMED BENHIMA (AÏCHA LAGHZAOUI)

BERRY BERENSON

MARISA BERENSON

CATHERINE "DEEDA" BLAIR

BILL BLASS

MRS. ALFRED BLOOMINGDALE (BETSY NEWLING)

MRS. DAVID BRUCE (EVANGELINE BELL)

GIANNI BULGARI

AMANDA BURDEN

MICHAEL BUTLER

ROBIN BUTLER

THE DUCHESS OF CADAVAL (CLAUDINE TRITZ)

MRS. JOHN CAREY-HUGHES (CARROLL)

PIERRE CARDIN

DIAHANN CARROLL

MARGARET CASE

GABRIELLE "COCO" CHANEL

JAMES COBURN

ANITA COLBY

SYBIL CONNOLLY

WYATT COOPER

COUNT RODOLFO CRESPI

FARAH DIBA

MRS. KIRK DOUGLAS (ANNE BUYDENS)

THE HON. ANGIER BIDDLE DUKE

MRS. ANGIER BIDDLE DUKE (ROBIN TIPPETT LYNN)

FAYE DUNAWAY

MRS. FREDERICK EBERSTADT (ISABEL NASH)

H.R.H. PRINCE EDWARD, THE DUKE OF WINDSOR

MRS. CHARLES ENGELHARD JR. (JANE REISS MANNHEIMER)

MRS. AHMET ERTEGUN (MICA BANU GRECIANU)

LUIS ESTÉVEZ

MRS. DAVID EVINS (MARILYN)

DONNA SIMONETTA FABIANI

DOUGLAS FAIRBANKS JR.

CRISTINA FORD (CRISTINA VETTORE AUSTIN)

PRINCESS IRA VON FÜRSTENBERG

PRINCESS IRÈNE GALITZINE

FRANK GIFFORD

SOPHIE GIMBEL

HUBERT DE GIVENCHY

CARY GRANT

MRS. MILTON H. GREENE (AMY FRANCO)

ROBERT L. GREEN

DOLORES GUINNESS

GLORIA GUINNESS

BARON NICOLAS DE GUNZBURG

MRS. MONTAGUE HACKETT (FLAVIA RIGGIO)

WALTER HALLE

GEORGE HAMILTON

LADY PAMELA HARLECH

ENID HAUPT

MRS. T. CHARLTON HENRY (JULIA BIDDLE)

AUDREY HEPBURN

SIGHSTEN HERRGARD

MRS. LYNDON B. JOHNSON (CLAUDIA "LADY BIRD" TAYLOR)

NAN KEMPNER

JACQUELINE KENNEDY

---

NEAR RIGHT: entertainer **DIAHANN CARROLL** in 1968 wearing Donald Brooks, who dressed her in the 1962 Broadway musical *No Strings,* for which she won a Tony Award for best actress in a musical. Photo by Milton H. Greene. TOP: **JACQUELINE KENNEDY** a few months before she became First Lady, at the Kennedy compound in Hyannis Port, Massachusetts. Photo by Jacques Lowe, 1960. BOTTOM, LEFT: **PIERRE CARDIN,** an Eleanor Lambert client, was admitted onto the first men's List, originally for fashion professionals only, in 1966. BOTTOM, RIGHT: designer **BILL BLASS** with close friend, client, and adviser **LOUISE GRUNWALD,** the philanthropist and former *Vogue* assistant, December 1964.

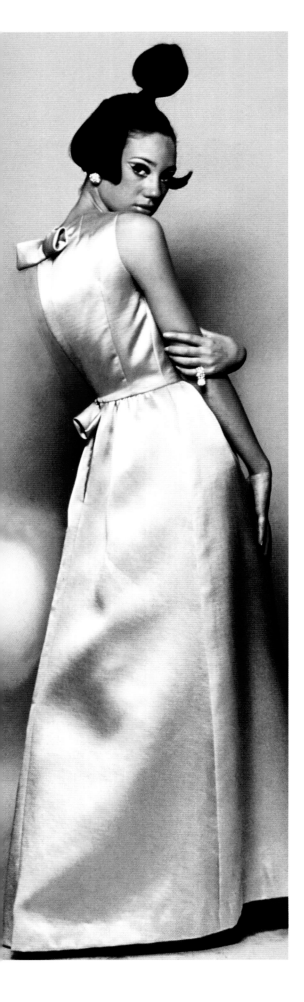

MRS. JOSEPH P. KENNEDY (ROSE FITZGERALD)

H.R.H. THE BEGUM AGA KHAN

EMMANUELLE KHANH

JEAN-CLAUDE KILLY

BERNARD LANVIN

MME. BERNARD LANVIN (MARYLL ORSINI)

MINOUCHE LE BLAN

THE EARL OF LICHFIELD (PATRICK)

MOLLIE PARNIS LIVINGSTON

SOPHIA LOREN

ALI MACGRAW

MRS. LAWRENCE MARCUS (SHELBY)

MRS. STANLEY MARCUS (MARY CANTRELL)

MARISOL

MRS. GRAHAM MATTISON (PERLA DE LUCENA)

MRS. TOM MAY (ANITA KEILER)

MRS. PAUL MELLON (BUNNY LOWE LAMBERT LLOYD)

DINA MERRILL

CATERINE MILINAIRE

MRS. MARK MILLER

MRS. VINCENTE MINNELLI (DENISE RADOSAVLJEVI)

MRS. SAMUEL NEWHOUSE (MITZI EPSTEIN)

CHARLOTTE FORD NIARCHOS

PATRICK O'HIGGINS

EVE ORTON

PRINCESS PAOLA OF BELGIUM

NORMAN PARKINSON

I. S. V. PATCEVITCH

H.R.H. PRINCE PHILIP, THE DUKE OF EDINBURGH

PRINCESS LUCIANA PIGNATELLI

MAYA PLISETSKAYA

MARY QUANT

LEE RADZIWILL

CHESSY RAYNER

MRS. RONALD REAGAN (NANCY ROBBINS)

BARON ALEXIS DE REDÉ

FRANÇOISE DE LA RENTA

MRS. CHARLES REVSON (LYN FISHER SHERESKY)

VICOMTESSE JACQUELINE DE RIBES

MRS. CHARLES SPITTAL ROBB (LYNDA JOHNSON)

HÉLÈNE ROCHAS

MRS. RICHARD RODGERS (DOROTHY FEINER)

MRS. WILLIAM ROSE (BERNICE)

BARON ERIC DE ROTHSCHILD

BARONESS PAULINE DE ROTHSCHILD

ELIETH ROUX

HELENA RUBINSTEIN

MRS. JOHN BARRY RYAN III (DORINDA "D. D." DIXON)

ROBERT SAKOWITZ

MRS. ROBERT SAKOWITZ (PAMELA ZAUDERER)

MRS. WALTHER MOREIRA SALLES (ELIZINHA)

MRS. RENNY SALTZMAN (ELLIN SADOWSKY)

LOUISE LIBERMAN SAVITT (LATER MELHADO, GRUNWALD)

GLORIA SCHIFF

H.M. QUEEN SIRIKIT OF THAILAND

CARMEL SNOW

BARBRA STREISAND

GERALDINE STUTZ

DAVID SUSSKIND

BETSY PICKERING THEODORACOPULOS

BARONESS FIONA THYSSEN-BORNEMISZA

PAULINE TRIGÈRE

MRS. GIANNI UZIELLI (ANNE FORD)

MRS. ALFRED G. VANDERBILT (JEAN HARVEY)

GLORIA VANDERBILT

PHILIPPE VENET

VERUSCHKA

DIANA VREELAND

JOHN WEITZ

GEORGE WIDENER

MRS. NORMAN K. WINSTON (ROSITA HALFPENNY)

JAYNE WRIGHTSMAN

FAR LEFT: **MARISA BERENSON** models a dress by Nat Kaplan for a spread in *Vogue's* September 15, 1965, issue. She first arrived on the List in 1965, when she was 18. Berenson's modeling career began when Diana Vreeland encountered her at a debutante ball and exclaimed, "Beauty like yours belongs to the world!" TOP, LEFT: **FRED ASTAIRE** with his Siamese cat, 1962. In 1968 he and the Duke of Windsor were the first men to enter the Hall of Fame. TOP, RIGHT: **BARBRA STREISAND** at a fund-raiser for Israel at the Hollywood Bowl, June 11, 1967. BOTTOM: **GLORIA GUINNESS,** photographed at home in Palm Beach, Florida, by Cecil Beaton. *Vogue admired everything about Guinness, from her "easy, lyrical" walk to the "effortless, untense perfection" with which she ran her houses, yacht, and jet.*

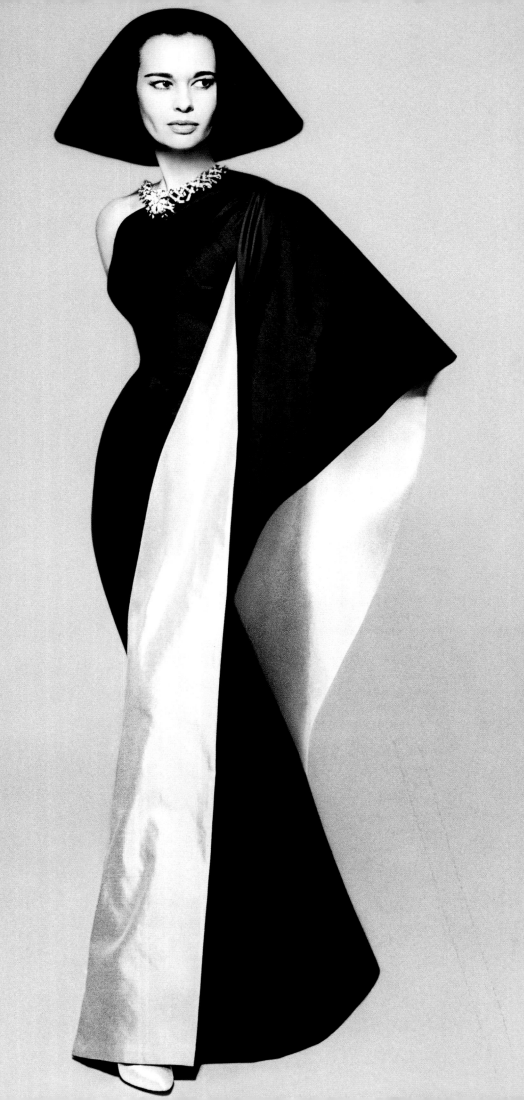

*"Only personality creates style.
Indeed, personality
not only can impose its bizarre
aspects on a period,
but even, to some extent,
creates the period itself."*

—CECIL BEATON

---

# *The* Secret Synod

With the founding generation of Best-Dressed immortals now spirited away to the Hall of Fame, space was cleared for the shiny new tribe of globe-trotters known as the jet set, formed after the launch of the Boeing 707 at the turn of the decade. The proudly American poll of a generation before was rebranded as "The Best Dressed Women in the World: Annual International Poll." To assume tighter control of her increasingly unwieldy instrument, Lambert late in 1959 tapped a small, elite coterie to act as a kind of electoral college to oversee and revise the raw data of tabulated votes. On December 7, 1959, she dispatched a telegram to Eugenia Sheppard; *Vogue* society editor Margaret Case; Diana Vreeland; Sally Kirkland of *Life*; Patricia Peterson of *The New York Times;* Nancy White of *Harper's Bazaar;* fashion designer and Lambert client Mollie Parnis; Constance Woodworth of *The New York Journal American;* and Jane Stark of *Glamour,* asking, "Can you lunch with me Wednesday December 23 1230 Pavillon to examine the results of the Best Dressed Poll and Finalize the List for 1959 Please call MU8-2130." Lambert announced in her January 1960 press release the formation of her anonymous band of experts, whose role, she stressed, was only to "analyze" votes. Later she would become cagey about even the existence of the secret coven.

But the truth of the matter was it convened annually. Depending on the year, the council would assemble either in the red-plush dining room of Le Pavillon, or in Lambert's office, with its ladylike Louis XV desk and Coromandel screen, or at a hotel (perhaps the Astor, in the Hunt Room, or the Plaza, in the White and Gold Suite), to veto or endorse candidates in secrecy, like a papal synod. At these conclaves, Lambert presided only as a figurehead. Never voting, she was an impassive Juno, inscribing others' judgments on her legal pad. "It is my labor of love," Lambert said, "because of fashion. I don't vote and never have." From the forum of her *Herald-Tribune* "Inside Fashion" column, Eugenia Sheppard neatly disposed of proliferating gossip about the List's hermetic inner circle. "It's a favorite old-wives tale that a catty committee goes through the ballots and prunes off the names it doesn't like," Sheppard averred. "Let the losers go on thinking so, if it makes them happy."

---

**GLORIA VANDERBILT,** dress by Mainbocher,
New York, March 11, 1960.
Photograph by Richard Avedon.

93

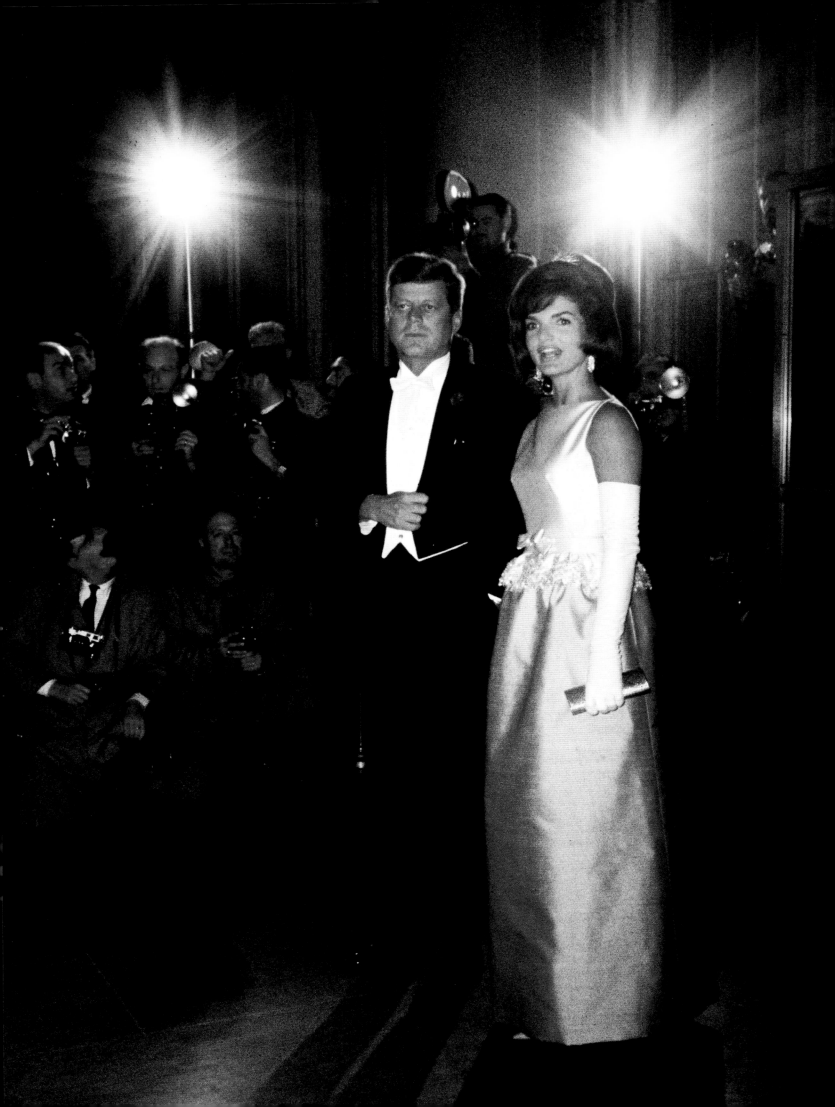

# The Ascension of Jackie

Passing through the first "catty committee's" alembic, in 1959, and heading the List (because this time Lambert marshaled her designees alphabetically), was Marella Agnelli, whom Truman Capote that year also proclaimed to be "the European swan numero uno." Lambert singled out the fetching wife of the Fiat chairman for her "exquisite taste," consisting of "slim, restrained clothes," "dashing slim slacks," and, for informal evenings at home, the rather singular uniform of "Persian semi-fitted coats." Agnelli was not too restrained to send off an enthusiastic telegram from Turin, informing Lambert how "very happy and very honored" and "even grateful" she was to be "enclosed [sic] in our [sic] annual choice." Making her maiden appearance on the same List was Balenciaga client Gloria Guinness (née Rubio), whom Lambert privately esteemed as "the most elegant woman in the world." To Lambert, Guinness was "a born beauty" and "a complete woman" with a "faultless figure." Given to ensembles of graphic black and white because, Sheppard said, "she looks like a fine pen-and-ink drawing," the Mexican-born wife of international banker Loel Guinness (husband No. 4), would always remain, to Lambert, "the woman who has everything." In the press release for the 1959 List, dated January 8, 1960, Lambert referred fleetingly also to a "governmental celebrity" whom her group of advisers had "mentioned" in passing, a Massachusetts senator's wife, Mrs. John Kennedy.

By the following year, just weeks before President Kennedy's inauguration, Lambert was trumpeting to the nation, "The landslide which failed to develop in her husband's recent race for the presidency materialized for Mrs. John F. Kennedy when the votes for world fashion were counted in New York this week. Mrs. Kennedy swept to the top of the list." At its bottom, on rung 12, was another alluring young wife of a head of state, the Balmain-and-chut-thai-swathed Queen Sirikit of Thailand, aged 28. Earlier in 1960, during a stop on their world tour, the royal couple (the king was a drum-playing jazz fan) had been fêted in Manhattan with a ticker-tape parade, which drew a cheering crowd of 750,000.

For the next two years, Kennedy—"symbol of fashion leadership to the average woman everywhere," with her "unfitted silhouette" and "loose but neatly buttoned coats"—held fast in first place. For once, popular opinion was aligned with the List's. "The entire country," Lambert remarked in 1963, "looks and dresses like small, medium, and large Jacqueline Kennedys." And in the January 5, 1963, *Saturday Evening Post,* Sheppard went even further. "No other woman in American history," she said, "has been so widely copied, from her bouffant hairdo to her low-heeled shoes."

Among the women who trailed on the First Lady's Cassini coattails were her mother-in-law, Rose Kennedy (whom *Women's Wear Daily's* John Fairchild perversely declared "the best dressed of the Kennedys"); her sister, Lee Radziwill, then a London-dwelling devotee of Saint Laurent and Courrèges and, briefly, a fashion reporter; Deeda Blair, wife of the ambassador to Denmark; the Balenciaga-bedecked Camelot cohort and horticultural enthusiast Bunny Mellon; and Jayne Wrightsman, a close ally and Palm Beach neighbor. *Time* called Wrightsman, a respected collector of French fashion, art, and furniture, the First Lady's "shopping consort." Though the taciturn Wrightsman declined to discuss her famous protégée, in a 1961 questionnaire preserved in Lambert's archives the oil millionaire's wife did offer up some rare views on fashion. Wrightsman's personal wardrobe philosophy was "respect, don't worship clothes." She believed attending "a collection is bad"; she recommended instead reviewing sketches privately at home, at one's leisure. To be a Best-Dressed woman, Wrightsman believed, "takes very little time but a great deal of thought and care." Publicly, by contrast, Kennedy affected indifference to her Best-Dressed stature. Clothing, she demurred when asked about her ongoing supremacy, "is at the bottom of the list of my most important things in life."

One of the clandestine committee's more public acts of veto took place in 1963, when it ruled unanimously that "in deference to Mrs. Kennedy's mourning her name was not to be discussed at all." In a less somber spirit, the committee cited, but did not name to the List, two movie stars: Elizabeth Taylor, buxom diva of that year's blockbuster, *Cleopatra,* for catalyzing "the swing of the fashion pendulum to a new period of sexiness," and Romy Schneider, just featured in Otto Preminger's *The Cardinal,* for igniting a craze for "Chanel suits, short brushed hair with a bow and low open-cut shoes," Lambert stated. The 1963 Kennedy ban did not extend to Lee Radziwill, whom Diana Vreeland always believed to be more chic than her sister. Hoisted to Kennedy's vacated pedestal, not surprisingly, was "the ultimate," Gloria Guinness—whose daughter, Dolores (married to Gloria's stepson Patrick Guinness), had meanwhile joined her mother on the List.

Restored to the List in 1964, Jackie Kennedy was acclaimed along with her mother-in-law for the "decision not to wear deep mourning over a long period"—a choice that "reflected the same sense of discipline and contemporary dignity which the late President always displayed."

# Lambert's Magic Wand *and* Its Vagaries

Following a clash between manufacturers and designers over Press Week show dates (which she viewed as a battle between commerce and creativity) Lambert, after 22 years, resigned from the Dress Institute's Couture Group. Kitty Campbell, its new press director (whom Lambert disliked), insisted—perhaps with a note of sour grapes—"We dropped the property because we felt it was phony." Whether or not the organization actually regretted the loss of the List, officially it was now entirely an Eleanor Lambert vehicle, propagated by Eleanor Lambert, Ltd., and her staff of approximately 17, from 32 East 57th Street. Just as when Lambert transplanted the List from Paris in 1940, she made certain it reappeared precisely on schedule, in early January, "as regular as Christmas bills," *Life* remarked.

Enamored of Mexicans and Mexico, the recently widowed Lambert bought Casa Leonor, a white house overlooking the bay in Acapulco, which she deemed "the New Riviera." There she mingled with Rothschilds; Agnellis; Merle Oberon and her husband, Bruno Pagliai; Warren Avis; designer Luis Estévez; and cosmetics mogul Charles Revson and his young Norell-dressed wife, Lyn. "And the next thing you knew," recalled illustrator Joe Eula, who worked with Lambert on her televised March of Dimes fashion shows, "the whole Mexico crowd stormed onto the List." There were of course myriad exceptions to Eula's insinuation of favoritism. Bizarrely, Helena Rubinstein (her mantra: "There are no ugly women, only lazy ones") appeared in 1964, a one-time wonder at the hoary age of 94. The beauty tycoon—whose belated arrival was likely the handiwork of List committeeman Patrick O'Higgins, a writer and leading Rubinstein walker—had in her spectacular career patronized every designer from Poiret to Saint Laurent, and every artist from Modigliani to Picasso. She brought lipstick to America, revived Victorian furniture and baroque pearls, and had just made news by foiling bandits in her bedroom. The plucky four-foot-ten nonagenarian had outwitted the armed intruders by dropping the keys to her safe into her bosom.

"Sure, Eleanor's clients and friends showed up on the list," *Women's Wear Daily*'s John Fairchild said. "After all, the universe is a limited place." Although Fairchild faithfully chronicled the lives and wardrobes of the "Impeccable BDL's"—Marella Agnelli, Babe Paley, Gloria Guinness ("Glorissima"), C. Z. Guest, Gloria Vanderbilt, Kitty Miller—he nonetheless dismissed the International Best-Dressed List as "a gimmick and a bunch of rot." He toyed with the ladies who scaled the slopes of Lambert's slippery Olympus by regularly scrutinizing in his paper not only whom the "cruel BDL committee" beatified but also which "tragic playthings" the capricious arbiters dropped. On the eve of the 1966 announcement, for instance, Fairchild divulged that he already knew the identities of the winners—and losers—but was "bound by a sacred oath" not to break the release date. "How," he wondered, would those expelled from high priestess Lambert's temple of elegance be able to "face themselves, their husbands, their hairdresser"? He called for "municipal authorities" to "patrol bridges and high places," because compared "to the cataclysm" of banishment from the list, "the Four Horsemen of the Apocalypse belong on a merry-go-round." Next to being an I.B.D.L. discard, "Marie Antoinette in the tumbril was lucky." *WWD* could be so relentless in skewering Lambert and the List, the paper once asserted that the publicist had boasted, "I own every fashion editor in America" and proposed that "B.D.L." really stood for "Buy Dame Lambert." The misquote precipitated a tempest in a thimble, with the American Society of Newspaper Editors and the *Columbia Journalism Review* all picking up the story and weighing in on Lambert's purported breach of ethics.

Though Lambert did not buy off the press, she was regularly besieged by List aspirants angling to corrupt her. She was offered not only kickbacks but also bribes—of up to $50,000, according to Eugenia Sheppard. And she was harassed; over the course of a year, one woman mailed 70 picture postcards of herself modeling all her latest outfits. Status seekers employed full-time publicists, *Town & Country* reported, "to drumbeat their 'fashion image' in the nation's press," with the objective of catching the committee's attention. For Eleanor Lambert wielded "a magic wand," John Fairchild wrote in 1965, that "lights the way into newspapers, magazines, and even into society." The List had become "to fashion," Lambert conceded in 1963, "what the Social Register and the Almanach de Gotha are to society." But, said Kenneth, the

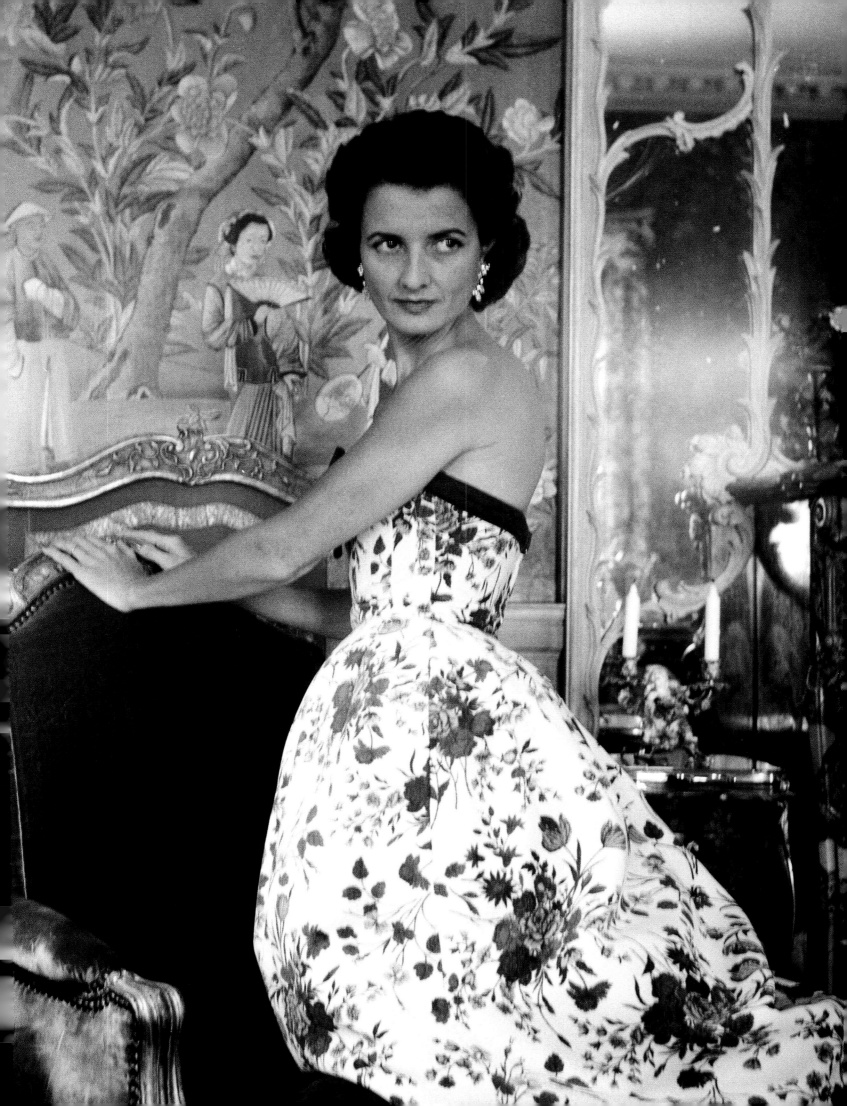

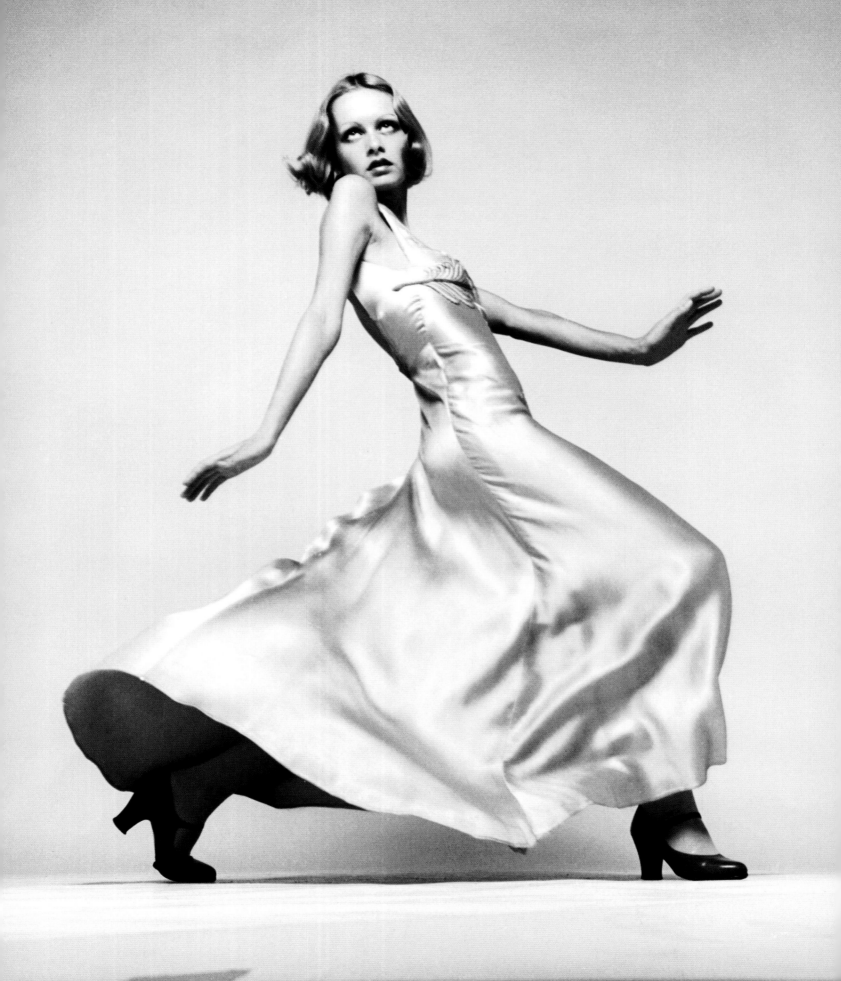

hairdresser, "very few people saw those books. The List, on the other hand, brought exposure around the world. So to certain women the List had more social cachet. They fought like tigers to get on it. Over the years several clients intimated they'd 'make it worth my while' if I'd vote for them."

Another List voter, designer Fernando Sánchez, said, "I remember a Spanish lady, rather grand, who wanted to marry with title and money. She called me from Spain, insisting that I must get her on. I didn't have that power. But Eleanor Lambert did." Said ex-model Betsy Kaiser (then Theodoracopulos), who first landed on the List in 1966, "It was amazing to receive that telegram. After all, it put you in some pretty good company." Nan Kempner, a 1966 winner in the Fashion Professionals category (she was then a *Harper's Bazaar* fashion editor), was no less thrilled. "I was so excited," she reminisced. "And so was my mother!" Kaiser continued, "I remember the photo of me that ran in the papers with the announcement. I was wearing Saint Laurent's peacoat with long brown boots." Kaiser said it drove one particular woman crazy when she got on. Both Kaiser and Kempner, who together achieved the Hall of Fame in 1971, suspected a certain lady who had scrambled up behind them of having bought her way on. As the saying goes, "The last one in always wants to close the door behind her." Or as designer Arnold Scaasi remarked, "The B.D.L. is still very important, especially to women who are not on it."

At least for the public, the criteria for inclusion became so cryptic Sheppard counseled hopefuls to have a "flat chest" and assume a "slouch posture," as "few women with conspicuously female figures have ever made the grade." Norman Hartnell, a voter, said, "I place first importance upon … the extremities—and by that I mean the hands, feet, shoes, stockings." Diana Vreeland, apotheosized as a Hall of Famer in 1964, even less helpfully proposed that serious contenders must be "romantic, alert, 'with-it.'" Finally, she gave up on concrete advice and uttered the arcane disclaimer "Part of it is myth and can't be expressed."

---

# *The* Youthquake *and* Cultural Revolution

"The world is moving so quickly," Lambert's client Pierre Cardin said in a 1967 *Town & Country* opinion roundup, "I doubt if the Best-Dressed List can keep up." The radical Rudi Gernreich, another Lambert client, stated, "The word 'best-dressed' is passé." But Mainbocher more evenhandedly declared, "Of course, the initial excitement of a premiere can hardly be sustained over so many years, but the truth is that people seem to adore lists and always read them, whether they agree or not…. As long as it is not taken too seriously, I think it is fun."

During the Summer of Love, Lambert turned the age of retirement—but at 65 she still streamed along fluidly with the current. One nod to the zeitgeist was the simultaneous elevation of mod miniskirt maven Mary Quant and her French counterpart, Emmanuelle Khanh, who had declared in 1965, "Haute couture is dead. I want to design for the street, a kind of socialist fashion for the masses." Lambert did not miss the irony that "radical people in the 60s, with all their anger and protest," still placed "a great emphasis on hair and clothes."

Another immediate regenerator for the List during what Vreeland termed the "youthquake" was the admission of men—experimentally at first, in 1966, in the Fashion Professionals category. ("Does that counteract women's lib, mummy?" gossip columnist Suzy asked rhetorically.) Harbingers of the Peacock Revolution (which put men in ruffles, heels, fur, long hair, and Nehru jackets), and symbolizing, Lambert opined, "the new variety and personality of masculine fashion," were designers (and clients) Pierre Cardin, Bill Blass, and John Weitz; photographer Norman Parkinson; Condé Nast publisher I. S. V. Patcevitch; and Patrick O'Higgins. When the List officially turned unisex, in 1968, Gloria Vanderbilt and her fourth husband, Wyatt Cooper, became "the first married couple to cop the best-dressed title," Lambert alerted the public. Vanderbilt explained, "If I wore a velvet patchwork skirt by Adolfo, Wyatt would put on a matching patchwork vest. It was fun." Vanderbilt had first entered the List in 1962, when she was married to her third husband, director Sidney Lumet. At that moment, she lamented, "Oh dear, no more blue jeans." (Ten years later Cooper's List win formed the subhead of his *New York Times* obituary.)

In 1968, instant Hall of Fame status was conferred for the first time on two men, the Duke of Windsor and Fred Astaire, whom the committee agreed had "never been topped in their lives"; normally, candidates were eligible for induction only after three appearances. (Privately, Lambert felt the Duke of Windsor was "embarrassing…. Whenever I was invited to their home for dinner, he would always ask if he was well-dressed.") As for Astaire, the dancer told the *Los Angeles Times*, "It's all very nice, but I can't say I understand it.

---

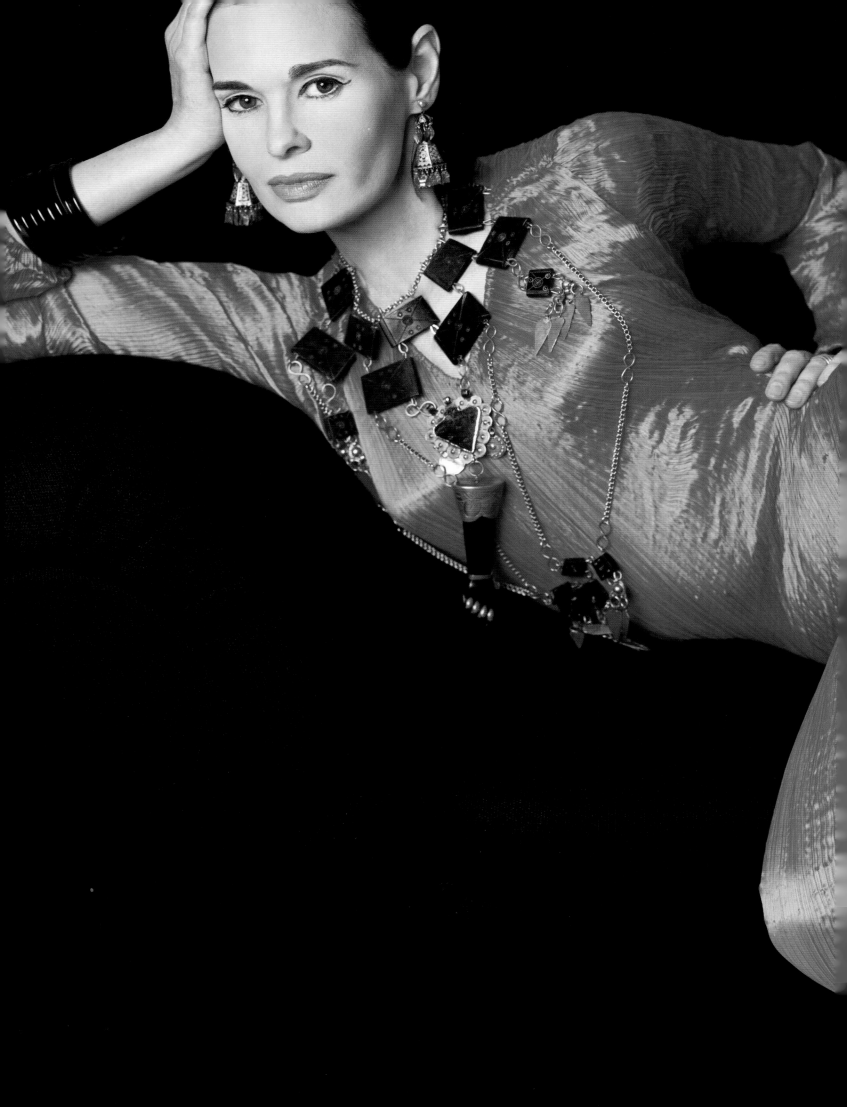

I just grab something out of the closet and wear it." (Typical of the moment's off-kilter schisms, Mao Tse-tung and Richard Nixon had each earned one vote in the 1968 men's Poll.)

In the same insurgent year, Lambert also split the women's List into two factions, the "best-dressed in the high classic tradition" and the "most original and inventive." Reflecting the alarming chaos of 1968 (assassinations of Martin Luther King Jr. and Robert F. Kennedy, riots in Paris and Chicago), Lambert announced that it was "confusing, if not impossible, to group the two distinct types of fashion expertise in a single list." When Galanos client Denise Hale (then married to director Vincente Minnelli) turned up among the Classicists, she informed her husband, "Now I have my Oscar." Other Classicists included her fellow Californian Betsy Bloomingdale, notable for her Diors and her sportswear from Jax, and Louise Savitt (now Grunwald), a worldly exponent of Seventh Avenue's own Bill Blass. A motley band, the rebel contingent included a quirky American-born aristocrat, Yves Saint Laurent and Balenciaga aficionado Pauline de Rothschild—named, surprisingly, for the first time at 60. About the lanky former top Hattie Carnegie designer, whose artistically eccentric innovations in entertaining, decorating, and dressing Diana Vreeland chronicled obsessively in *Vogue,* Cecil Beaton said, "the affectations" have "become completely natural." There was also haute hippie Marisa Berenson, 21, known for her sky-high platforms, her layered gypsy-like costumes, and her semi-psychedelic Irving Penn *Vogue* covers. Surely her grandmother Elsa Schiaparelli, who inexplicably never appeared on the List, must have been pleased, as the year before she had griped that the annual roster was "monstrously monotonous." Also categorized as "original" was a diverse bevy of celebrities. The jet-haired Venezuelan-born Pop sculptor Marisol was dependably striking, Lambert wrote, "whether in a neat mini-skirt or in a dramatic evening fantasy by avant-garde designer Giorgio di Sant'Angelo." Barbra Streisand (who said her mother "thought Balenciaga was a bodega in Brooklyn") drew praise for her one-of-a-kind thrift-shop finds as well as her ability to carry off the zany confections of Arnold Scaasi. Equally "original" was Diahann Carroll, the List's first African-American woman. Having demonstrated her sartorial flair while playing a model in Richard Rodgers's interracial musical romance, *No Strings,* Carroll was in 1968 breaking ground in the post–Civil Rights Act TV series *Julia*—in which she performed the title role. And in 1969, the second year for men, the List, again playing catch-up with the times, named Harry Belafonte, calypso king and civil-rights activist, as the List's first African-American man.

**GLORIA VANDERBILT,** dress by Fortuny, New York, June 19, 1969. Photograph by Richard Avedon.

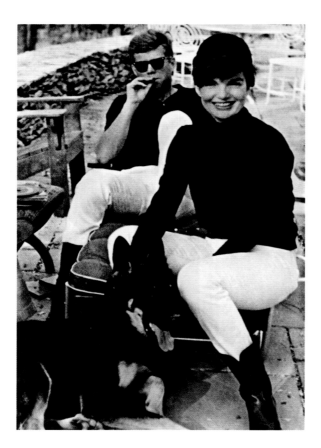

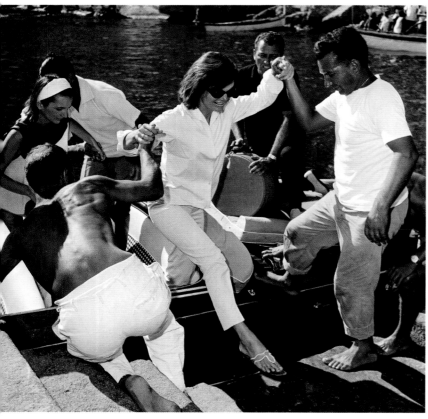

TOP: President John F. Kennedy and **FIRST LADY JACQUELINE KENNEDY** near Middleburg, Virginia, 1963. An equestrienne since she was three, Jackie attributed her erect comportment to her many years of competitive riding. ABOVE: First Lady Jacqueline Kennedy steps off a boat in Amalfi, Italy, during a vacation with daughter Caroline and sister Lee Radziwill, August 19, 1962. Eleanor Lambert praised Jackie's "casual ease" while off-duty and "correct good taste in public life." RIGHT: Jacqueline in a limousine after her arrival in Rome from a trip to Thailand and Cambodia, November 11, 1967. Though no longer First Lady, she still displayed what Eleanor Lambert called her "neat, buttoned-up" look.

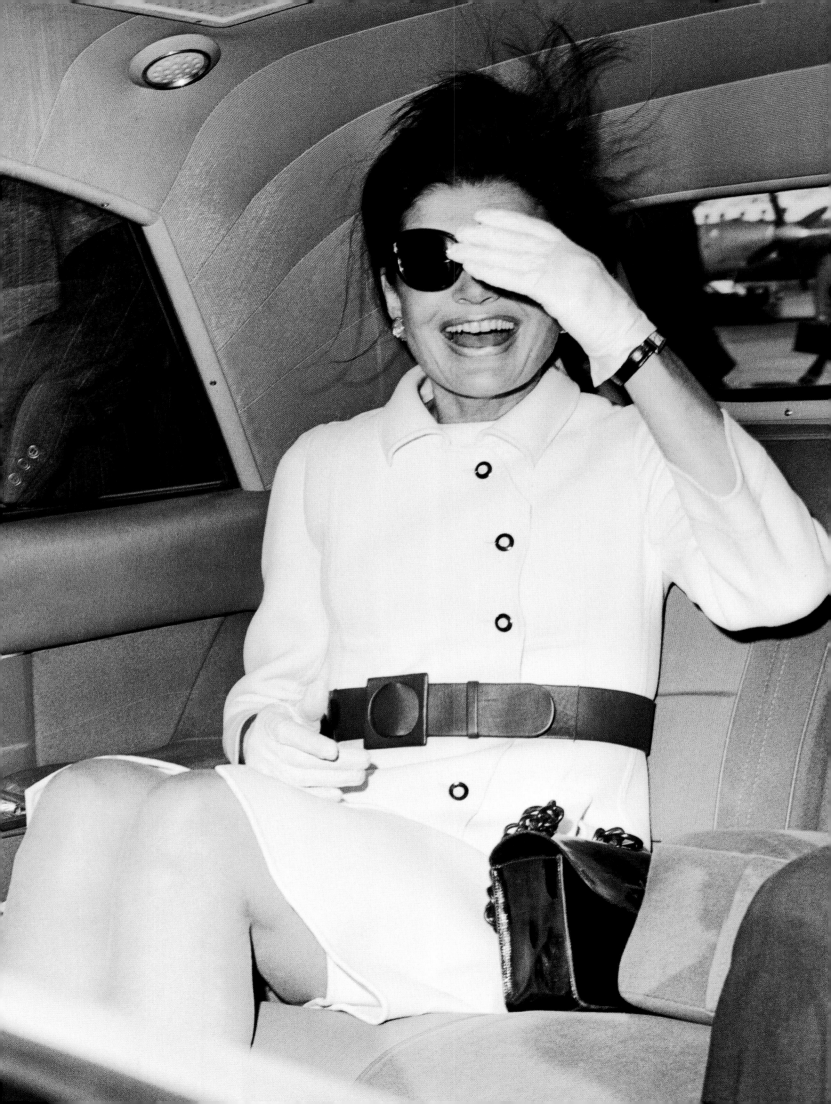

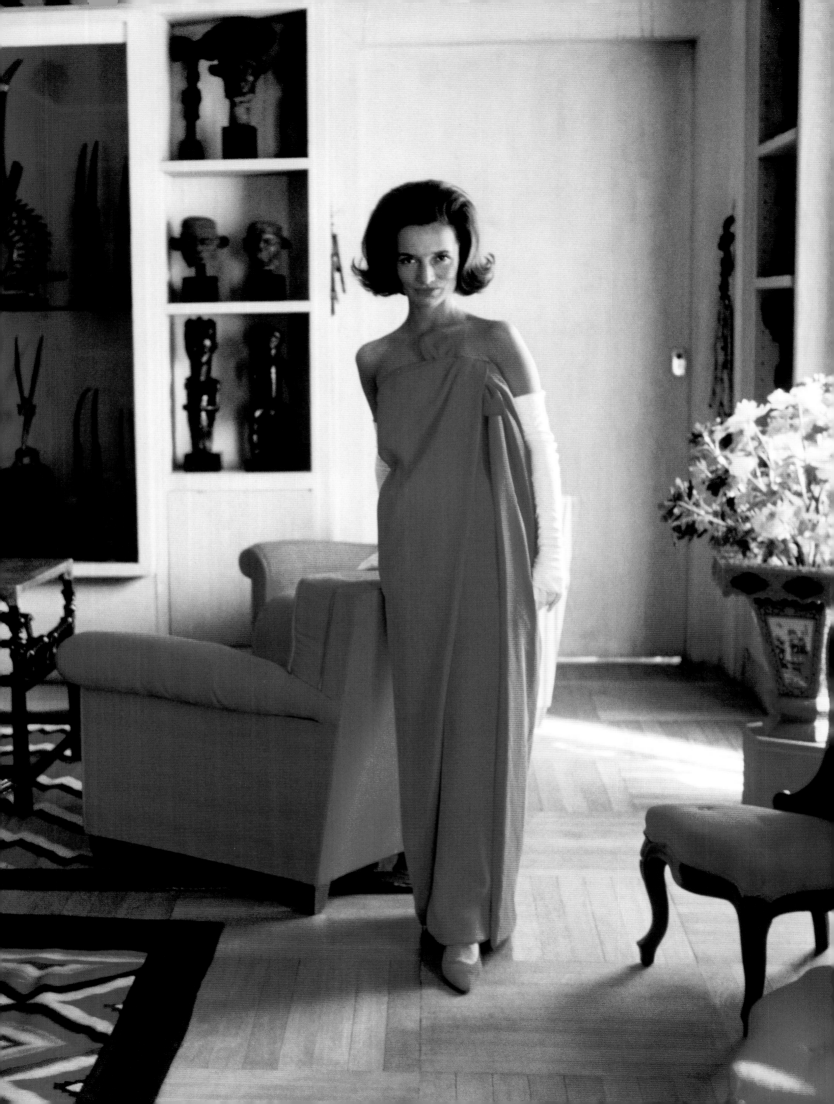

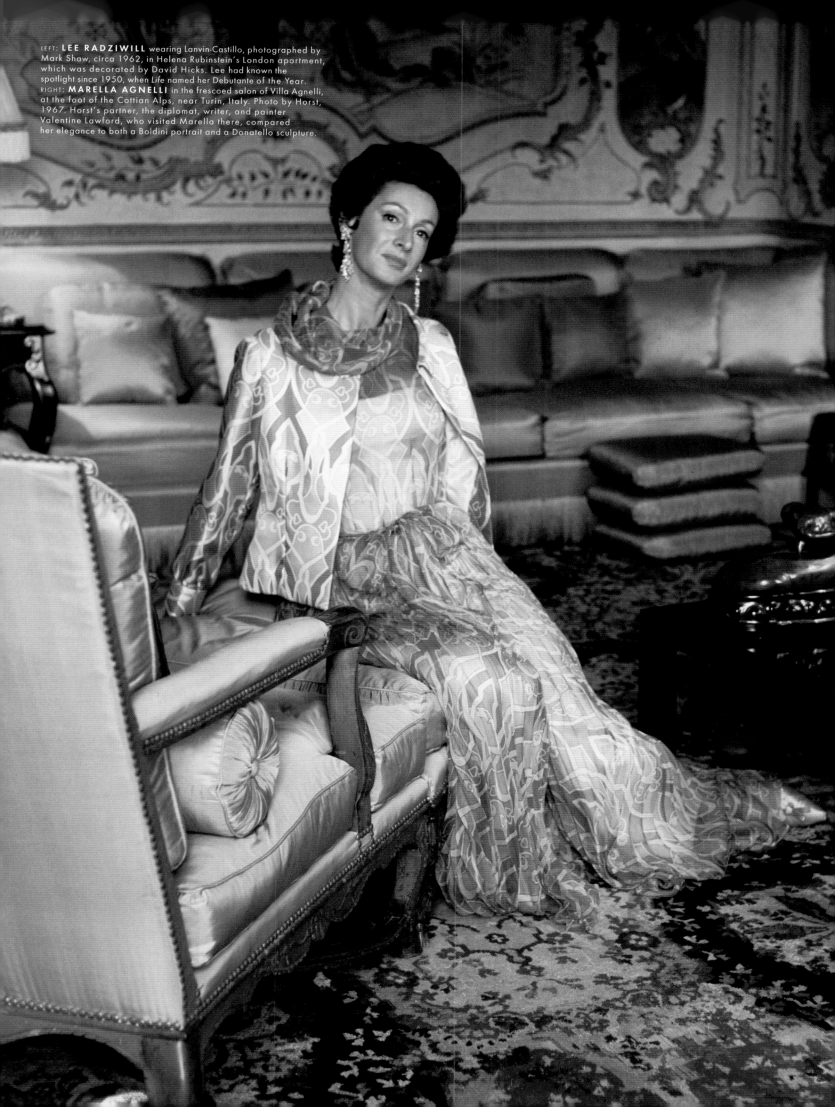

LEFT: **LEE RADZIWILL** wearing Lanvin-Castillo, photographed by Mark Shaw, circa 1962, in Helena Rubinstein's London apartment, which was decorated by David Hicks. Lee had known the spotlight since 1950, when *Life* named her Debutante of the Year. RIGHT: **MARELLA AGNELLI** in the frescoed salon of Villa Agnelli, at the foot of the Cottian Alps, near Turin, Italy. Photo by Horst, 1967. Horst's partner, the diplomat, writer, and painter Valentine Lawford, who visited Marella there, compared her elegance to both a Boldini portrait and a Donatello sculpture.

PRECEDING SPREAD, LEFT: **GIANNI AGNELLI,** the chairman of Fiat. Agnelli, whose tailor was A. Caraceni of Milan, habitually wore his wristwatch over his shirt cuff. He also liked the back tail of his necktie to hang longer than the front blade. RIGHT: **GLORIA GUINNESS,** a contributor to *Harper's Bazaar,* in her Paris flat, wearing a white crêpe Lanvin-Castillo. She sits on a fauteuil covered in white suede, beneath a Balthus painting. "Her personal electricity sparks ideas everywhere," *Vogue* remarked about the Veracruz, Mexico, native, "triggering, sometimes, a new direction in fashion."

LEFT: **CARY GRANT,** shot by Milton H. Greene in New York for *McCall's* magazine. The dapper actor believed that "simplicity" was "the essence of good taste." He had suits made at Dunhill and in Hong Kong, but he also bought off the rack. ABOVE: singer, actor, and civil-rights activist **HARRY BELAFONTE** at the Venice Lido. A Tony and Emmy winner, Belafonte became the first African-American man named to the List, in 1969. Eleanor Lambert noted that Belafonte had "popularized the open shirt for men at resorts." RIGHT: Actress **FAYE DUNAWAY** on location for *The Thomas Crown Affair,* at the North End Greenmarket, Boston, Massachusetts, 1968.

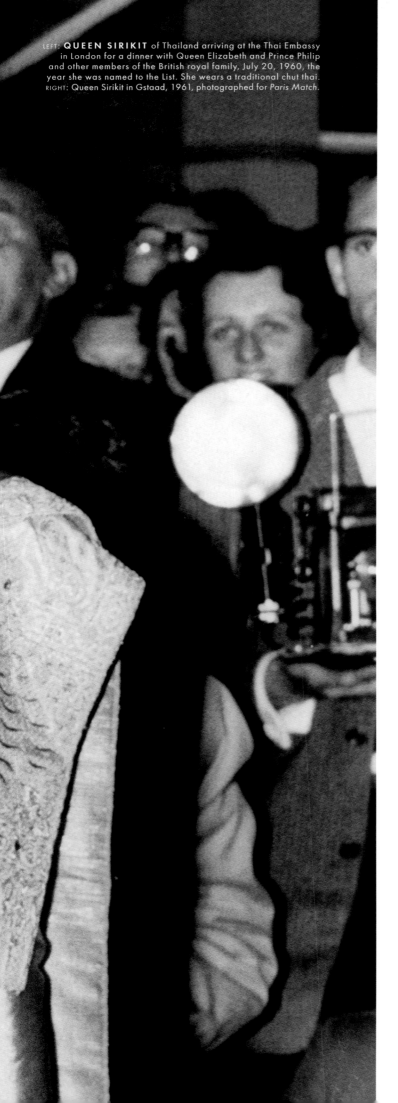

LEFT: **QUEEN SIRIKIT** of Thailand arriving at the Thai Embassy in London for a dinner with Queen Elizabeth and Prince Philip and other members of the British royal family, July 20, 1960, the year she was named to the List. She wears a traditional chut thai. RIGHT: Queen Sirikit in Gstaad, 1961, photographed for *Paris Match*.

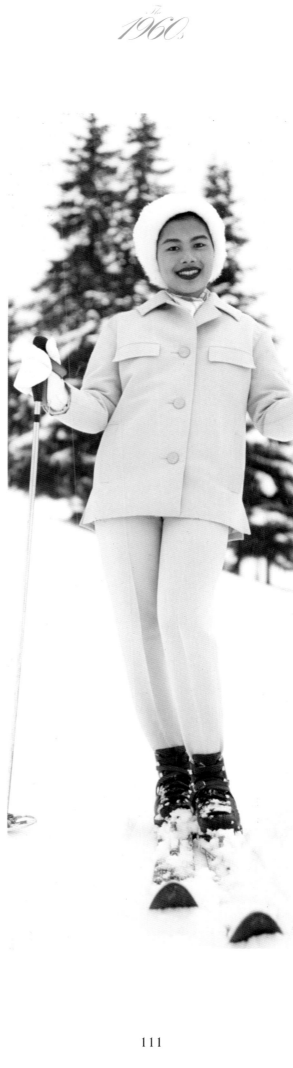

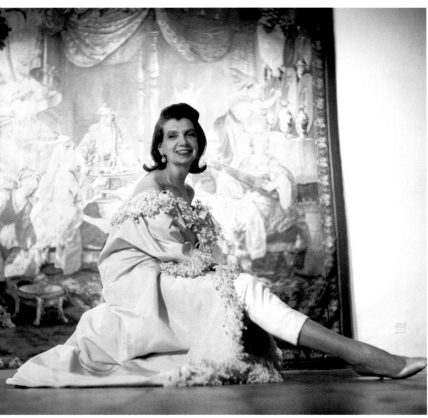

LEFT, TOP: **DOLORES GUINNESS,** the jet-set daughter of Gloria Guinness, was married to her stepbrother, Patrick Guinness. A baroness through her mother's second marriage, to Franz-Egon von Fürstenberg, she is photographed by Slim Aarons with her children at her house in Porto Cervo, Sardinia, and is dressed in Pucci, 1967. LEFT, BOTTOM: **PAULINE DE ROTHSCHILD,** wearing Balenciaga, sits in front of a 17th-century Beauvais tapestry in the subterranean Museum of Wine at her husband's Château Mouton, in Médoc, France. Photographed by Horst, 1963. Before her marriage to Baron Philippe de Rothschild, Pauline designed for Hattie Carnegie in New York. RIGHT: actress and model **ALI MACGRAW,** formerly Diana Vreeland's assistant at *Harper's Bazaar,* on a boat in the Caribbean, wearing a shirt and shorts by Koret of California and a scarf by Crista, 1967.

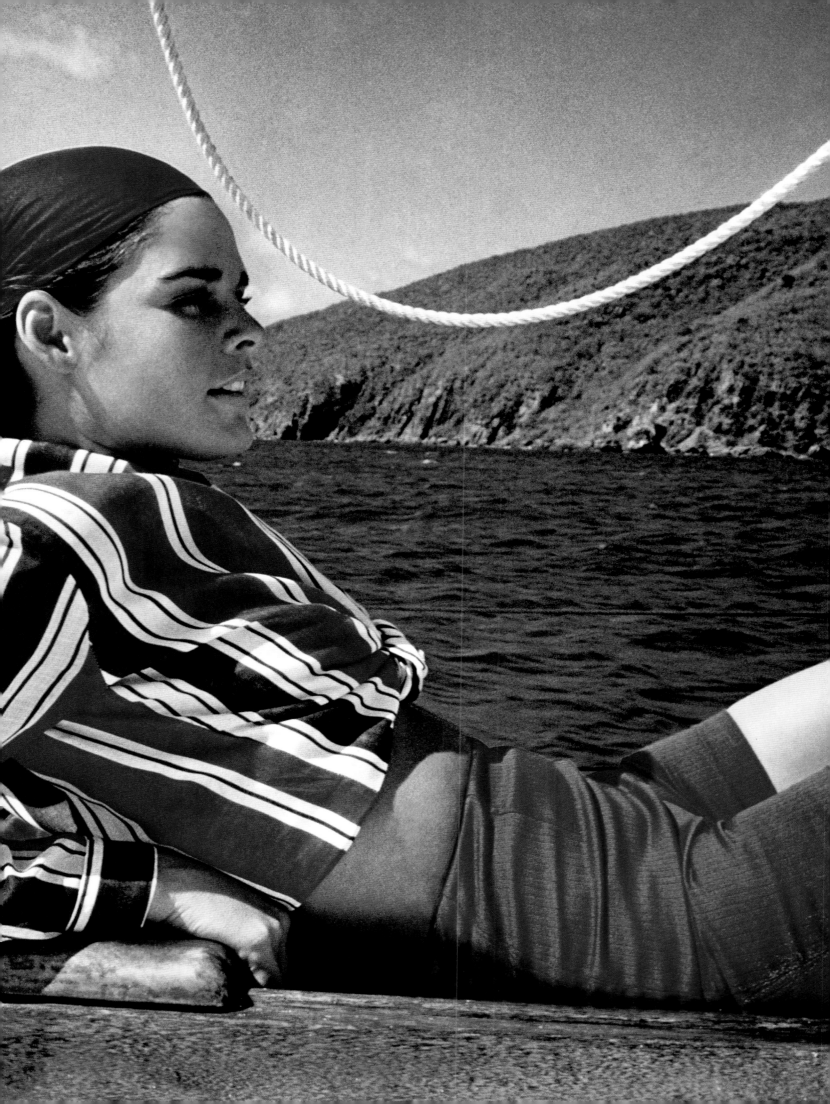

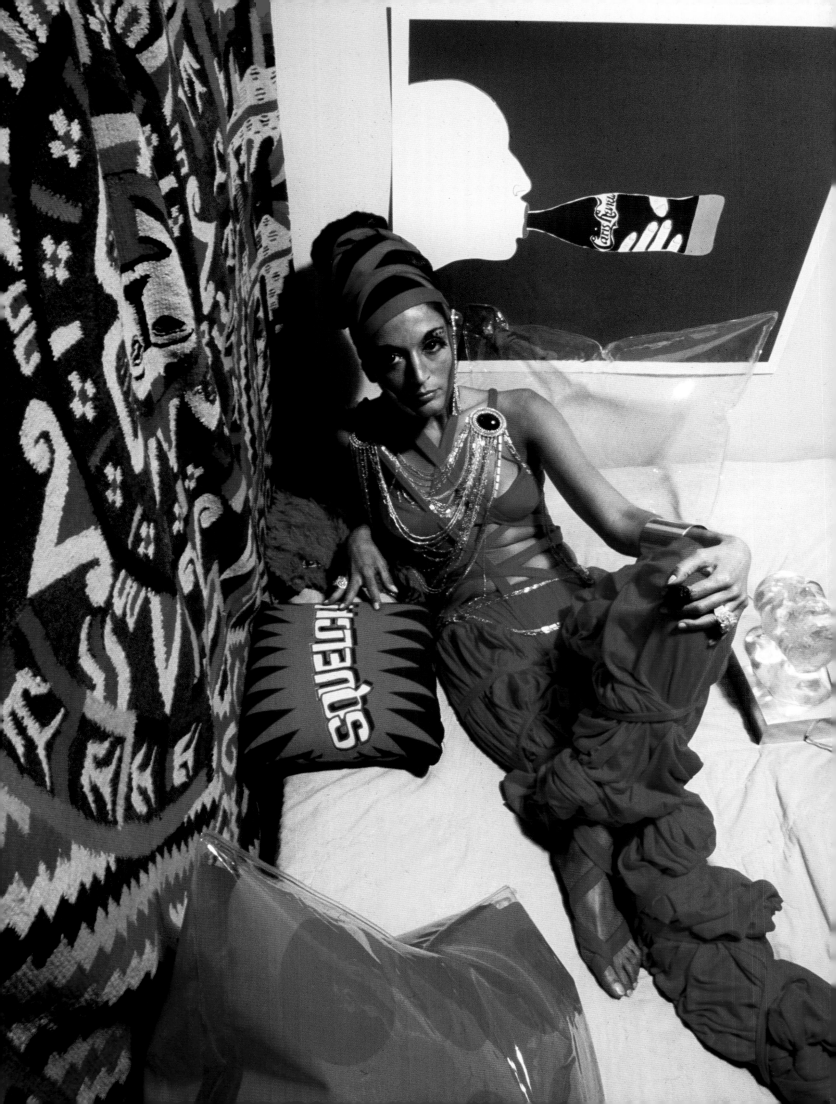

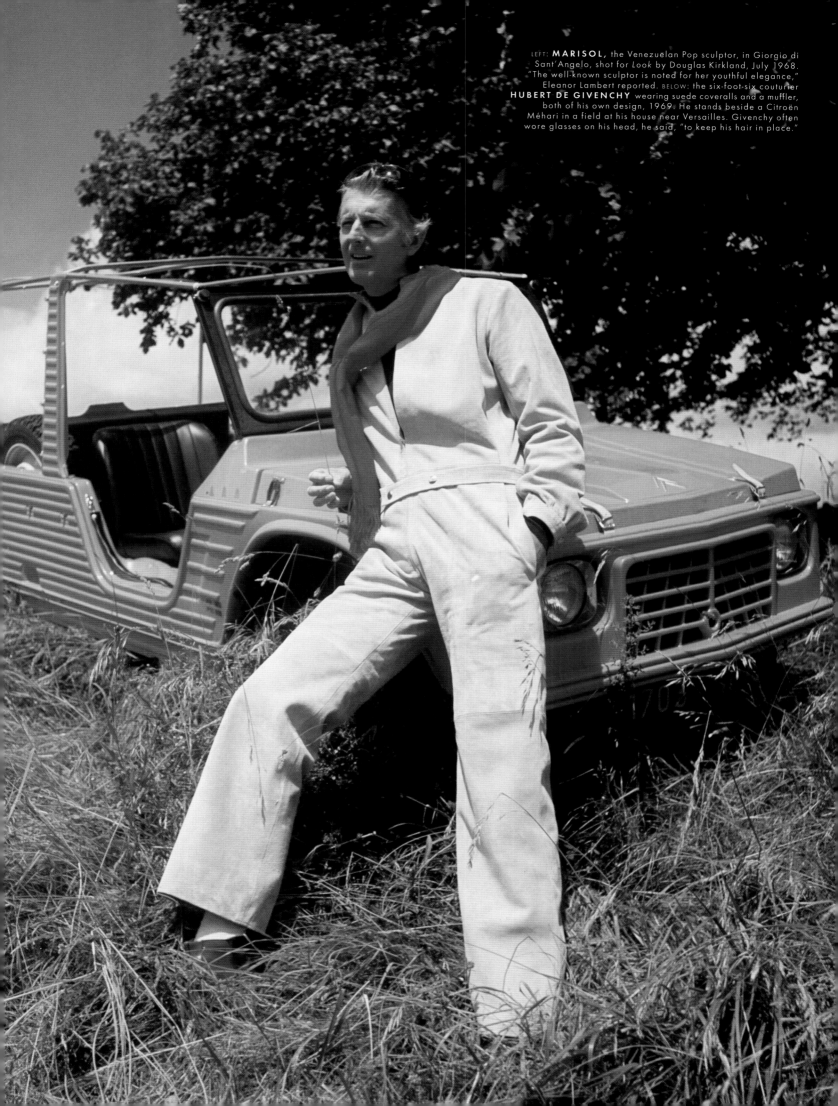

LEFT: **MARISOL**, the Venezuelan Pop sculptor, in Giorgio di Sant'Angelo, shot for *Look* by Douglas Kirkland, July 1968. "The well-known sculptor is noted for her youthful elegance," Eleanor Lambert reported. BELOW: the six-foot-six couturier **HUBERT DE GIVENCHY** wearing suede coveralls and a muffler, both of his own design, 1969. He stands beside a Citroën Méhari in a field at his house near Versailles. Givenchy often wore glasses on his head, he said, "to keep his hair in place."

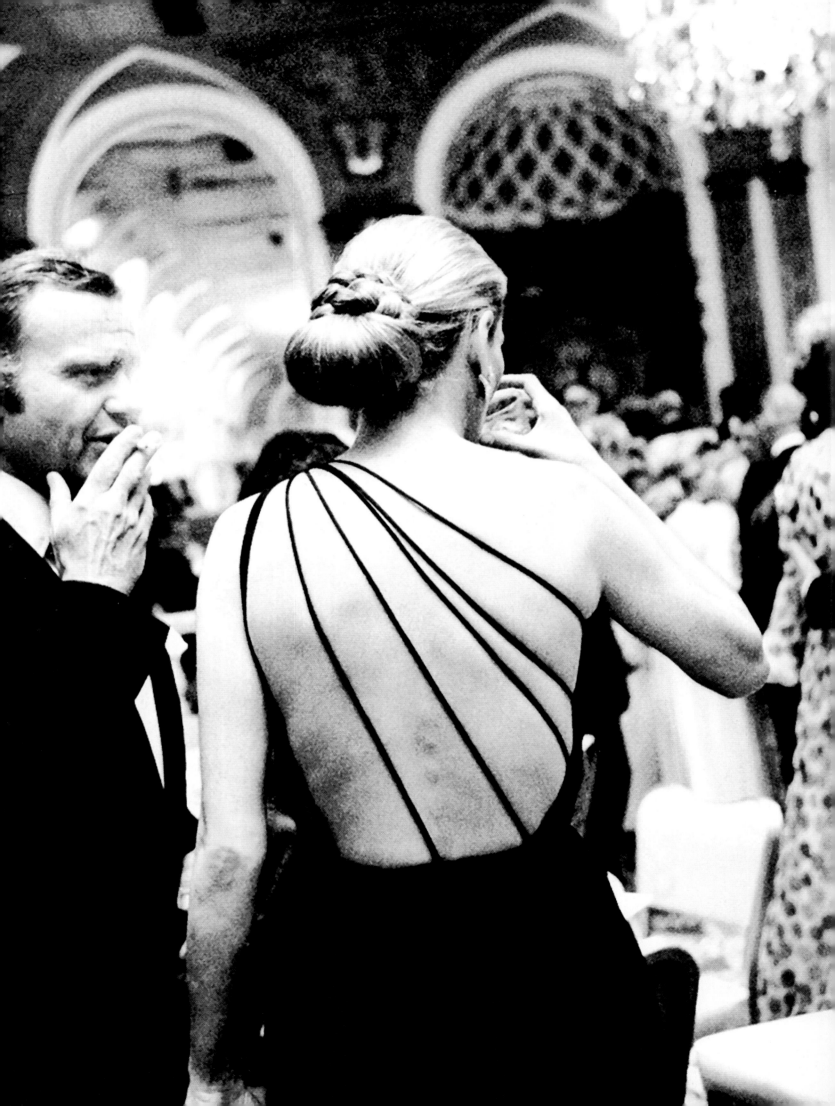

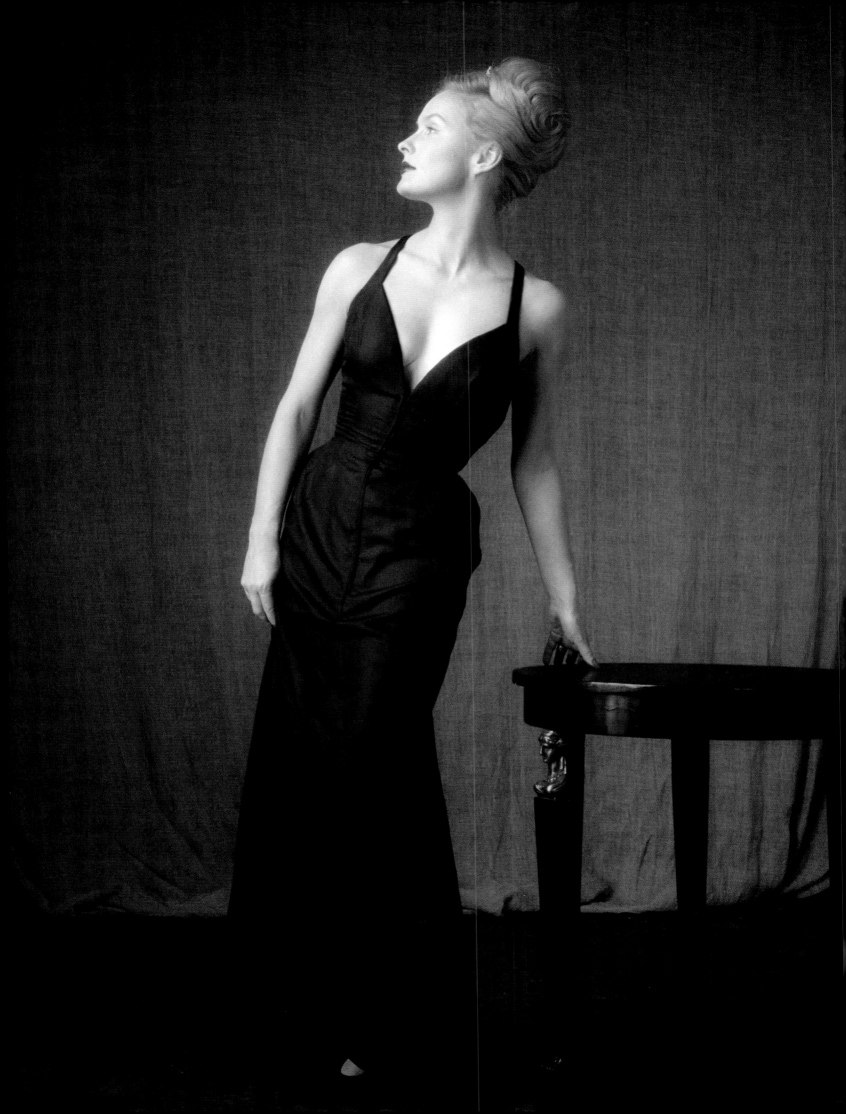

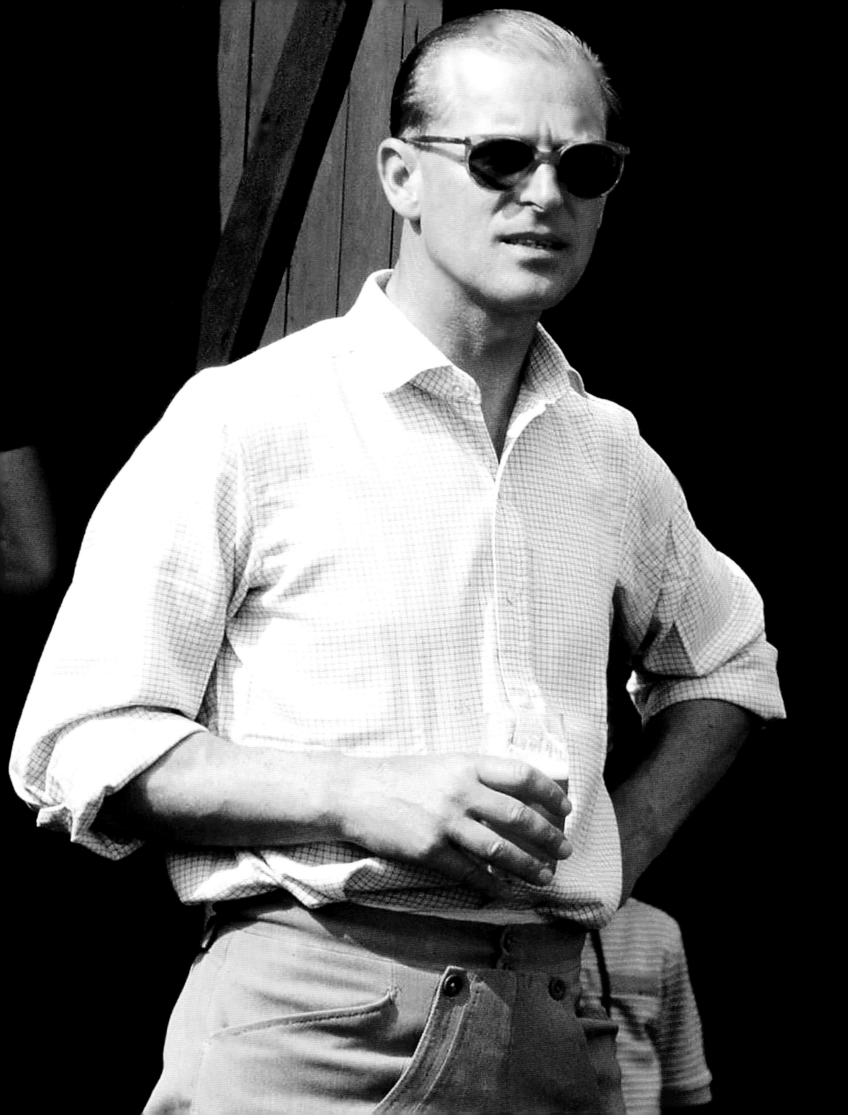

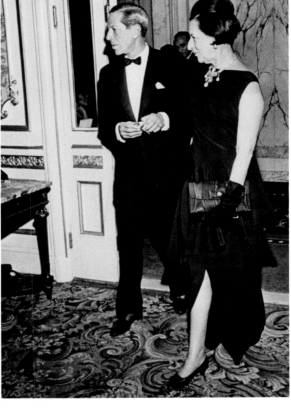

PRECEDING SPREAD, LEFT: ubiquitous fashion plate and wit
**NAN KEMPNER,** seen from behind, communing with
**BILL BLASS** at the Plaza Hotel. "There are no chic women in
America," Diana Vreeland said, hyperbolically. "The one
exception is Nan Kempner." RIGHT: **DINA MERRILL,** actress
and heiress, posed to resemble John Singer Sargent's
*Madame X,* in a black crêpe Luis Estévez dress. Her
grandfather was cereal magnate C. W. Post, and her
mother, Marjorie Merriweather Post, built Mar-a-Lago, in
Palm Beach, Florida. Photo by Milton H. Greene.

LEFT: **PRINCE PHILIP,** beer in hand, umpires a polo
match at Ham Common, Richmond, England, 1961.
ABOVE, LEFT: the enigmatic Anglo-Indian movie star
**MERLE OBERON,** 1963. Her nephew Michael Korda,
who wrote a fictionalized account of her life, noted,
"Her greatest achievement was not in her roles but
herself, as Merle Oberon." ABOVE, RIGHT: *Bazaar and
Vogue* fashion editor and former *Town & Country*
editor-in-chief **BARON NICOLAS DE GUNZBURG**
with **DIANA VREELAND,** his colleague and sometime
adversary, at the Plaza Hotel, New York, February 15, 1966.
After spending the last of his money on one lavish party
in Paris, he moved to America, where he became the
mentor of Bill Blass and Calvin Klein, among others.
RIGHT: **HELENA RUBINSTEIN** dressed in a brocade
Balenciaga in her triplex penthouse at 625 Park Avenue,
in front of one of her Salvador Dalí murals. Ninety-four
when she was named to the List, Rubinstein cultivated,
even in her dotage, young couturiers and decorators such
as Yves Saint Laurent and David Hicks.

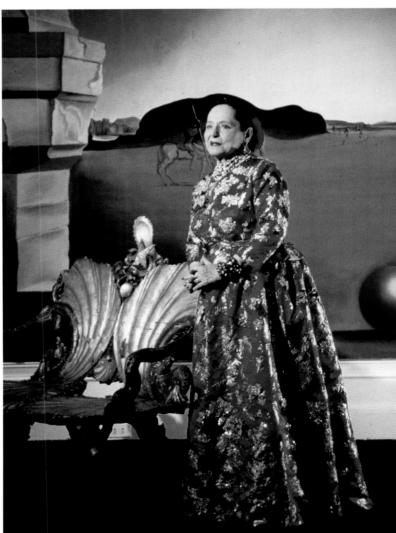

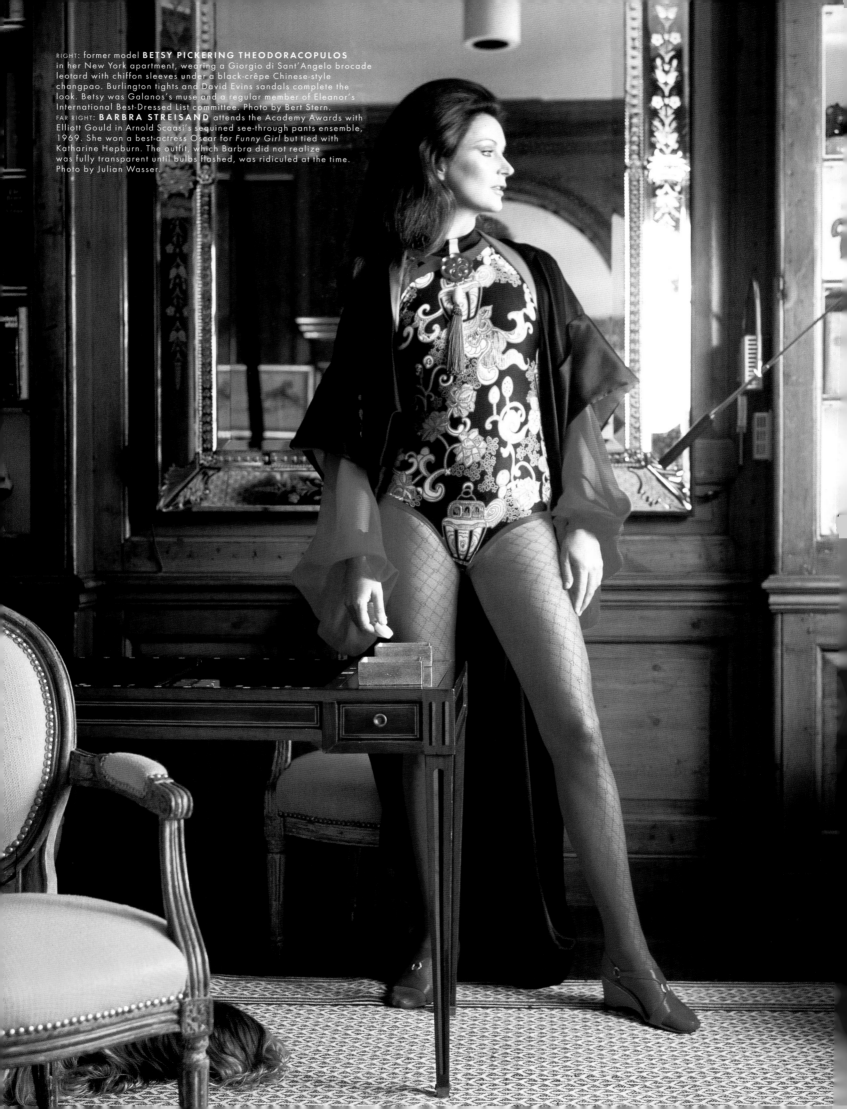

RIGHT: former model **BETSY PICKERING THEODORACOPULOS** in her New York apartment, wearing a Giorgio di Sant'Angelo brocade leotard with chiffon sleeves under a black-crêpe Chinese-style changpao. Burlington tights and David Evins sandals complete the look. Betsy was Galanos's muse and a regular member of Eleanor's International Best-Dressed List committee. Photo by Bert Stern.
FAR RIGHT: **BARBRA STREISAND** attends the Academy Awards with Elliott Gould in Arnold Scaasi's sequined see-through pants ensemble, 1969. She won a best-actress Oscar for *Funny Girl* but tied with Katharine Hepburn. The outfit, which Barbra did not realize was fully transparent until bulbs flashed, was ridiculed at the time. Photo by Julian Wasser.

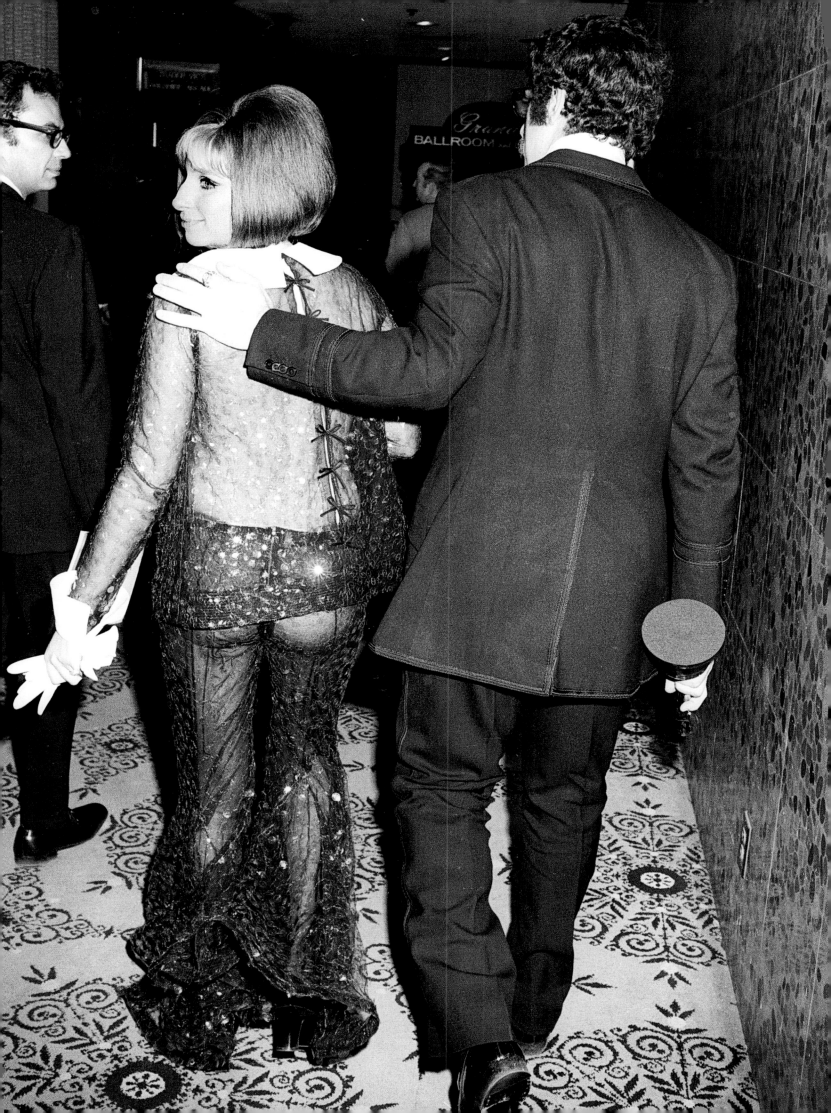

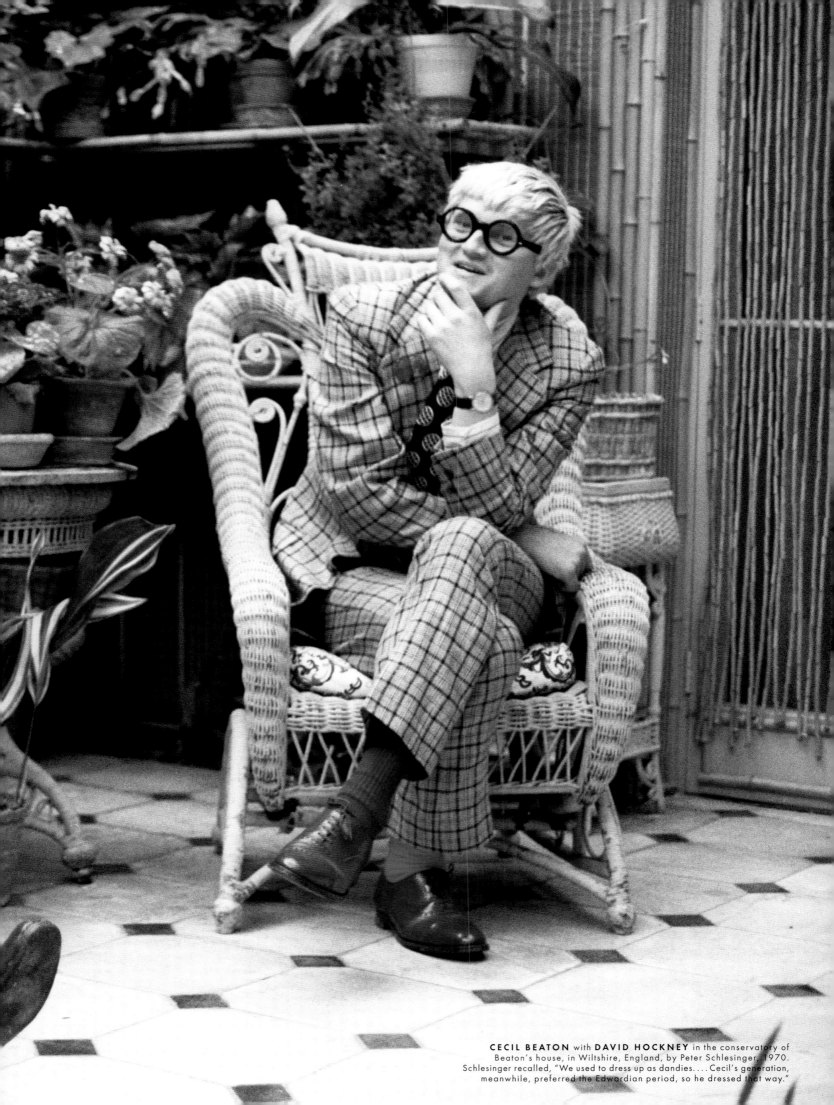

**CECIL BEATON** with **DAVID HOCKNEY** in the conservatory of Beaton's house, in Wiltshire, England, by Peter Schlesinger, 1970. Schlesinger recalled, "We used to dress up as dandies. . . . Cecil's generation, meanwhile, preferred the Edwardian period, so he dressed that way."

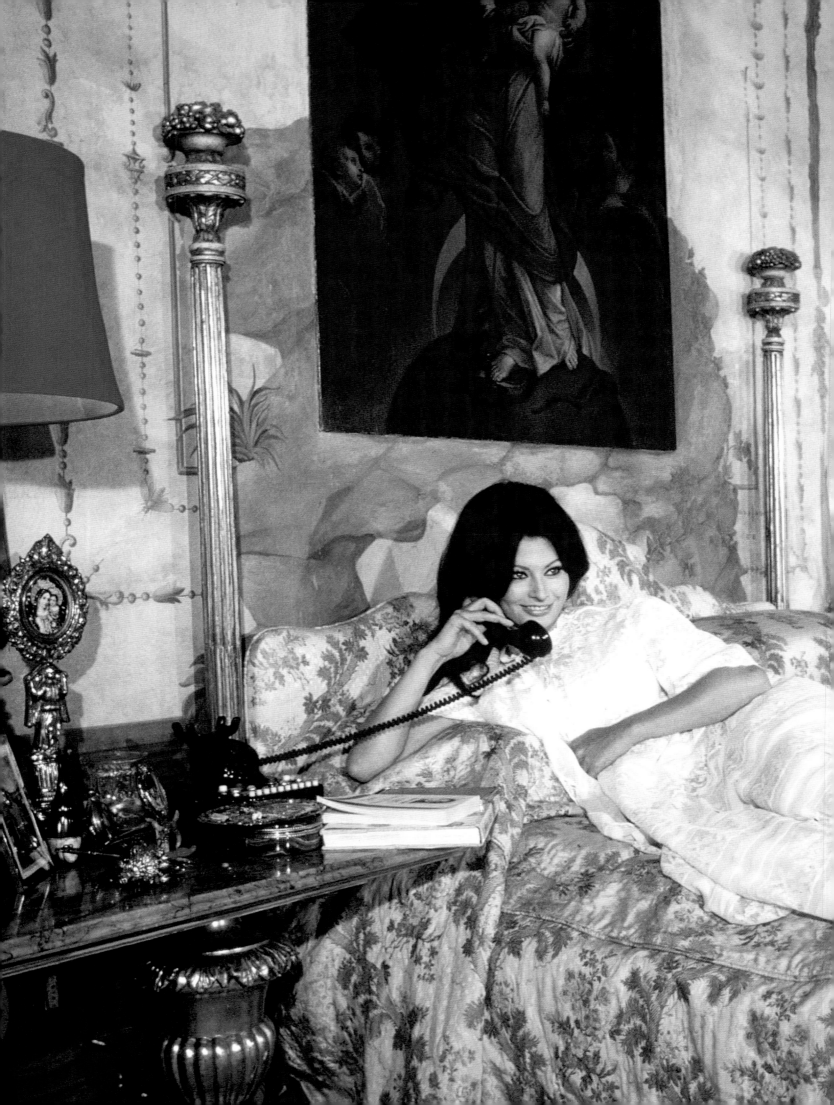

LEFT: Italian screen goddess **SOPHIA LOREN** answers the phone at home, 1964. That same year she received a million-dollar paycheck for her role of Lucilla in the box-office disappointment *Fall of the Roman Empire*. RIGHT, TOP: the Bolshoi Ballet's **MAYA PLISETSKAYA**, renowned for her technical and dramatic brilliance, with **YVES SAINT LAURENT**, whose dress she wears. The dancer's "impact as a woman of outstanding elegance was established on her recent world tour, when she bought clothes in many capitals," Eleanor Lambert noted. RIGHT, BOTTOM: **FARAH DIBA**, Empress of Iran, with **YVES SAINT LAURENT** for a fitting at Dior, shortly before he founded his own house. Yves had made the Shahbanu's wedding dress in 1959.

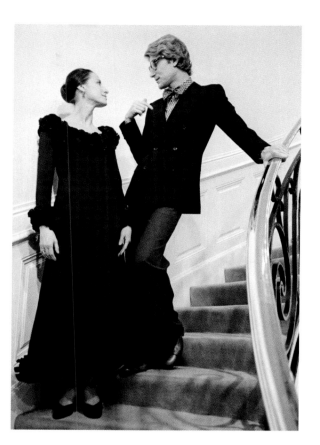

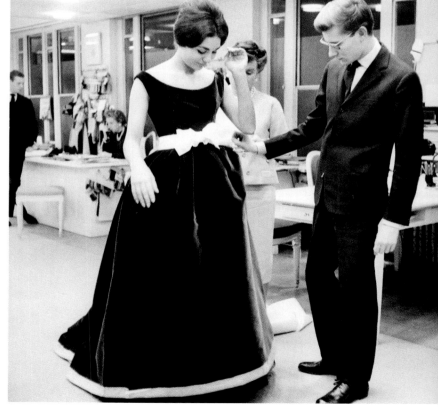

125

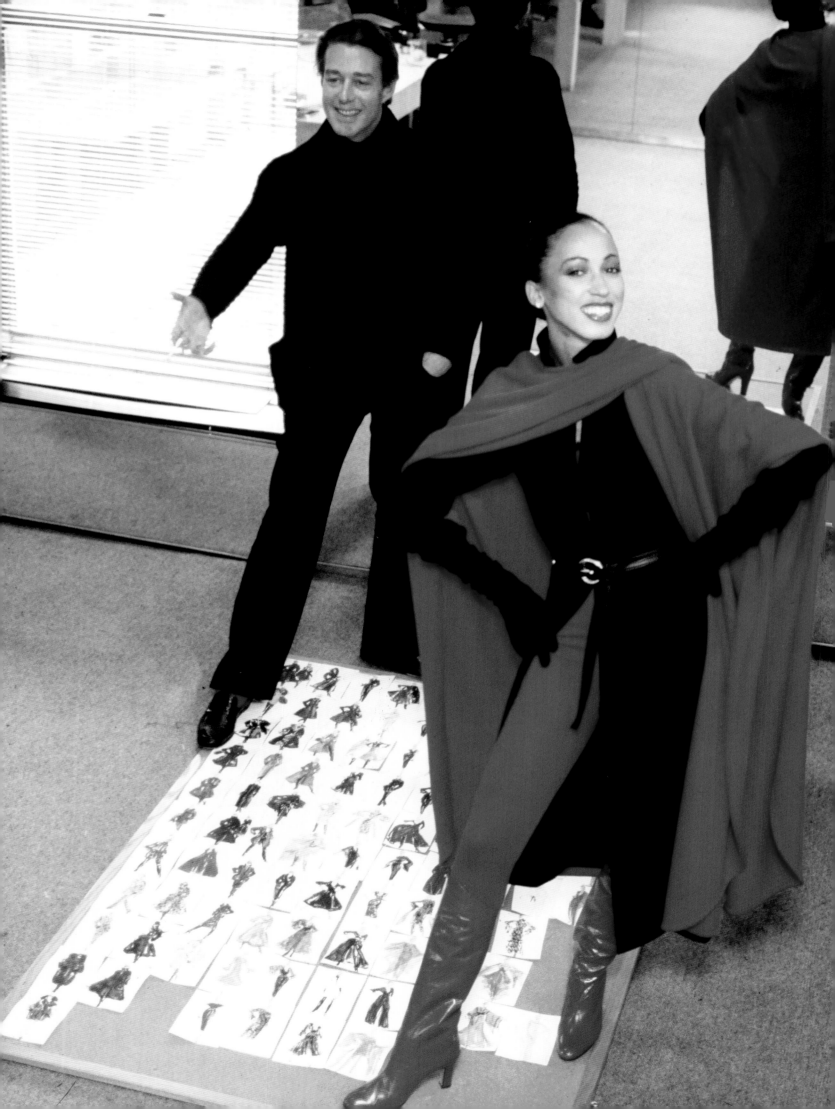

# The 1970s

—

# EGALITARIANISM,
# CRISES,
# *and*
# LIST-GATE

**HALSTON**, in his signature black turtleneck, with model **PAT CLEVELAND**, who steps over Joe Eula's sketches of the designer's fall 1977 collection.
Pat wears a look from the line, a red cashmere body stocking under a black cotton-flannel shirtdress, cinched with an Elsa Peretti belt,
and topped by a red cashmere wrap. Photo by Sal Traina.

127

# THE LIST

| | |
|---|---|
| MRS. BRUCE ADDISON (GILLIS MCGILL) | MRS. GERALD FORD (BETTY BLOOMER WARREN) |
| BARBARA ALLEN | LADY ANTONIA FRASER |
| HARDY AMIES | WALT FRAZIER |
| GIORGIO ARMANI | DIANE VON FURSTENBERG |
| MRS. SMITH BAGLEY (ELIZABETH FRAWLEY) | PRINCE EGON VON FÜRSTENBERG |
| BILLY BALDWIN | SRA. GIANLUIGI GABETTI (BETTINA SICHEL) |
| MIKHAIL BARYSHNIKOV | JAMES GALANOS |
| WILKES BASHFORD | JOHN GALLIHER |
| THE MARQUESS OF BATH (HENRY THYNNE) | LUIZ GASTAL |
| OLIVE BEHRENDT | VITAS GERULAITIS |
| HARRY BELAFONTE | MRS. GORDON GETTY (ANN GILBERT) |
| MME. AHMED BENHIMA (AÏCHA LAGHZAOUI) | GIANCARLO GIAMMETTI |
| MARISA BERENSON | SIR JOHN GIELGUD |
| CANDICE BERGEN | FRANK GIFFORD |
| EARL BLACKWELL | PRESIDENT VALÉRY GISCARD D'ESTAING |
| DEEDA BLAIR | SENATOR BARRY GOLDWATER |
| CONTE BRANDO BRANDOLINI D'ADDA | KATHARINE GRAHAM |
| CONTESSA BRANDO BRANDOLINI D'ADDA (CRISTIANA AGNELLI) | MURIEL GRATEAU |
| MRS. SIDNEY BRODY (FRANCES LASKER) | ROBERT L. GREEN |
| THE HON. DAVID BRUCE | MME. GRÈS (ALIX) |
| ROBERT BRYAN | BARON NICOLAS DE GUNZBURG |
| YUL BRYNNER | HALSTON (FROWICK) |
| MRS. WILLIAM F. BUCKLEY JR. (PAT TAYLOR) | GEORGE HAMILTON |
| GIANNI BULGARI | UVA HARDEN |
| GUY BURGOS | LADY PAMELA HARLECH |
| JEFFREY BUTLER | PAMELA HARRIMAN |
| J. FREDERICK BYERS III | KITTY HAWKS |
| THE DUCHESS OF CADAVAL (CLAUDINE TRITZ) | CAROLINA HERRERA |
| THE DUCHESS OF CADIZ (MARIA DEL CARMEN MARTINEZ-BORDIU Y FRANCO) | REINALDO HERRERA |
| GOVERNOR HUGH CAREY | CHARLES HIX |
| MME. BERNARD CAMU (GINETTE VAN DER STRATEN WAILLET) | J. J. HOOKER |
| PRINCESS CAROLINE OF MONACO | FRED HUGHES |
| DIAHANN CARROLL | ANJELICA HUSTON |
| *BETTY CATROUX | THE COUNTESS OF IVEAGH, MIRANDA GUINNESS (MIRANDA SMILEY) |
| ANTONIO CERUTTI | BIANCA JAGGER |
| H.R.H. PRINCE CHARLES, THE PRINCE OF WALES | MICK JAGGER |
| CHER | ALEXANDER JULIAN |
| ALDO CIPULLO | NORMA KAMALI |
| PAT CLEVELAND | DONNA KARAN |
| GRACE CODDINGTON | DIANE KEATON |
| ALISTAIR COOKE | HORACE KELLAND |
| HERNANDO COURTWRIGHT | NAN KEMPNER |
| TED DAWSON | H.R.H. THE BEGUM AGA KHAN |
| CATHERINE DENEUVE | MRS. HENRY KISSINGER (NANCY MAGINNES) |
| FARAH DIBA | ANNE KLEIN |
| ANGELO DONGHIA | CALVIN KLEIN |
| CARRIE DONOVAN | ELSA KLENSCH |
| SRA. GABRIEL ECHEVARRÍA (PILAR CRESPI) | THADÉE KLOSSOWSKI |
| AHMET ERTEGUN | KENNETH JAY LANE |
| KIM D'ESTAINVILLE | RALPH LAUREN |
| MAX EVANS | MARY WELLS LAWRENCE |
| ROBERT EVANS | MRS. IRVING LAZAR (MARY VAN NUYS) |
| MRS. DAVID EVINS (MARILYN) | ARTHUR LEVITT JR. |
| LOULOU DE LA FALAISE | JOHN LINDSAY |
| MAXIME DE LA FALAISE | H.S.H. PRINCESS EDOUARD DE LOBKOWICZ (FRANÇOISE DE BOURBON-PARME) |
| TOM FALLON | THE HON. HENRY CABOT LODGE |
| CRISTINA FORD (CRISTINA VETTORE AUSTIN) | SOPHIA LOREN |

TOP, LEFT: **KATHARINE GRAHAM,** publisher of *The Washington Post,* in Halston for the premiere of *All the President's Men,* April 4, 1976. Her newspaper broke the story by Carl Bernstein and Bob Woodward that led to the Watergate hearings and the resignation of President Nixon, which became the subject of their book and the film. TOP, RIGHT: Yves Saint Laurent muse and accessories designer **LOULOU DE LA FALAISE** at a costume ball at the nightclub Le Palace, Paris, 1978. FAR RIGHT: model and beauty entrepreneur **NAOMI SIMS** in New York, 1975. "She broke down all the social barriers," Halston said in 1974. BOTTOM: Saint Laurent muse **BETTY CATROUX** leading a conga line, with fellow Listees **ALEX DE REDÉ,** center, and **OSCAR DE LA RENTA,** far left, at Versailles, France, November 30, 1973.

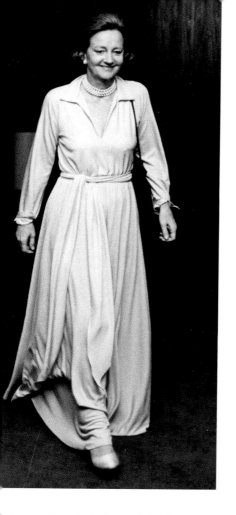

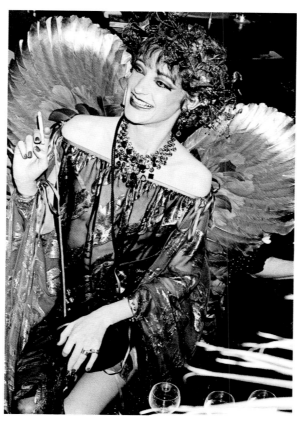

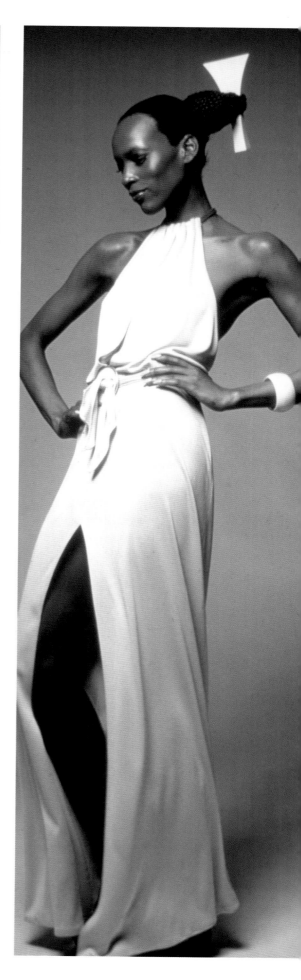

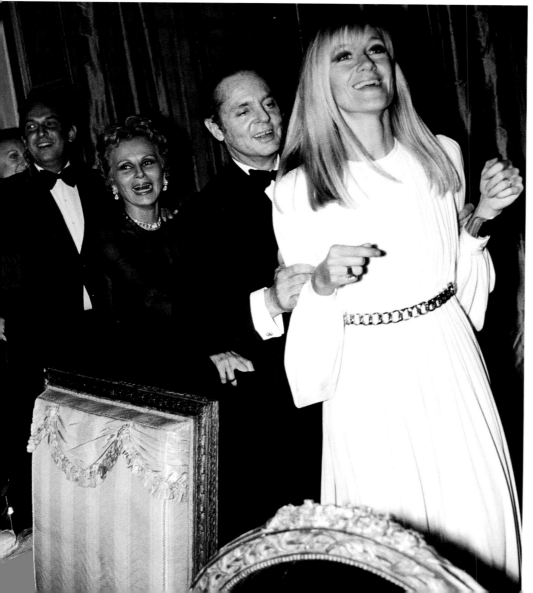

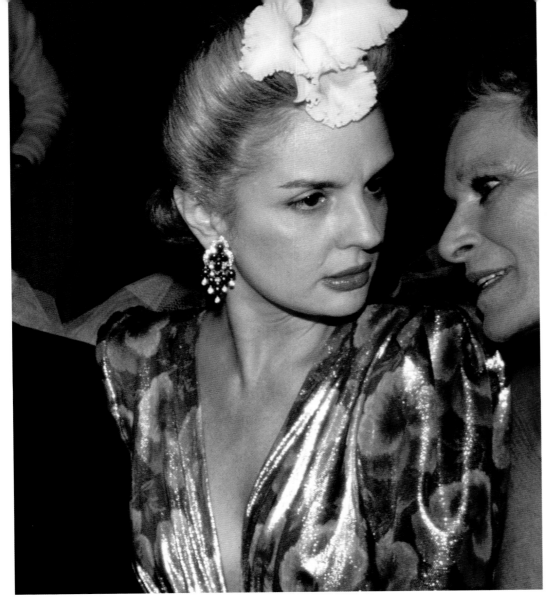

GOVERNOR JOHN LOVE

RUPERT LYCETT-GREEN

SRA. MANUEL MACHADO MACEDO (JACKIE ANSLEY)

CHINA MACHADO

JERRY MAGNIN

DAVID MAHONEY

JOSÉ MALDONADO

SILVANA MANGANO

MRS. HERBERT MARCUS (MINNIE LICHTENSTEIN)

MARCELLO MASTROIANNI

SRA. ANTONIO MAYRINK-VEIGA (CARMEN SOLBIATI)

MARY MCFADDEN

LOUISE MELHADO (FORMERLY SAVITT, LATER GRUNWALD)

NANDO MIGLIO

JOHNNY MILLER

DENISE MINNELLI (DENISE RADOSAVLJEVI)

LIZA MINNELLI

GRACE MIRABELLA

OTTAVIO MISSONI

MARCHESA ALESSANDRO DI MONTEZEMOLO (CATHERINE MURRAY)

MARY TYLER MOORE

CONTESSA DONINA CICOGNA MOZZONI (DONINA TOEPLITZ DE GRAND RY)

JEAN MUIR

GERRY MULLIGAN

LACEY NEUHAUS

MRS. DAVID NEUSTETER (SHIRLEY ROSENTHAL)

LOUISE NEVELSON

MME. TIMOTHÉE N'GUETTA AHOUA (GERMAINE)

H.M. QUEEN NOOR OF JORDAN (LISA HALABY)

PIERO NUTI

ANTHONY THOMAS "TOMMY" NUTTER

COLONEL SERGE OBOLENSKY

THE HON. ANGUS OGILVY

ANDRÉ OLIVER

COMTESSE HUBERT D'ORNANO (ISABELLE POTOCKA)

ARMANDO ORSINI

EVE ORTON

H.I.M. MOHAMMAD REZA SHAH PAHLAVI OF IRAN

CARLO PALAZZI

GIORGIO PAVONE

MRS. PAUL PERALTA-RAMOS (INGA RIZELL)

MRS. CHARLES PERCY (LORAINE GUYER)

ELSA PERETTI

ANNA PIAGGI

PALOMA PICASSO

MRS. RICHARD PISTELL (CARROLL)

MME. GEORGES POMPIDOU (CLAUDE CAHOUR)

SIDNEY POITIER

DAN RATHER

MRS. RONALD REAGAN (NANCY ROBBINS)

BARON ALEXIS DE REDÉ

ROBERT REDFORD

MRS. SAMUEL P. REED (ANNETTE MANHEIMER)

FRANÇOISE DE LA RENTA

OSCAR DE LA RENTA

PETER REVSON

MRS. CHARLES REVSON (LYN FISHER SHERESKY)

BARONESS ARNAUD DE ROSNAY (ISABEL GOLDSMITH)

DIANA ROSS

ROBERTO ROSSELLINI JR.

BARON DAVID DE ROTHSCHILD

BARONESS OLIMPIA DE ROTHSCHILD

MME. JACQUES ROUËT (LOUISE LINDQVIST)

RICHARD ROUNDTREE

ELIETH ROUX

MARY RUSSELL

VALERIAN RYBAR

SONIA RYKIEL

PRESIDENT ANWAR SADAT

YVES SAINT LAURENT

ROBERT SAKOWITZ

MRS. ROBERT SAKOWITZ (PAMELA ZAUDERER)

ELLIN SALTZMAN

TELLY SAVALAS

MARINA SCHIANO

GLORIA SCHIFF

THOMAS SCHIPPERS

MME. PIERRE SCHLUMBERGER (SÃO DA DINIZ CONCEICAO)

JOEL SCHUMACHER

HENRY SELL

THOMAS SHEVLIN

ALEXANDER SHIELDS

BOBBY SHORT

THE HON. SARGENT SHRIVER

O. J. SIMPSON

NAOMI SIMS

AUDREY SMALTZ

LORD SNOWDON (ANTONY ARMSTRONG-JONES)

JAY SPECTRE

DAVID SUSSKIND

MRS. T. SUFFERN TAILER (MAUDE LORILLARD)

THE MARQUESS OF TAVISTOCK (ROBIN RUSSELL)

BETSY PICKERING THEODORACOPULOS

CHIP TOLBERT

JOHN TRAVOLTA

THOMAS TRYON

SENATOR JOHN TUNNEY

TWIGGY

DICK VAN DYKE

PHILIPPE VENET

YVES VIDAL

THE MARQUIS OF VILLAVERDE, CRISTÓBAL MARTÍNEZ-BORDIÚ Y ORTEGA

BARONESS HUBERT DE WANGEN (LORNA HYDE)

MRS. THOMAS WATSON JR. (OLIVE CAWLEY)

MRS. YANN WEYMOUTH (LALLY GRAHAM)

BILLY DEE WILLIAMS

FRED WILLIAMSON

LEE WRIGHT

LYNN WYATT

MICHAEL YORK

ANDREW YOUNG

DANIEL ZAREM

BARONESS THIERRY VAN ZUYLEN (GABY IGLESIAS VELAYOS Y TALIAFERRO)

---

TOP: **CAROLINA HERRERA**, in Giorgio di Sant'Angelo, with **NAN KEMPNER**.
NEAR LEFT: **CALVIN KLEIN** in his office, January 14, 1975.
BOTTOM, RIGHT: Nicaraguan human-rights advocate **BIANCA JAGGER** in New York, circa 1970.
She was named to the List in 1971, the year she married Mick Jagger.
BOTTOM, LEFT: **CATHERINE DENEUVE**, carrying a Louis Vuitton bag, 1973.

> *"What is important*
> *in a dress*
> *is the woman who*
> *is wearing it."*
> — YVES SAINT LAURENT

---

# *The* List's Knotty 1970 Family Tree

O n the occasion of the release of the 1970 List, and paralleling the nostalgia movement in fashion, Lambert wrote a retrospective article for the A.P. wire service about the origins and meaning of her 30-year-old poll. "What a study of the records did for me," she mused, "was convince me the term 'best-dressed' is neither casual nor temporary.... The lists have an amazing consistency, not just in 'repeaters,' but in women whose descendants appear on later lists." From 1970's List and Hall of Fame alone, one could diagram a very densely tangled family tree.

The Begum Aga Khan (Princess Salimah) was the stepdaughter-in-law of the Begum Aga Khan who had appeared in 1939 on the final Paris Dressmakers' Poll. (About the then current Begum, who had previously been British model Sarah Croker-Poole, Suzy pointedly commented, "She had to marry Karim and wrap herself in a sari before anyone said anything about being best dressed.") Valentino assistant Pilar Crespi was the daughter of Consuelo Crespi, the former model and *Vogue* editor who had first made the List in 1952. Dolores Guinness turned up in the 1970 Hall of Fame, only six years after her mother, Gloria. In the two-year-old men's Hall of Fame were Gianni Agnelli, spouse of Marella, who had herself risen to that station seven years earlier; banker Éric de Rothschild, by marriage a cousin of Pauline de Rothschild; and Count Rodolfo Crespi, likewise united in the List's "Valhalla" (as Eugenia Sheppard termed it) with his wife, Consuelo. (Rodolfo, who represented Italian fashion designers in America, was instrumental in "making the committee more social and the List more international," Reinaldo Herrera remembers.) Pat Patcevitch, president of Condé Nast, achieved the ultimate honor just one year before his stepdaughter, fashion editor and decorator Chessy Rayner.

Among those named to the regular 1970 men's List were Lord Snowdon, the husband of Princess Margaret; museum trustee J. Frederick Byers III, the stepson-in-law of Babe Paley, stepbrother-in-law of Amanda Burden (first Listed in 1966), and son-in-law of Dorothy Paley Hirshon; Sargent Shriver, brother-in-law of Jacqueline Kennedy; and sportsman Thomas Shevlin, the ex of Lorraine Shevlin from Lambert's inaugural 1940 List. Annette Reed and Oscar de la Renta both entered the List for the first time in 1970. An unrelated pair then, they married 17 years later. Also on the inbred early 70s Lists were the progenitors or stepparents-to-be of future List-makers: Carolina Herrera (mother of Carolina junior and Patricia), Ellin Saltzman (mother of Elizabeth), and Lady Pamela Harlech (stepmother of Lady Amanda). Herrera's candidacy, according to husband Reinaldo, himself an eventual Hall of Famer, had been advanced by Mary McFadden, at a time when both women's careers as designers still lay in the future.

If Lambert's List at age 30 seemed as incestuous as a Hapsburg court, paradoxically it was also continuing to open up. Naomi Sims—pioneering cover model and avatar of the Black Is Beautiful

---

ANJELICA HUSTON *wearing*
*an Alexander Calder necklace, photographed*
*by Evelyn Hofer, New York, 1976.*

133

movement—presided in the Fashion Professionals category, while cabaret performer Bobby Short, known for his Savile Row dinner jackets and for breaching the racial barriers of the *Social Register,* broke into the men's category.

---

# Recession, Populism, *and* Main Street

Though it still remained (to paraphrase Tammy Wynette and George Jones's 1973 country hit) more "jet set" than "old Chevrolet set," the List skewed populist during the 1970s. As the affluent 60s gave way to a decade plagued by inflation, recession, and energy crises, John Fairchild declared that "the BP's became the boring people. No one wants to be characterized as a Beautiful Person anymore. It's an anachronism." *The New York Times*'s Marylin Bender agreed in 1971: "When youth became so anti-materialistic ... the Beautiful People had to go." Social consciousness for some Listees seemed a more urgent matter than the social swim; Amanda Burden took a position teaching at a Harlem elementary school, and List stalwart Jacqueline Kennedy Onassis, whose remarriage exposed what appeared to be mercenary feet of clay, now "stood for nothing, poor thing," Marylin Bender said. *Time* stopped publishing the List altogether in 1972, dismissing the roster in its final write-up as an "annual January infestation." Fashion locomotives such as Consuelo Crespi defected from the haute couture houses—considered dinosaurian—in order to explore funky boutiques. An almost literal emblem of the financial downturn was the midi, which overnight had rendered the exuberant mini of the 60s' go-go economy obsolete. Even Gloria Guinness endorsed the look. "A covered up woman can look so much more mysterious," she suggested. In 1971, Lambert conceded, "Fashion is theatre, and this is such a changing era in fashion that women can express any mood they desire." The Nixons, Lambert felt, were sartorially out of step with the eclectic mood. "Patricia Nixon and her daughter Tricia are not leaders," Lambert replied to the *Daily News* when asked which women would not qualify for the List. "They play it safe all the time."

In the spirit of egalitarianism, Lambert phased out numerical rankings. Incongruously, rarefied fashion creatures such as Nan Kempner, Betsy Theodoracopulos, and Carolina Herrera—"neat, pretty, never gaudy," Suzy wrote in 1973—began to share billing with crowd-pleasing prime-time-TV personalities. The bespangled, navel-baring Cher, of *The Sonny and Cher Comedy Hour*, the Tootsie Roll Pop–wielding Telly Savalas of *Kojak,* and the approachable career gal Mary Tyler Moore, star of the eponymous sitcom (commended for transmitting her "classic American look throughout the world"), each made a one-time showing. Eugenia Sheppard called Moore's "conservative, healthy taste.... the answer" to the regular folks in flyover towns "who complain every year, 'My wife or my secretary is the best dressed woman I know.'" Diane Keaton, whose rumpled *Annie Hall* look "swept the world," Sheppard wrote, was the largest 1977 vote-getter, but the androgynously attired star never had a return engagement. John Travolta vaulted onto the List in 1978, yet another one-off following his tenure as the heartthrob of TV's *Welcome Back, Kotter* and his box-office triumphs as the "guido" hero of both *Saturday Night Fever* and *Grease.* Ice-skater Dorothy Hamill, the nation's darling during the 1976 Olympics, was lauded (but not Listed) for instigating a fad for "wedge" hairdos, while Buffalo Bill fullback O. J. Simpson became the List's first football V.I.P. "I appreciate the recognition," Simpson wrote Lambert, "certainly unusual for a guy who makes his living in a red, white and blue uniform."

Counterbalancing the down-market drift, Lambert temporarily restored a queen of the *ancien régime* by suspending the Hall of Fame in 1974, instead crowning the regal Babe Paley the Super Dresser of Our Time. "Mrs. Paley at all times through the years has invariably worn contemporary, appropriate, becoming, and flawlessly tasteful clothes," Lambert stated in her press release of January 1975.

To meet head-on the recurrent charges of "elitism"—a buzzword of the period—in 1975, Lambert laid plans to go barnstorming around the country to a hundred "Main Streets" for an "American Cities' Best-Dressed List," to be sponsored by Cadillac, and to be telecast as a one-hour TV fashion special. "While it has been most gratifying to see the Best Dressed Poll become a worldwide standard of fashion excellence in the more than 40 years of its existence," Lambert wrote, "I have been increasingly conscious of the need to recognize the much broader scope of fashion consciousness that exists today. The spotlight can very logically be turned on hundreds of women, in their own communities ... regional polls ... will dramatically demonstrate what is meant by being best dressed.... Sponsor investment budget could be as little as $150,000." It appears that Lambert may have hit a few cities, but evidently she never received the full funding she sought.

---

**MARY TYLER MOORE** at the Lion Country Safari in
Laguna Hills, California, April 24, 1971. When she was voted onto
the List, she was starring in her eponymous sitcom, which
won a record-breaking 29 Emmy Awards. Photo by Ron Galella.

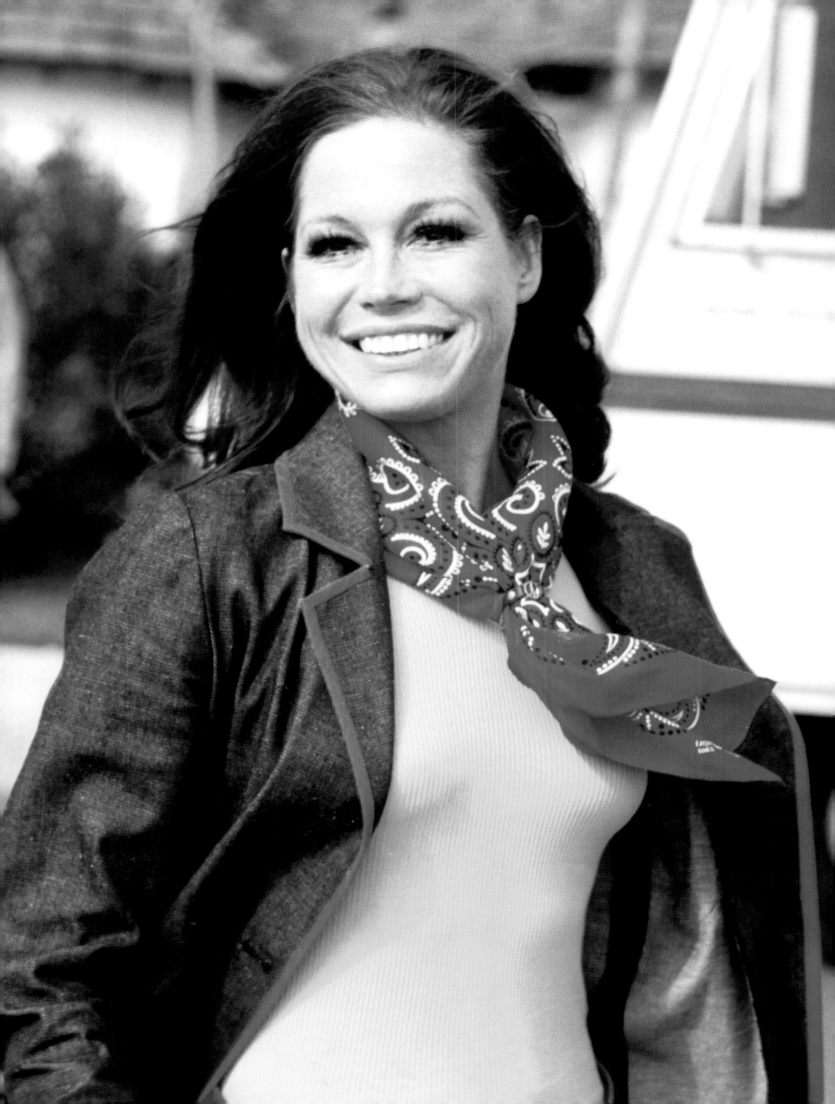

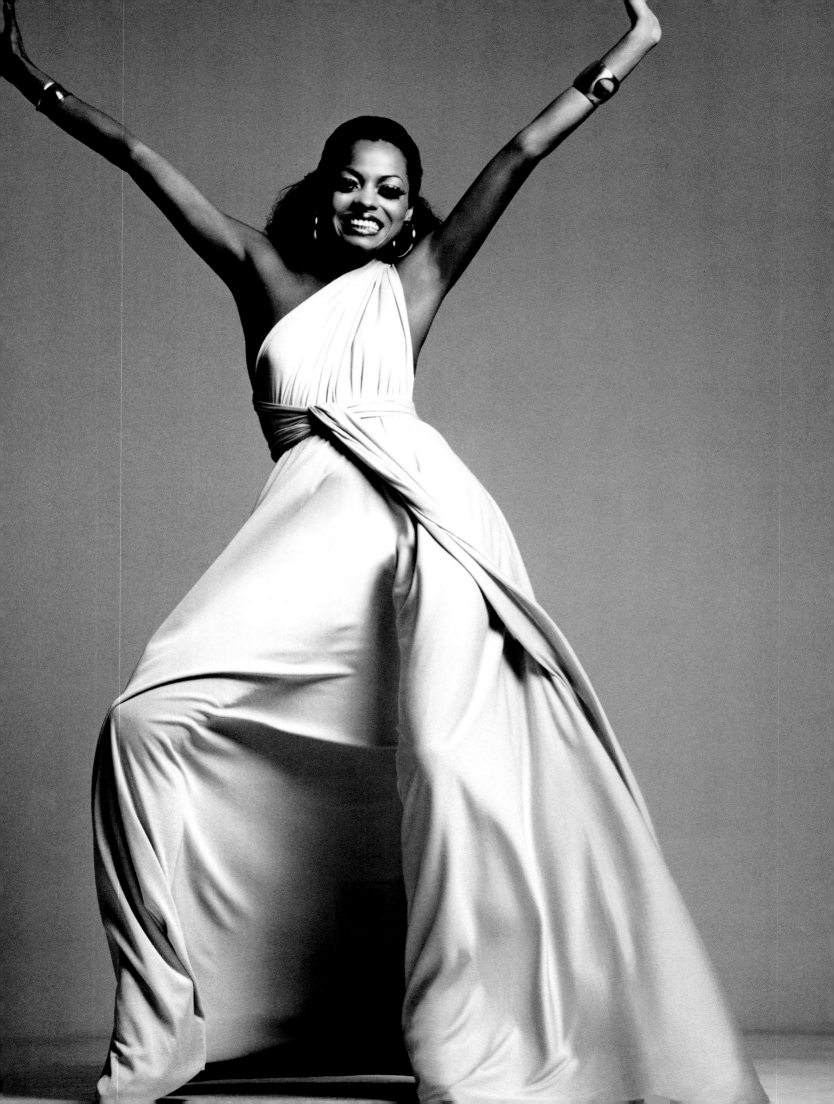

# List-Gate

Perhaps under the influence of the post-Watergate-era fascination with covert operations and "gotcha" journalism, in 1977 *People* magazine reporter Lee Wohlfert turned an invitation to become an I.B.D.L. committee member into a mink-lined cloak-and-dagger case of espionage, betrayal, and denial. Having joined a group of seven in Lambert's office for an hour-and-a-half lunchtime meeting (sandwiches and candy were served), Wohlfert stole back to her typewriter to submit copy that violated the committee's long-standing confidentiality policy. Not only did she divulge who had been in attendance, she also revealed snippets of what they had said, some of it viperous. "It was clear that society and fashion columnist Sheppard wielded the strongest influence," Wohlfert reported in the February 28, 1977, issue of *People,* "along with Hall of Famer Baron Nicolas de Gunzburg… the lone male." She ridiculed Sheppard for being too nearsighted to see anyone's clothes clearly, and surmised that the diminutive journalistic powerhouse worked "by divination" to determine who was ready for the Hall of Fame (Bianca Jagger, in this case, and Louise Grunwald). Jagger, according to Lambert, "was one of the first who dressed in a theatrical way without looking like an unmade bed." Sheppard concurred that Pamela Harriman's taste had advanced sufficiently since her days of dressing "like a candy box." Committee members ejected both Princess Caroline of Monaco and Marisa Berenson as "tacky." Diane von Furstenberg's name elicited "only low moans," Wohlfert wrote. Farah Diba, on shaky ground for her showy jewelry, was given a dispensation after a *Town & Country* editor invoked cultural relativism. (The Iranian currency, the editor reasoned, was based on the crown jewels.) Sheppard damned a stockbroker's wife (whose identity Wohlfert protected) with the faint praise that "some people who should be on it can't because they try too hard." Only the Sybil-like sculptor Louise Nevelson, as old as the century and a winner just that year, seems to have eluded the committee of seven's contumely.

When the *People* story broke, Sheppard and Lambert retaliated. The three women duked it out on live television, each standing by her version of the events. "If you're going to belong to a group to finalize something," Lambert said, "I do feel there is a sort of privacy that should be respected."

United Features fashion columnist Florence De Santis ran her own commentary on List-gate, under the headline BEST-DRESSED LIST IS A BAD HABIT OR A JOKE. She suggested that perhaps a more urgent concern in the crime-infested, filthy, and bankrupt fashion capital would be Mayor Abe Beame's failing efforts to make Seventh Avenue a safe urban street. If the Garment District remained derelict and dangerous, she feared, "there may well be no New York clothes in the future for the Best-Dressed ladies to buy."

# The List's Victory for American Fashion

Lambert closed off the decade by once again reviewing her teeming scrolls. In her January 1979 release, pertaining to the 1978 List, she spotlighted four outstanding living Hall of Famers, three of them golden-era movie stars. She anointed Fred Astaire the "best-dressed man of our time, the strongest influence of freestyle elegance in the 20th Century." She saluted Diana Vreeland for "her profound impact on the world of fashion through her extraordinary personal flair and her professional inspiration as editor and museum consultant." And she hailed Claudette Colbert and Lauren Bacall for "their superb and inspirational personal style which has remained contemporary over a long period of time." In deference to the Iran hostage crisis, which erupted around the same time the ballots usually went out, Lambert canceled the 1979 List—the first such suspension since World War II.

Kenneth, the hairdresser, reflected, "The Best-Dressed List really had a great deal to do with getting American fashion out to the world. You could argue that without it there'd never have been a Versailles" —the triumphant 1973 Lambert-organized benefit presentation of American fashion at the royal palace, the event that famously finally forced the French to recognize the significance of New York designers. Though the Dress Institute—the alliance of manufacturers and unions that had hired Lambert back in 1939—no longer existed, Lambert, List-keeper and crusader for American fashion, had more than fulfilled its ambitious mission.

**DIANA ROSS,** dress by Halston,
New York, January 12, 1973.
Photograph by Richard Avedon.

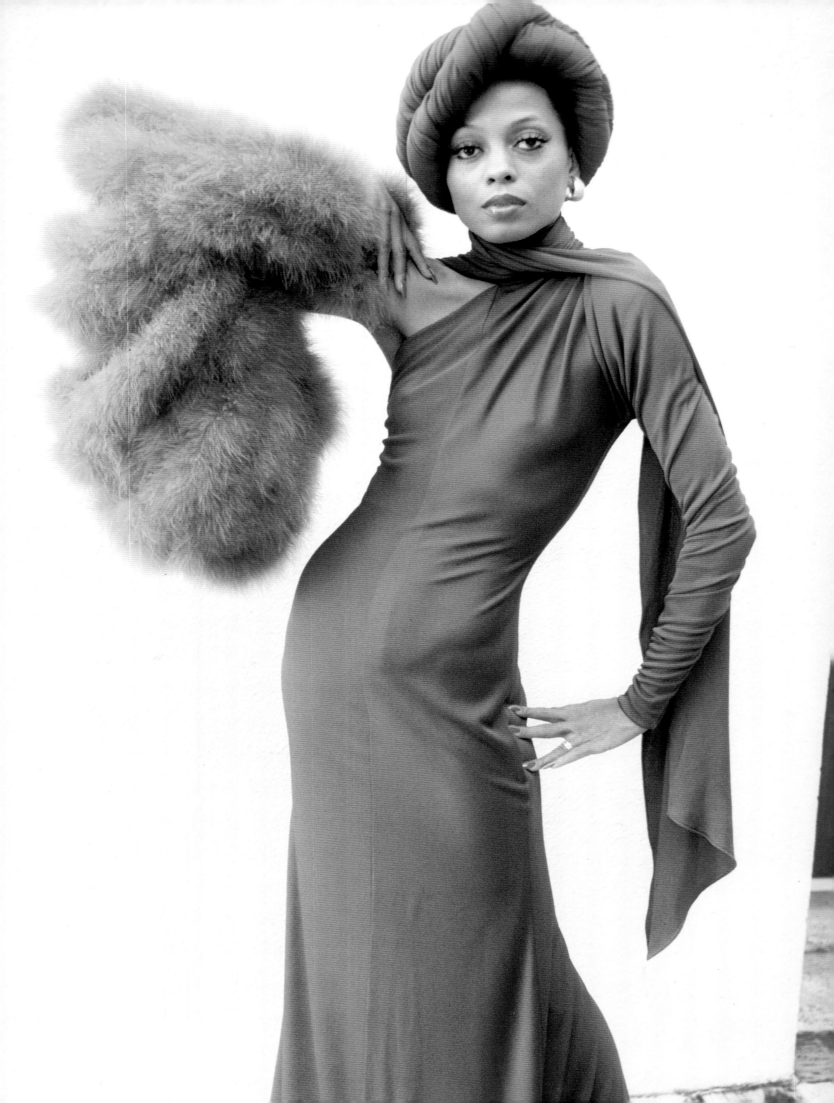

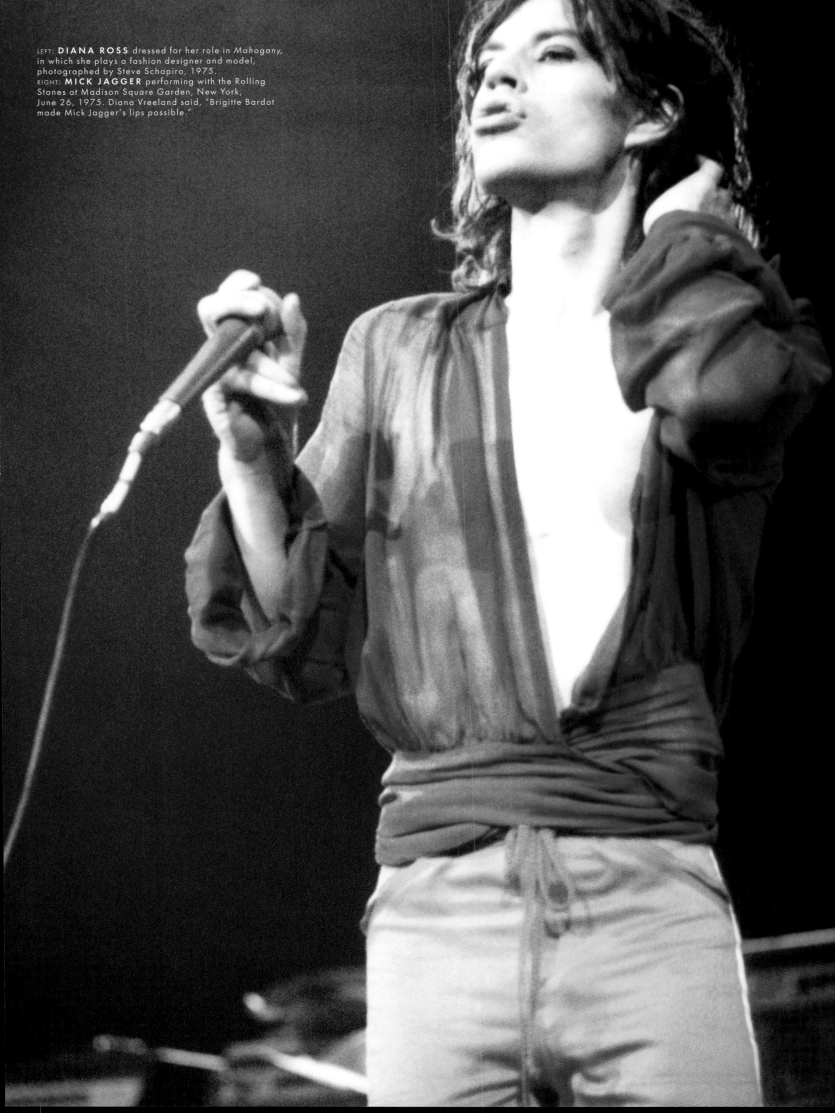

LEFT: **DIANA ROSS** dressed for her role in *Mahogany*, in which she plays a fashion designer and model, photographed by Steve Schapiro, 1975.
RIGHT: **MICK JAGGER** performing with the Rolling Stones at Madison Square Garden, New York, June 26, 1975. Diana Vreeland said, "Brigitte Bardot made Mick Jagger's lips possible."

The 1970s

TOP: designer **MARY McFADDEN**, right, and Houston-based philanthropist **LYNN WYATT** at the Pierre hotel for a benefit fashion show, dinner, and disco dance honoring Mary, September 21, 1978. Before starting her own company, in 1976, Mary was a publicity director for Dior New York and an editor at South African Vogue. ABOVE: designer **NORMA KAMALI,** photographed in 1977. Kamali's retro, broad-shouldered silhouettes, high-style swimsuits, and innovative use of sweatshirting fabric anticipated the 80s and beyond. RIGHT: **CAROLINA HERRERA,** right, in Giorgio di Sant'Angelo, with **BIANCA JAGGER** at Studio 54, New York, circa 1979, by Robin Platzer.

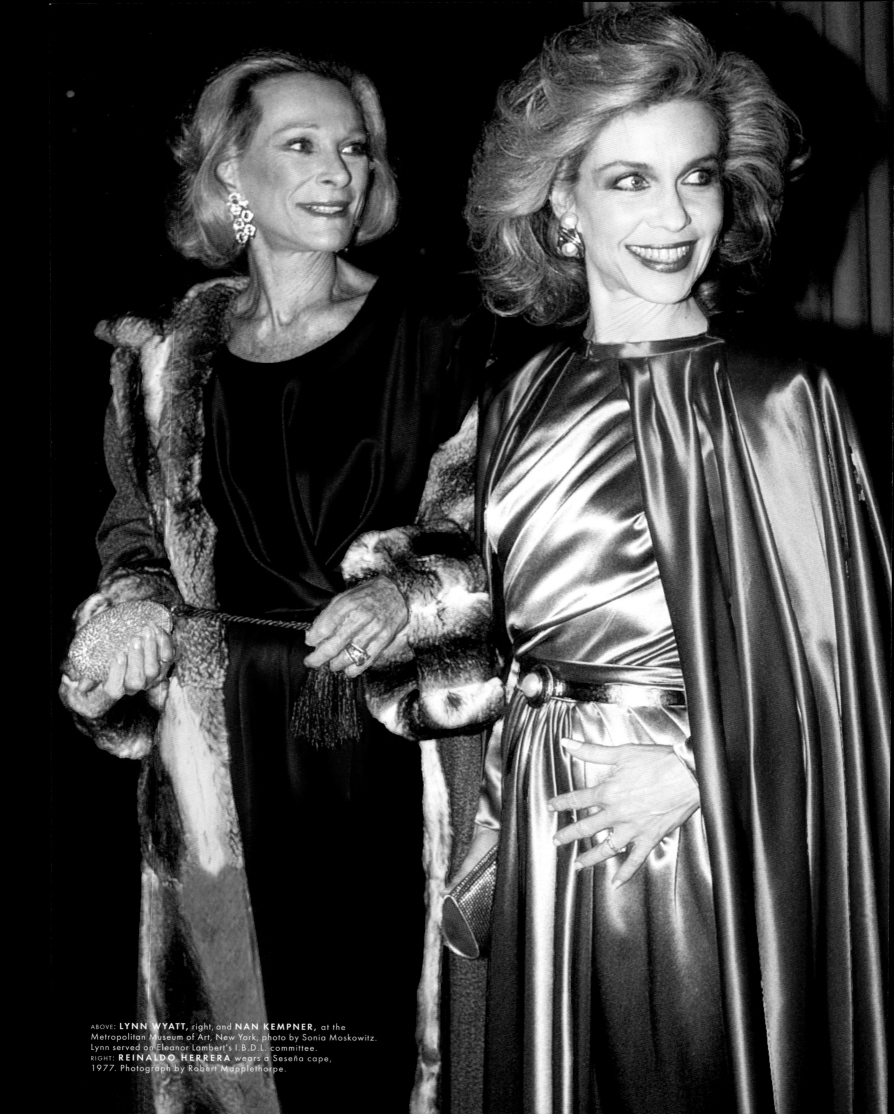

ABOVE: **LYNN WYATT,** right, and **NAN KEMPNER,** at the
Metropolitan Museum of Art, New York, photo by Sonia Moskowitz.
Lynn served on Eleanor Lambert's I.B.D.L. committee.
RIGHT: **REINALDO HERRERA** wears a Seseña cape,
1977. Photograph by Robert Mapplethorpe.

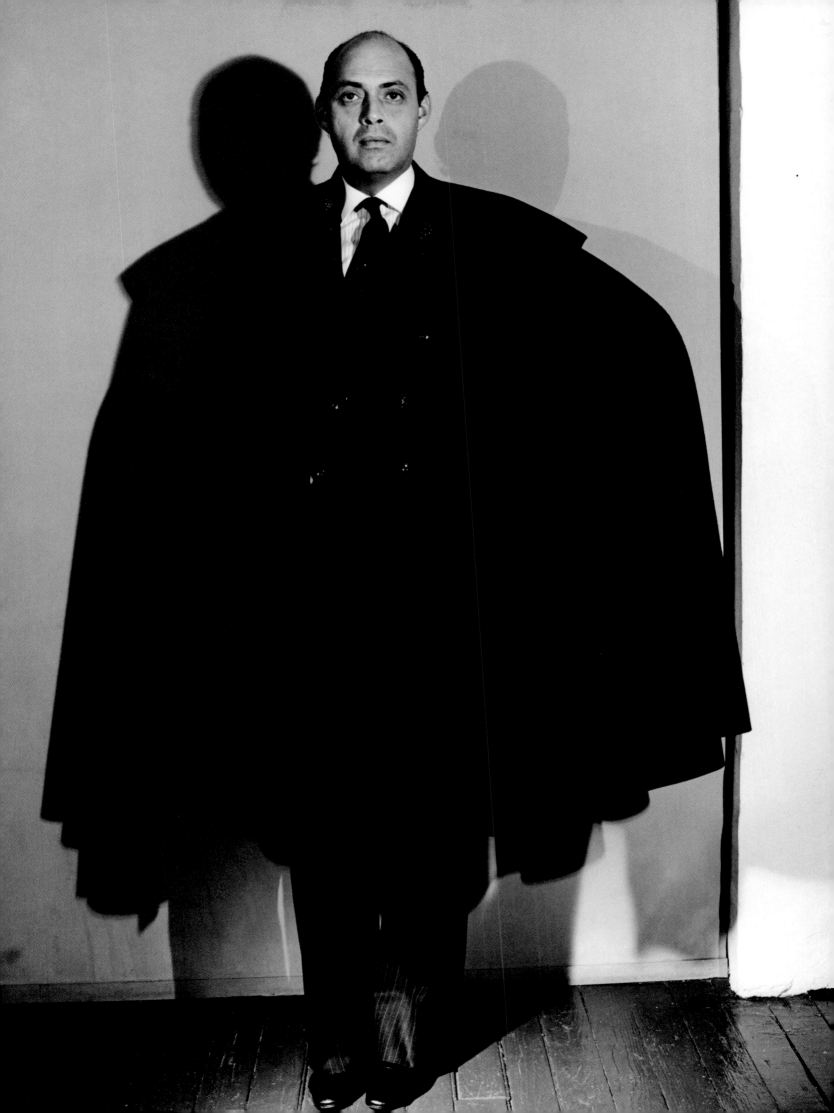

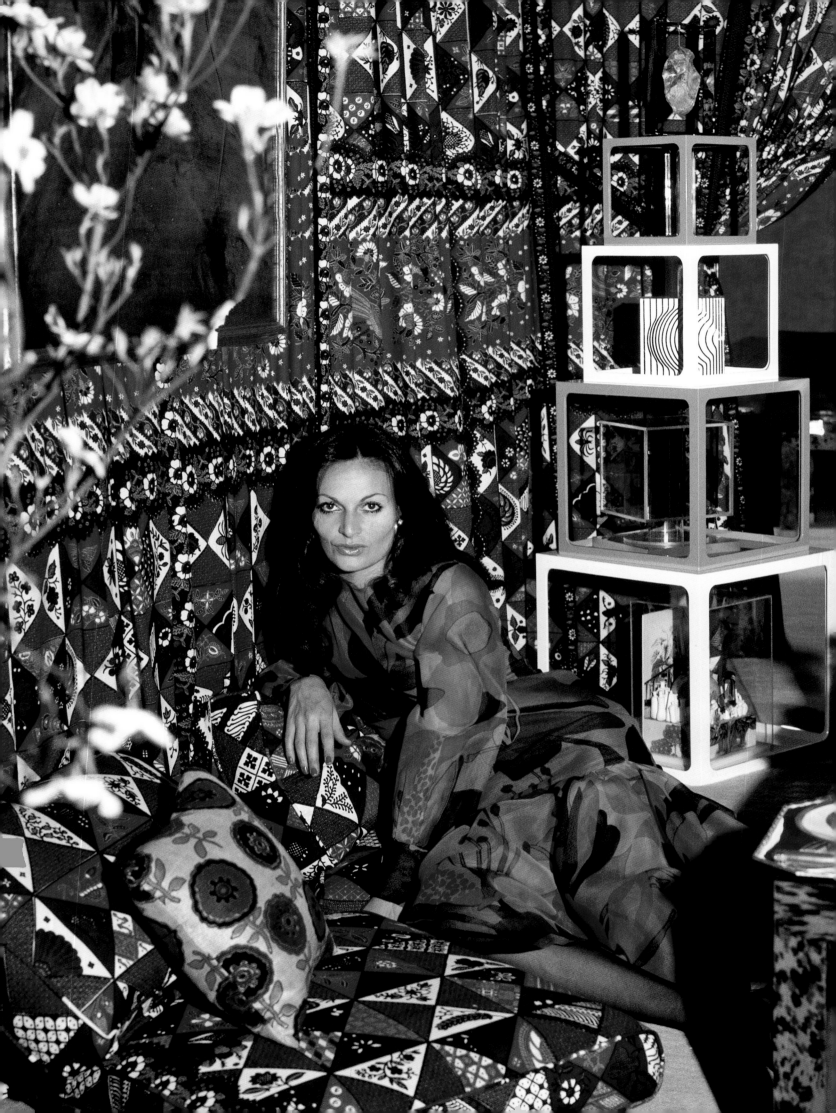

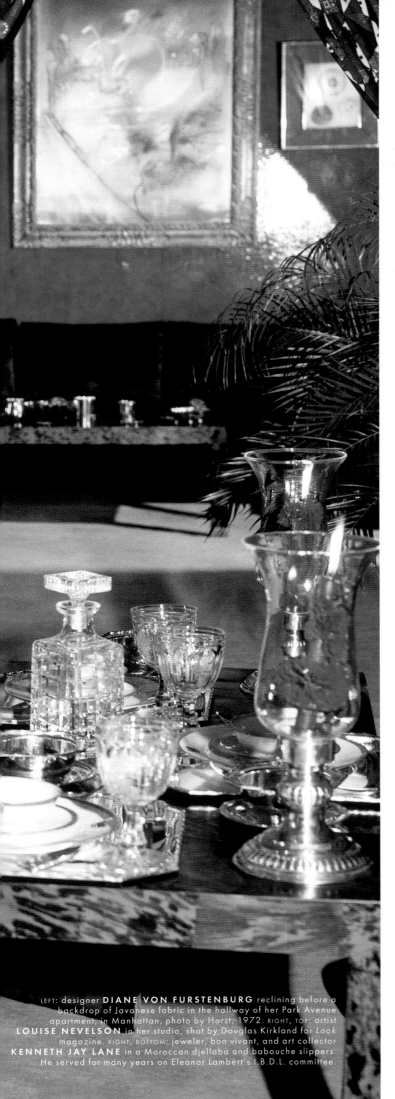

LEFT: designer **DIANE VON FURSTENBURG** reclining before a backdrop of Javanese fabric in the hallway of her Park Avenue apartment, in Manhattan, photo by Horst, 1972. RIGHT, TOP: artist **LOUISE NEVELSON** in her studio, shot by Douglas Kirkland for *Look* magazine. RIGHT, BOTTOM: jeweler, bon vivant, and art collector **KENNETH JAY LANE** in a Moroccan djellaba and babouche slippers. He served for many years on Eleanor Lambert's I.B.D.L. committee.

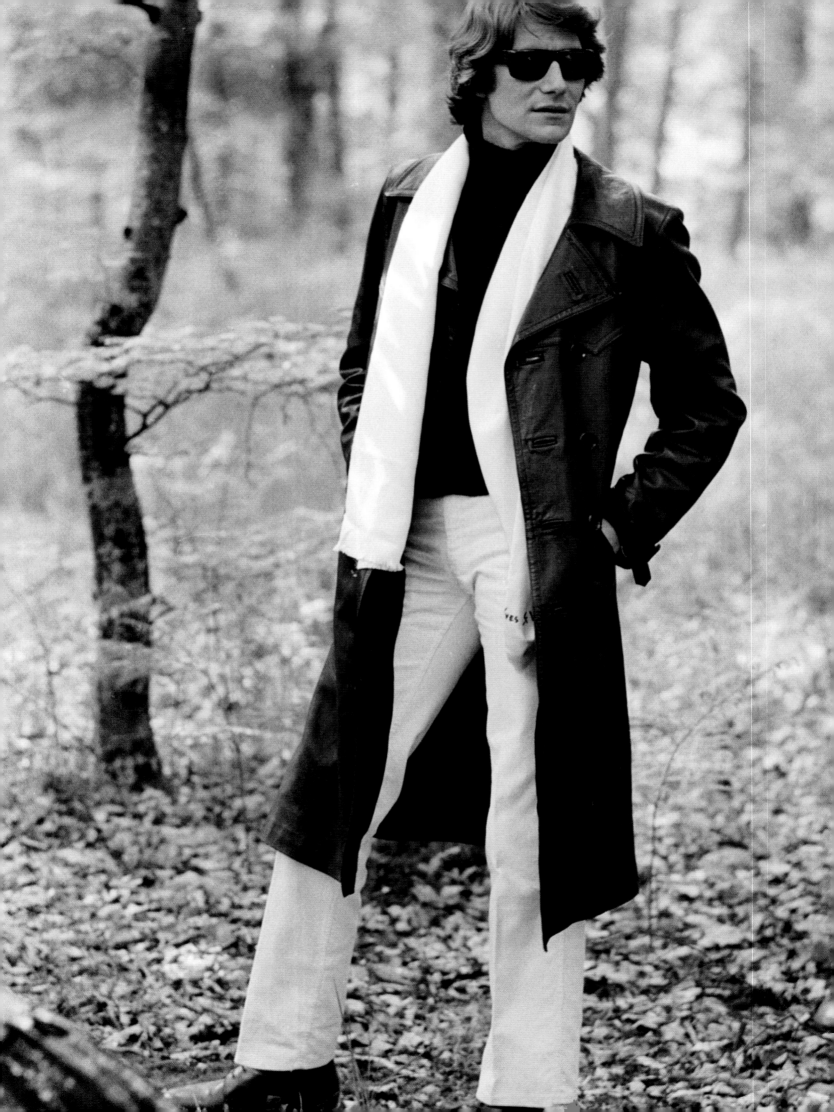

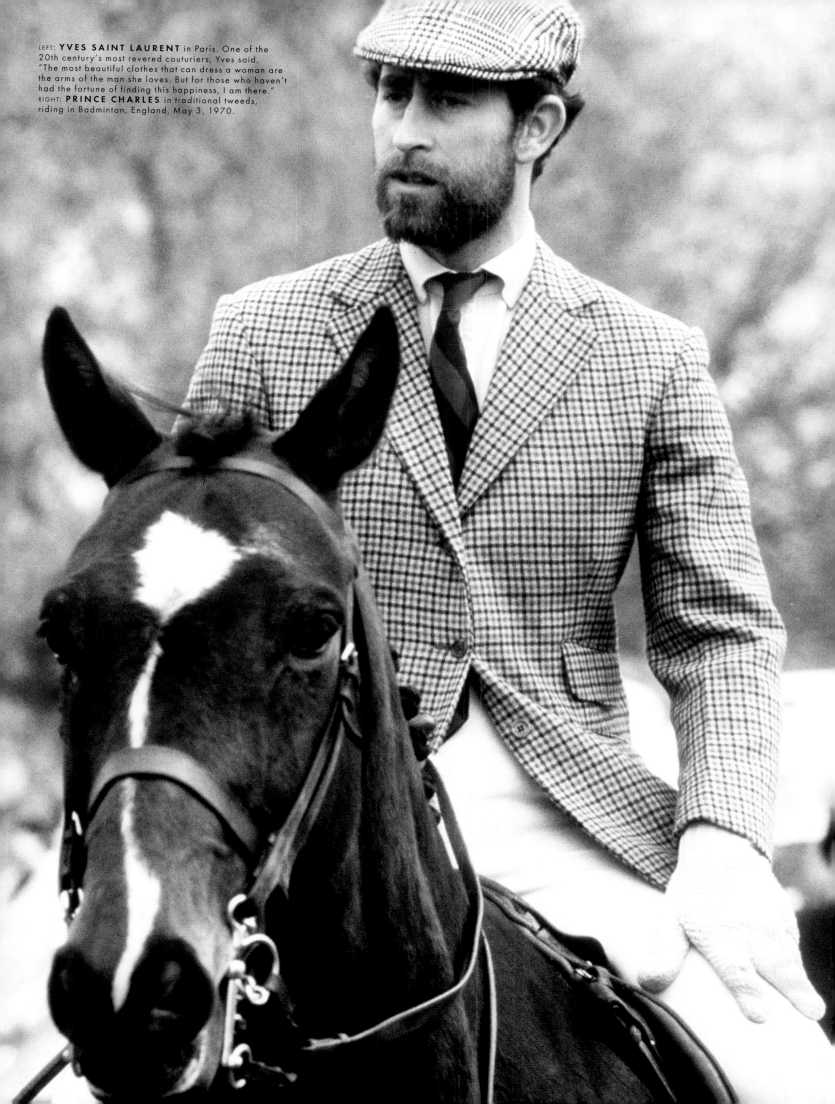

LEFT: **YVES SAINT LAURENT** in Paris. One of the 20th century's most revered couturiers, Yves said, "The most beautiful clothes that can dress a woman are the arms of the man she loves. But for those who haven't had the fortune of finding this happiness, I am there." RIGHT: **PRINCE CHARLES** in traditional tweeds, riding in Badminton, England, May 3, 1970.

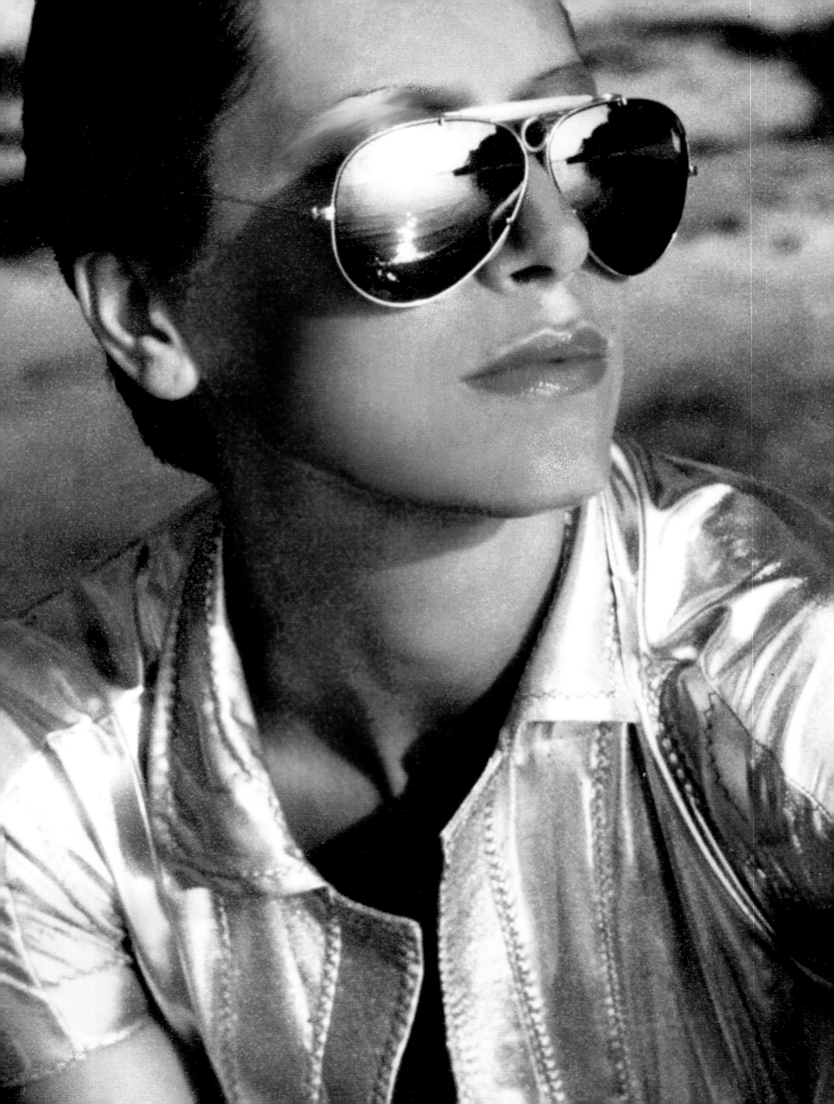

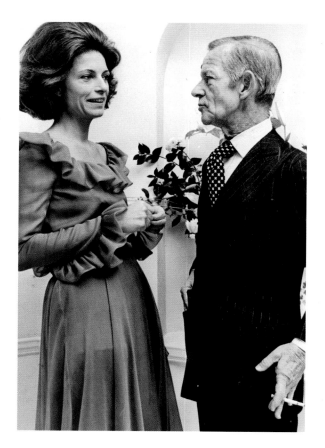

PRECEDING SPREAD, LEFT: model, jewelry designer, and philanthropist **ELSA PERETTI** wearing Stephen Burrows in Montauk, New York, 1972. RIGHT: **SIDNEY POITIER** in a still from his movie *In the Heat of the Night,* for which he received a Golden Globe nomination. Alan Levine did the costumes, uncredited, for the film. Poitier was the first black man to win an Oscar for best actor.

FAR LEFT: **JOHN LINDSAY** at the Metropolitan Museum of Art's Centennial Ball, April 13, 1970. Mayor of New York, a job he called "the second toughest" in America, from 1966 to 1973, he was also briefly a Democratic candidate in the 1972 presidential race. LEFT: philanthropist **DEEDA BLAIR** and interior designer **BILLY BALDWIN** at her party in Washington, D.C., celebrating the publication of his book, *Billy Baldwin Remembers,* October 21, 1974. ABOVE: **SILVANA MANGANO,** Italian actress and wife of producer Dino De Laurentiis, with their daughter, Francesca, in 1971, the year she co-starred in Luchino Visconti's *Death in Venice.*

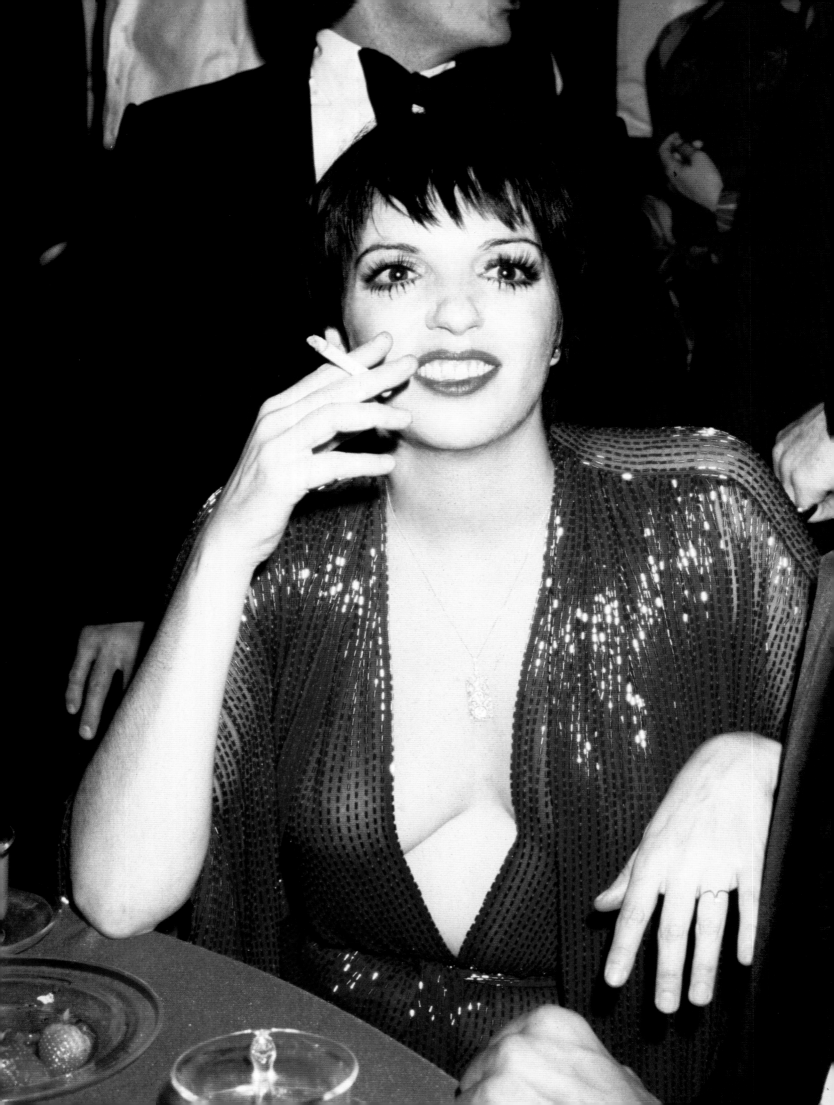

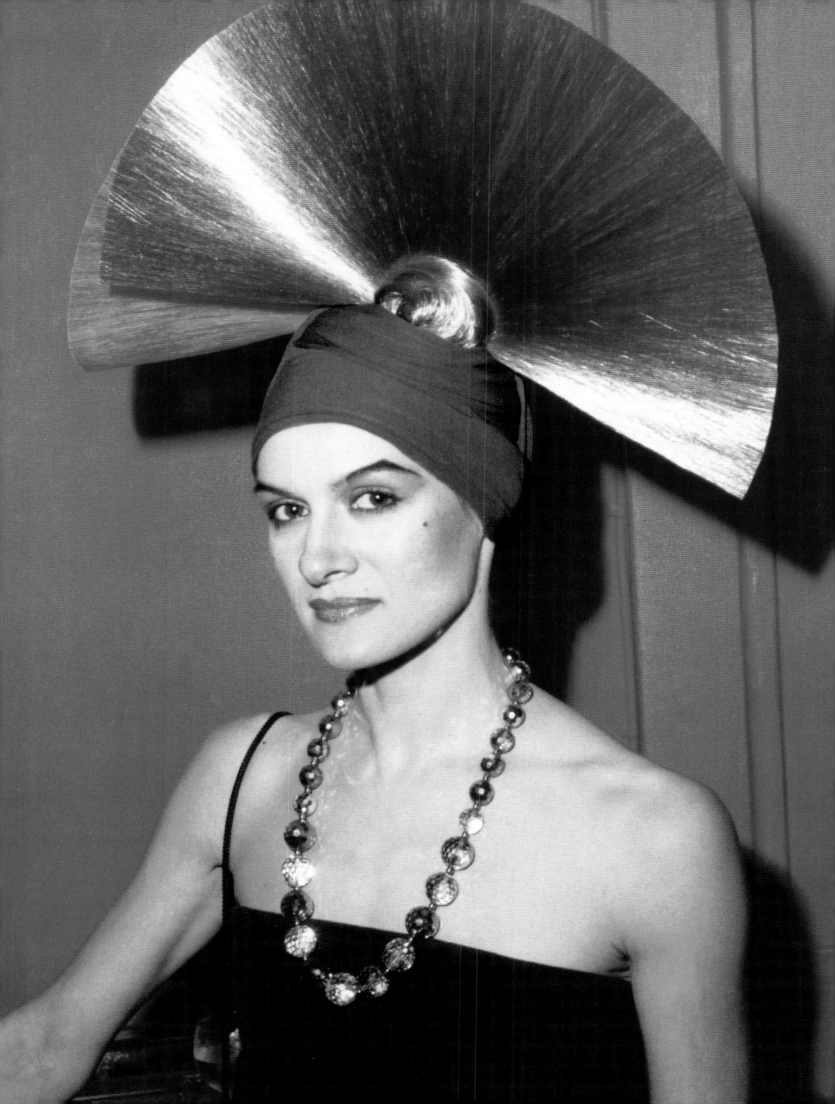

PRECEDING SPREAD, LEFT: **LIZA MINNELLI** in Halston, celebrating her 33rd birthday at Studio 54, 1979. RIGHT: **PALOMA PICASSO,** dressed for a party at Le Palace, the Paris club that ruled the city's nightlife from 1978 to 1983. Thierry Mugler designed the waiters' costumes, and Roland Barthes wrote that Le Palace offered "a whole range of sensations designed to make people happy during the space of a night."

LEFT: **PRINCESS CAROLINE OF MONACO** at the Red Cross Gala in Monte Carlo, August 12, 1974, the year she first won a spot on the List, at age 17. ABOVE: cabaret artist and master of the American Songbook **BOBBY SHORT** on Park Avenue in New York, holding one of his evening pumps, June 17, 1978. RIGHT: **MIKHAIL BARYSHNIKOV** practicing with the National Ballet of Canada in Toronto, July 10, 1974, 11 days after his defection from the Soviet Union. Eleanor Lambert commented that, while the dancer "did not inspire followers for any specific costume, his romantic-macho dress has been a strong influence on masculine styles."

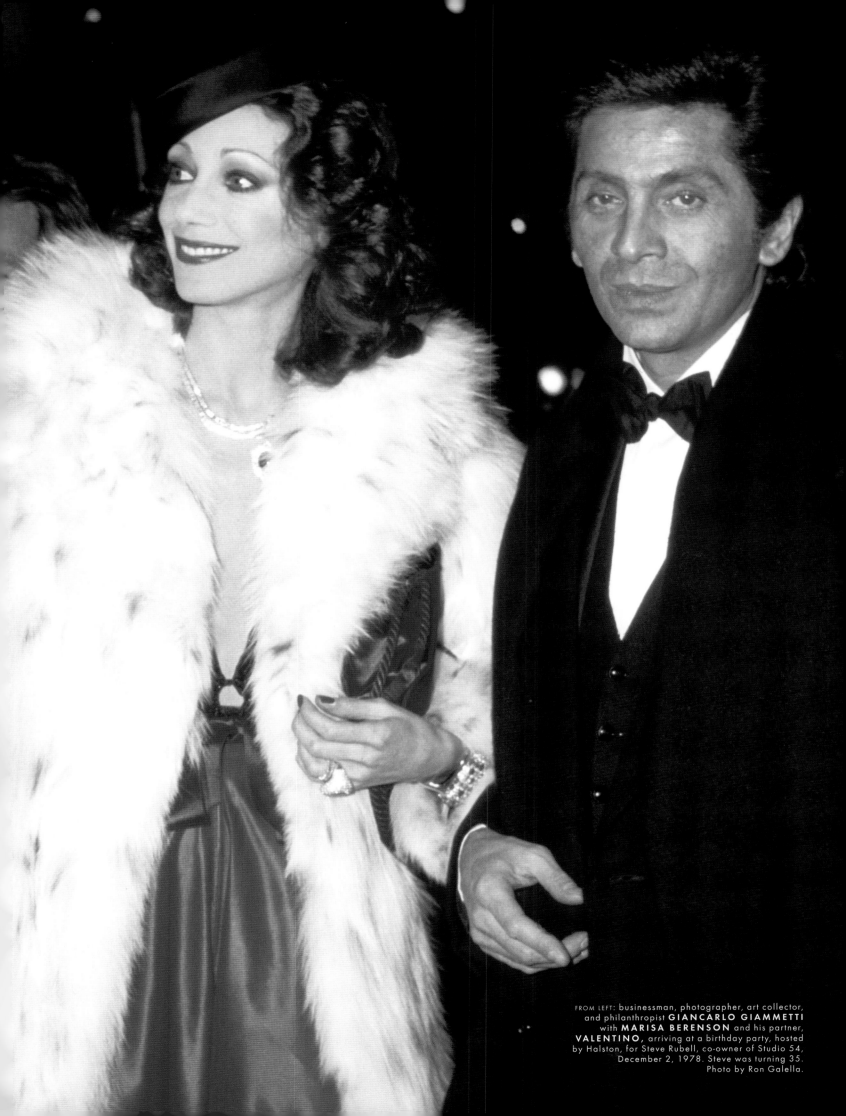

FROM LEFT: businessman, photographer, art collector, and philanthropist **GIANCARLO GIAMMETTI** with **MARISA BERENSON** and his partner, **VALENTINO,** arriving at a birthday party, hosted by Halston, for Steve Rubell, co-owner of Studio 54, December 2, 1978. Steve was turning 35. Photo by Ron Galella.

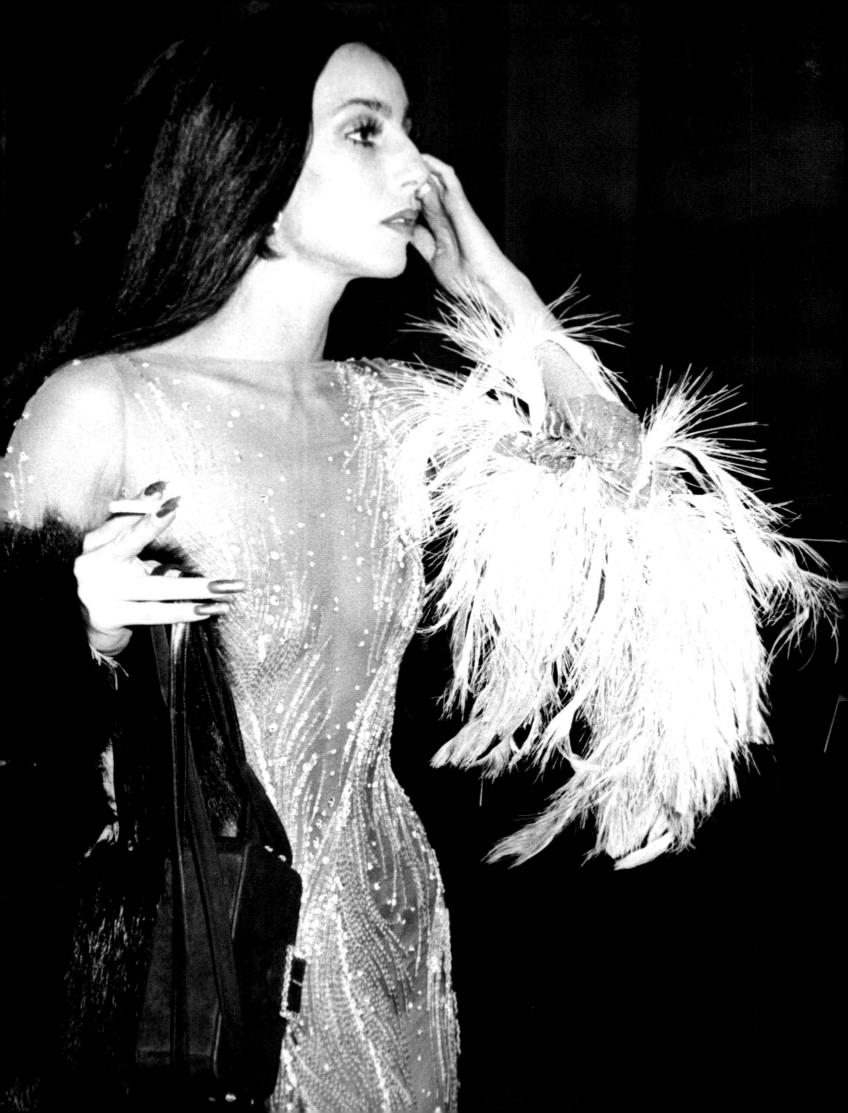

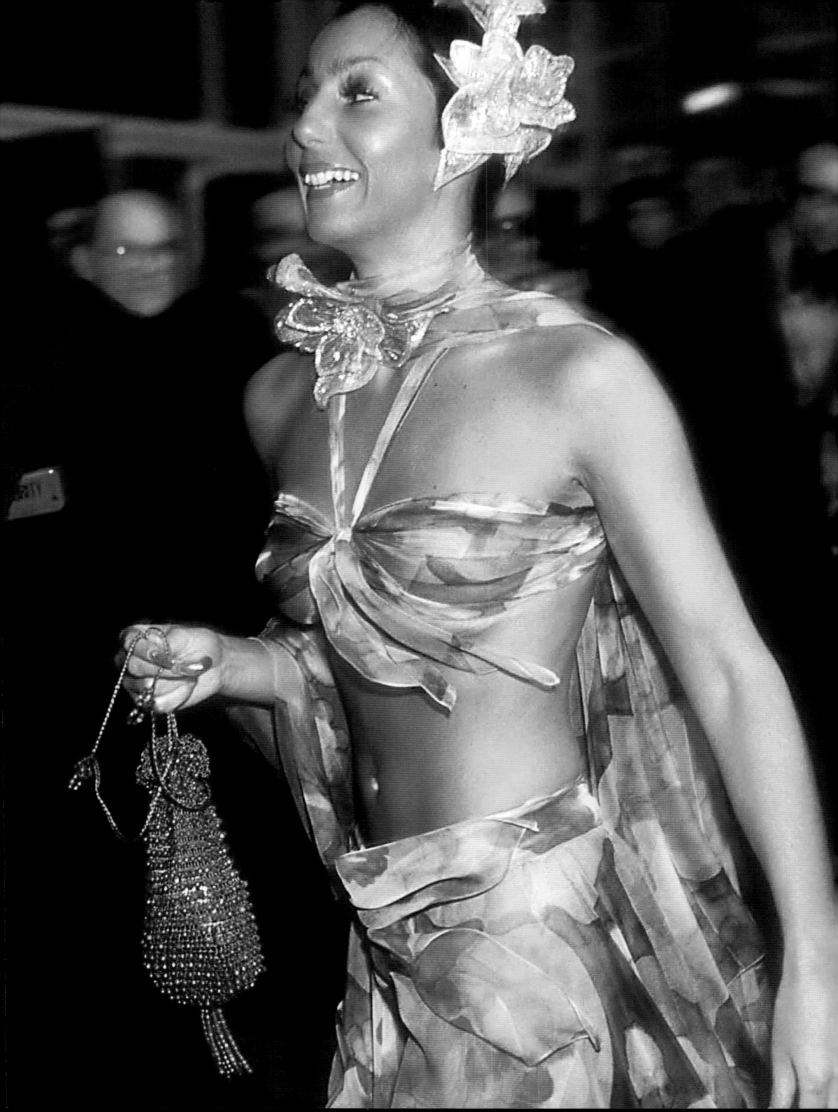

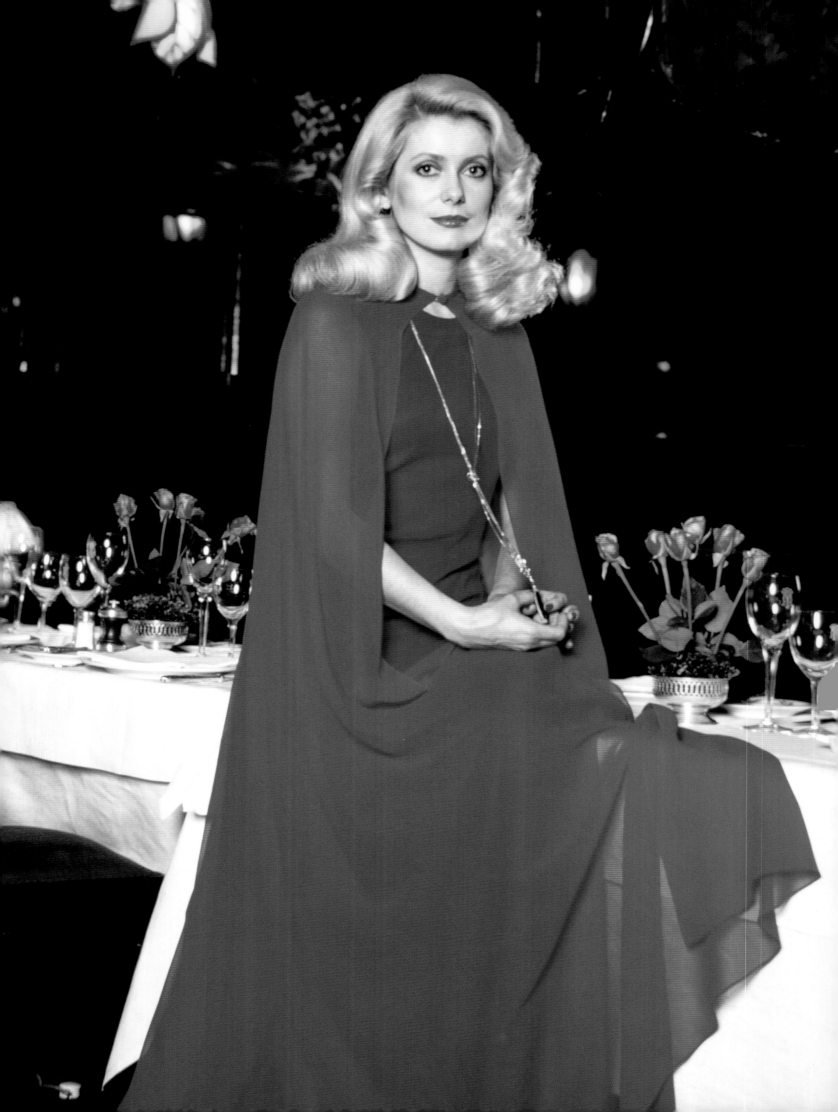

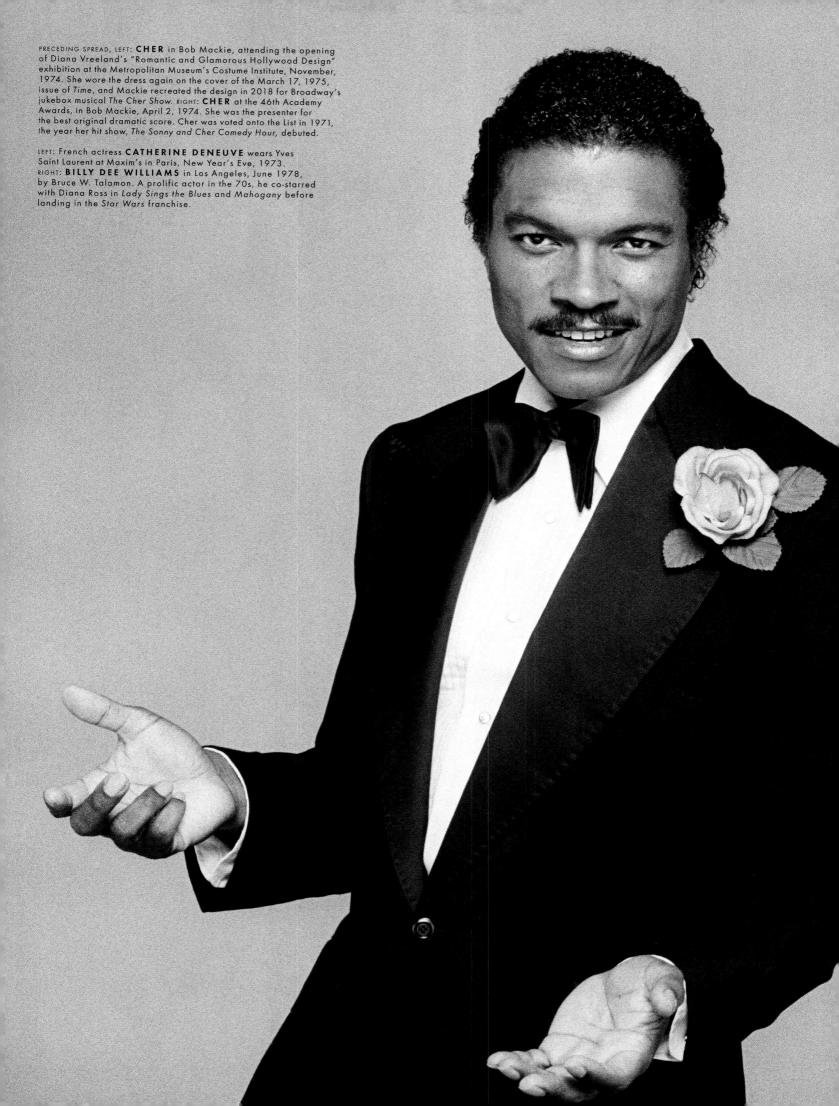

PRECEDING SPREAD, LEFT: **CHER** in Bob Mackie, attending the opening of Diana Vreeland's "Romantic and Glamorous Hollywood Design" exhibition at the Metropolitan Museum's Costume Institute, November, 1974. She wore the dress again on the cover of the March 17, 1975, issue of *Time*, and Mackie recreated the design in 2018 for Broadway's jukebox musical *The Cher Show*. RIGHT: **CHER** at the 46th Academy Awards, in Bob Mackie, April 2, 1974. She was the presenter for the best original dramatic score. Cher was voted onto the List in 1971, the year her hit show, *The Sonny and Cher Comedy Hour*, debuted.

LEFT: French actress **CATHERINE DENEUVE** wears Yves Saint Laurent at Maxim's in Paris, New Year's Eve, 1973. RIGHT: **BILLY DEE WILLIAMS** in Los Angeles, June 1978, by Bruce W. Talamon. A prolific actor in the 70s, he co-starred with Diana Ross in *Lady Sings the Blues* and *Mahogany* before landing in the *Star Wars* franchise.

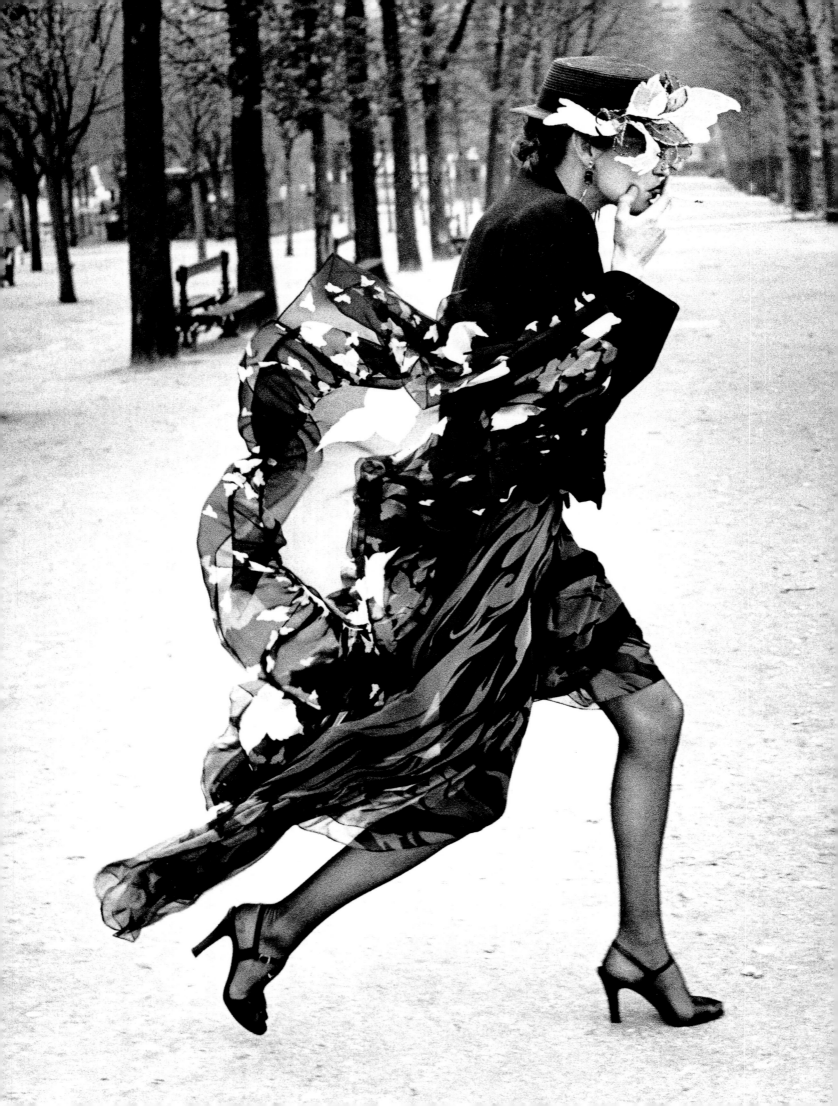

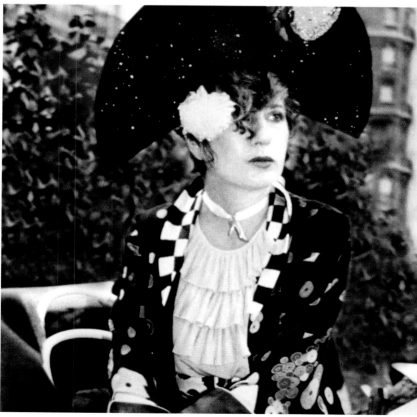

LEFT: Yves Saint Laurent's accessories designer and muse, **LOULOU DE LA FALAISE**, in Yves Saint Laurent, by Helmut Newton for *Egoïste*, Paris, 1978. TOP: model and fashion editor **CHINA MACHADO** at the Rose Ballroom in New York, 1972. Richard Avedon, with whom she worked closely, said China, of East Indian, Chinese, and Portuguese descent, was "the most beautiful woman in the world." ABOVE: Italian fashion journalist and muse **ANNA PIAGGI** during the Paris haute couture shows, 1979, by Roxanne Lowit. "My philosophy of fashion is humor, jokes and games," Piaggi said in 1978.

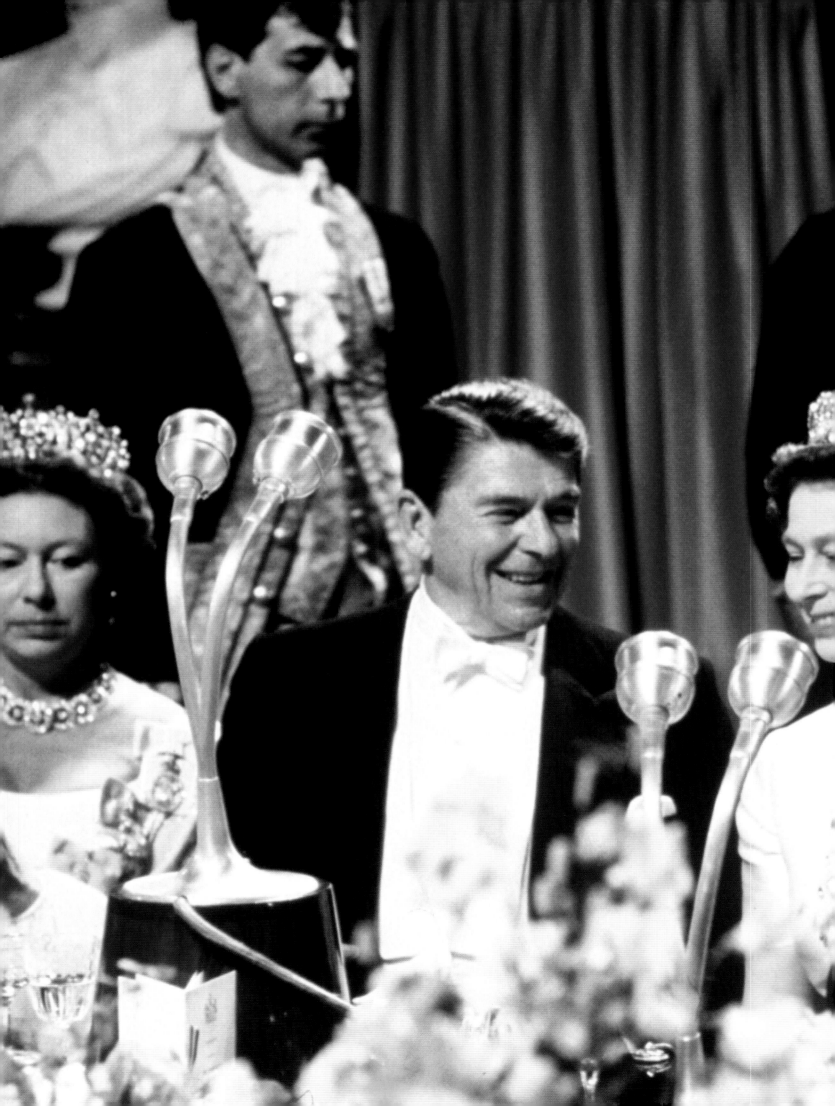

# The 1980s

## The REAGANS, DI, and the DOW

PRINCESS MARGARET, left, and QUEEN ELIZABETH II
with PRESIDENT RONALD REAGAN at
Windsor Castle during his state visit to England, June 1982.

THE HON. ANTHONY ACKLAND

SRA. UMBERTO AGNELLI (ALLEGRA CARACCIOLO)

ANOUK AIMÉE

MME. NOUHA ALHEGELAN (NOUHA TARAZI)

BARBARA ALLEN

THOMAS AMMANN

PRINCE ANDREW OF GREAT BRITAIN AND NORTHERN IRELAND

GIORGIO ARMANI

KAROLE ARMITAGE

ARTHUR ASHE

BROOKE ASTOR

ALEC BALDWIN

JEFFREY BANKS

WILKES BASHFORD

ANNE BASS

ROGER BAUGH

PETER BEARD

ROBERT BEAUCHAMP

THE DUKE OF BEAUFORT (DAVID SOMERSET)

THE DUKE OF BEDFORD (IAN RUSSELL)

MME. PETER BEMBERG (GWENDOLINE LEVIÉ FFOULKE)

MICHEL BERGERAC

CORBIN BERNSEN

BENAZIR BHUTTO

LAURA BIAGIOTTI

BIJAN (PAKZAD)

MARK BIRLEY

JACQUELINE BISSET

EVANGELINA BLAHNIK

MANOLO BLAHNIK

MRS. DIXON BOARDMAN (PAULINE MUNN BAKER)

ERIC BOMAN

HELENA BONHAM CARTER

DAVID BOWIE

MARK BOXER

CONTESSA TIBERTO BRANDOLINI (BORN PRINCESS GEORGINA DE FAUCIGNY-LUCINGE ET COLIGNY)

ARLETTE BRISSON

MME. CLAUDE BROUET

JOAN JULIET BUCK

MARINA BULGARI

THE HON. RICHARD BURT

PRESIDENT GEORGE BUSH

THE DUCHESS OF CADAVAL (CLAUDINE TRITZ)

MRS. MICHAEL CAINE (SHAKIRA BAKSH)

PRINCESS ANNE CARACCIOLO

H.M. KING JUAN CARLOS OF SPAIN

RICHARD CARROLL

MRS. JOHNNY CARSON (JOANNA ULRICH HOLLAND)

GRAYDON CARTER

CATHERINE DE CASTELBAJAC

LEO CASTELLI

JEAN-BAPTISTE CAUMONT

FRÉDÉRIC CHANDON DE BRIAILLES

COMTESSE FRÉDÉRIC CHANDON DE BRIAILLES (CAMILLA PARAVICINI MAVROLEON)

TINA CHOW

MRS. GUSTAVO CISNEROS (PATRICIA PHELPS)

NICHOLAS COLERIDGE

ALISTAIR COOKE

MLLE. FRANCINE CRESCENT

COUNT BRANDO CRESPI

KITTY D'ALESSIO

DANIEL DAY-LEWIS

JACQUES DEHORNOIS

JOHN DELOREAN

H.R.H. PRINCESS DIANA, PRINCESS OF WALES (DIANA SPENCER)

H.R.H. PRINCE DIMITRI OF YUGOSLAVIA

ELIZABETH DOLE

MRS. MICHAEL DOUGLAS (DIANDRA LUKER)

MRS. GUILFORD DUDLEY (JANE ANDERSON)

GILLES DUFOUR

SRA. GABRIEL ECHEVARRÍA (PILAR CRESPI)

H.R.H. PRINCE EDWARD OF GREAT BRITAIN AND NORTHERN IRELAND

LINDA EVANS

JOHN FAIRCHILD

TOM FALLON

SRA. MARIA PIA FANFANI (MARIA PIA TAVAZZANI)

SRA. ALFONSO FIERRO (TRINIDAD "TRINI" JIMENEZ-LOPERA Y ALVAREZ)

H.R.H. PRINCESS FIRYAL OF JORDAN (FIRYAL IRSHAID)

THE DUCHESS OF FERIA (NATIVIDAD ABASCAL SMITH)

LEONARDO FERRAGAMO

MASSIMO FERRAGAMO

BRYAN FERRY

ALAN FLUSSER

CHRISTOPHER "KIP" FORBES

JOHN FORSYTHE

LADY CHARLOTTE FRASER (CHARLOTTE GREVILLE)

INÈS DE LA FRESSANGE

PRINCE HEINRICH FÜRSTENBERG

JAMES GALANOS

COMTE PAUL DE GANAY

COUNT SEBASTIAN DE GANAY

MRS. GORDON GETTY (ANN GILBERT)

ROMEO GIGLI

DONATELLA GIROMBELLI

NINA GRISCOM (NINA RENSHAW)

CLIFFORD GRODD

DIDIER GRUMBACH

MRS. CHRISTIAN DE GUIGNÉ III (ELEANOR CHRISTENSEN)

MRS. JOHN GUTFREUND (SUSAN KAPOSTA PENN)

GENERAL ALEXANDER HAIG

PRENTIS COBB HALE

ARSENIO HALL

JERRY HALL

MRS. OSCAR HAMMERSTEIN (DOROTHY BLANCHARD JACOBSON)

MARK HAMPTON

CATHY HARDWICK

MRS. DONALD HARRINGTON (SYBIL BUCKINGHAM)

H.M. KING HASSAN II OF MOROCCO

EDWARD W. HAYES

MRS. JOHN R. HEARST (KATHLEEN BICKLEY)

ANOUSKA HEMPEL

JOY HENDERIKS

JEAN-LOUIS DUMAS HERMÈS

CAROLINA HERRERA

CAROLINA HERRERA JR.

GREGORY HINES

DAVID HOCKNEY

JAMES HOGE

LENA HORNE

WHITNEY HOUSTON

FRED HUGHES

ANJELICA HUSTON

LAUREN HUTTON

JULIO IGLESIAS

IMAN

JEREMY IRONS

H.H. THE RAJMATA OF JAIPUR (PRINCESS GAYATRI DEVI, "AYESHA")

PETER JENNINGS

VERNON JORDAN

ALEXANDER JULIAN

NORMA KAMALI

JUN KANAI

H.R.H. KATHARINE, DUCHESS OF KENT

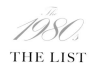

# THE LIST

STEVEN KAUFMAN

MRS. FRANCIS KELLOGG (MERCEDES TAVACOLI)

JOHN F. KENNEDY JR.

MRS. BARRY KIESELSTEIN-CORD (CECE EDDY)

CALVIN KLEIN

KELLY KLEIN

ELSA KLENSCH

KEVIN KLINE

CAROLYNE ROEHM KRAVIS

H.R.H. PRINCE KYRIL OF BULGARIA

KARL LAGERFELD

CLAUDE LALANNE

IRITH LANDEAU

BERNARD LANVIN

MME. BERNARD LANVIN (MARYLL ORSINI)

ESTÉE LAUDER

CARMEN DE LAVALLADE

SUGAR RAY LEONARD

LEO LERMAN

ALEXANDER LIBERMAN

MME. CATHERINE DE LIMUR (CATHERINE CONRAT)

RENATE LINSENMEYER

RAFAEL LOPEZ-SANCHEZ

JENNY LUMET

RUPERT LYCETT-GREEN

JOYCE MA

CHINA MACHADO

MARIUCCIA MANDELLI

MONSIEUR MARC (DE COSTER)

JEAN-PIERRE MARCIE-RIVIÈRE

STEVE MARTIN

MARIAN MCEVOY

HENRY MCILHENNY

ANNE MCNALLY

SONNY MEHTA

ZUBIN MEHTA

MME. DREDA MELE

DAWN MELLO

CONSTANCE MELLON

CROWN PRINCESS MICHIKO OF JAPAN
(MICHIKO SHODA)

PHILIP MILLER

PRESIDENT FRANÇOIS MITTERRAND

ISSEY MIYAKE

BEPPE MODENESE

LAURA MONTALBAN

NONNIE MOORE

DANIELE MOREIRA

CONTESSA DONINA CICOGNA MOZZONI
(DONINA TOEPLITZ DE GRAND RY)

JEAN MUIR

MRS. RUPERT MURDOCH (ANNA TORV)

PAUL NEWMAN

MME. PHILIPPE NIARCHOS (VICTORIA GUINNESS)

MRS. SPYROS NIARCHOS (DAPHNE GUINNESS)

DAVID NIVEN

JAMES NIVEN

H.M. QUEEN NOOR OF JORDAN (LISA HALABY)

SRA. VITTORIA DI NORA

COMTESSE HUBERT D'ORNANO
(ISABELLE POTOCKA)

MARINA PALMA

FRANCES PATIKY STEIN

MME. ANTÉNOR PATIÑO
(BEATRIZ DE RIVERA Y DIGEON)

GREGORY PECK

ROGER PENSKE

SENATOR CHARLES PERCY

MIRELLA PETTINI

CHARLES PFEIFFER

ANNA PIAGGI

PALOMA PICASSO

PRESIDENT JOSÉ LÓPEZ PORTILLO

GENE PRESSMAN

MRS. CHARLES H. PRICE II (CAROL SWANSON)

LEE RADZIWILL

DAN RATHER

PRESIDENT RONALD REAGAN

JOSEPH VERNER REED

SAMUEL P. REED

SENATOR ABRAHAM RIBICOFF

MRS. ABRAHAM RIBICOFF (CASEY MELL)

JOAN RIVERS

JACKIE ROGERS

DIANA ROSS

ROBERTO ROSSELLINI JR.

BARON DAVID DE ROTHSCHILD

BARONESS EDOUARD DE ROTHSCHILD
(MATHILDE DE LA FERTÉ)

BARONESS OLIMPIA DE ROTHSCHILD

ELIETH ROUX

HIS EXCELLENCY CARLOS ORTIZ DE ROZAS

MRS. HOWARD RUBY (YVETTE MIMIEUX DONEN)

VALERIAN RYBAR

ELIZABETH SALTZMAN

ELLIN SALTZMAN

RAFAËL LÓPEZ SÁNCHEZ

JULIO MARIO SANTO DOMINGO

SRA. JULIO MARIO SANTO DOMINGO
(BEATRICE DÁVILA ROCHA)

DIANE SAWYER

MARINA SCHIANO

JULIAN SCHNABEL

MRS. JULIAN SCHNABEL (JACQUELINE BEAURANG)

TOM SELLECK

PETER SHARP

BOBBY SHORT

MARIA SHRIVER

MRS. FRANK SINATRA (BARBARA BLAKELEY MARX)

VICTOR SKREBNESKI

EARL E. T. SMITH JR.

PAUL SMITH

MARIA SNYDER

CARLA SOZZANI

MRS. RAY STARK (FRANCES BRICE)

FRANCES PATIKY STEIN

ANDRÉ LEON TALLEY

MRS. ALFRED TAUBMAN (JUDITH MAZOR)

MARGARET THATCHER

ALEXANDRA THEODORACOPULOS

MME. SAMIR TRABOULSI (PAULA MELLIN
DE VASCONCELLOS)

MRS. DONALD TRUMP
(IVANA ZELNÍKOVÁ WINKLMAYR)

MRS. ROBERT TRUMP (BLAINE BEARD RETCHIN)

VALENTINO

ADRIENNE VITTADINI

ALEXANDER VREELAND

BARONESS SYLVIA DE WALDNER

BARBARA WALTERS

THE COUNTESS OF DUDLEY (GRACE WARD)

ANDY WARHOL

RAQUEL WELCH

MRS. GALEN WESTON (HILARY FRAYNE)

PAUL WILMOT

MRS. R. THORNTON WILSON JR.
(JOSIE STROTHER MCCARTHY)

ANNA WINTOUR

TOM WOLFE

COUNT ANGELO ZEGNA

ERMENEGILDO ZEGNA

JEROME ZIPKIN

ZORAN (LADICORBIC)

GUSTAV ZUMSTEG

---

FAR LEFT: **PRINCESS DIANA** watching Prince Charles play polo at Cowdray Park, West Sussex, England, on their second wedding anniversary, July 29, 1983. TOP, LEFT: dancer and actress **CARMEN DE LAVALLADE,** photographed by Marina Garnier, October 1987. TOP, RIGHT: philanthropists **ANNE BASS,** left, and **DEEDA BLAIR** at the New York City Ballet gala, photographed by Roxanne Lowit. BOTTOM: politician **BENAZIR BHUTTO** in Cannes, France, November 6, 1985, during her exile from Pakistan. Harvard-and-Oxford educated, she became the first woman to lead a democratic government in a Muslim nation when she was elected Pakistan's prime minister in 1988, the year she was voted onto the List.

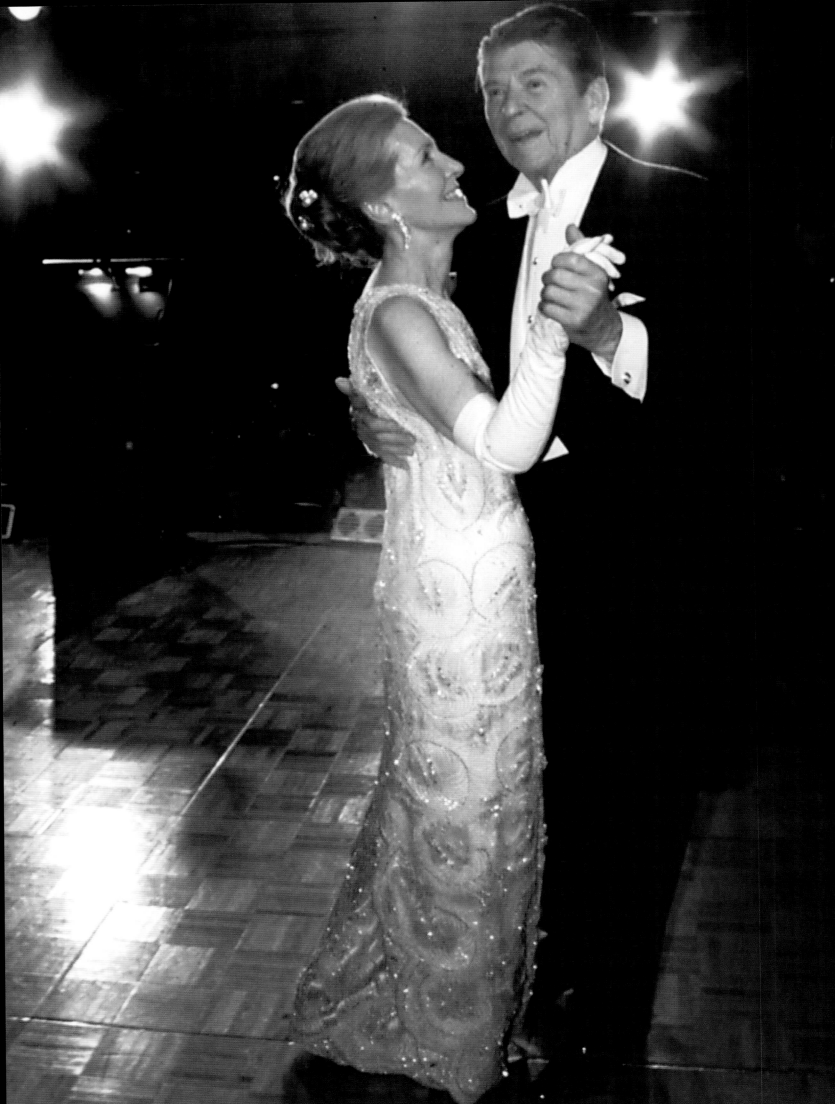

*"It's not about the dress you wear,*
*but the life you lead*
*in the dress."*

— DIANA VREELAND

## The Reagans and Their Entourage

The gilded seed that would germinate in the 1980s had already been sown back in the late 60s, when the wife of California governor, Nancy Reagan, ignored by the List in her actress days, became one of Lambert's reliable "repeaters." In 1972, Suzy had deemed her "neat, pretty and bandboxy," and in 1973 (though a Republican) "not too conservative to wear halter-neck dresses that dip to about six inches above the coccyx." On February 20, 1974, after she had secured her permanent place among the "unutterably chic" (again Suzy's words) of the Hall of Fame, the First Lady of California wrote a thank-you note to Lambert on her Sacramento stationery: "I'm very flattered!"

With (in Lambert's words) "the decade of kooky dressing" fading fast into memory, the Iran hostage crisis finally resolved, and the Reagans now securely ensconced in the White House, the List acquired a fresh patina of glitz. Like Reagan's optimistic vision of the country, the List now appeared "prouder and stronger and better." For 1981, Nancy Reagan and her entire West Coast entourage—Betsy Bloomingdale, Harriet Deutsch, Frances Brody, Marion Jorgensen, Fran Stark, Lee Annenberg, Elizabeth Wilson, Carol Price—received a mass benediction "for focusing the attention of women throughout the world on the luxurious but casual California style," Lambert wrote in her new women's-page column, "She," for Field Newspaper Syndicate. Though they did not all make the List, Lambert noted that "they have shifted the fashion ideal away from Parisian chic to the American Look." Secretary of State Alexander Haig, the "fiery," pin-striped cynosure of TV viewers during his Senate confirmation hearings, joined the List's Washington brigade, along with Jerome Zipkin, the First Lady's cufflink-collecting confidant—about whom John Fairchild coined the term "walker." There initially had been some committee concern that "the press and public ... might consider the selection" of Zipkin "frivolous," according to *The Washington Star.*

Ronald Reagan, the List's first American president, arrived a year after his inauguration, even though, according to his wife, he would be happiest "in blue jeans forevermore," Suzy reported. The same 1982 committee that boosted the president onto the List—Bob Colacello, Aileen "Suzy" Mehle, nightclub impresario Regine—also agreed unanimously to reject the suddenly single, scandal-tainted Claus von Bülow.

FIRST LADY NANCY REAGAN and PRESIDENT RONALD REAGAN at an inaugural ball, January 20, 1981. Nancy wears a white satin and beaded-lace, one-shouldered Galanos sheath, which cost $22,500. "Nancy was very fair and charming and definite, and had a sense of humor," Galanos said. "She always looked neat." Nancy entered the Hall of Fame in 1973, as First Lady of California.

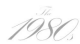

# The Gown Gaffe *and* Nancy Reagan Red

Once in the national spotlight, Nancy Reagan's fondness for clothes and ability to wear them with panache brought her nearly as much grief as admiration. In June 1980, in the heat of the presidential campaign, *People* had predicted in an accurate headline, IF NANCY REAGAN MAKES IT TO THE WHITE HOUSE, SO WILL DESIGNER JAMES GALANOS. The magazine also correctly credited Reagan's 1974 enshrinement in the Hall of Fame to the slender California-based couturier, himself awarded the ultimate distinction in 1982.

For Reagan's 1981 inauguration, Galanos crafted a white satin and beaded-lace one-shouldered sheath, now at the Smithsonian, for a cost of $22,500. And for the 1985 inaugural gown, now at the Reagan Library, his technicians spent more than 300 hours embroidering silver and white vermicelli beads and stones into a tracery of shimmering palm fronds. The eminent designer joined the First Couple's glittering court not only as gown-maker but also as "a good friend," Mrs. Reagan said—an association that permanently elevated the social status of Galanos's profession but temporarily compromised his most visible client's carefully lacquered image.

In 1982, the First Lady confessed to the White House staff that she had not paid for most of the costly apparel in her wardrobe, the Galanos inaugural gown included. Contrite that "her acceptance of such fancy items posed a political problem for the White House, she promised to stop the practice," *Time* magazine reported. The "political problem" in question was the fact that all gifts to the president and his wife by law had to be reported on federal income-tax returns. The White House, however, contended that Mrs. Reagan's free outfits were loans rather than gifts, and promised that similar transactions would henceforth be reported annually under the Ethics in Government Act. But in 1988 *Time* revealed that Mrs. Reagan was still borrowing clothes that had apparently not been returned (e.g., a white Galanos mink). Garry Trudeau lampooned the shenanigans in a series of "Doonesbury" comic strips—and found that his readers tended to share the First Lady's weakness for a good gown.

In her memoir, *My Turn,* Reagan—speaking in a voice reminiscent of Lambert's own—justified her actions by citing the precedent of French First Ladies, for whom borrowing clothes was a routine "way of helping one of the country's most important industries." Reagan, in fact, was right about the trickle-down effect of her sumptuous attire on the yuppies, parvenus, Eurotrash, and other 80s types benefiting from the era's extraordinary bull market. At minimum, the First Lady was "a symbol ... responsible for making bright red the most popular fashion color," Lambert noted in 1986. The committee, however, that year also nostalgically cited Reagan's predecessor Jacqueline Onassis for "remaining consistently the woman other women want to look like." Australian journalist Geraldine Pascall, a List voter during the Reagan era, was, understandably, mystified by Lambert's poll-driven, elegance-assessing enterprise. "Only an American," Pascall pointed out, "would think it possible to tabulate taste."

# Princess Di, Uneven Icon

The July 1981 marriage of Diana Spencer to Prince Charles delivered to the List a more beloved fashion idol, lavishly gift-wrapped in taffeta, ruffles, and Carrickmacross lace. Though the unchallenged front-runner of the popular vote, Shy Di in 1981 barely squeaked past the List committee. The Elders of the List would always be more convinced of Princess Di's influence than of her taste. The initial problem, it seemed, was "those hats!" as one List juror lamented, "too small for her head and wrong for her hairdo." After the 1981 committee meeting, James Brady reported on the *New York Post*'s "Page Six," "There was quite a donnybrook ... when her name came up."

Yielding to majority opinion, in 1984 Lambert consecrated the Princess of Wales as "the world's most influential woman of fashion today," even though at that moment she was pregnant with Harry. (Suzy, who now had first-exclusive access to the List, found the Princess "most beautiful" in that condition.) All year, the 22-year-old had, according to Lambert's release, been "the inspiration for a sweeping trend away from eccentricity and toward dressing up." And during the holiday season she had ignited "the bursts of sequins and glitter that lighted fall and winter parties," Eugenia Sheppard remarked in her *New York Post* "Around the Town" column of February 24, 1984.

PRINCESS DIANA, PRINCE WILLIAM, aged seven, and PRINCE CHARLES
arrive at the Church of St. Mary for the wedding of Charles Spencer and
Victoria Lockwood, Great Brington, England, September 16, 1989.

Yet in the same breath the committee chided Princess Diana for "allowing her fervor for promoting British fashion designers to confuse her innate good personal taste." This misplaced zeal, and "mannequin attitude," the committee warned via press release, had "clouded her world-wide fashion leadership." Echoing the committee's ambivalence, *W* magazine in 1985 reprimanded Di for her lack of discipline. "Her clothes are still copied [but unless] she follows her own quite simple style," the magazine cautioned, "it is easy to become a fashion victim." In spite of all the equivocating, the People's Princess won four times during the decade, and finally, in 1989, she escaped further criticism by passing into the safe harbor of the Hall of Fame. (Her husband, Prince Charles, had filled a niche there since 1980.) And the scrutiny of Princess Di had the spinoff effect of pulling in other British royal-family members, a phenomenon that had last occurred during her mother-in-law's coronation. Even while serving (at the Queen's insistence) in uniform during the Falklands War on the aircraft carrier *Invincible,* Di's brother-in-law Prince Andrew was voted onto the 1982 List. Likewise, Di's youngest, "independent minded" brother-in-law, Prince Edward, won in 1986, and Lady Penelope Romsey, a cousin by marriage, was cited (but not Listed) as a "symbol of the young, conservative swing."

## *The* Television Set

That other 80s embodiment of big money, power, hair, and shoulder pads—*Dynasty*'s Linda Evans—surfaced in 1983, but quickly receded. John Forsythe, who portrayed Evans's husband on the over-the-top mega-hit soap, followed a duplicate trajectory. "The men who influence … today," explained committee member and Fashion Institute of Technology professor Jack Hyde, "are the … public personalities who appear constantly on the home screen." Other little-screen Listees (with perhaps more snob appeal) were the cash-strapped Duke of Bedford, who won after saturating the airwaves with his "Do you know me?" ads for American Express, and *Masterpiece Theatre*'s ubiquitous M.C. Alistair Cooke. Beamed into view via the new cable medium of MTV were Michael Jackson, Tina Turner, Grace Jones, Madonna, and Prince ("the Liberace of the 80s," Lambert wrote), whom the committee, while not electing them to the List per se, cited collectively as "impact personalities influencing adolescent dress in 1984." No actual punk rockers ever made the List, but Lambert respected their efforts. "Can you imagine all the trouble it takes," she inquired rhetorically, "for the punks to get dressed, with their outrageous hairdos?"

## Haute Couture's Comeback, Nouvelle Society's Advent, *and a* Dandy Revival

A magical elixir, the 80s boom resuscitated haute couture, which had been suffering death throes just a few years before. Starting in 1982, Karl Lagerfeld's showy send-ups of Coco's classics—in the precise spirit of the decade, if not of Coco herself—jolted the moribund house of Chanel back to life. America's freshly minted Shiny Set, spirited to France by the Concorde, descended in droves upon Lagerfeld's re-invigorated Chanel, and on those other exuberant 80s favorites, Emanuel Ungaro and Christian Lacroix. With the exchange rate reaching a delirious 11 francs to the dollar, the frenzy among spendthrift Americans for custom-made Dior, Givenchy, Saint Laurent, and Grès was so extreme, recalled Louise Grunwald, "it was like the last days of Nero's Rome." Dressed in Paris couture with JAR jewels, or in the best of American ready-to-wear (Beene, Blass, Galanos, Oscar, Herrera), the philanthropic flock whom *Women's Wear Daily* branded "nouvelle society"—Carolyne Roehm, Gayfryd Steinberg, Anne Bass, Mercedes Bass, Susan Gutfreund, Judy Taubman, Blaine Trump—alighted onto the List, most soaring swiftly to the Hall of Fame.

Tom Wolfe, merciless chronicler of the opulent 80s, found himself dropped among some of the very "Social X-Rays" and "Masters of the Universe" whom he was busy parodying in *The Bonfire of the Vanities.* Deemed "tops among innovative dressers," he swooped onto the Hall of Fame in 1984. "I've had a good time with clothes over the years," he wrote Lambert, "and this is a swell coronation indeed!"

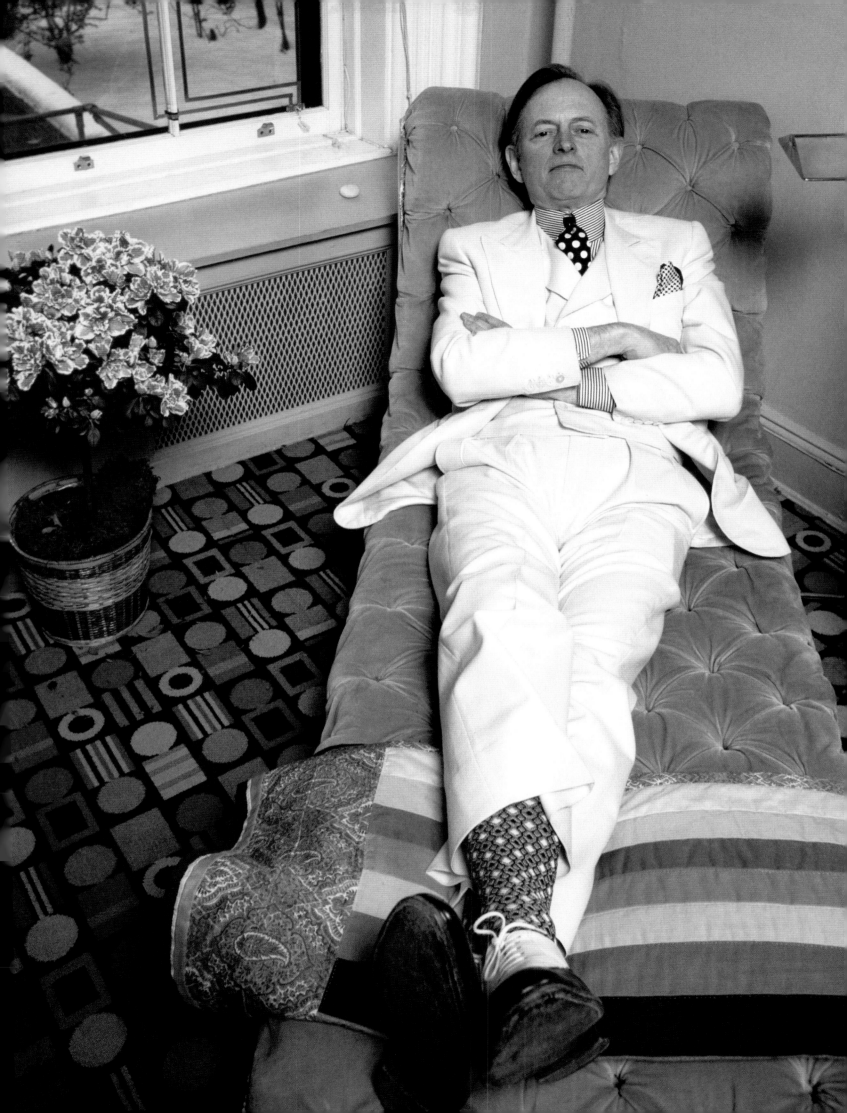

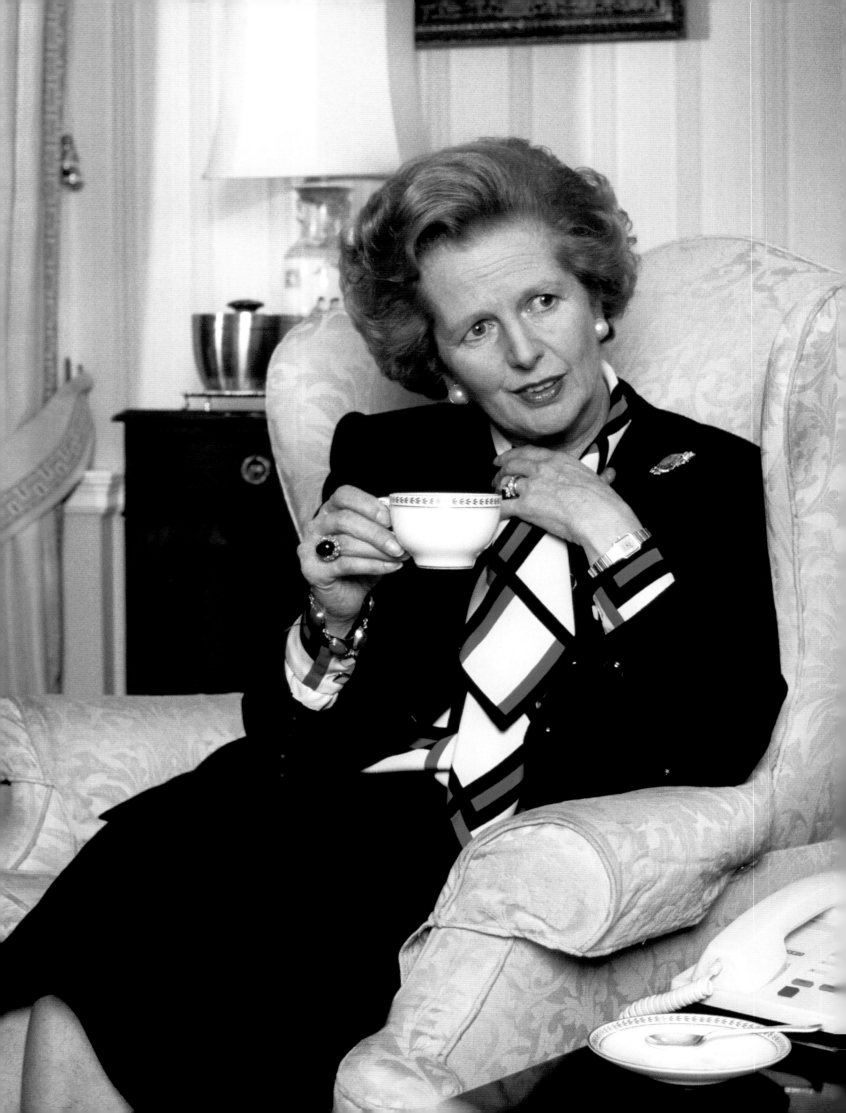

With his ice-cream suits, swagger sticks, and spats, Wolfe had once been considered too "eccentric" for inclusion. His genteel dandyism, however, was soon trumped by the 80s Fashion Professionals who filed onto the List alongside him: the fastidiously retro Manolo Blahnik, the extravagantly bedizened André Leon Talley, and the fright-wigged Andy Warhol—engaged in the early 80s as a model by the Zoli agency. These hard-working pros, the endlessly adaptable Lambert explained, were "frequently the people who influence you and me more than the public figures on the 'regular' lists."

# Female Heads *of* State

Even the soberly garbed Conservative prime minister of Great Britain, Margaret Thatcher, in whom François Mitterrand saw "the lips of Marilyn Monroe and the eyes of Caligula," had her 80s Best-Dressed moment. The committee—which in 1987 included Bill Blass, Reinaldo Herrera, and Jerry Zipkin—canonized the Iron Lady for her "classic middle of the road elegance," consisting of a dress-for-success uniform of pussycat bows, strong-shouldered suits, and low-heeled pumps. Thatcher wrote to Lambert on 10 Downing Street notepaper, "It was kind of you to pay tribute to my personal style. This has been achieved carefully over the years." And to journalist Suzy Menkes the prime minister confided that winning her spot on the List was "one of the greatest moments of my life." Thatcher believed she owed the coveted tribute to the all-Aquascutum wardrobe—centered on a sable-collared camel coat—that she had packed for her 1987 trip to visit Mikhail Gorbachev in Moscow, where she quietly upstaged his more fussily attired wife, Raisa. Proposed for consideration after her husband's White House summit in December of that year, Raisa was then summarily discarded as a "noninfluential" nobody. Far worthier in Lambert's view was Pakistan's shalwar-kameez-draped Benazir Bhutto, elected to the List just a few months after she became the first female leader of a Muslim country, in 1988. "I consider this honour as a flattering tribute," Bhutto wrote to Lambert on April 13, 1989. "My personal style seeks to blend the simplicity of the traditional with the imaginative application of the modern." (Lambert called the note a "gooey letter.")

# Best *of the* Best Dressed: Museum *of the* City *of* New York

In the festive mood of the decade, Lambert helped to organize a glamorous retrospective, "The Best of the Best Dressed List," which ran from October 1986 to May 1987 at the Museum of the City New York. Sponsored by Gucci, and curated by JoAnne Olian and Phyllis Magidson, the exhibition showcased the wardrobes of 13 living and deceased female members of the Hall of Fame: C. Z. Guest, Mary Martin, the Duchess of Windsor, Mona Bismarck, Lauren Bacall, Jacqueline Kennedy, Claudette Colbert, Millicent Rogers, Thelma Foy, Austine Hearst, Paloma Picasso, Babe Paley, and Diana Vreeland. Thirty-eight of their ensembles—by Mainbocher, Chanel, Vionnet, Schiaparelli, Saint Laurent, Lagerfeld, Balenciaga, Norell, Charles James, Alaïa, Dior—were displayed chronologically alongside examples of concurrent developments in technology and culture. Videotaped interviews and period photographs were juxtaposed with such rarefied incunabula as invoices from couture houses, vintage International Best-Dressed List ballots, and a guest book from Mona Bismarck's yacht. Among the luminaries gliding into the museum on October 20, 1986, for the opening-night dinner dance were Jacqueline Kennedy (who contributed to the show her inaugural gown), Diana Vreeland, Paloma Picasso, Nan Kempner, Louise Grunwald, Betsy Kaiser, C. Z. Guest, Isabel Eberstadt, Carroll Petrie, Brooke Astor, and Happy Rockefeller.

"The curators," *The Atlantic* said in its exhibition review, "have managed neatly to establish each of the women as a distinct personality." Curator Olian explained, "These women didn't want to look like everyone else. But everyone else wanted to look like them." Lambert informed *USA Today,* which also reported at length on the show, "This is not the Nobel Prize.... It is just ... a sociological record of our time." And to the *Los Angeles Times* Lambert elaborated, "It is as relevant a historical record of how we lived as anything else."

PRIME MINISTER MARGARET THATCHER, the first woman to hold the office in Great Britain, drinks tea in the drawing room of 10 Downing Street, London, 1987. Thatcher's philosophy of dressing was "never flashy, just appropriate." Aquascutum was her preferred purveyor.

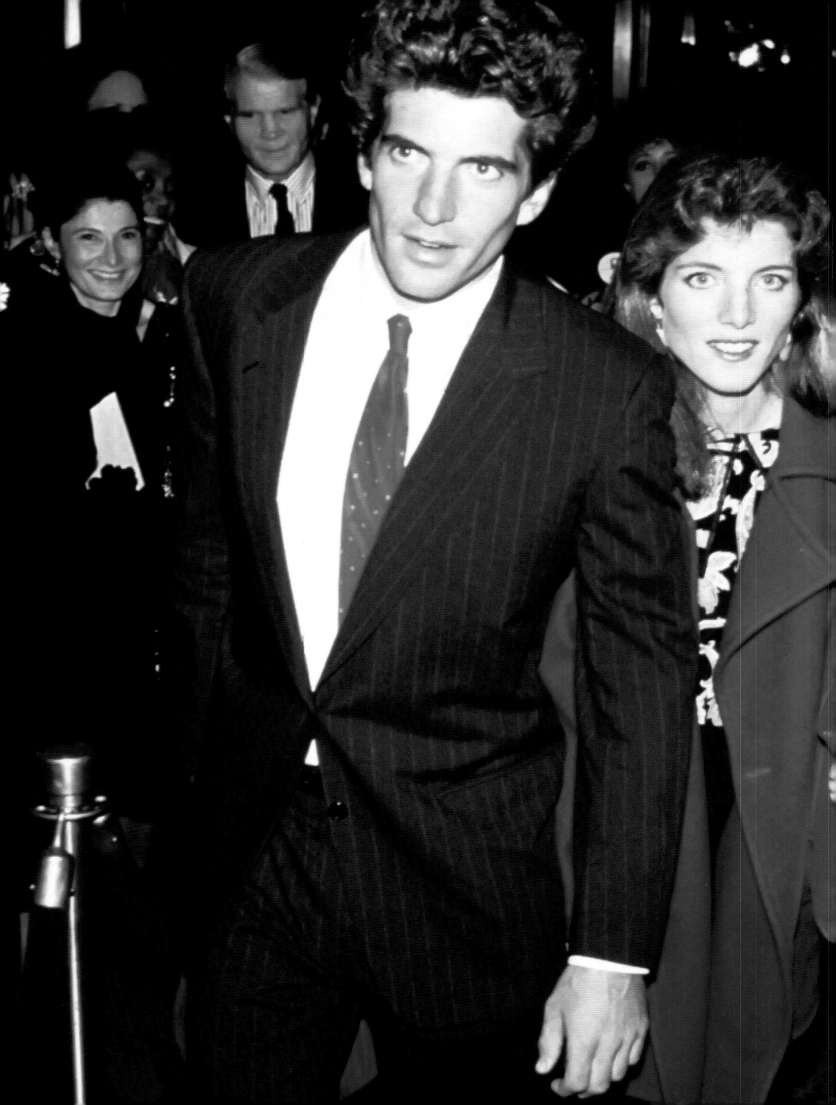

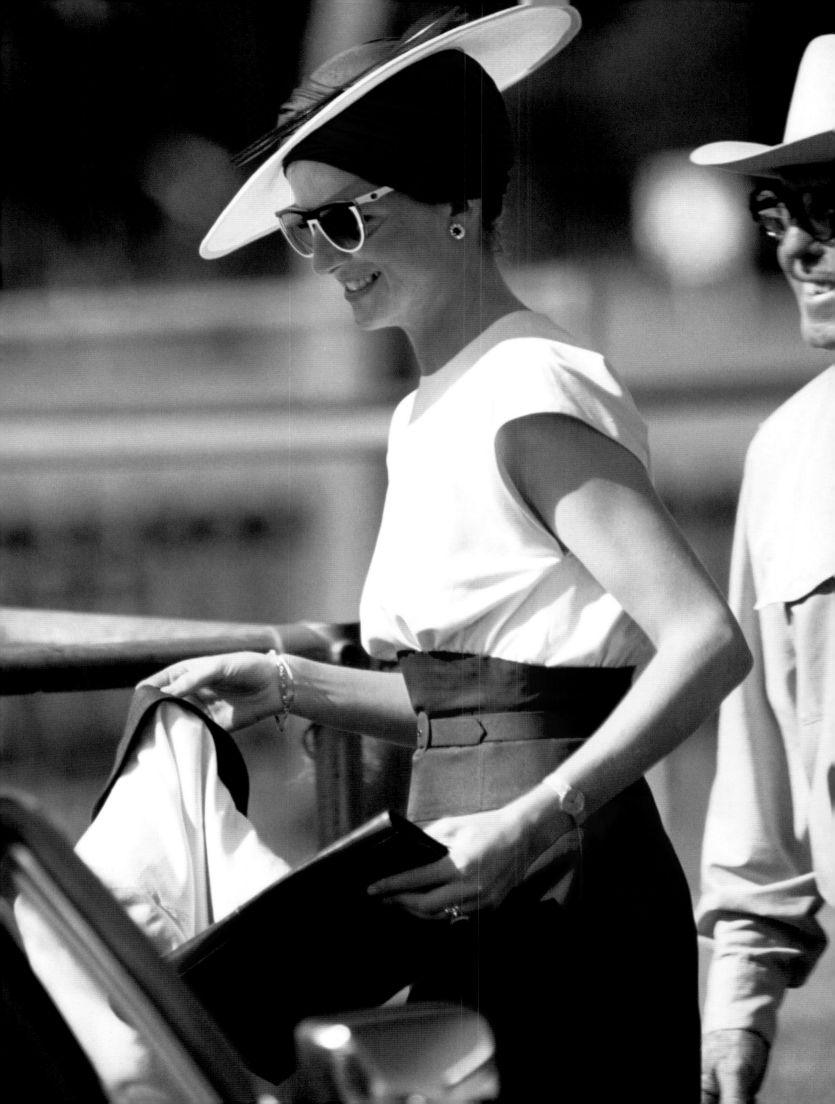

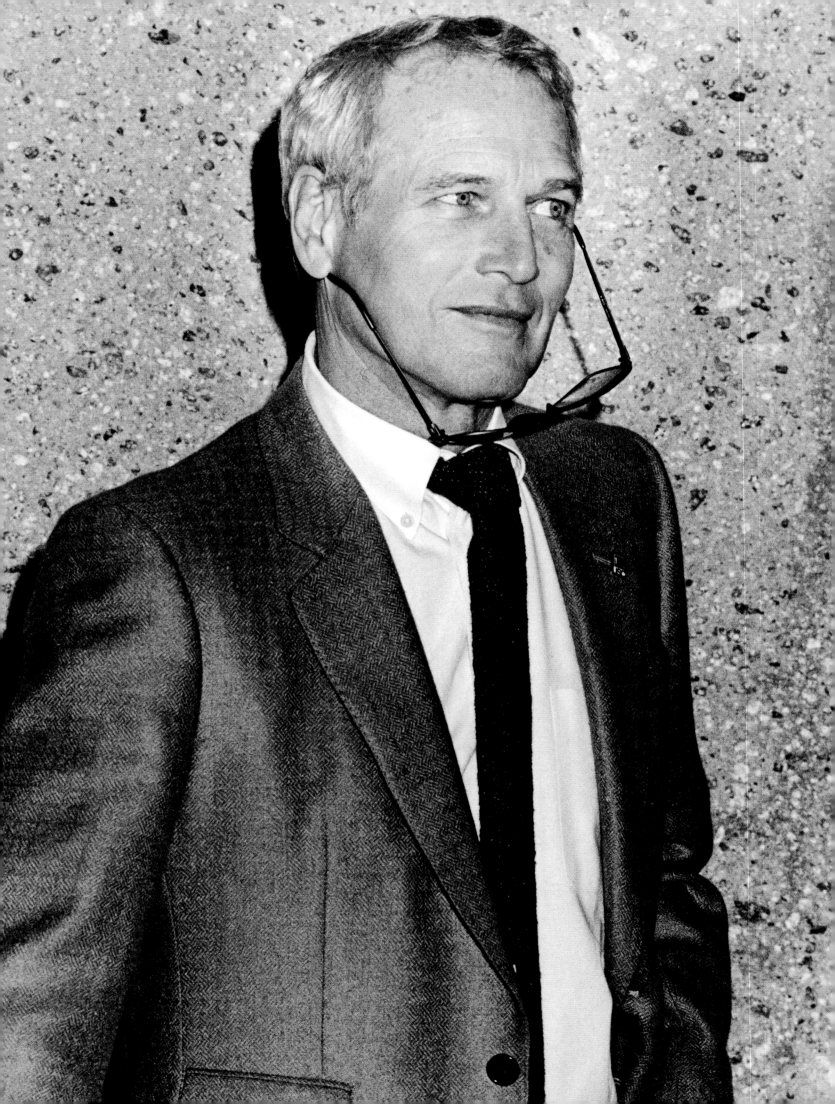

PRECEDING SPREAD, LEFT: **JOHN F. KENNEDY JR.**
and Caroline Kennedy, photographed by Robin Platzer
at the Ziegfeld Theatre in New York, October 6, 1989.
RIGHT: **PRINCESS DIANA,** wearing a turban
hat by Philip Somerville, at the Guards Polo Club,
Windsor Great Park, England, June 1989.

LEFT: actor **PAUL NEWMAN** at a press conference
endowing the Scott Newman Foundation at the University of
Southern California, Los Angeles, California, April 1, 1985.
ABOVE: Spanish singer **JULIO IGLESIAS** in Palma de
Mallorca, Spain, August 12, 1983. During the 80s,
he recorded in English and won two Grammy Awards.
RIGHT: Grammy-winning singer, actress, dancer, and civil-rights
activist **LENA HORNE,** left, with **DIAHANN CARROLL.**

LEFT: **AHMET ERTEGUN,** music producer, songwriter, and co-founder of Atlantic Records, June 1982. ABOVE: designer **JAMES GALANOS** at Saks Fifth Avenue in Chicago, notepad and tape measure in hand, March 1980. "Galanos was the best in the market for workmanship and detail—it was consummate, faultless," said Bergdorf Goodman executive Dawn Mello.
RIGHT: Somalian supermodel, actress, designer, philanthropist, and cosmetics mogul **IMAN** wearing a dress from Bill Blass's fall 1985 collection, May 3, 1985. Yves Saint Laurent, who featured her both in an 80s ad campaign and on the runway, said, "My dream woman is Iman."

FOLLOWING SPREAD, FROM LEFT: journalist Ben Brantley, *Women's Wear Daily* publisher **JOHN FAIRCHILD,** **PALOMA PICASSO,** and Portuguese-born Paris hostess **SÃO SCHLUMBERGER** occupy the front row at an Yves Saint Laurent show.

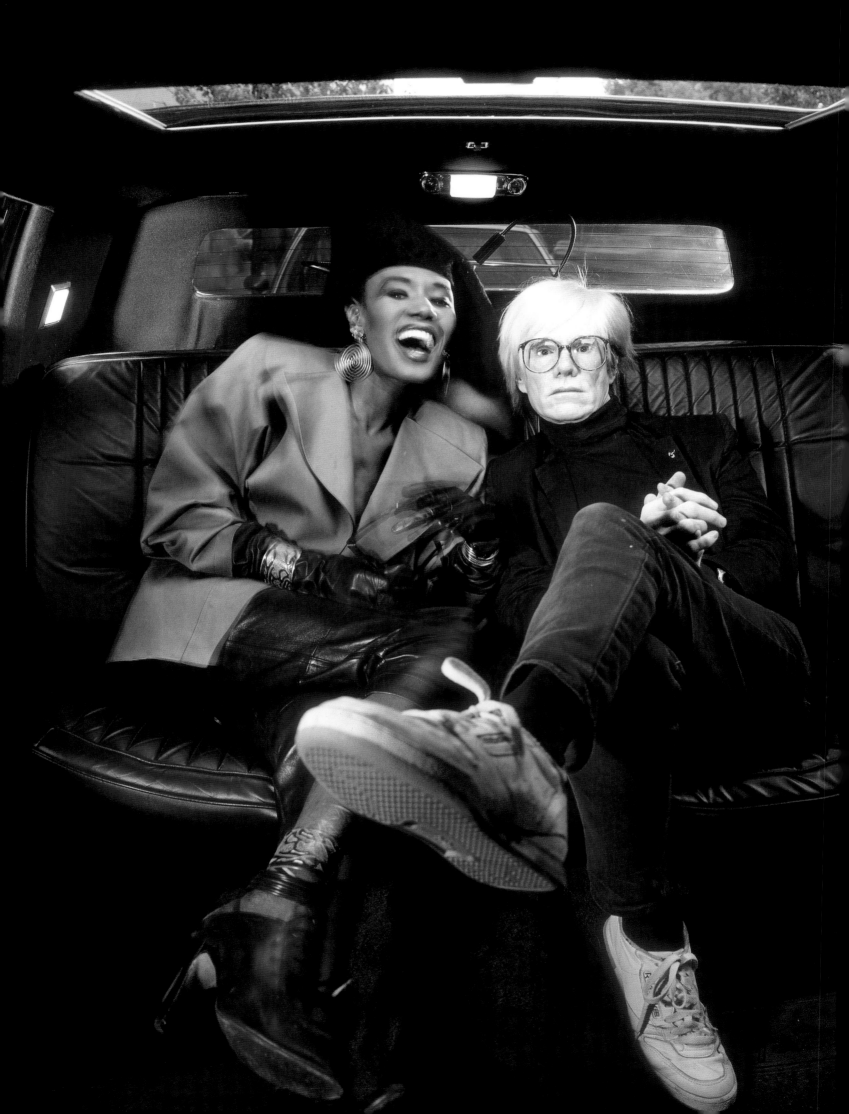

LEFT: performer Grace Jones and artist **ANDY WARHOL,** seated in a limo in New York, by Elliott Erwitt, 1986. That year the two celebrities went as each other's date to the wedding of Maria Shriver and Arnold Schwarzenegger.
ABOVE: **PRINCESS MICHIKO** of Japan arriving at her welcome ceremony in Fairhaven, Massachusetts, October 4, 1987. Michiko graduated magna cum laude from Harvard in 1985 and became empress when her husband acceded to the imperial throne in early 1989.

LEFT: **MANOLO BLAHNIK** at his house in Bath, England, 1986, photographed by Michael Roberts. RIGHT: muse, collector, and jewelry designer **TINA CHOW** wearing a dress from Chanel's spring-summer 1983 haute couture collection, the second one Karl Lagerfeld designed for the house. The silk dress is beaded by Lesage with trompe l'oeil necklaces and belts. Chow has added her own jewelry to the mix.

FAR LEFT: **BRYAN FERRY** performing with Roxy Music in London at Wembley Arena, September 23, 1982. LEFT: philanthropist **GAYFRYD STEINBERG** in Galanos at the American Ballet Theatre gala, 1988, photographed by Roxanne Lowit. ABOVE: actor **GREGORY PECK** attending a film premiere. His wife, Veronique, holds his arm.

FOLLOWING SPREAD: **CHRISTIAN LACROIX,** far right, directs the placement of a hat on his fit model, muse, and salon *directrice*, Marie Seznec Martinez, as he prepares his first eponymous haute couture collection in Paris, 1987. Lacroix described Marie as "spirited, whimsical, funny, exquisite...half dowager, half little girl, so Paris, so couture, so Eighties." Lacroix, who rejuvenated haute couture in the 80s, first arrived on the List in 1991.

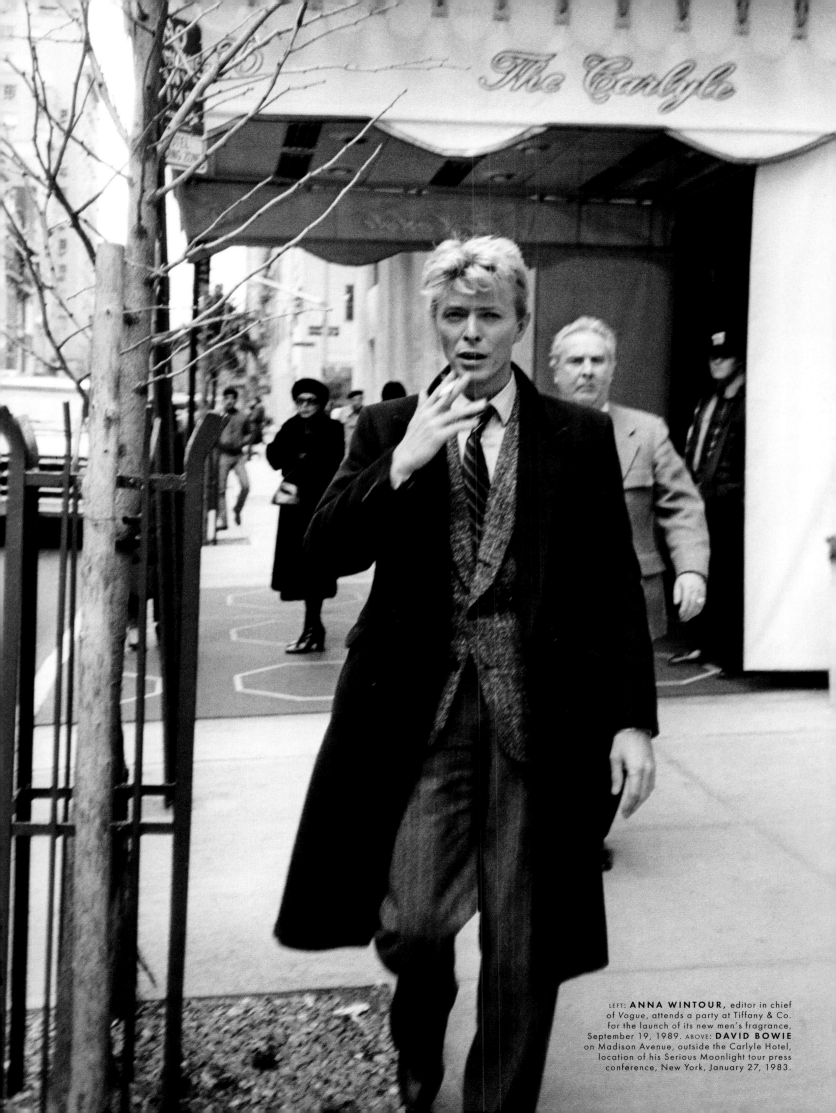

LEFT: **ANNA WINTOUR,** editor in chief of *Vogue*, attends a party at Tiffany & Co. for the launch of its new men's fragrance, September 19, 1989. ABOVE: **DAVID BOWIE** on Madison Avenue, outside the Carlyle Hotel, location of his Serious Moonlight tour press conference, New York, January 27, 1983.

CLOCKWISE FROM TOP LEFT: **MARIAN McEVOY**, "channeling Pierrot," she says, for a party at Le Palace, Paris, circa 1980; bedecked with red and green crêpe paper bows, Christmas Eve, Paris, 1979; and with **KARL LAGERFELD**, Paris, 1981. RIGHT: fashion-world titans **ANDRÉ LEON TALLEY** and **MARINA SCHIANO,** New York, 1980. At the time, André was at *Women's Wear Daily,* and Marina, a former model, was an Yves Saint Laurent executive. André later joined *Vogue,* among other pursuits, and Marina became a *Vanity Fair* editor and a jewelry designer.

FOLLOWING SPREAD, LEFT: model and actress **LAUREN HUTTON** at the premiere of *Starflight,* a sci-fi film in which she co-starred, Los Angeles, February 4, 1983. RIGHT: **DAVID HOCKNEY,** photographed by Herb Ritts for *Vogue Australia,* August 1, 1992. Hockney appeared on the List three times in the 80s.

# The 1990s

---

## The
# RECESSION,
# INDISCRETION,
## and
# POSTMODERN
# CHAOS

---

Actress **KRISTIN SCOTT THOMAS** at the
Draycott Hotel, London, by Steve Pyke.
She entered the List in 1996.

JOSEPH ABBOUD

MARTIN AMIS

H.R.H. COUNTESS ARCO (BORN ARCHDUCHESS MARIA-BEATRICE OF AUSTRIA-ESTE)

LADY ANNUNZIATA ASQUITH

CONTESSA DONATELLA ASTA (DONATELLA KE-CHLER)

DR. DANIEL BAKER

MARTHA BAKER

NINA GRISCOM BAKER (NINA RENSHAW)

JEFFREY BANKS

LUCIANO BARBERA

JOHN BARTLETT

ANNE H. BASS

JONATHAN BECKER

NALLY BELLATI

ROSAMOND BERNIER

CAROLYN BESSETTE-KENNEDY

COUNTESS LEOPOLD VON BISMARCK (DEBON-NAIRE PATTERSON)

TONY BLAIR

ISABELLA BLOW

DIXON BOARDMAN

MRS. DIXON BOARDMAN (PAULINE MUNN BAKER)

OZWALD BOATENG

ELIZA REED BOLEN

JON BON JOVI

DAVID BOWIE

HAMISH BOWLES

ED BRADLEY

COMTESSE FRÉDÉRIC CHANDON DE BRIAILLES (CAMILLA PARAVICINI MAVROLEON)

MAYOR WILLIE BROWN

LIZA BRUCE

ROBERT BRYAN

AMANDA BURDEN

JOHN CAHILL

MRS. MICHAEL CAINE (SHAKIRA BAKSH)

NAOMI CAMPBELL

MICHAEL CANNON

ISABEL CANOVAS

PRINCESS CAROLINE OF MONACO

GRAYDON CARTER

VICTOIRE DE CASTELLANE

THE EARL OF CAWDOR (COLIN CAMPBELL)

CARLYNE CERF DE DUDZEELE

LADY SARAH CHATTO (SARAH ARMSTRONG-JONES)

KENNETH CHENAULT

NENEH CHERRY

CHINA CHOW

FRANCESCO CLEMENTE

AMY FINE COLLINS

HARRY CONNICK JR.

FERNANDO DE CORDOBA HOHENLOHE

MADISON COX

COMTESSE FLORENCE DE DAMPIERRE

CECILIA DEAN

THIERRY DESPONT

CAMERON DIAZ

MATT DILLON

MICHAEL DOUGLAS

TONY DUQUETTE

PRINCE PIERRE D'ARENBERG

LUIGI D'URSO

GIMMO ETRO

RUPERT EVERETT

DANIEL DE LA FALAISE

LUCIE DE LA FALAISE

SUSAN FALES-HILL

THE HON. HARRY FANE

MASSIMO FERRAGAMO

LUCY FERRY

THE HON. TIM FOLEY

TOM FORD

LADY CHARLOTTE FRASER (CHARLOTTE GREVILLE)

NATASHA FRASER

INÈS DE LA FRESSANGE

COUNT ROFFREDO GAETANI

COMTE PAUL DE GANAY

PIA MILLER GETTY

HUGH GRANT

CLIFFORD GRODD

DIDIER GRUMBACH

DAPHNE GUINNESS

BRYANT GUMBEL

CHARLES GWATHMEY

PHILIP VON HABSBURG

MARK HAMPTON

LADY GERALDINE HANSON (GERALDINE KAELIN)

AMANDA HARLECH

THE HON. PAMELA HARRIMAN

PHILLIPS "PETE" HATHAWAY

EDWARD W. HAYES

MRS. RANDOLPH HEARST (VERONICA)

ANOUSKA HEMPEL

JOY HENDERIKS

JEAN-LOUIS DUMAS HERMÈS

CAROLINA HERRERA

CAROLINA HERRERA JR.

PATRICIA HERRERA

ALLEGRA HICKS

LORD HINDLIP (CHARLES)

GREGORY HINES

GENE HOVIS

LAUREN HUTTON

---

FAR RIGHT: actress **NICOLE KIDMAN** arrives at the Academy Awards wearing an embroidered chinoiserie dress from John Galliano's first haute couture collection for Dior, March 24, 1997. Her then husband, Tom Cruise, was nominated that year for *Jerry Maguire*. TOP, LEFT: writer **SUSAN FALES-HILL** wears Nina Ricci to the American Ballet Theatre's Spring Gala, Metropolitan Opera House, New York. TOP, RIGHT: performer, muse, and philanthropist **DAPHNE GUINNESS** and designer **MANOLO BLAHNIK** at the Dorchester Collection Prize award ceremony in London. BOTTOM: singer **TINA TURNER** at the Shoreline Amphitheater, in Mountain View, California, during her Wildest Dreams tour, May 23, 1997.

JADE JAGGER

EARVIN "MAGIC" JOHNSON

ANNE JONES

JUN KANAI

REI KAWAKUBO

THOMAS KEMPNER

JOHN F. KENNEDY JR.

IMRAN KHAN

JEMIMA KHAN

NICOLE KIDMAN

MRS. BARRY KIESELSTEIN-CORD (CECE EDDY)

KELLY KLEIN

HARUMI KLOSSOWSKA DE ROLA

CAROLYNE ROEHM KRAVIS

HENRY KRAVIS

MRS. HENRY KRAVIS (MARIE-JOSÉE DROUIN)

LENNY KRAVITZ

H.R.H. PRINCE KYRIL OF BULGARIA

H.R.H. PRINCESS KYRIL OF BULGARIA (ROSARIO)

CHRISTIAN LACROIX

RICHARD LAMBERTSON

MATT LAUER

ANDREW LAUREN

JULIETTE LEWIS

VISCOUNT LINLEY (DAVID ARMSTRONG-JONES)

VISCOUNTESS LINLEY, SERENA ARMSTRONG-JONES
(SERENA STANHOPE)

CHRISTIAN LOUBOUTIN

COURTNEY LOVE

H.S.H. RUPERT VON UND ZU LÖWENSTEIN

JOYCE MA

WYNTON MARSALIS

STEVE MARTIN

PETER MARTINS

MAXWELL

PATRICK MCCARTHY

DYLAN MCDERMOTT

MARIAN MCEVOY

MARY MCFADDEN

SONNY MEHTA

DAWN MELLO

DAVID METCALFE

H.R.H. PRINCE MICHAEL OF KENT

ALEXANDRA MILLER

JEFFREY MILLER

PHILIP MILLER

CARRIE MODINE

LAURA MONTALBAN

NONNIE MOORE

COMTESSE CHARLES-LOUIS DE MORTEMART
(HÉLÈNE PAULTRE DE LAMOTTE)

MRS. KENNETH NATORI (JOSEFINA
"JOSIE" ALMEDA CRUZ)

MRS. S. I. NEWHOUSE (VICTORIA CARRINGTON
BENEDICT DE RAMEL)

PAUL NEWMAN

JAMES NIVEN

JESSYE NORMAN

MRS. EMILIO DE OCAMPO (BROOKE DOUGLASS)

GWYNETH PALTROW

H.R.H. PRINCESS PAVLOS OF GREECE
(MARIE-CHANTAL MILLER)

COSIMA VON BÜLOW PAVONCELLI

SERGIO LORO PIANA

SRA. ANGELA PINTALDI

GERARD PIPART

BRAD PITT

MRS. COLIN POWELL (ALMA JOHNSON)

PAT RILEY

JOAN RIVERS

KHALIL RIZK

JULIA ROBERTS

PRESIDENT MARY ROBINSON

MME. FRANÇOIS ROCHAS (CAROLE)

MRS. FELIX ROHATYN (ELIZABETH)

SIR EVELYN DE ROTHSCHILD

LADY VICTORIA DE ROTHSCHILD

ROBERT RUFINO

MARINA RUST

PRINCESS ELISABETH VON SACHSEN-WEIMAR

MRS. EDMOND SAFRA (LILY WATKINS BENDAHAN)

FERNANDO SÁNCHEZ

MRS. JULIAN SCHNABEL (JACQUELINE BEAURANG)

KRISTIN SCOTT THOMAS

TOM SELLECK

CHLOË SEVIGNY

ANNE SLATER

ROBIN SMITH-RYLAND

CARLA SOZZANI

TERENCE STAMP

JOHN STEFANIDIS

GAYFRYD STEINBERG

STING

SHARON STONE

MRS. MARTIN SUMMERS (ANN TYSEN)

ANDRÉ LEON TALLEY

TAKI THEODORACOPULOS

UMA THURMAN

DANIELLE STEEL TRAINA

MRS. ROBERT TRUMP (BLAINE BEARD RETCHIN)

TINA TURNER

ADRIENNE VITTADINI

THE EARL OF WARWICK (DAVID GREVILLE)

DENZEL WASHINGTON

FAYE WATTLETON

GALEN WESTON

VIVIENNE WESTWOOD

H.R.H. PRINCE WILLIAM, DUKE OF CAMBRIDGE

PAUL WILMOT

ANNA WINTOUR

JAYNE WRIGHTSMAN

AERIN LAUDER ZINTERHOFER

TOP: singer and actress **COURTNEY LOVE** arrives at the *Vanity Fair* Oscar party, March 27, 1995. NEAR LEFT: model **NAOMI CAMPBELL** wears
Versace at the fifth annual California Fashion Industry Friends of AIDS Project Benefit honoring Gianni Versace, Los Angeles, February 13, 1991.
BOTTOM, LEFT: jewelry designer **VICTOIRE DE CASTELLANE,** left, in her Chanel haute couture wedding dress, with designer **GILLES DUFOUR**
and model Claudia Schiffer, 1994. BOTTOM, RIGHT: opera star **JESSYE NORMAN** at the Hôtel de Crillon in Paris. She performed
*La Marseillaise* during French bicentennial celebrations at the Place de la Concorde, July 9, 1989.

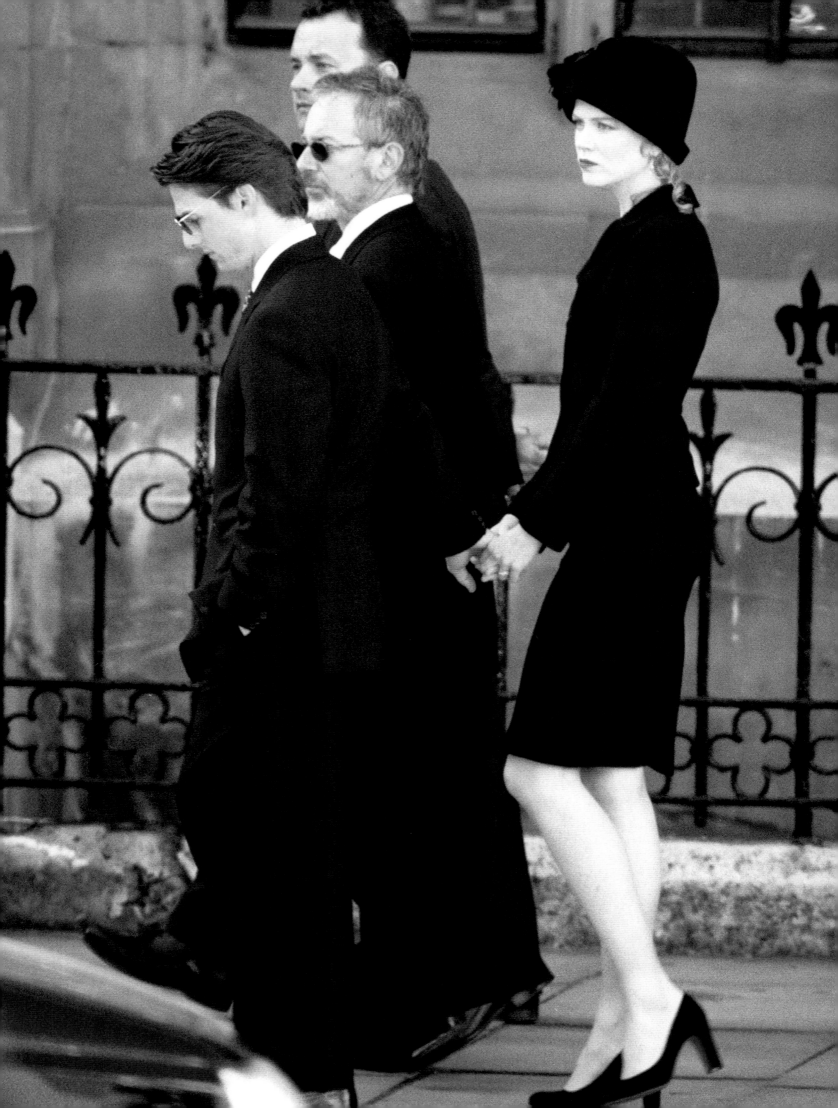

> *"A woman is closest to being naked when she is well dressed."*
>
> —COCO CHANEL

## A Grim Mood

Exactly 12 months after the Museum of the City of New York's gala opening, the market crashed, and then, in 1990, America joined the Gulf War against Saddam Hussein. The List lost its leavening agents of cash and optimism, and the normally sanguine Lambert blamed "the general blues and blahs of the international economic situation for the inertia of both design creativity and notable personal style." She even went as far as to compare the "grim mood of recession and war with a power-mad dictator" to the dire atmosphere of 1940, when she cautiously unveiled her first List.

With Lambert approaching 90, several long-standing List watchers felt that her entire enterprise was faltering. Already, in 1989, Aileen Mehle had complained to *Connoisseur* magazine that too many "Jennys-come lately" had elbowed their way onto the List simply by spending "enormous amounts of money." In the same *Connoisseur* cover story, Karl Lagerfeld (named in 1982) pronounced the List "a little boring, no?" Kenneth Jay Lane, who entered the Hall of Fame in 1974 and served a long tour of duty on the committee, also believed the List had become "less about quality, and more about fame and money." Tiffany's John Loring, a Lambert confidant and committee member, was convinced that newcomers to the panel, which now convened at Lambert's Fifth Avenue apartment, "didn't remember or care that the List's purpose was to help American fashion, to inspire people to be better dressed. They saw it as an opportunity to maneuver invitations to weekend houses and dinner parties."

## The Fabulous Fifty

If Lambert felt the List was losing its way, then, as usual, she pragmatically reached for a remedy. In 1990, to commemorate the first half-century of her endeavor, and to give it a quick lift, she culled from the 1,170 names in her thronged roster an honor roll of the "Fabulous Fifty, instant fashion symbols of the 20th century": Mona Bismarck, Millicent Rogers, Gloria Vanderbilt ("America's most appealing heiress/career-girl"), Twiggy ("symbol of gangling adolescent elegance"), Diana Vreeland ("made it fashionable to be homely"), Audrey Hepburn ("since 1956 an enduring image of instinctive young elegance"), Claudette Colbert, Marella Agnelli, Cary Grant, Harry Belafonte ("establishing the acceptance of the open shirt in international resorts"), Tom Wolfe, and John Kennedy Jr. ("inheritor of his father's style and charisma").

For good measure, Lambert threw in some "impact personalities," who had never made the List but who for better or worse "introduced worldwide fashion fads": James Dean, a "lasting symbol of 'rebellious' youth dress, particularly in leather," Prime Minister Nehru, of India, "who made the Nehru jacket immortal," Joan Crawford for her "wide shoulders," Michael Jackson for his "sequin glove," and Chairman Mao, who "made the Mao jacket a world classic."

FROM LEFT: Tom Cruise, Steven Spielberg, Tom Hanks, and **NICOLE KIDMAN,** arriving at Westminster Abbey for Princess Diana's funeral, London, August 31, 1997.

# Cuckoo Birds *and* Classicists

During the recession year of 1992, with unemployment rates spiking to 7.8 percent, and the AIDS epidemic devastating lives everywhere in the industry, Lambert dutifully acknowledged the schism between "classic fashion evolution and jump-start experiments like 'grunge.'" She termed the raggedy Courtney Love, the brazen Naomi Campbell, the post-punk Neneh Cherry, and the eccentric Isabella Blow "leading fashion dissidents," who "clashed" with the "fashion classicism" of Jessye Norman, Pamela Harriman, and Ireland's president Mary Robinson. Lambert detected the effects not only of a dire economic recession and a calamitous talent erosion, but also of "a deep fashion recession," as it was "the first time in 25 years that there has been such a dichotomy in fashion attitudes."

Robinson's presence so startled Ireland's *Sunday Independent* that it accused the president's advisers of having "wined and dined" Lambert to secure the leader's place on the List. Lambert indignantly lobbed a letter back to the editor: "I have managed to make my living quite honourably and am plump enough to resist extra meals."

Aileen Mehle implored Lambert from her column, now situated in *Women's Wear Daily,* to "go back to the original formula that worked—when making the List meant something." By admitting individuals who were "a mockery of beauty and elegance in dress," Mehle wrote, the List had become a nest for "cuckoo-birds." Harold Koda, a committee member in the 90s, said, "Strange juxtapositions showed up because the needle began to spin all over the compass. The committee's old guard resisted change, and newer members tried too hard to force it. There were memorably tense moments, such as the time Jerry Zipkin or someone asked if Maxwell was the coffee heir, and when some of us had to explain carefully to the *grandes dames* who Hole was." At another meeting, society columnist Billy Norwich, a committee novice, was rebuked by a List mandarin for daring to "mention the name of the King of Spain and George Michael in the same breath," he wrote in 1990. But Lambert "rolled with the punches," Koda recalled. "She was unflappable." Not quite able to make sense of the shape-shifting List or its inexhaustibly adaptable founder, the London *Sunday Express* concluded that the apparatus was "as delightfully erratic as Lambert herself and alters its format according to her whim." And she could well afford to indulge in these mutations—as, according to her 1992 estimate, the whole undertaking cost her a mere "$1,000 a year."

# Loose Lips

The kind of *People* magazine breach of confidentiality that had infuriated Lambert in the 70s occurred with increasing regularity in the 90s. Even though he was warned not "to say a word about us," Billy Norwich leaked some of the 1990 meeting proceedings to *Harpers & Queen.* In 1991, another member spilled the names of the "anonymous" committee—Elsa Klensch, China Machado, Michael Gross, Ellin Saltzman, Anne Slater—to the *New York Observer* and revealed that the group had booed when Queen Latifah's name came up. (The musician who made it past the jury was Harry Connick Jr.) In 1996, Michael Gross disclosed that when Queen Latifah was invoked again she was mistaken this time by a venerable committee arbiter for an actual royal. And in 1998, André Leon Talley devoted his entire *Vogue* column, "Style Fax," to the annual séance in Lambert's living room. Although he disguised some of the participants' identities, Talley faithfully transcribed a certain "boulevardier's" comments that Miuccia Prada "always looks like she's dressed in a dish towel" and that Carolyn Bessette-Kennedy "looks like a schoolmistress." And he relayed an "Impeccable Blonde Socialite's" disgust with Kate Moss, whom she found distastefully "dirty."

In 1999, Lambert finally gave her own voice to the loose lips and offered up tattle herself to *The New York Post.* Her team of style arbiters—Nan Kempner, Lynn Wyatt, Anne Slater, Kenneth Jay Lane—"all screamed for joy," she divulged, at the drop of Lenny Kravitz's name. Lane and Reinaldo Herrera, she reluctantly conceded, locked horns over one eventual winner. And when Gwyneth Paltrow's candidacy was mentioned, "the women members of the committee said, 'but her Oscars dress didn't fit!' We gave her the benefit of the doubt."

**CAROLYN BESSETTE-KENNEDY** and **JOHN F. KENNEDY JR.** (behind her)
at the Bright Night Whitney gala in New York, March 9, 1999,
four months before their deaths in a plane crash.

## Elegant Resisters

Lambert's leitmotif of the "kicky" versus "conservative" partisan sects returned for a third time in 1997 (the List was announced in April 1998), while the fashion world was still reeling from Gianni Versace's murder, Princess Di's car crash, and President Clinton's embroilment in the Monica Lewinsky affair. Longtime Hall of Fame members Carolina Herrera (1980), Jayne Wrightsman (1965), and Mary McFadden (1977) were extolled by Lambert as the "elegant resisters" of "momentary fads"—and the restrained antitheses of the audacious extremism proposed by both Alexander McQueen and John Galliano at their respective debuts for Givenchy and Dior.

## Portrait *of a* Decade

In a 1994 *Town & Country* article, Suzy Menkes viewed the List's fragmentation as symptomatic of "postmodern fashion chaos." Yet the Lists of the 90s seemed more confused close-up than they do from a distance. With the advantage of hindsight, what emerges is a fairly accurate portrait of the decade, composed with surer strokes than anyone, except perhaps Lambert, may have realized at the time. Just as there were proliferating television channels, splintering niche markets, and myriad new media outlets developing via the Internet, so there was a plurality of ways to dress, all of them correct, depending on identity and demographic. As Oscar de la Renta told Menkes in her *Town & Country* story, "There have been divisions in society, and each phenomenon has its own icons." It was an era of reverse chic, high-low, minimalism, and hip-hop—sometimes all in one outfit, as was nearly the case with Sharon Stone's (1993, 1995) famously improvised 1996 Oscar ensemble of, apparently, an Armani jacket, a Valentino trumpet skirt, and a Gap black turtleneck tee.

Prophetic about the future, the 90s Lists pinpointed junior fashion stars—Daphne Guinness, Tom Ford, Hamish Bowles—who would rise high in the new millennium. Conscious of the past, the List promoted dynastic personalities—Princess Caroline of Monaco, John Kennedy, Carolina Herrera Jr. (1994), Carolyn Bessette-Kennedy (1996), Prince William (1997)—who reinforced a sense of legitimacy and continuity. The List also presciently identified the "new personalities" of Hollywood, such as Denzel Washington (1993), Brad Pitt (1994), and Nicole Kidman (1996), all of whom would quickly mature into Oscar or Golden Globe winners. And the List caught up with provocative performers—from Jon Bon Jovi (1996) to Tina Turner (straight to the Hall of Fame, 1996)—who by the 90s were mainstream and Establishment. In 1997, Lambert even predicted that informal California styles would emanate eastward from Silicon Valley, due to the growing power of the "geek cult."

## Gallows Humor *and* *an* Homage *to the* Committee

In 1999, *New York* magazine gently ridiculed the 95-year-old Lambert and the ballots she generated, at that point via fax. On the Hall of Fame directory, attached to the ballots as a reference for voters, one living member—Bill Blass consultant Steven Kaufmann—was categorized as deceased. Conversely, two deceased members—Barry Goldwater and Henry Cabot Lodge—were classified as living. When *New York* pointed out to Lambert the careless resurrection of the two late senators, she told the reporter, "I think I'd better kill myself." And then she added, "*You* seem rather ghoulish—if so, you can be on our committee."

On the CNN fashion program *Style with Elsa Klensch*, Lambert was asked what she had most enjoyed about her half-century supervising the List. "The most fun for me," Lambert answered, "has been the meeting of the committee because they are so off-the-wall. You just don't know how they are going to arrive at anything, and when it's all over, there is a List and it holds water."

British designer
**OZWALD BOATENG,**
photographed by Colin Bell, 1998.

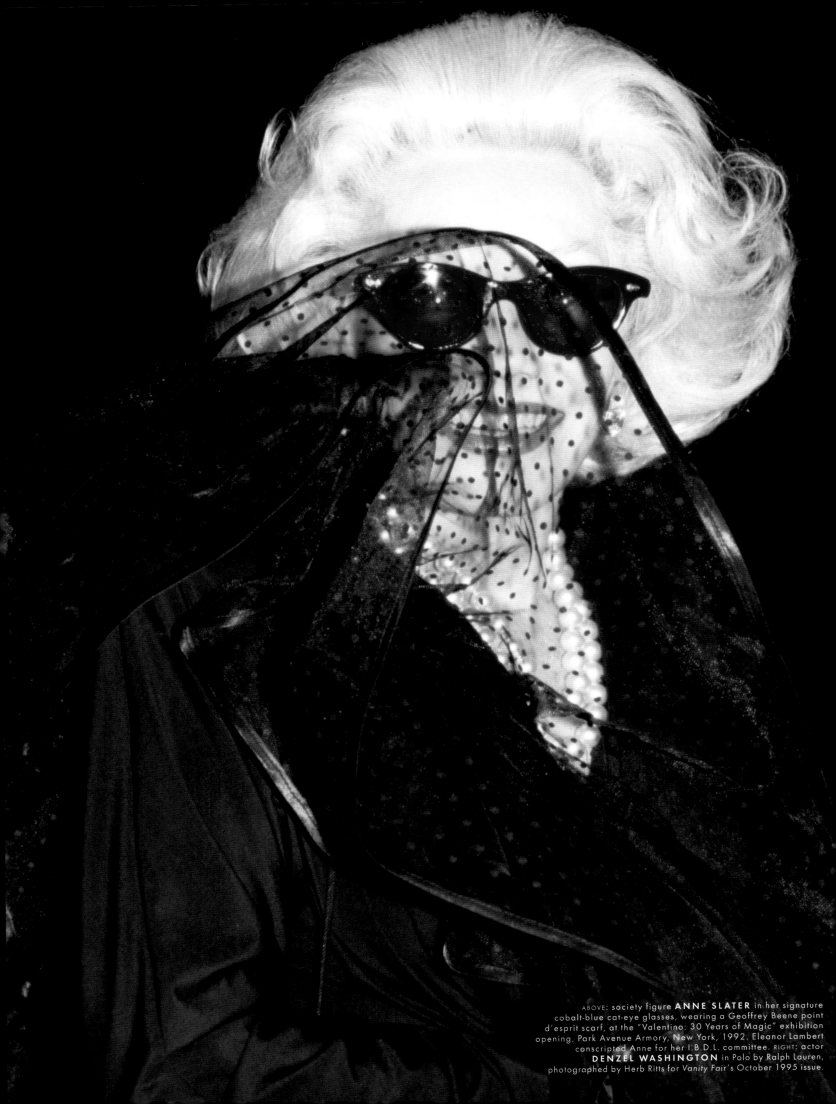

ABOVE: society figure **ANNE SLATER** in her signature
cobalt-blue cat-eye glasses, wearing a Geoffrey Beene point
d'esprit scarf, at the "Valentino: 30 Years of Magic" exhibition
opening, Park Avenue Armory, New York, 1992. Eleanor Lambert
conscripted Anne for her I.B.D.L. committee. RIGHT: actor
**DENZEL WASHINGTON** in Polo by Ralph Lauren,
photographed by Herb Ritts for *Vanity Fair's* October 1995 issue.

ABOVE: **CAROLINA HERRERA JR.** in Carolina Herrera, photographed by John Huba in Paris.
RIGHT: **PATRICIA HERRERA**, also in Carolina Herrera, photographed by Anders Overgaard in Madrid.

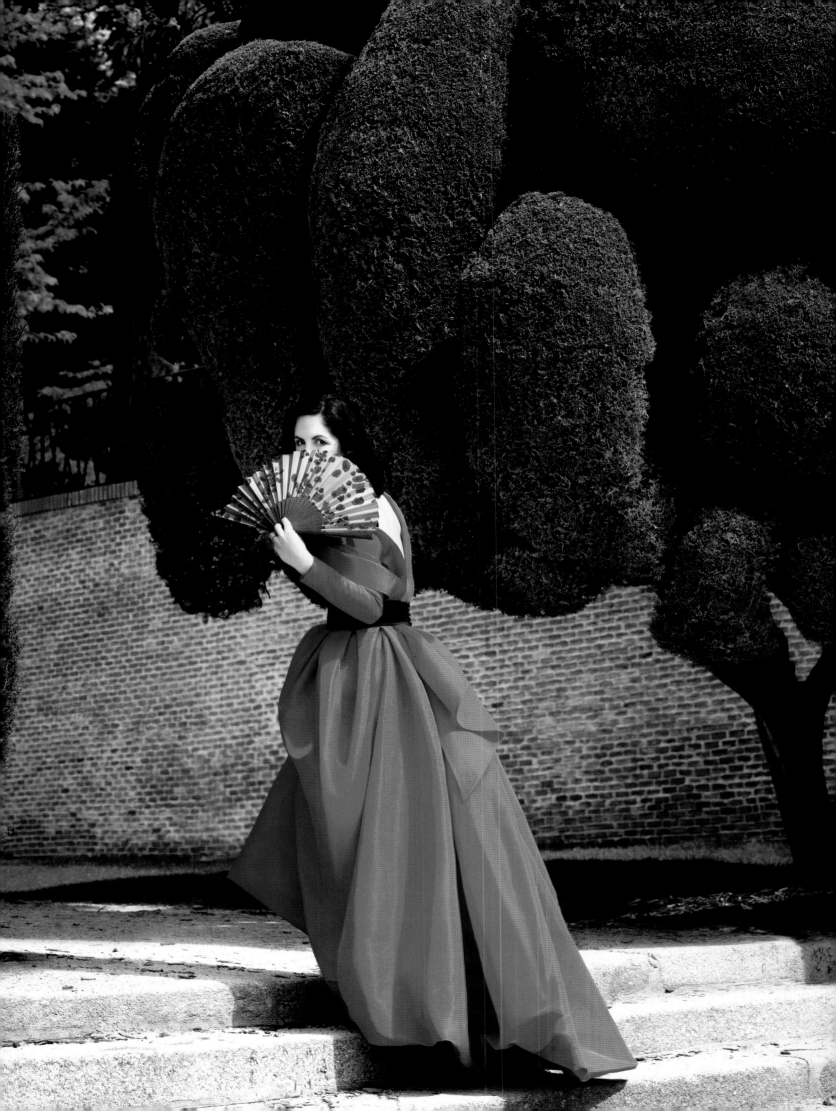

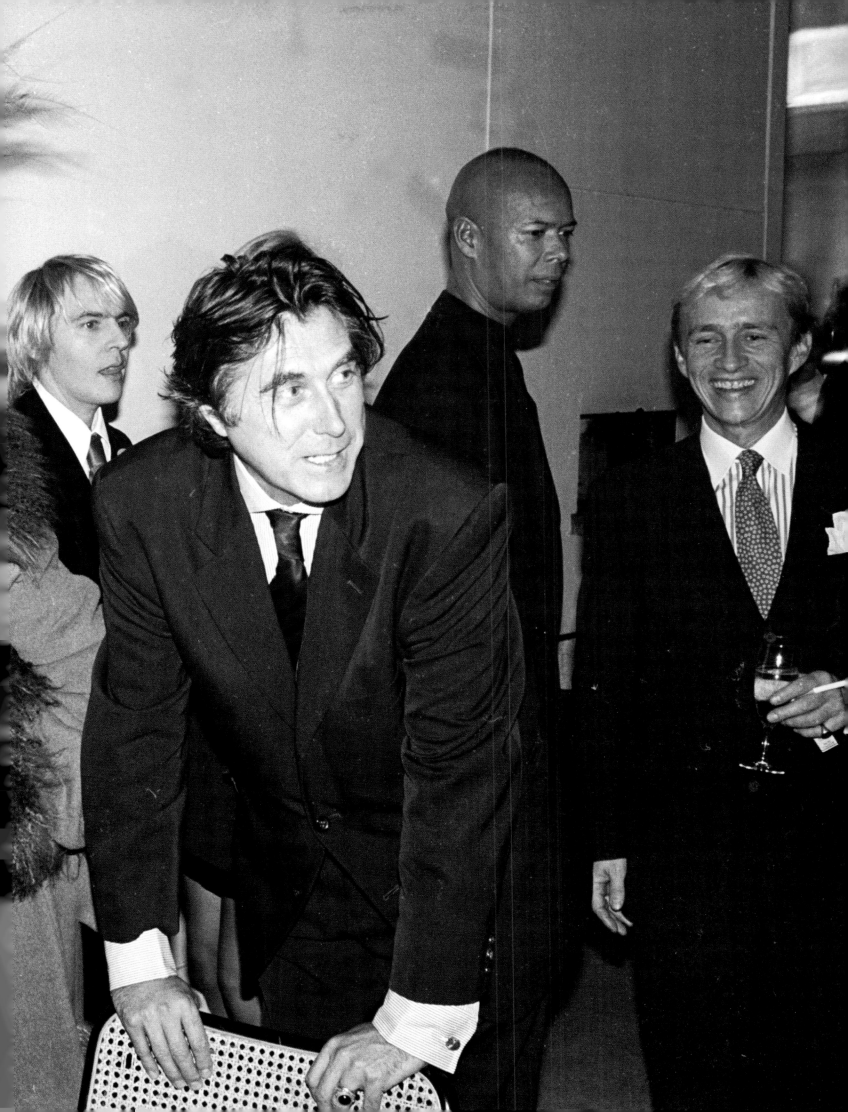

PRECEDING SPREAD, FROM LEFT: **MANOLO BLAHNIK,** fashion editor and muse **ISABELLA BLOW,** Nick Rhodes of Duran Duran, **BRYAN FERRY,** journalist and filmmaker **MICHAEL ROBERTS,** and designer Jasper Conran at the River Café for *Vanity Fair*'s Swinging London dinner, November 20, 1996. Photo by Dafydd Jones.

LEFT: **ISABELLA BLOW** sits in the front row at the inaugural Julien MacDonald fashion show, which she styled, wearing a Swarovski crystal-studded hat made by Erik Halley from an actual lobster, Queen's Gate, London, February 24, 1998. "Isabella was both the most gifted and giving lady," Halley said. "But if you look up the word eccentric in the dictionary, it should have her face next to it." Halley hadn't had time to clean the lobster carcass thoroughly, so the hat began to putrefy, a development that pleased Blow as the stench worked as a people-repellent. BELOW: Tiffany & Co. executive, magazine editor, and fashion-industry veteran **ROBERT RUFINO** with his Jack Russell terrier, Arnold, 1995. Both wear Gene Meyer. RIGHT: fashion editor and muse **ISABELLA BLOW,** left, with Karl Lagerfeld's creative consultant **AMANDA HARLECH,** photographed by Ellen von Unwerth for *Vogue Italia,* March 1, 1997.

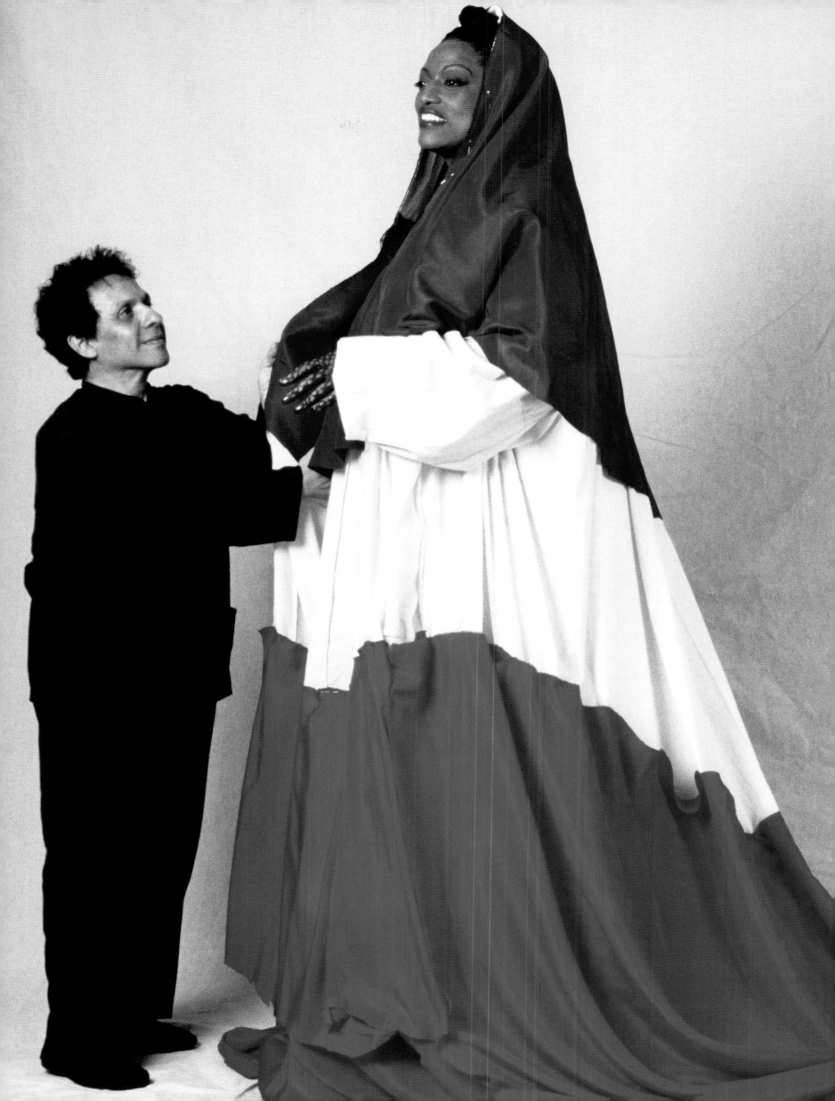

PRECEDING SPREAD, LEFT: *Vogue* international editor-at-large **HAMISH BOWLES** wearing a Gene Meyer tie and pocket square, and Richard James suit, photographed by Nigel Parry, New York, 1996. RIGHT: Tunisian-born French designer **AZZEDINE ALAÏA** working on opera star **JESSYE NORMAN**'s costume for the great parade celebrating the 200th anniversary of the French Revolution, 1989.

FAR LEFT: jewelry designer **VICTOIRE DE CASTELLANE**, photographed by Pierre-Olivier Deschamps in Paris.
TOP, LEFT: designer **CHRISTIAN LOUBOUTIN**, foreground, and *Vogue*'s **HAMISH BOWLES**, photographed by Roxanne Lowit, at Lisa Marie Presley's party in Paris, 1996.
TOP, RIGHT: model and socialite **LUCY FERRY** with model **KATE MOSS** during London fashion week, 1993.
LEFT: **ALLEGRA HICKS**, with her daughter Angelica, wears a vintage 1930s silk-satin dress, possibly by Adrian. Photo by Carolyn Cowan.

LEFT: model **NAOMI CAMPBELL** arriving at Isaac Mizrahi's spring fashion show, November 7, 1991. RIGHT: singer **LENNY KRAVITZ** performing in Paris, June 30, 1999. Kravitz won a Grammy that year for "American Woman."

LEFT: **CHLOË SEVIGNY** wearing Yves Saint Laurent at the 72nd Academy Awards, March 26, 2000. Chloë was nominated as best supporting actress, for *Boys Don't Cry*. ABOVE: **JULIA ROBERTS** in a 1992 Valentino dress at the Academy Awards. "I have dressed so many people, but I have to be sincere," Valentino said. "The person that made me feel so very, very happy was Julia Roberts when she got the Academy Award for *Erin Brockovich*." RIGHT: **UMA THURMAN**, in Prada, at the Governors Ball after the Academy Awards, March 27, 1995. Uma was nominated as best supporting actress for *Pulp Fiction*.

FOLLOWING SPREAD, LEFT: **SHARON STONE**, photographed at the Cannes Film Festival, 1995. That year she won a Golden Globe for best actress in *Casino*. RIGHT: designer **AZZEDINE ALAÏA** and singer **TINA TURNER**, wearing Alaïa, New York, 1997. Model **CHRISTY TURLINGTON**, in the background, also wears Alaïa. Photo by Marina Garnier.

226

# The 2000s

## The

# GODMOTHER

## and the

# GUARDIANS

**PRINCE WILLIAM** and **KATE MIDDLETON,** Duke and Duchess of Cambridge, arrive at the 2011 BAFTA
"Brits to Watch" event at the Belasco Theatre in Los Angeles. The duchess wears a lilac Alexander McQueen
dress with earrings borrowed from Queen Elizabeth, and Jimmy Choo sandals and clutch, July 9, 2011.

# THE LIST

ADWOA ABOAH

CHIMAMANDA NGOZI ADICHIE

WARIS AHLUWALIA

AZZEDINE ALAÏA

DUCHESS OF ALBA
(CAYETANA FITZ-JAMES STUART)

COUNTESS OF ALBEMARLE (SALLY TADAYON)

H.R.H. PRINCESS ALEXANDRA OF GREECE
& NICOLAS MIRZAYANTZ

FRANCESCA AMFITHEATROF

SOPHIA AMORUSO

WES ANDERSON

RAINER ANDREESEN

IRIS APFEL

SERENA & DAVID ARMSTRONG-JONES,
VISCOUNTESS & VISCOUNT LINLEY

ALEXANDRE ARNAULT

AMY ASTLEY

HOPE ATHERTON

CATHERINE BABA

ALEX BADIA

MIGUEL BAEZ

CHRISTOPHER BAILEY

ANDRÉ BALAZS

ALEC BALDWIN

TIKI BARBER

JAVIER BARDEM

PETER BEARD

ERIKA BEARMAN

JONATHAN BECKER

VICTORIA & DAVID BECKHAM

GEOFFREY BEENE

STACEY BENDET

ANDRE 3000 BENJAMIN

HALLE BERRY

BEYONCÉ

H.M. KING OF BHUTAN
(JIGME K. N. WANGCHUCK)

JOE BIDEN

FAN BINGBING

SELMA BLAIR

CATE BLANCHETT

DELFINA BLAQUIER & NACHO FIGUERAS

ISABELLA BLOW

EMILY BLUNT

CARLA BRUNI-SARKOZY

OZWALD BOATENG

ROBERTO BOLLE

ANDREW BOLTON

MATT BOMER & SIMON HALLS

HELENA BONHAM CARTER

BEATRICE BORROMEO & PIERRE CASIRAGHI

FERNANDO BOTERO

BIANCA BRANDOLINI d'ADDA

ANDREW BOLTON & THOM BROWNE

CARLA BRUNI-SARKOZY

GISELE BÜNDCHEN & TOM BRADY

TORY BURCH

LAUREN BUSH & DAVID LAUREN

ARPAD BUSSON

ARKI BUSSON

JENSON BUTTON

JOHN CAHILL

H.R.H. THE DUCHESS OF CAMBRIDGE
(CATHERINE "KATE" MIDDLETON)

SAMANTHA CAMERON

LADY ISABELLA STANHOPE & COLIN CAMPBELL,
COUNTESS & EARL OF CAWDOR

MICHAEL CANNON

H.R.H. PRINCE CARL PHILIP OF SWEDEN

FRANCESCO CARROZZINI

CHARLOTTE CASIRAGHI

VICTOIRE DE CASTELLANE

CARLYNE CERF DE DUDZEELE

GEMMA CHAN

OLIVIA CHANTECAILLE

GEORGINA CHAPMAN

H.S.H. PRINCESS CHARLENE OF MONACO

JESSICA CHASTAIN

MAUREEN CHIQUET

DAO-YI CHOW & MAXWELL OSBORNE

GIUSEPPE CIPRIANI

ALBA CLEMENTE

ANDREA & PIETRO CLEMENTE

CHIARA CLEMENTE

ANNA CLEVELAND

PAT CLEVELAND

AMAL CLOONEY

GEORGE CLOONEY

PETRA COLLINS

SEAN COMBS

MARINA RUST CONNOR

ANDERSON COOPER

MISTY COPELAND

SOFIA COPPOLA

LUCA CORDERO DI MONTEZEMOLO

CLAIRE, JENNA, PRISCA,
& VIRGINIE COURTIN-CLARINS

ROBERT COUTURIER

DANIEL CRAIG

PENÉLOPE CRUZ

VICTOR CRUZ

PALOMA CUEVAS & ENRIQUE PONCE

BENEDICT CUMBERBATCH

BILL CUNNINGHAM

ANDRA DAY

CECILIA DEAN

CARA, CHLOE, & POPPY DELEVINGNE

ANDREA DELLAL

CHARLOTTE OLYMPIA DELLAL

CARMEN DELL'OREFICE

DAVEED DIGGS

MICHELLE DOCKERY

LOU DOILLON & CHARLOTTE GAINSBOURG

INÉS DOMECQ

MERCEDES DOMECQ

ANH DUONG

AURÉLIE DUPONT

MARIO D'URSO

LISA EISNER

IDRIS ELBA

ALBER ELBAZ

H.M. QUEEN ELIZABETH II OF GREAT BRITAIN
AND NORTHERN IRELAND

GINEVRA ELKANN & GIOVANNI GAETANI

DELL'AQUILA D'ARAGONA

LAPO ELKANN

LAVINIA & JOHN ELKANN

GIOVANNA BATTAGLIA ENGELBERT

NORA EPHRON

H.R.H. PRINCE ERNST AUGUST OF HANOVER

SUSAN FALES-HILL

EMILIA & PEPE FANJUL

LINDA FARGO

RONAN FARROW

MICHAEL FASSBENDER

ROGER FEDERER

DELFINA DELETTREZ FENDI

DUKE OF FERIA (RAFAEL DE MEDINA)

ISAAC, OTIS, & TARA FERRY

SYDNEY & CHARLES FINCH

LIVIA & COLIN FIRTH

FKA TWIGS

TOM FORD

NICHOLAS FOULKES

H.R.H. CROWN PRINCE FREDERIK OF DENMARK

KATHY FRESTON

H.S.H. PRINCE HEINRICH VON
UND ZU FÜRSTENBERG

T.S.H. PRINCESS MATILDE VON
FÜRSTENBERG-BORROMEO & PRINCE
ANTONIUS VON FÜRSTENBERG

GAL GADOT

COUNT ROFFREDO GAETANI

JOHN GALLIANO

AUDREY GELMAN

VANESSA GETTY

COUNT MANFREDI DELLA GHERARDESCA

ALEXANDER GILKES

DONALD GLOVER

PAMELA GOLBIN

HENRY GOLDING

SHEHERAZADE & ZAC GOLDSMITH

RICHARD E. GRANT

KIRSTEN GREEN

MARJORIE GUBELMANN

GIORGIO GUIDOTTI

AGNES GUND

MAGGIE & JAKE GYLLENHAAL

JEFFERSON HACK

ARMIE HAMMER

MICHELLE HARPER

NEIL PATRICK HARRIS

H.R.H. PRINCE HARRY, THE DUKE OF SUSSEX

STEVE HARVEY

NICKY HASLAM

ANNE HATHAWAY

AMANDA HEARST

GABRIELA HEARST

DREE HEMINGWAY

ALI HEWSON

MELLODY HOBSON

GEOFFREY HOLDER

SOPHIE HUNTER & BENEDICT CUMBERBATCH

JACK HUSTON

CAROLINE ISSA

JONATHAN IVE

AURORA JAMES

LEBRON JAMES

LILY JAMES

JAY-Z

RICHARD JOHNSON

ANGELINA JOLIE & BRAD PITT

JILL KARGMAN

REI KAWAKUBO

LIYA KEBEDE

JOSEPH KENNEDY III

ALICIA KEYS

JEMIMA KHAN

FARIDA KHELFA

JEMMA KIDD & ARTHUR WELLESLEY,
MARCHIONESS & MARQUESS OF DOURO

NICOLE KIDMAN

KARLIE KLOSS

SOLANGE KNOWLES

JULIA KOCH

HAROLD KODA

HENRY KOEHLER

JEFF KOONS

---

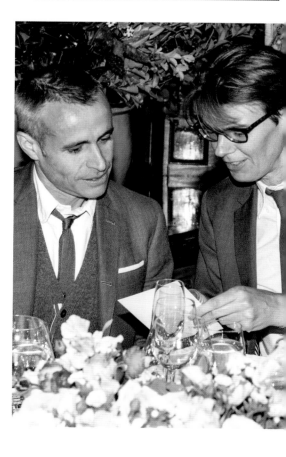

# THE LIST

ALEXANDRA KOTUR & FIONA KOTUR MARIN

MRS. HENRY KRAVIS (MARIE-JOSÉE DROUIN)

LENNY KRAVITZ

ZOË KRAVITZ

DIANE KRUGER

LADY GAGA

CHRISTINE LAGARDE

KARL LAGERFELD

NICO LANDRIGAN

EVELYN LAUDER

JANE & AERIN LAUDER

MATT LAUER

ANDREW, DAVID, & DYLAN LAUREN

RICKY LAUREN

JUDE LAW

FRAN LEBOWITZ

CINDI LEIVE

BERNARD-HENRI LÉVY

H.M. QUEEN LETIZIA OF SPAIN

PENG LIYUAN

WILLIAM IVEY LONG

BRYAN LOURD

H.S.H. PRINCE RUPERT VON UND ZU LÖWENSTEIN

HENRIK LUNDQVIST

KELLY LYNCH & MITCH GLAZER

JENNA LYONS

YO-YO MA

CRISTINA MACAYA

BRIGITTE & EMMANUEL MACRON

PRINCESS MAFALDA OF HESSE

FRÉDÉRIC MALLE

JUMAN MALOUF & WES ANDERSON

PETER MANNING

PRINCESS MARIE-CHANTAL & T.R.H. CROWN

PRINCE PAVLOS OF GREECE

H.R.H. CROWN PRINCESS MARY OF DENMARK

MATTEO MARZOTTO

NATALIE MASSENET

H.R.H. CROWN PRINCESS MATHILDE OF BELGIUM

H.M. QUEEN MÁXIMA & T.M. KING WILLEM-ALEXANDER OF THE NETHERLANDS

GUGU MBATHA-RAW

PATRICK MCCARTHY

STELLA MCCARTNEY

MARIAN MCEVOY

ANNE MCNALLY

LUIS & RAFAEL MEDINA

MATHILDE MEYER-AGOSTINELLI

SIENNA MILLER

HELEN MIRREN

MARGHERITA MISSONI

JEAN-GABRIEL MITTERRAND

JANELLE MONÁE

SHALA MONROQUE

H.H. SHEIKHA MOZA BINT NASSER OF QATAR

DEMI MOORE & ASHTON KUTCHER

KATE MOSS

H.H. SHEIKHA MOZAH OF QATAR

CAREY MULLIGAN

WENDI MURDOCH

HIDETOSHI NAKATA

RUTH NEGGA

ENID NEMY

LORRY NEWHOUSE

EUGENIE & STAVROS NIARCHOS

BILL NIGHY

LARS NILSSON

LUPITA NYONG'O

MICHELLE & BARACK OBAMA

H.R.H. PRINCESS OLGA OF GREECE

LESLIE ODOM JR.

OLIVIA PALERMO

VANESSA PARADIS & JOHNNY DEPP

SARAH JESSICA PARKER

DEV PATEL

JAY PENSKE

H.R.H. PRINCE PHILIP, THE DUKE OF EDINBURGH

OGDEN PHIPPS II

ANNA PIAGGI

HERVÉ PIERRE

JEAN PIGOZZI

STEFANO PILATI

ZAC POSEN

COLIN POWELL

MIUCCIA PRADA

CANDY PRATTS PRICE

H.M. QUEEN RANIA OF JORDAN

REBECCA DE RAVENEL

EDDIE REDMAYNE

JULIA & VLADIMIR RESTOIN-ROITFELD

CONDOLEEZZA RICE

KEITH RICHARDS

RIHANNA

KELLY RIPA

MICHAEL ROBERTS

ROO ROGERS

CARINE ROITFELD

DANIEL ROMUALDEZ

KATHERINE ROSS

TRACEE ELLIS ROSS

EMMY ROSSUM

RACHEL ROY & DAMON DASH

ROBERT RUFINO

MORLEY SAFER

MARCUS SAMUELSSON

GINA SANDERS

JUAN SANTA CRUZ

CHARLOTTE & ALEJANDRO SANTO DOMINGO

LAUREN & ANDRÉS SANTO DOMINGO

TATIANA SANTO DOMINGO

NICOLAS SARKOZY

ALLISON SAROFIM

OLYMPIA SCARRY

JACK SCHLOSSBERG

JULIAN SCHNABEL

VITO SCHNABEL

MARTIN SCORSESE

ULYANA SERGEENKO

CHLOË SEVIGNY

LÉA SEYDOUX

BEE SHAFFER

BROOKE SHIELDS

CHARLIE SIEM

EUGENIA SILVA & ALEJANDRO SANTO DOMINGO

TABITHA SIMMONS & CRAIG MCDEAN

RENA SINDI

HEDI SLIMANE

JADEN SMITH

ZADIE SMITH

CARLOS SOUZA

FRANCA SOZZANI

LOUIS SPENCER

ST. VINCENT

GWEN STEFANI

STING

EMMA STONE

LARA STONE & DAVID WALLIAMS

HARRY STYLES

H.R.H. THE DUCHESS OF SUSSEX (MEGHAN MARKLE)

TAYLOR SWIFT

TILDA SWINTON

GAY TALESE

DONNA TARTT

DIANA TAYLOR & MICHAEL BLOOMBERG

DITA VON TEESE

ALICE TEMPERLEY

STELLA TENNANT

MARIO TESTINO

TAKI THEODORACOPULOS

CHARLIZE THERON

UMA THURMAN

JUSTIN TIMBERLAKE

LIZZIE & JONATHAN TISCH

ISABEL & RUBEN TOLEDO

ÉLIE TOP

VANESSA & VICTORIA TRAINA

JUSTIN TRUDEAU

BLAINE TRUMP

IVANKA TRUMP

EUGENE TSAI TONG

CHRISTY TURLINGTON & ED BURNS

CY TWOMBLY

MISH TWORKOWSKI

MITSUKO UCHIDA

IKÉ UDÉ

ALICIA VIKANDER

NATALIA VODIANOVA & JUSTIN PORTMAN

CONNIE WALD

DARREN WALKER

SHELLEY WANGER & DAVID MORTIMER

JANE LAUDER WARSH

KERRY WASHINGTON

JOHN WATERS

EMMA WATSON

CHARLIE WATTS

BRUCE WEBER

H.R.H. THE COUNTESS OF WESSEX (SOPHIE RHYS-JONES)

KANYE WEST

RUSSELL WESTBROOK

ELETTRA WIEDEMANN

H.R.H. PRINCE WILLIAM, THE DUKE OF CAMBRIDGE

BRIAN WILLIAMS

PHARRELL WILLIAMS

RUSSELL WILSON

LADY AMELIA WINDSOR

OPRAH WINFREY

NICK WOOSTER

SHIRIN VON WULFFEN & FRÉDÉRIC FEKKAI

MADEMOISELLE YULIA

CHOW YUN-FAT

GEOFFREY ZAKARIAN

RENÉE ZELLWEGER

DASHA ZHUKOVA

AERIN LAUDER ZINTERHOFER

---

FAR LEFT: retired New York Giants wide receiver **VICTOR CRUZ** in a Ralph Lauren Black Label suit, Gucci shirt, and John Lobb shoes. Photographed by Ben Watts for *GQ*, June 2012. TOP, LEFT: former mayor of New York **MICHAEL BLOOMBERG** with former New York State superintendent of banks **DIANA TAYLOR** arriving at the Metropolitan Museum of Art's Costume Institute gala celebrating "American Woman: Fashioning a National Identity," New York, May 3, 2010. TOP, RIGHT: French jewelry designer **ÉLIE TOP** at the Musée Gustave Moreau in Paris, December 4, 2016. BOTTOM: burlesque artist **DITA VON TEESE** with designer **ZAC POSEN** at the Metropolitan Museum's Costume Institute gala celebrating "Charles James: Beyond Fashion," May 5, 2014. Dita wears a Zac Posen dress inspired by Charles James.

*"One should either be a work of art,*
*or wear a work of art."*

— OSCAR WILDE

---

## The Plague of the Stylists

In early 2000, Geoffrey Beene (Listed 2001) described his 96-year-old friend as "the same in her personal life as in her business life, all woman, both compassionate and tender." Even Lambert seemed a little impressed, if not by her own longevity, then by that of the List—a durability that the London *Independent* ascribed to Lambert's "exemplary incorruptibility." On April 21, 2000, the seemingly invincible Lambert heralded "the entrance of this 60-year-old tradition of the fashion world into the 21st century." Victoire de Castellane, Chloë Sevigny, and Eliza Reed represented to Lambert a welcome "renewal of a more classic style." Lambert, however, was troubled by one trend. Asked why the 1999/2000 List featured only two film stars (Nicole Kidman and Chloë Sevigny), Lambert blamed the rising phenomenon of "Hollywood stylists whose impersonal attention is replacing ... personal style."

Later that year, in the downtown magazine *Paper,* Lambert carried her anti-stylist vendetta even further. "The stylist is the termite of the fashion industry," she fumed. "These people just collect other people's clothes and hang them on [celebrities]." In the same article, Lynn Wyatt (Hall of Fame, 1977) seconded Lambert's opinion: "If a stylist dresses a celebrity, it takes away from the celebrity's own sense of style. And they are already acting different parts, so who's to know what they really think and who the real person is anyway?" *Paper* hosted a semi-ironic lunch for Lambert at Indochine, at which phony guidelines for making the List were distributed to guests (e.g., "Wear tight underpants" and "Send Eleanor Lambert expensive gifts"). Nobody's fool, Lambert was fully in on the joke. At the lunch, *The New York Times* reported, she "made one of the shortest thank-you speeches on record. It was nice, she said, that a young magazine was recognizing 'an old woman.' Then she sat down, to applause."

In her April 2001 press release Lambert observed that "this was not a year when any fashion designer caused change." But she noted more brightly that "personal style" appeared to be triumphing over "temporary trends." (A skeptical Aileen Mehle shot back from her *WWD* column, "You think?") Lambert added hopefully, "The current shifts and confusion within the fashion industry today have made women of taste everywhere more keen to depend on themselves when choosing clothes." Lauren Bacall, Gayfryd Steinberg, and Marisa Berenson, all presumably tastefully self-sufficient, rose to the Hall of Fame, while Yo-Yo Ma debuted on the men's list.

---

## Lambert's Last List

Undeterred, incredibly, by either 9/11 or the encroachment of her 99th year, Lambert soldiered on. In January 2002 she began to assemble her committee. Faxed invitations rolled out to Aimée Bell, Amy Fine Collins, Sally Singer, Billy Norwich, Kitty D'Alessio, Anne Slater, Betsy Kaiser, Elsa Klensch, Hal Rubenstein, Mickey Boardman, David Patrick Columbia, Reinaldo Herrera, Graydon Carter, and others, to meet from 12 to 2:30 at her apartment on Tuesday, March 26. On Friday, March 29, 2002,

Model **ANNA CLEVELAND,** daughter of
model Pat Cleveland, at a charity shopping event
in New York, April 15, 2015.

Aileen Mehle (who still held first-exclusive for the List) announced the results of what would be Lambert's final poll. "The List is always controversial," Mehle reflected. "Maybe that's why, after all these years, it still has a certain amount of validity. Some live and die by it. Some think it's patently silly. Members of the committee have their favorites whom they are not loath to push. Some even have axes to grind. That's all well and good, but the List, after all, is only as good as the judges." Lambert dedicated her 2001/2002 lineup to "the younger generations who respect individuality in dress, because there is no designer who must be followed." Lambert sincerely regretted the extinction of omnipotent designers on the order of Dior, Balenciaga, or Chanel—creators with a vision so metamorphically powerful they "made you feel you had to change your way of looking," she told *WWD*.

Three months later, on June 30, 2002, Lambert closed her office at 245 East 58th Street. "My theory is that when you get very old," Lambert said, "you go to pieces from the bottom up or from the top down. Luckily I'm going from the feet up." Still with all her marbles (as she put it), she worked from home on the few accounts she retained, such as Tiffany & Co. But, for the first time in 63 years (1942 and 1979 excluded), Lambert did not generate an International Best-Dressed List. In 1999 she had told the *Dallas Morning News* that she had not yet appointed an heir for the List. "It's always been a personal thing," she said. But she in fact had a plan for succession. On June 29, 2002, Lambert—having guided the List through five wars, cyclical counterculture upheavals, 13 presidents, and onward into a new millennium—officially gave her invention to four "friends at *Vanity Fair*": Graydon Carter, Aimée Bell, Amy Fine Collins, and Reinaldo Herrera. When the legend who referred to herself as the "oldest living data base" died in her sleep, on October 7, 2003, two months after her 100th-birthday party, and two weeks after ordering a jacket from Geoffrey Beene's latest show, she knew the List would not expire with her—not any more than fashion itself would.

# Guardianship *of the* Four Editors, *2003–Present*

"The list," Graydon Carter wrote in his September 2009 Editor's Letter, "is an enduring record of the best-heeled, best-tailored, best-style-conversant people in the world." Under the auspices of *Vanity Fair,* the List continued to accommodate cultural shifts, all the while maintaining respect for its history and methods, and reverence for its founder. With the 21st-century apotheosis of the celebrity and the related fusion of the fashion and entertainment industries, more film and fashion notables—Nicole Kidman, George Clooney, Sofia Coppola, Jeremy Irons, Giancarlo Giammetti, Lauren Hutton, Kate Moss—rose to the Hall of Fame. Monitoring these changes, *The New York Times* reported in 2008 that the List now had "more people who thrive at the intersection of fashion, pop culture, and the media." Influenced by the expanding global economy, the List's voters selected some of the first Chinese winners (Fan Bingbing) since Mme. Chiang Kai-shek and the first Russians (Natalia Vodianova) since the days of Princess Natalia Paley and Maya Plisetskaya. Sensitive to such movements as #HollywoodSoWhite and #OscarsSoWhite, the List embraced more people of color (Lupita Nyong'o, Idris Elba, Rihanna, Janelle Monáe), and, reflecting the 2015 Supreme Court ruling on same-sex marriage, the List that year bestowed honors for the first time on a gay couple, Thom Browne and Andrew Bolton.

Respecting the widening possibilities for individual style, the List instituted more categories—Couples, Hollywood, Originals—and, in response to the digital-media explosion, it opened itself up for two years to contestants from all over the World Wide Web, via vf.com's Best-Dressed Challenge. The List also evolved into a leading driver of the magazine's website traffic, particularly when the alt-right periodical *Breitbart* incited its readership to complain to vf.com about the absence of Melania Trump from the 2017 List. That same year, Graydon Carter left *Vanity Fair.* Just as in 1962, when Lambert transferred the List from the Dress Institute to her own offices, the List once again continues as an independent entity, supervised by the I.B.D.L. team whom she appointed in 2002 to be her successors.

One fundamental fact that has not altered since 1940 is that everywhere hopefuls—wishing to be rewarded for the daily rite of getting dressed—are still vying for a place on the List. Asked in 1977 if the kind of haute elegance she had made synonymous with the International Best-Dressed List was dead, Lambert answered impatiently, "Yes, just like they say God is dead." And then she added in earnest, "You cannot separate people, their yearnings, their dreams, and their inborn vanity from an interest in clothes."

Actress, singer, and producer **JANELLE MONÁE** wears a label-embellished Thom Browne shorts suit to attend the Thom Browne fashion show at the École des Beaux-Arts, Paris, March 3, 2019. Outside, she told the female paparazzi they were allowed to shoot her before their male counterparts.

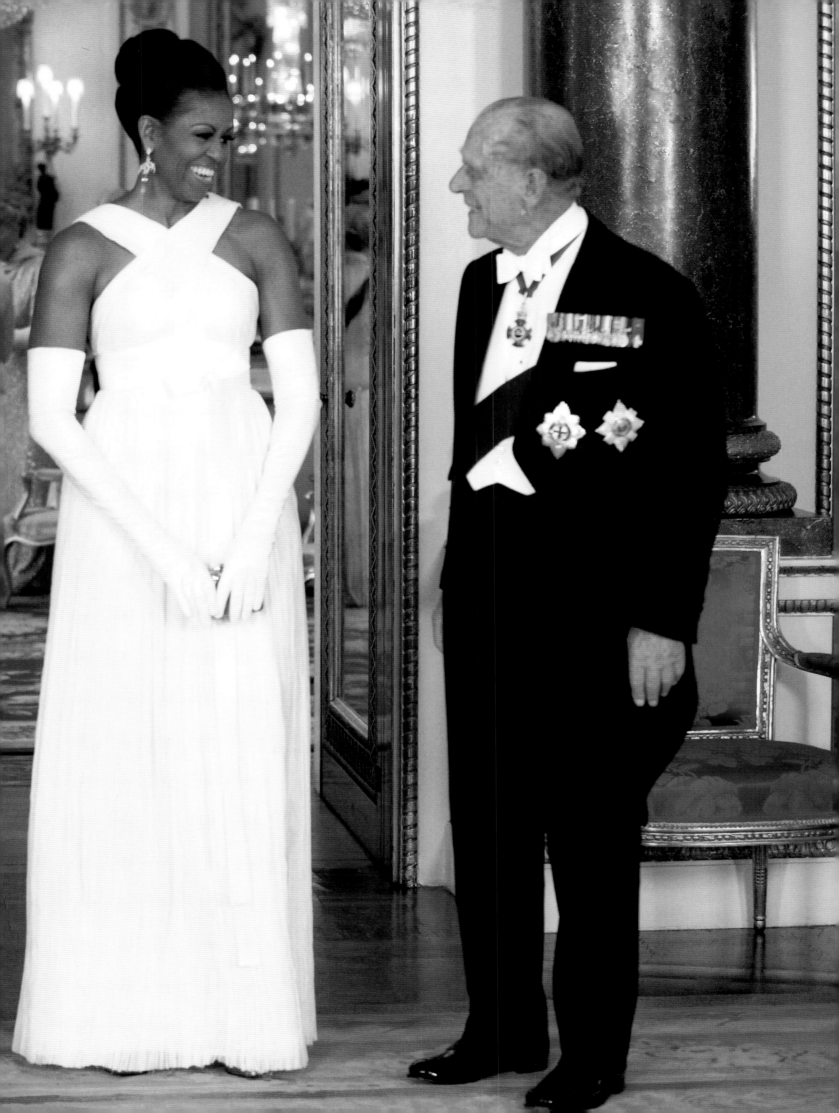

PRECEDING SPREAD: **QUEEN ELIZABETH II** and **PRINCE PHILIP** with **PRESIDENT BARACK OBAMA** and **FIRST LADY MICHELLE OBAMA** in the Music Room of Buckingham Palace for a banquet in honor of the Obamas' state visit to the United Kingdom, May 24, 2011. The First Lady wears a silk-georgette dress by Tom Ford.

FAR LEFT: **OPRAH WINFREY** at the 77th Academy Awards, February 27, 2005. Oprah's dress and clutch are by Vera Wang. LEFT: **QUEEN LETIZIA** of Spain arrives at a meeting for the Asociación Española Contra el Cáncer, of which she is honorary president, Madrid, December 21, 2017. The queen wears a Hugo Boss coat and turtleneck with a Carolina Herrera skirt, Magrit boots, and a Zara bag. ABOVE: human-rights lawyer **AMAL CLOONEY,** wearing John Galliano for Maison Margiela, and her husband, actor **GEORGE CLOONEY,** attend the Metropolitan Museum's Costume Institute gala celebrating "China Through the Looking Glass," May 4, 2015.

FOLLOWING SPREAD, LEFT: singer **BEYONCÉ** arriving at the Metropolitan Museum for the opening of the Costume Institute's "Punk: Chaos to Couture," wearing Riccardo Tisci for Givenchy, May 6, 2013. At the time, she was in the midst of her Mrs. Carter Show World Tour. RIGHT: actress **RENÉE ZELLWEGER,** photographed for *Vogue* by Arthur Elgort, wearing an Yves Saint Laurent haute couture dress, 2001. That year she starred in her breakout role, in *Bridget Jones's Diary.*

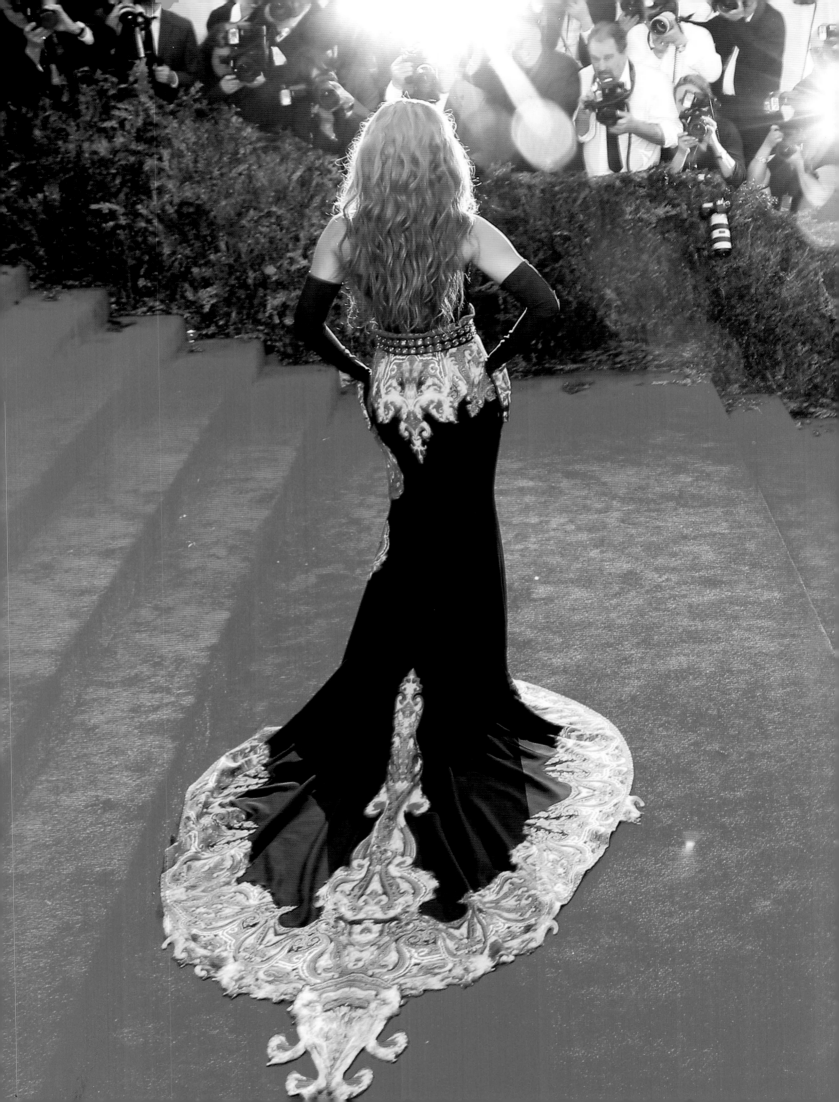

PRECEDING SPREAD, LEFT: **PRINCE HARRY** and **MEGHAN MARKLE,** newly named Duke and Duchess of Sussex, depart St. George's Chapel, at Windsor Castle, after their wedding ceremony, May 19, 2018. Meghan's dress was designed by Clare Waight Keller for Givenchy. The duchess's diamond tiara was created for Harry's great-great-grandmother Queen Mary. Harry is wearing the frock-coat uniform of the Blues and Royals, a cavalry regiment of the British Army. RIGHT: basketball player **LEBRON JAMES,** of the Cleveland Cavaliers, dressed in Thom Browne, arrives at Game Two of the 2018 N.B.A. finals, against the Golden State Warriors, in Oakland, California, June 3, 2018. The Warriors won.

LEFT: artist **IKÉ UDÉ** with two of his self-portraits from his *Sartorial Anarchy* series, at the Leila Heller gallery during the installation of his show "Style and Sympathies," New York, October 8, 2013. ABOVE: television news personality **ANDERSON COOPER,** by Meredith Jenks, 2016. Anderson's mother, Gloria Vanderbilt, preceded him onto the List by several decades. RIGHT: Actress **GAL GADOT** wearing a velvet Prada dress to the London premiere of *Batman v Superman: Dawn of Justice,* in which she played Wonder Woman, March 22, 2016.

248

PRECEDING SPREAD: designer **ISABEL TOLEDO** and her husband, artist **RUBEN TOLEDO,** in their New York studio, photographed by Max Vadukul, 2008.

FAR LEFT: model **CARMEN DELL'OREFICE,** shot at the Musée National de Céramique by Ali Mahdavi for the retrospective about Carmen, in honor of her 80th birthday, curated by David Downton at the London College of Fashion, 2011.
LEFT: model **STELLA TENNANT** with **KARL LAGERFELD** at the Chanel shop at 15 East 57th Street, in New York.
ABOVE: actress **CATE BLANCHETT** arrives at a dinner hosted by Prince William at Windsor Castle, in Windsor, England, to celebrate Ralph Lauren's charitable donation to the Royal Marsden Hospital, May 13, 2014.

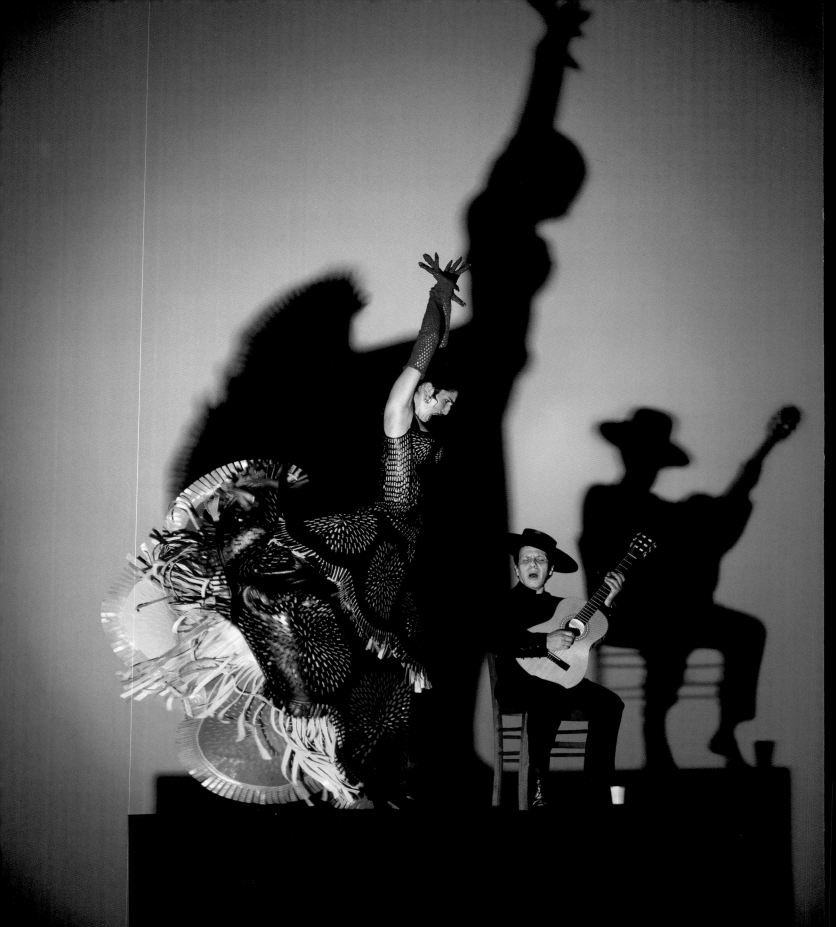

2000s

255

**AZZEDINE ALAÏA,** the Tunisian-born French designer, wears his signature uniform of Chinese pajamas, but for the occasion of this photo shoot, he has added a traditional flamenco guitarist's felt Cordobés hat. The flamenco dancer is Mercedes Metal, who is performing in a dress by Alaïa. Photo by Jean-Paul Goude, Paris, 1998.

255

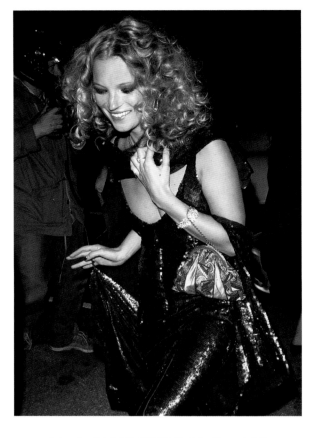

LEFT: model and artist **ANH DUONG** at the Memorial Sloan Kettering gala at Cipriani in New York, February 14, 2001. Photo by Hannah Thomson. ABOVE: model **KATE MOSS** in vintage sequins for her "Beautiful and Damned" 30th birthday party, which ended, it was reported, with an orgy at Claridge's, London, January 16, 2004. RIGHT: **KATE MOSS** at the Metropolitan Museum's Costume Institute gala celebrating "The Model as Muse: Embodying Fashion," wearing a dress by Marc Jacobs, who co-hosted the event with her, May 4, 2009.

FOLLOWING SPREAD, LEFT: **KEITH RICHARDS,** of the Rolling Stones, in concert, Boston, Massachusetts, June 14. 2013. RIGHT: **STACEY BENDET,** creative director and C.E.O. of Alice and Olivia, in an Alice and Olivia Art Deco–inspired hand-sequined, chevron-patterned, maxi-length dress, November 18, 2018. Photo by Rony Alwin.

ABOVE: actress **GEMMA CHAN,** in a spring-summer 2019
Valentino couture dress by Pierpaolo Piccioli, at the
2019 Academy Awards. Before pursuing acting, Gemma
studied law at Worcester College, Oxford. In 2018, the year
she entered the List, Gemma appeared in the all-Asian
romantic comedy, *Crazy Rich Asians,* and in 2019 she
co-starred in *Captain Marvel.* RIGHT: fashion executive and
philanthropist **LAUREN SANTO DOMINGO,** right, in
Nina Ricci, and writer **MARINA RUST,** left, at the
Metropolitan Museum's Costume Institute gala celebrating
"Superheroes: Fashion and Fantasy," May 5, 2008.

FOLLOWING SPREAD, LEFT: singer, actress, and designer **RIHANNA**
attending the *Okja* screening at the 70th Cannes Film Festival,
May 19, 2017. She wears Andy Wolf sunglasses and a Dior
haute couture dress. RIGHT: performer **LADY GAGA** in Valentino
haute couture's "Flamingo" dress, from the fall-winter 2018–19
collection, designed by Pierpaolo Piccioli. She is walking the
red carpet for the premiere of *A Star Is Born* during the 75th
Venice Film Festival, August 31, 2018. The dress is organza and
is embroidered with tiers of pale pink feathers.

# The International
# BEST-DRESSED
# LIST

— THE COMPLETE LISTS —

*A note on the names as they appear in the Lists below: During Eleanor Lambert's time, from 1940 to 2002, women named to the List were generally designated by their husbands' names, preceded by "Mrs." For clarity, we have added women's maiden names and first names in parentheses wherever possible. If an honoree was married more than once, she is listed under the name of her husband at the time of her election to the I.B.D.L. Her maiden name appears in parentheses, followed by her prior married name, e.g., The Duchess of Windsor (Wallis Warfield Simpson). Many honorees appear on the List more than once and under different names, in which case all stylings of their names are also included in parentheses. Titled men and women have been listed by their title, as styled at the year of their arrival. Their birth names are included in parentheses, where applicable. Allowing for some inconsistencies due to the fact that many of these women were married and divorced multiple times, and records are not readily available for all names, the Lists generally adhere to Eleanor's original methods of styling names, until 2004. From 2004 onward, after Aimée Bell, Graydon Carter, Amy Fine Collins, and Reinaldo Herrera became guardians of the International Best-Dressed List, honorees are listed by the names for which they were best known at the time of selection, whether married or otherwise. Dates in parentheses refer to the release dates of the Lists.*

# The 1940s

## 1940
(DECEMBER 27, 1940)

### Women
Ina Claire (later as Mrs. William Wallace)
Lynn Fontanne
Mrs. Byron Foy (Thelma Chrysler)
Countess Haugwitz-Reventlow (Barbara Hutton)
Mrs. S. Kent Legare (Minnie Zimmerman)
Mrs. Howard Linn (Lucy McCormick Blair)
Mrs. Gilbert Miller (Kathryn "Kitty" Bache)
Mrs. William Paley (Dorothy Hart Hearst)
Mrs. William Rhinelander Stewart (Janet Newbold)
Millicent Rogers
Mrs. Thomas Shevlin (Lorraine Arnold Rowan)
Gladys Swarthout
Mrs. Harold E. Talbott (Margaret "Peggy" Thayer)
Mrs. Lawrence Tibbett (Jane "Jennie" Marston Burgard)
Mrs. Harrison Williams (Mona Strader, previously Mrs. James Bush) (see Countess Mona von Bismarck)
*15 named to Women's list*

## 1941
(DECEMBER 30, 1941)

### Women
Mme. Felipe A. Espil (Courtney Letts Borden)
Mrs. Byron Foy (Thelma Chrysler)
Mrs. Rodman Arturo de Heeren (Aimée Lopes de Sotomaior)
Mrs. Robert W. Miller (Elizabeth Jane Folger)
Mrs. Stanley Mortimer (Barbara "Babe" Cushing) (see Barbara Cushing Mortimer Paley)
Rosalind Russell
Mrs. Robert Sherwood (Madeline Hurlock)
Mrs. Thomas Shevlin (Lorraine Arnold Rowan)
Mrs. Harrison Williams (Mona Strader, previously Mrs. James Bush) (see Countess Mona von Bismarck)
The Duchess of Windsor (Wallis Warfield Simpson)
*10 named to Women's list*

## 1942
NO LIST

## 1943
(DECEMBER 27, 1943)

### Women
Mrs. André Embiricos (Beatrice Ammidon)
Mrs. Byron Foy (Thelma Chrysler)
Mme. Chiang Kai-shek (Soong Mei-ling)
Mrs. Walter Hoving (Pauline Vandervoort Rogers)
The Hon. Clare Boothe Luce
Lily Pons
Rosalind Russell
Mrs. Harold E. Talbott (Margaret "Peggy" Thayer)
Mrs. Lawrence Tibbett (Jane "Jennie" Marston Burgard)
Mrs. Harrison Williams (Mona Strader, previously Mrs. James Bush) (see Countess Mona von Bismarck)
The Duchess of Windsor (Wallis Warfield Simpson)
*11 named to Women's list*

## 1944
(JANUARY 21, 1945)

### Women
Mrs. André Embiricos (Beatrice Ammidon)
Mrs. Byron Foy (Thelma Chrysler)
Mrs. Howard Hawks (Nancy "Slim" Gross)
Mrs. S. Kent Legare (Minnie Zimmerman)
The Hon. Clare Boothe Luce
Mrs. Stanley Mortimer (Barbara "Babe" Cushing) (see Barbara Cushing Mortimer Paley)
Mrs. William Paley (Dorothy Hart Hearst)
Mrs. Michael Phipps (Muriel "Molly" Lane)
Mrs. William Rhinelander Stewart (Janet Newbold)
The Duchess of Windsor (Wallis Warfield Simpson)
*10 named to Women's list*

## 1945
(DECEMBER 26, 1945)

### Women
Mrs. Byron Foy (Thelma Chrysler)
Mrs. Harry Hopkins (Louise Macy)
The Hon. Clare Boothe Luce
Mrs. Stanley Mortimer (Barbara "Babe" Cushing) (see Barbara Cushing Mortimer Paley)
Millicent Rogers
Rosalind Russell
Mrs. Robert Sarnoff (Esme O'Brien)
Mrs. George Schlee (Valentina Sanina)
Mrs. Lawrence Tibbett (Jane "Jennie" Marston Burgard)
The Duchess of Windsor (Wallis Warfield Simpson)
*10 named to Women's list*

## 1946
(DECEMBER 27, 1946)

### Women
Mrs. Gilbert Adrian (Janet Gaynor) (later named to Fashion Professionals list)
Leonora Corbett
Mrs. Byron Foy (Thelma Chrysler)
Mrs. Howard Hawks (Nancy "Slim" Gross)
The Hon. Clare Boothe Luce
Barbara Cushing Mortimer (Barbara "Babe" Cushing) (see Barbara Cushing Mortimer Paley)
Mrs. William Paley (Dorothy Hart Hearst)
Millicent Rogers
Mrs. George Schlee (Valentina Sanina)
Mrs. Thomas Shevlin (Lorraine Arnold Rowan)
Mrs. William Rhinelander Stewart (Janet Newbold)
Mrs. Harrison Williams (Mona Strader, previously Mrs. James Bush) (see Countess Mona von Bismarck)
The Duchess of Windsor (Wallis Warfield Simpson)
*13 named to Women's list*

## 1947
(DECEMBER 29, 1947)

### Women
Mrs. Byron Foy (Thelma Chrysler)
Mrs. Geoffrey Gates (Louise Macy Hopkins)
Mrs. Howard Hawks (Nancy "Slim" Gross)
Barbara Cushing Mortimer Paley ("Babe")
Mrs. William Rhinelander Stewart (Janet Newbold)
Millicent Rogers
Mrs. William Wallace (Ina Claire)

Mrs. Harrison Williams (Mona Strader, previously Mrs. James Bush) (see Countess Mona von Bismarck)
Mrs. John C. Wilson (Princess Natalia Paley) (later named to Fashion Professionals list)
The Duchess of Windsor (Wallis Warfield Simpson)

### Fashion Professionals, Women
Mrs. Gilbert Adrian (Janet Gaynor)
Sophie Gimbel
Mrs. Orson Munn (Carrie Nunder)
Mrs. George Schlee (Valentina Sanina)
*10 named to Women's list; First year for Fashion Professionals, Women, list; 4 named*

## 1948
(DECEMBER 27, 1948)

### Women
Mme. Louis Arpels (Hélène Ostrowska)
Mrs. André Embiricos (Beatrice Ammidon)
Mrs. Howard Hawks (Nancy "Slim" Gross)
Mrs. William Randolph Hearst Jr. (Austine "Bootsie" McDonnell Cassini)
H.R.H. the Duchess of Kent (born Princess Marina of Greece)
Barbara Cushing Mortimer Paley ("Babe")
Millicent Rogers
Mrs. Alfred G. Vanderbilt (Jean Harvey)
Mrs. Harrison Williams (Mona Strader, previously Mrs. James Bush) (see Countess Mona von Bismarck)
The Duchess of Windsor (Wallis Warfield Simpson)

### Fashion Professionals, Women
Mrs. Gilbert Adrian (Janet Gaynor)
Sophie Gimbel
Mrs. George Schlee (Valentina Sanina)
Gene Tierney
Mrs. John C. Wilson (Natalia Paley)
*10 named to Women's list; 5 named to Fashion Professionals, Women, list*

## 1949
(DECEMBER 27, 1949)

### Women
Mme. Louis Arpels (Hélène Ostrowska)
Mrs. Kingman Douglass (see Adele Astaire)
Mrs. Byron Foy (Thelma Chrysler)
Mrs. Leland Hayward (Nancy "Slim" Gross)
Mrs. William Randolph Hearst Jr. (Austine "Bootsie" McDonnell Cassini)
H.R.H. the Duchess of Kent (born Princess Marina of Greece)
Mary Martin
Barbara Cushing Mortimer Paley ("Babe")
Mrs. Harrison Williams (Mona Strader, previously Mrs. James Bush) (see Countess Mona von Bismarck)
The Duchess of Windsor (Wallis Warfield Simpson)

### Fashion Professionals, Women
Mrs. Gilbert Adrian (Janet Gaynor)
Countess Alain de la Falaise (Maxime Birley)
Sophie Gimbel
Mrs. George Schlee (Valentina Sanina)
Mrs. John C. Wilson (Princess Natalia Paley)
*10 named to Women's list; 5 named to Fashion Professionals, Women, list*

## 1950
(DECEMBER 31, 1950)

### Women

Mme. Louis Arpels (Hélène Ostrowska)

Mrs. André Embiricos (Beatrice Ammidon)

Faye Emerson

Mrs. Byron Foy (Thelma Chrysler)

Mrs. Leland Hayward (Nancy "Slim" Gross)

Mrs. William Randolph Hearst Jr. (Austine "Bootsie" McDonnell Cassini)

Mrs. William O'Dwyer (Elizabeth Simpson)

Barbara Cushing Mortimer Paley ("Babe")

Gloria Swanson

The Duchess of Windsor (Wallis Warfield Simpson)

### Fashion Professionals, Women

Mrs. Gilbert Adrian (Janet Gaynor)

Sophie Gimbel

Mrs. George Schlee (Valentina Sanina)

Mrs. John C. Wilson (Princess Natalia Paley)

*10 named to Women's list; 4 named to Fashion Professionals, Women, list*

## 1951
(DECEMBER 30, 1951)

### Women

Mme. Louis Arpels (Hélène Ostrowska)

Countess Uberto Corti (born Duchess Mita Colonna di Cesarò)

Marlene Dietrich

Irene Dunne

Mrs. Henry Ford II (Anne McDonnell) (see Mrs. Deane Johnson [Anne])

Mrs. Byron Foy (Thelma Chrysler)

H.R.H. Princess Margaret of Great Britain and Northern Ireland

Mrs. William Randolph Hearst Jr. (Austine "Bootsie" McDonnell Cassini)

H.R.H. the Duchess of Kent (born Princess Marina of Greece)

Mrs. Douglas MacArthur (Jean Faircloth)

Mrs. George McGhee (Cecilia DeGolyer)

Barbara Cushing Mortimer Paley ("Babe")

Mrs. Alfred G. Vanderbilt (Jean Harvey)

The Duchess of Windsor (Wallis Warfield Simpson)

### Fashion Professionals, Women

Mrs. Gilbert Adrian (Janet Gaynor)

Margaret Case

Geneviève Fath

Sophie Gimbel

Mrs. Leon Mandel (Carola Panerai)

Mrs. Orson Munn (Carrie Nunder)

Mrs. George Schlee (Valentina Sanina)

Gloria Swanson

Gene Tierney

Mrs. John C. Wilson (Princess Natalia Paley)

*14 named to Women's list; 10 named to Fashion Professionals, Women, list*

## 1952
(DECEMBER 28, 1952)

### Women

Mme. Louis Arpels (Hélène Ostrowska)

Mme. Henri Bonnet (Hellé Zervoudaki)

Contessa Rodolfo Crespi (Consuelo O'Connor)

Marlene Dietrich

Mrs. Dwight D. Eisenhower (Mary "Mamie" Doud)

Mrs. Byron Foy (Thelma Chrysler)

Mrs. Winston Guest (C. Z. Cochrane)

Mrs. William Randolph Hearst Jr. (Austine "Bootsie" McDonnell Cassini)

Oveta Culp Hobby

H.R.H. the Duchess of Kent (born Princess Marina of Greece)

Barbara Cushing Mortimer Paley ("Babe")

The Duchess of Windsor (Wallis Warfield Simpson)

### Fashion Professionals, Women

Mrs. Gilbert Adrian (Janet Gaynor)

Bettina Ballard

Geneviève Fath

Sophie Gimbel

Mrs. Andrew Goodman (Nena Manach)

Mrs. Leon Mandel (Carola Panerai)

Mrs. Orson Munn (Carrie Nunder)

Mrs. George Schlee (Valentina Sanina)

Gene Tierney

*12 named to Women's list; 9 named to Fashion Professionals, Women, list*

## 1953
(JANUARY 4, 1954)

### Women

Mme. Louis Arpels (Hélène Ostrowska)

Mme. Henri Bonnet (Hellé Zervoudaki)

Mrs. Henry Ford II (Anne McDonnell) (see Mrs. Deane Johnson [Anne])

Mrs. Byron Foy (Thelma Chrysler)

Mrs. Winston Guest (C. Z. Cochrane)

Mrs. William Randolph Hearst Jr. (Austine "Bootsie" McDonnell Cassini)

Oveta Culp Hobby

H.R.H. Princess Margaret of Great Britain and Northern Ireland

Mary Martin

Barbara Cushing Mortimer Paley ("Babe")

Mrs. Alfred G. Vanderbilt (Jean Harvey)

The Duchess of Windsor (Wallis Warfield Simpson)

### Fashion Professionals, Women

Mrs. Gilbert Adrian (Janet Gaynor)

Margaret Case

Geneviève Fath

Sophie Gimbel

Mrs. Andrew Goodman (Nena Manach)

Mrs. Leon Mandel (Carola Panerai)

Mrs. Orson Munn (Carrie Nunder)

Mrs. George Schlee (Valentina Sanina)

## Mrs. John C. Wilson (Princess Natalia Paley)

*12 named to Women's list; 9 named to Fashion Professionals, Women, list*

## 1954
(JANUARY 3, 1955)

### Women

Mme. Louis Arpels (Hélène Ostrowska)

Mme. Henri Bonnet (Hellé Zervoudaki) (later named to Fashion Professionals list)

Mrs. Byron Foy (Thelma Chrysler)

H.R.H. Princess Margaret of Great Britain and Northern Ireland

Queen Frederika of Greece

Mrs. William Randolph Hearst Jr. (Austine "Bootsie" McDonnell Cassini)

Grace Kelly (see H.S.H. Princess Grace of Monaco)

Mme. Arturo López-Willshaw (Patricia López-Huici)

The Hon. Clare Boothe Luce

Barbara Cushing Mortimer Paley ("Babe")

Mrs. Harold E. Talbott (Margaret "Peggy" Thayer)

Mrs. Alfred G. Vanderbilt (Jean Harvey)

The Duchess of Windsor (Wallis Warfield Simpson)

### Fashion Professionals, Women

Margaret Case

Donna Simonetta Fabiani

Geneviève Fath

Sophie Gimbel

Enid Haupt

Mrs. Walter Hoving (Pauline Vandervoort Rogers)

Mrs. Leon Mandel (Carola Panerai)

Mrs. George Schlee (Valentina Sanina)

Diana Vreeland

Mrs. John C. Wilson (Princess Natalia Paley)

*13 named to Women's list; 10 named to Fashion Professionals, Women, list*

## 1955
(JANUARY 5, 1956)

### Women

Mme. Jacques Balsan (Consuelo Vanderbilt)

Contessa Rodolfo Crespi (Consuelo O'Connor)

Mrs. Henry Ford II (Anne McDonnell) (see Mrs. Deane Johnson [Anne])

Mrs. Byron Foy (Thelma Chrysler)

H.R.H. Princess Margaret of Great Britain and Northern Ireland

Mrs. Winston Guest (C. Z. Cochrane)

Mrs. William Randolph Hearst Jr. (Austine "Bootsie" McDonnell Cassini)

Oveta Culp Hobby

Grace Kelly (see H.S.H. Princess Grace of Monaco)

Mme. Arturo Lopez-Willshaw (Patricia López-Huici)

Barbara Cushing Mortimer Paley ("Babe")

Aline, Countess of Quintanilla (Aline Griffith) (see Aline, Countess of Romanones)

Mrs. Alfred G. Vanderbilt (Jean Harvey)

The Duchess of Windsor (Wallis Warfield Simpson)

## 1956
(JANUARY 3, 1957)

### Women

Countess Mona von Bismarck (Mona Strader, previously Mrs. Harrison Williams) (see Mrs. James Bush)

Contessa Rodolfo Crespi (Consuelo O'Connor)

Marlene Dietrich

Mrs. Henry Ford II (Anne McDonnell) (see Mrs. Deane Johnson [Anne])

H.R.H. Princess Margaret of Great Britain and Northern Ireland

Mrs. Winston Guest (C. Z. Cochrane)

Mrs. William Randolph Hearst Jr. (Austine "Bootsie" McDonnell Cassini)

Audrey Hepburn

H.R.H. the Duchess of Kent (born Princess Marina of Greece)

H.S.H. Princess Grace of Monaco

Barbara Cushing Mortimer Paley ("Babe")

Aline, Countess of Quintanilla (Aline Griffith) (see Aline, Countess of Romanones)

Rosalind Russell

The Duchess of Windsor (Wallis Warfield Simpson)

### Fashion Professionals, Women

Mme. Henri Bonnet (Hellé Zervoudaki)

Mrs. Hector Escobosa (Joan Raisbeck)

Donna Simonetta Fabiani

Mrs. Leon Mandel (Carola Panerai)

Mrs. Stanley Marcus (Mary Cantrell)

Catherine McManus

Phyllis Digby Morton

Vicomtesse Jacqueline de Ribes (Jacqueline Bonnin de La Bonninière de Beaumont) (see Comtesse Jacqueline de Ribes) (later named to regular Women's list)

Mrs. George Schlee (Valentina Sanina)

Carmel Snow

*14 named to Women's list; 10 named to Fashion Professionals, Women, list*

## 1957
(JANUARY 3, 1958)

### Women

Mrs. Thomas Bancroft Jr. (Margaret Bedford; later Princess D'Arenberg)

Countess Mona von Bismarck (Mona Strader, previously Mrs. Harrison Williams) (see Mrs. James Bush)

### Fashion Professionals, Women

Donna Simonetta Fabiani

Geneviève Fath

Anne Fogarty

Sophie Gimbel

Mrs. Andrew Goodman (Nena Manach)

Mrs. Stanley Marcus (Mary Cantrell)

Phyllis Digby Morton

Mrs. George Schlee (Valentina Sanina)

Carmel Snow

Diana Vreeland

*14 named to Women's list; 10 named to Fashion Professionals, Women, list*

Claudette Colbert

Contessa Rodolfo Crespi (Consuelo O'Connor)

Mrs. Henry Ford II (Anne McDonnell) (see Mrs. Deane Johnson [Anne])

H.M. Queen Elizabeth II of Great Britain and Northern Ireland

Mrs. Winston Guest (C. Z. Cochrane)

Mrs. William Randolph Hearst Jr. (Austine "Bootsie" McDonnell Cassini)

Audrey Hepburn

Barbara Cushing Mortimer Paley ("Babe")

Aline, Countess of Quintanilla (Aline Griffith) (see Aline, Countess of Romanones)

Vicomtesse Jacqueline de Ribes (Jacqueline Bonnin de La Bonninière de Beaumont) (see Comtesse Jacqueline de Ribes)

The Duchess of Windsor (Wallis Warfield Simpson)

Mrs. Norman K. Winston (Rosita Halfpenny)

### Fashion Professionals, Women

Mme. Hélène Arpels

Margaret Case

Coco Chanel (Gabrielle)

Sybil Connolly

Donna Simonetta Fabiani

Enid Haupt

Mrs. Stanley Marcus (Mary Cantrell)

Mrs. Earl E. T. Smith (Florence Pritchett Canning)

Carmel Snow

Pauline Trigère

Diana Vreeland

*14 named to Women's list; 11 named to Fashion Professionals, Women, list*

## 1958
(JANUARY 5, 1959)

### Women

Mrs. Thomas Bancroft Jr. (Margaret Bedford; later Princess D'Arenberg)

Mrs. David Bruce (Evangeline Bell)

Contessa Rodolfo Crespi (Consuelo O'Connor)

Mrs. Henry Ford II (Anne McDonnell) (see Mrs. Deane Johnson [Anne])

H.R.H. Princess Margaret of Great Britain and Northern Ireland

Mrs. Winston Guest (C. Z. Cochrane)

Mrs. William Randolph Hearst Jr. (Austine "Bootsie" McDonnell Cassini)

Audrey Hepburn

Kay Kendall

Dina Merrill (see Dina Merrill Hartley)

Mrs. Bruno Pagliai (Merle Oberon)

Aline, Countess of Quintanilla (Aline Griffith) (see Aline, Countess of Romanones)

Mrs. Norman K. Winston (Rosita Halfpenny)

### Fashion Professionals, Women

Mrs. Gilbert Adrian (Janet Gaynor)

Mme. Hélène Arpels

Coco Chanel (Gabrielle)

Sybil Connolly

Donna Simonetta Fabiani

Sophie Gimbel

Enid Haupt

Mrs. Leon Mandel (Carola Panerai)

Mrs. Stanley Marcus (Mary Cantrell)

Mrs. Tom May (Anita Keiler)

Carmel Snow

Pauline Trigère

### Hall of Fame (H.O.F.), Women

Mme. Jacques Balsan (Consuelo Vanderbilt)

Countess Mona von Bismarck (Mona Strader, previously Mrs. Harrison Williams) (see Mrs. James Bush)

Claudette Colbert

Irene Dunne

H.M. Queen Elizabeth II of Great Britain and Northern Ireland

Mary Martin

Barbara Cushing Mortimer Paley ("Babe")

The Duchess of Windsor (Wallis Warfield Simpson)

*13 named to Women's list; 12 named to Fashion Professionals, Women, list; first year for Hall of Fame, Women, 8 named*

## 1959
(JANUARY 8, 1960)

### Women

Sra. Giovanni Agnelli (born Princess Marella Caracciolo di Castagneto)

Mme. Hervé Alphand (Nicole Merenda Bunau-Varilla)

Mrs. Thomas Bancroft Jr. (Margaret Bedford, later Princess D'Arenberg)

Mrs. Loel Guinness (Gloria Rubio Alatorre Fakhry)

Audrey Hepburn

Princess Alexandra of Kent (see Princess Alexandra of Kent [Mrs. Angus Ogilvy])

H.S.H. Princess Grace of Monaco

Mrs. Bruno Pagliai (Merle Oberon)

Vicomtesse Jacqueline de Ribes (Jacqueline Bonnin de La Bonninière de Beaumont) (see Comtesse Jacqueline de Ribes)

Mrs. John Barry Ryan III (Dorinda "D. D." Dixon)

Mrs. Walther Moreira Salles (Elizinha) (see Elizinha Gonçalves)

Mrs. Norman K. Winston (Rosita Halfpenny)

### Fashion Professionals, Women

Coco Chanel (Gabrielle)

Donna Simonetta Fabiani

Princess Irène Galitzine

Sophie Gimbel

Mrs. Leon Mandel (Carola Panerai)

Mrs. Lawrence Marcus (Shelby)

Mrs. Tom May (Anita Keiler)

Carmel Snow

Geraldine Stutz

Pauline Trigère

### H.O.F., Women

Contessa Rodolfo Crespi (Consuelo O'Connor)

Mrs. Henry Ford II (Anne McDonnell) (see Mrs. Deane Johnson [Anne])

Mrs. Winston Guest (C. Z. Cochrane)

Mrs. William Randolph Hearst Jr. (Austine "Bootsie" McDonnell Cassini)

*12 names to Women's list; 10 named to Fashion Professionals, Women, list; 4 named to Hall of Fame, Women*

# The 1960s

## 1960
(JANUARY 6, 1961)

### Women

Sra. Giovanni Agnelli (born Princess Marella Caracciolo di Castagneto)
Mrs. David Bruce (Evangeline Bell)
Mrs. Loel Guinness (Gloria Rubio Alatorre Fakhry)
Mrs. Patrick Guinness (Freiin Dolores von Fürstenberg-Herdringen)
Audrey Hepburn
Mrs. John F. Kennedy (Jacqueline Bouvier) (see Jacqueline Kennedy Onassis)
Princess Alexandra of Kent (see Princess Alexandra of Kent [Mrs. Angus Ogilvy])
Charlotte Ford Niarchos
Vicomtesse Jacqueline de Ribes (Jacqueline Bonnin de La Bonninière de Beaumont) (see Comtesse Jacqueline de Ribes)
Mrs. John Barry Ryan III (Dorinda "D. D." Dixon)
H.M. Queen Sirikit of Thailand
Mrs. Norman K. Winston (Rosita Halfpenny)

### Fashion Professionals, Women

Coco Chanel (Gabrielle)
Sybil Connolly
Donna Simonetta Fabiani
Sophie Gimbel
Enid Haupt
Mrs. Stanley Marcus (Mary Cantrell)
Mme. Hélène Rochas
Carmel Snow
Pauline Trigère
Diana Vreeland

### H.O.F., Women

H.R.H. the Duchess of Kent (born Princess Marina of Greece)
Mme. Arturo Lopez-Willshaw (Patricia López-Huici)
H.S.H. Princess Grace of Monaco
Mrs. Bruno Pagliai (Merle Oberon)

*12 named to Women's list; 10 named to Fashion Professionals, Women, list; 4 named to Hall of Fame, Women*

## 1961
(JANUARY 5, 1962)

### Women

Sra. Giovanni Agnelli (born Princess Marella Caracciolo di Castagneto)
Sra. Umberto Agnelli (Antonella Piaggio)
Mme. Hervé Alphand (Nicole Merenda Bunau-Varilla)
Mrs. David Bruce (Evangeline Bell)
Mrs. Loel Guinness (Gloria Rubio Alatorre Fakhry)
Mrs. John F. Kennedy (Jacqueline Bouvier) (see Jacqueline Kennedy Onassis)
Princess Alexandra of Kent (see Princess Alexandra of Kent [Mrs. Angus Ogilvy])
Princess Lee Radziwill (Lee Bouvier, previously Mrs. Michael Canfield) (see Lee Radziwill) (see Lee Radziwill Ross)
Vicomtesse Jacqueline de Ribes (Jacqueline Bonnin de La Bonninière de Beaumont) (see Comtesse Jacqueline de Ribes)

---

Mrs. John Barry Ryan III (Dorinda "D. D." Dixon)
H.M. Queen Sirikit of Thailand
Mrs. Charles Wrightsman (Jayne Larkin)

### Fashion Professionals, Women

Mme. Hélène Arpels
Coco Chanel (Gabrielle)
Sybil Connolly
Donna Simonetta Fabiani
Sophie Gimbel
Mrs. Lawrence Marcus (Shelby)
Mrs. Tom May (Anita Keiler)
Mme. Hélène Rochas
Pauline Trigère
Diana Vreeland

### H.O.F., Women

Audrey Hepburn
Mrs. Norman K. Winston (Rosita Halfpenny)

*12 named to Women's list; 10 named to Fashion Professionals, Women, list; 2 named to Hall of Fame, Women*

## 1962
(JANUARY 4, 1963)

### Women

Sra. Giovanni Agnelli (born Princess Marella Caracciolo di Castagneto)
Mme. Hervé Alphand (Nicole Merenda Bunau-Varilla)
Mrs. David Bruce (Evangeline Bell)
Mrs. Frederick Eberstadt (Isabel Nash)
Mrs. Loel Guinness (Gloria Rubio Alatorre Fakhry)
Mrs. John F. Kennedy (Jacqueline Bouvier) (see Jacqueline Kennedy Onassis)
Gloria Vanderbilt Lumet (see Gloria Vanderbilt)
Princess Lee Radziwill (Lee Bouvier, previously Mrs. Michael Canfield) (see Lee Radziwill) (see Lee Radziwill Ross)
Mrs. John Barry Ryan III (Dorinda "D. D." Dixon)
Mrs. Walther Moreira Salles (Elizinha) (see Elizinha Gonçalves)
Baroness Fiona Thyssen-Bornemisza
Mrs. Charles Wrightsman (Jayne Larkin)

### Fashion Professionals, Women

Coco Chanel (Gabrielle)
Anita Colby (see Mrs. Palen Flagler [Anita Colby])
Sybil Connolly
Donna Simonetta Fabiani
Sophie Gimbel
Enid Haupt
Mrs. Stanley Marcus (Mary Cantrell)
Mrs. Tom May (Anita Keiler)
Mrs. Samuel Newhouse (Mitzi Epstein)
Mme. Hélène Rochas
Pauline Trigère
Diana Vreeland

### H.O.F., Women

Vicomtesse Jacqueline de Ribes (Jacqueline Bonnin de La Bonninière de Beaumont) (see Comtesse Jacqueline de Ribes)
Aline, Countess of Quintanilla (Aline Griffith) (see Aline, Countess of Romanones)

*12 named to Women's list; 12 named to Professionals, Women, list; 2 named to Hall of Fame, Women*

## 1963
(JANUARY 5, 1964)

### Women

Princess Alexandra of Kent (Mrs. Angus Ogilvy)
Mrs. David Bruce (Evangeline Bell)
Mrs. Wyatt Cooper (Gloria Vanderbilt) (see Gloria Vanderbilt)
Mrs. Loel Guinness (Gloria Rubio Alatorre Fakhry)
Mrs. T. Charlton Henry (Julia Biddle)
Dina Merrill (see Dina Merrill Hartley)
Empress Farah Pahlavi (Farah Diba)
Princess Lee Radziwill (Lee Bouvier, previously Mrs. Michael Canfield) (see Lee Radziwill) (see Lee Radziwill Ross)
Mrs. Walther Moreira Salles (Elizinha) (see Elizinha Gonçalves)
Baroness Fiona Thyssen-Bornemisza
Mrs. Alfred G. Vanderbilt (Jean Harvey)
Mrs. Charles Wrightsman (Jayne Larkin)

### Fashion Professionals, Women

Margaret Case
Coco Chanel (Gabrielle)
Mrs. David Evins (Marilyn)
Donna Simonetta Fabiani
Princess Irène Galitzine
Sophie Gimbel
Mrs. Milton H. Greene (Amy Franco)
Mrs. Stanley Marcus (Mary Cantrell)
Mrs. Samuel Newhouse (Mitzi Epstein)
Geraldine Stutz
Pauline Trigère
Diana Vreeland

### H.O.F., Women

Sra. Giovanni Agnelli (born Princess Marella Caracciolo di Castagneto)
Mme. Hervé Alphand (Nicole Merenda Bunau-Varilla)
Mrs. John Barry Ryan III (Dorinda "D. D." Dixon)

*12 named to Women's list; 12 named to Fashion Professionals, Women, list; 3 named to Hall of Fame, Women*

## 1964
(JANUARY 3, 1965)

### Women

Mrs. William McCormick Blair Jr. (Catherine "Deeda" Gerlach Jelke)
Mrs. Alfred Bloomingdale (Betsy Newling)
Mrs. Wyatt Cooper (Gloria Vanderbilt) (see Gloria Vanderbilt)
Mrs. John F. Kennedy (Jacqueline Bouvier) (see Jacqueline Kennedy Onassis)
Mrs. Samuel Newhouse (Mitzi Epstein)
Mrs. Joseph P. Kennedy (Rose Fitzgerald)
Mrs. Paul Mellon (Bunny Lowe Lambert Lloyd)
Dina Merrill (see Dina Merrill Hartley)
Charlotte Ford Niarchos
Princess Lee Radziwill (Lee Bouvier, previously Mrs. Michael Canfield) (see Lee Radziwill) (see Lee Radziwill Ross)
H.M. Queen Sirikit of Thailand

*12 named to Women's list; 12 named to Professionals, Women, list; 2 named to Hall of Fame, Women*

## 1965
(JANUARY 14, 1966)

### Women

Princess Paola of Belgium
Mrs. William McCormick Blair Jr. (Catherine "Deeda" Gerlach Jelke)
Amanda Burden
Mrs. Wyatt Cooper (Gloria Vanderbilt) (see Gloria Vanderbilt)
Mrs. Kirk Douglas (Anne Buydens)
Mrs. Charles Engelhard Jr. (Jane Reiss Mannheimer)
Mrs. Joseph P. Kennedy (Rose Fitzgerald)
Princess Alexandra of Kent (Mrs. Angus Ogilvy)
Charlotte Ford Niarchos
Princess Luciana Pignatelli (later named to Fashion Professionals list)
Barbra Streisand
Mrs. Gianni Uzielli (Anne Ford)
Mrs. Alfred G. Vanderbilt (Jean Harvey)

### Fashion Professionals, Women

Marisa Berenson (later named to regular Women's list)
Robin Butler
Mrs. Frederick Eberstadt (Isabel Nash)
Mrs. David Evins (Marilyn)
Mrs. Milton H. Greene (Amy Franco)

---

Mrs. Gianni Uzielli (Anne Ford)
Mrs. Alfred G. Vanderbilt (Jean Harvey)
Mrs. Charles Wrightsman (Jayne Larkin)

### Fashion Professionals, Women

Robin Butler (see Mrs. Rupert Hambro [Robin Boyer Butler])
Mrs. Frederick Eberstadt (Isabel Nash)
Mrs. David Evins (Marilyn)
Mrs. Milton H. Greene (Amy Franco)
Mollie Parnis Livingston
Mrs. Samuel Newhouse (Mitzi Epstein)
Mary Quant
Mrs. Richard Rodgers (Dorothy Feiner)
Mrs. William Rose (Bernice)
Mme. Helena Rubinstein
Gloria Schiff
Geraldine Stutz

### H.O.F., Women

Mrs. David Bruce (Evangeline Bell)
Margaret Case
Coco Chanel (Gabrielle)
Donna Simonetta Fabiani
Sophie Gimbel
Mrs. Loel Guinness (Gloria Rubio Alatorre Fakhry)
Mrs. T. Charlton Henry (Julia Biddle)
Mrs. Stanley Marcus (Mary Cantrell)
Mrs. Tom May (Anita Keiler)
Mme. Hélène Rochas
Rosalind Russell
Mrs. Walther Moreira Salles (Elizinha) (see Elizinha Gonçalves)
Pauline Trigère
Diana Vreeland

*13 named to Women's list; 12 named to Fashion Professionals, Women, list; 14 named to Hall of Fame, Women*

## 1966
(JANUARY 3, 1967)

### Women

Lauren Bacall
Amanda Burden
Mrs. Wyatt Cooper (Gloria Vanderbilt) (see Gloria Vanderbilt)
Mrs. Angier Biddle Duke (Robin Tippett Lynn)
Cristina Ford (Cristina Vettore Austin)
Mrs. Patrick Guinness (Freiin Dolores von Fürstenberg-Herdringen)
Mrs. Lyndon B. Johnson (Claudia "Lady Bird" Taylor)
Sophia Loren
Charlotte Ford Niarchos
Princess Lee Radziwill (Lee Bouvier, previously Mrs. Michael Canfield) (see Lee Radziwill) (see Lee Radziwill Ross)
Betsy Pickering Theodoracopulos (see Mrs. Michael Kaiser [Betsy])
Mrs. Alfred G. Vanderbilt (Jean Harvey)

### Fashion Professionals, Women

Marisa Berenson (later named to regular Women's list)
Robin Butler
Mrs. Frederick Eberstadt (Isabel Nash)
Mrs. David Evins (Marilyn)
Mrs. Montague Hackett (Flavia Riggio)
Mrs. Thomas L. Kempner (Nan Schlesinger)
Mme. Françoise de Langlade (see Françoise de la Renta)
Mollie Parnis Livingston
Caterine Milinaire
Princess Luciana Pignatelli
Gloria Schiff
Baroness Fiona Thyssen-Bornemisza

### Fashion Professionals, Men

Bill Blass
Pierre Cardin
Patrick O'Higgins
Norman Parkinson
I. S. V. Patcevitch
John Weitz

---

Emmanuelle Khanh
Mollie Parnis Livingston
Caterine Milinaire
Mrs. Mark Miller
Mary Quant
Mrs. Richard Rodgers (Dorothy Feiner)
Mrs. William Rose (Bernice)

### H.O.F., Women

Anita Colby (see Mrs. Palen Flagler [Anita Colby])
Sybil Connolly
Dame Margot Fonteyn
Princess Irène Galitzine
Enid Haupt
Mrs. John F. Kennedy (Jacqueline Bouvier) (see Jacqueline Kennedy Onassis)
Dina Merrill (see Dina Merrill Hartley)
Mrs. Gilbert Miller (Kathryn "Kitty" Bache)
Mrs. Samuel Newhouse (Mitzi Epstein)
Geraldine Stutz
H.M. Queen Sirikit of Thailand
Mrs. Charles Wrightsman (Jayne Larkin)

*13 named to Women's list; 12 named to Fashion Professionals, Women, list; 12 named to Hall of Fame, Women*

## H.O.F., Women

Mrs. Joseph P. Kennedy (Rose Fitzgerald)

*12 named to Women's list; 12 named to Fashion Professionals, Women, list; first year for Fashion Professionals, Men, list; 6 named; 1 named to Hall of Fame, Women*

## 1967
(JANUARY 12, 1968)

### Women

Lauren Bacall
Amanda Burden
Mrs. Wyatt Cooper (Gloria Vanderbilt) (see Gloria Vanderbilt)
Mrs. Angier Biddle Duke (Robin Tippett Lynn)
Faye Dunaway
Cristina Ford (Cristina Vettore Austin)
Princess Alexandra of Kent (Mrs. Angus Ogilvy)
Charlotte Ford Niarchos
Princess Lee Radziwill (Lee Bouvier, previously Mrs. Michael Canfield) (see Lee Radziwill) (see Lee Radziwill Ross)
Mrs. Ronald Reagan (Nancy Robbins)
Mrs. Charles Spittal Robb (Lynda Johnson)
Betsy Pickering Theodoracopulos (see Mrs. Michael Kaiser [Betsy])

### Fashion Professionals, Women

Marisa Berenson (later named to regular Women's list)
Mrs. David Evins (Marilyn)
Mrs. Montague Hackett (Flavia Riggio)
Mrs. Thomas L. Kempner (Nan Schlesinger)
Mme. Bernard Lanvin (Maryll Orsini)
Princess Luciana Pignatelli
Mary Quant
Françoise de la Renta
Mme. Elieth Roux
Mrs. Renny Saltzman (Ellin Sadowsky)
Gloria Schiff
Veruschka (Countess Vera von Lehndorff)

### H.O.F., Women

Robin Butler
Mrs. Frederick Eberstadt (Isabel Nash)
Mollie Parnis Livingston

*12 named to Women's list; 12 named to Fashion Professionals, Women, list; no Fashion Professionals, Men, list; 3 named to Hall of Fame, Women*

## 1968
(JANUARY 13, 1969)

*Women's list divided into two categories:*

### Great Fashion Classicists

Mme. Ahmed Benhima (Aïcha Laghzaoui)
Mrs. Alfred Bloomingdale (Betsy Newling)
The Duchess of Cadaval (Claudine Tritz) (later named to Fashion Professionals list)
Mrs. John Carey-Hughes (Carroll McDaniel, previously the Marquesa de Portago) (see Mrs. Milton Petrie)
Mrs. Charles Engelhard Jr. (Jane Reiss Mannheimer)
Princess Ira von Fürstenberg

Mrs. Graham Mattison (Perla de Lucena)
Mrs. Vincente Minnelli (Lee Anderson)
Mrs. Charles Revson (Lyn Fisher Sheresky)
Mrs. Liberman Savitt (Louise, see Mrs. Frederick Melhado) (see Mrs. Henry Grunwald)
Betsy Pickering Theodoracopulos (see Mrs. Michael Kaiser [Betsy])
Mrs. Gianni Uzielli (Anne Ford)

## Most Imaginative Women in Current Fashion

Marisa Berenson
Robin Butler (had been named to Hall of Fame in 1967)
Diahann Carroll
Mrs. Wyatt Cooper (Gloria Vanderbilt) (see Gloria Vanderbilt)
Mrs. Ahmet Ertegun (Mica Banu Grecianu)
Mrs. Thomas L. Kempner (Nan Schlesinger)

Marisol (Escobar)
Maya Plisetskaya
Chessy Rayner
Baroness Philippe de Rothschild (Pauline Potter Leser)
Mrs. Renny Saltzman (Ellin Sadowsky)
Barbra Streisand

## Men

Cecil Beaton
Bill Blass
Wyatt Cooper
Count Rodolfo Crespi
Comte Hubert de Givenchy
George Hamilton
Jean-Claude Killy
Bernard Lanvin
The Earl of Lichfield (Patrick)
H.R.H. Prince Philip, the Duke of Edinburgh
Baron Alexis de Redé
George Widener

## H.O.F., Men

Fred Astaire
H.R.H. Prince Edward, the Duke of Windsor

## 1969
(JANUARY 10, 1970)

### Women

Mme. Ahmed Benhima (Aïcha Laghzaoui)
Mrs. William McCormick Blair Jr. (Catherine "Deeda" Gerlach Jelke)
Mrs. Wyatt Cooper (Gloria Vanderbilt) (see Gloria Vanderbilt)
Mrs. Kirk Douglas (Anne Buydens)
Mrs. Ahmet Ertegun (Mica Banu Grecianu)
Mrs. Robert Evans (Ali MacGraw)
Mrs. Patrick Guinness (Freiin Dolores von Fürstenberg-Herdringen)
H.R.H. the Begum Aga Khan (see Princess Salimah Aga Khan)
Mrs. Graham Mattison (Perla de Lucena)
Charlotte Ford Niarchos
Chessy Rayner
Mrs. Charles Revson (Lyn Fisher Sheresky)
Mrs. Robert Sakowitz (Pamela Zauderer)
Betsy Pickering Theodoracopulos (see Mrs. Michael Kaiser [Betsy])

### Fashion Professionals, Women

Berry Berenson
Marisa Berenson (later named to regular Women's list)
Mrs. David Evins (Marilyn)
Lady Pamela Harlech
Mrs. Thomas L. Kempner (Nan Schlesinger)
Minouche Le Blan
Eve Orton
Françoise de la Renta
Mrs. Renny Saltzman (Ellin Sadowsky)
Gloria Schiff
Veruschka (Countess Vera von Lehndorff) (Robin Butler was mistakenly named—she was named to the H.O.F. in 1967)

### Men

Giovanni "Gianni" Agnelli
Adolphus Andrews
Harry Belafonte
Gianni Bulgari
Michael Butler
James Coburn
Wyatt Cooper
Frank Gifford
George Hamilton
Jean-Claude Killy
Baron Eric de Rothschild
David Susskind

### Fashion Professionals, Men

Bill Blass
Luis Estévez
Comte Hubert de Givenchy
Robert L. Green
Baron Nicolas de Gunzburg
Walter Halle
Sighsten Herrgard
Bernard Lanvin
The Earl of Lichfield (Patrick)
Robert Sakowitz
Philippe Venet
John Weitz

### H.O.F., Women

Baroness Philippe de Rothschild (Pauline Potter Leser)

### H.O.F., Men

The Hon. Dean Acheson
The Hon. Angier Biddle Duke
H.R.H. Prince Philip, the Duke of Edinburgh
Douglas Fairbanks Jr.
Cary Grant

# The 1970s

## 1970
(JANUARY 11, 1971)

### Women

Mme. Ahmed Benhima (Aïcha Laghzaoui)
Diahann Carroll
Catherine Deneuve
H.R.H. the Begum Aga Khan (see Princess Salimah Aga Khan)
Sophia Loren
Denise Minnelli (Denise Radosavljević, previously Denise de Gigante) (see Mrs. Prentis Cobb Hale [Denise])
Mrs. Richard Pistell (Carroll McDaniel, previously Mrs. John Carey-Hughes (see the Marquesa de Portago) (see Mrs. Milton Petrie)
Mme. Georges Pompidou (Claude Cahour)
Mrs. Ronald Reagan (Nancy Robbins)
Mrs. Samuel P. Reed (Annette Manheimer) (see Annette de la Renta)
Mrs. Charles Revson (Lyn Fisher Sheresky)
Betsy Pickering Theodoracopulos (see Mrs. Michael Kaiser [Betsy])

### Fashion Professionals, Women

Marisa Berenson (later named to regular Women's list)
Pilar Crespi
Mrs. David Evins (Marilyn)
Lady Pamela Harlech
Mrs. Thomas L. Kempner (Nan Schlesinger)
Anne Klein
China Machado
Eve Orton
Sonia Rykiel
Mrs. Robert Sakowitz (Pamela Zauderer)
Mrs. Renny Saltzman (Ellin Sadowsky)
Naomi Sims

### Men

Yul Brynner
J. Frederick Byers III
Hernando Courtwright
John Galliher
The Hon. Angus Ogilvy (see The Rt. Hon. Sir Angus Ogilvy)
Armando Orsini
Giorgio Pavone
Baron Alexis de Redé
Thomas Shevlin
Bobby Short
The Hon. Sargent Shriver
Lord Snowdon, Antony Armstrong-Jones

### Fashion Professionals, Men

Hardy Amies (see Sir Hardy Amies)
Antonio Cerutti
Baron Nicolas de Gunzburg
Kenneth Jay Lane
Anthony Thomas "Tommy" Nutter
André Oliver
Oscar de la Renta
Robert Sakowitz
Alexander Shields
Chip Tolbert
Philippe Venet
Daniel Zarem

### H.O.F., Women

Mrs. William McCormick Blair Jr. (Catherine "Deeda" Gerlach Jelke)
Mrs. Alfred Bloomingdale (Betsy Newling)
Mrs. Wyatt Cooper (Gloria Vanderbilt) (see Gloria Vanderbilt)
Mrs. Kirk Douglas (Anne Buydens)
Mrs. Patrick Guinness (Freiin Dolores von Fürstenberg-Herdringen)

### H.O.F., Men

Giovanni "Gianni" Agnelli
Cecil Beaton
Bill Blass
Pierre Cardin
Count Rodolfo Crespi
Comte Hubert de Givenchy
Bernard Lanvin
The Hon. Henry Cabot Lodge
Colonel Serge Obolensky
Norman Parkinson
I. S. V. Patcevitch
Baron Eric de Rothschild
John Weitz

## 1971
(JANUARY 7, 1972)

### Women

Mrs. Sidney Brody (Frances Lasker)
Mme. François Catroux (Betty Saint)
Cher
Kitty Hawks
Mrs. Reinaldo Herrera Jr. (Carolina Pacanins y Niño) (see Carolina Herrera)
H.R.H. the Begum Aga Khan (see Princess Salimah Aga Khan)
Mrs. Frederick Melhado (Louise Liberman, previously Mrs. Richard Savitt) (see Mrs. Henry Grunwald)
Liza Minnelli
Mrs. Richard Pistell (Carroll McDaniel, previously Mrs. John Carey-Hughes (see the Marquesa de Portago) (see Mrs. Milton Petrie)
Mrs. Ronald Reagan (Nancy Robbins)
Mme. Pierre Schlumberger (São da Diniz Conceicao)
Twiggy
Mrs. Yann Weymouth (Lally Graham)

### Fashion Professionals, Women

Mrs. Bruce Addison (Gillis McGill)
Marisa Berenson (later named to regular Women's list)
Diane von Furstenberg
Mme. Grès (Alix)
Mary McFadden
Eve Orton
Elsa Peretti
Françoise de la Renta
Mrs. Robert Sakowitz (Pamela Zauderer)
Mrs. Renny Saltzman (Ellin Sadowsky)
Gloria Schiff
Naomi Sims

### Men

Billy Baldwin
Harry Belafonte
Gianni Bulgari
Frank Gifford
Mick Jagger
The Hon. John V. Lindsay
Sidney Poitier
Baron Alexis de Redé
Robert Redford
Thomas Schippers
Lord Snowdon, Antony Armstrong-Jones
The Marquis of Villaverde, Cristóbal Martínez-Bordiú y Ortega

### Fashion Professionals, Men

Hardy Amies (see Sir Hardy Amies)
Robert L. Green
Kenneth Jay Lane
Anthony Thomas "Tommy" Nutter
André Oliver
Oscar de la Renta
Robert Sakowitz
Chip Tolbert
Philippe Venet
Daniel Zarem

### H.O.F., Women

Mrs. Ahmet Ertegun (Mica Banu Grecianu)
Mrs. Thomas L. Kempner (Nan Schlesinger)
Chessy Rayner
Mrs. Charles Revson (Lyn Fisher Sheresky)
Betsy Pickering Theodoracopulos (see Mrs. Michael Kaiser [Betsy])

### H.O.F., Men

The Earl of Lichfield (Patrick)
Baron Nicolas de Gunzburg

## 1972
(JANUARY 3, 1973)

### Women

Marisa Berenson
Mrs. William F. Buckley Jr. (Pat Taylor)
Cristina Ford (Cristina Vettore Austin)
Mrs. William Clay Ford (Martha Firestone)
Sra. Gianluigi Gabetti (Bettina Sichel)
Mrs. Reinaldo Herrera Jr. (Carolina Pacanins y Niño) (see Carolina Herrera)
Bianca Jagger
Princess Salimah Aga Khan
Mrs. Frederick Melhado (Louise Liberman, previously Mrs. Richard Savitt) (see Mrs. Henry Grunwald)
Mrs. Ronald Reagan (Nancy Robbins)
Mrs. Samuel P. Reed (Annette Manheimer) (see Annette de la Renta)
Baroness Thierry van Zuylen (Gaby Iglesias Velayos y Taliaferro)

### Fashion Professionals, Women

Mrs. Bruce Addison (Gillis McGill)
Loulou de la Falaise (see Mme. Thadée Klossowski [Loulou de la Falaise])
Maxime de la Falaise McKendry (Maxime Birley) (see Maxime de la Falaise)
Diane von Furstenberg
Mary McFadden
Grace Mirabella
Jean Muir
Eve Orton
Elsa Peretti
Françoise de la Renta
Mrs. Renny Saltzman (Ellin Sadowsky)
Naomi Sims

### Men

Robert Evans
Gianni Bulgari
Billy Baldwin
John Galliher
Fred Hughes
Mick Jagger
The Hon. John V. Lindsay
David Mahoney
Armando Orsini
Robert Redford
Richard Roundtree
David Susskind

### Fashion Professionals, Men

Hardy Amies (see Sir Hardy Amies)
Max Evans
James Galanos
Halston (Frowick)
Kenneth Jay Lane
Yves Saint Laurent
Anthony Thomas "Tommy" Nutter
André Oliver
Oscar de la Renta
Joel Schumacher
Henry Sell
Philippe Venet

### H.O.F., Women

Mrs. Charles Engelhard Jr. (Jane Reiss Mannheimer)
Mrs. David Evins (Marilyn)
Mme. Grès (Alix)
Mrs. Graham Mattison (Perla de Lucena)
Mrs. Richard Pistell (Carroll McDaniel, previously Mrs. John Carey-Hughes (see the Marquesa de Portago) (see Mrs. Milton Petrie)

### H.O.F., Men

The Earl of Airlie (David Ogilvy)
Harry Belafonte
Robert L. Green
The Hon. Angus Ogilvy (see The Rt. Hon. Sir Angus Ogilvy)
Sidney Poitier
Baron Alexis de Redé

## 1973
(FEBRUARY 11, 1974)

### Women

Marisa Berenson
Contessa Brando Brandolini d'Adda (Cristiana Agnelli)
Mrs. Sidney Brody (Frances Lasker)
The Duchess of Cadaval (Claudine Tritz) (later named to Fashion Professionals list)
The Duchess of Cadiz (Maria del Carmen Martinez-Bordiu y Franco)
Mme. Bernard Camu (Ginette van der Straten Waillet)
Mme. François Catroux (Betty Saint)

Mrs. Reinaldo Herrera Jr. (Carolina Pacanins y Niño)
Mary Wells Lawrence
Baroness Arnaud de Rosnay (Isabel Goldsmith)
Mrs. Oscar Wyatt Jr. (Lynn Sakowitz)
Baroness Thierry van Zuylen (Gaby Iglesias Velayos y Taliaferro)

## Fashion Professionals, Women
Carrie Donovan
Loulou de la Falaise (see Mme. Thadée Klossowski [Loulou de la Falaise])
Diane von Furstenberg
Anjelica Huston (later named to regular Women's list)
Grace Mirabella
Contessa Alessandro di Montezemolo (Catherine Murray) (see Marchesa Alessandro di Montezemolo)
Jean Muir
Mrs. Robert Sakowitz (Pamela Zauderer)
Audrey Smaltz

## Men
Conte Brando Brandolini d'Adda
The Hon. David Bruce
Luiz Gastal
Senator Barry Goldwater
Reinaldo Herrera Jr.
Horace Kelland
Peter Revson
Baron David de Rothschild
Valerian Rybar
Yves Vidal
Billy Dee Williams
Michael York

## Fashion Professionals, Men
Max Evans
James Galanos
Giancarlo Giammetti
Kenneth Jay Lane
Ralph Lauren
Yves Saint Laurent
José Maldonado
Piero Nuti
Anthony Thomas "Tommy" Nutter
Carlo Palazzi
Chip Tolbert
Daniel Zarem

## H.O.F., Women
Cristina Ford (Cristina Vettore Austin)
Princess Salimah Aga Khan
Elsa Peretti
Mrs. Ronald Reagan (Nancy Robbins)
Mrs. Samuel P. Reed (Annette Manheimer) (see Annette de la Renta)
Françoise de la Renta

## H.O.F., Men
Nino Cerruti
Hernando Courtwright
John Galliher
André Oliver
Oscar de la Renta
Philippe Venet

*12 named to Women's list; 9 named to Fashion Professionals, Women, list; 12 named to Men's list; 12 named to Fashion Professionals, Men, list; 6 named to Hall of Fame, Women; 6 named to Hall of Fame, Men*

# 1974
(FEBRUARY 28, 1975)

## Women
Mrs. William F. Buckley Jr. (Pat Taylor)
Mme. Bernard Camu (Ginette van der Straten Waillet) (later named to Fashion Professionals list)
Mme. François Catroux (Betty Saint)
Sra. Gabriel Echevarría (Pilar Crespi) (see Pilar Crespi)

Mrs. Gerald Ford (Betty Bloomer Warren)
Katharine Graham
Mrs. Henry Kissinger (Nancy Maginnes)
Mary Wells Lawrence
Mrs. Frederick Melhado (Louise Liberman, previously Mrs. Richard Savitt) (see Mrs. Henry Grunwald)
Princess Caroline of Monaco (see H.R.H. Princess Caroline of Hanover)
Baroness Arnaud de Rosnay (Isabel Goldsmith)
Mrs. Yann Weymouth (Lally Graham)

## Fashion Professionals, Women
Carrie Donovan
Diane von Furstenberg
Mary McFadden
Grace Mirabella
Marchesa Alessandro di Montezemolo (Catherine Murray)
Mrs. David Neusteter (Shirley Rosenthal)
Mme. Jacques Rouët (Louise Lindqvist)
Mary Russell
Mrs. Robert Sakowitz (Pamela Zauderer)
Marina Schiano
Audrey Smaltz
Baroness Hubert de Wangen (Lorna Hyde)

## Men
Guy Burgos
H.R.H. Prince Charles, the Prince of Wales
President Valéry Giscard d'Estaing
Angelo Donghia
Frank Gifford
J. J. Hooker
Johnny Miller
Telly Savalas
Thomas Schippers
Senator John Tunney
Yves Vidal
Fred Williamson

## Fashion Professionals, Men
Giorgio Armani
Robert Bryan
Aldo Cipullo
James Galanos
Uva Harden
José Maldonado
Nando Miglio
Ottavio Missoni
Anthony Thomas "Tommy" Nutter
Yves Saint Laurent
Robert Sakowitz
Joel Schumacher

## H.O.F., Men
Hardy Amies (see Sir Hardy Amies)
Billy Baldwin
Max Evans
Kenneth Jay Lane
Chip Tolbert
Van Day Truex

*12 named to Women's list; 12 named to Fashion Professionals, Women, list; 12 named to Men's list; 12 named to Fashion Professionals, Men, list; 6 named to Hall of Fame, Men*

# 1975
(FEBRUARY 13, 1976)

## Women
Marisa Berenson
Mme. François Catroux (Betty Saint)
Kitty Hawks
Mrs. Reinaldo Herrera Jr. (Carolina Pacanins y Niño) (see Carolina Herrera)
Mrs. Irving Lazar (Mary Van Nuys)
H.S.H. Princess Edouard de Lobkowicz (Françoise de Bourbon-Parme)

Sra. Manuel Machado Macedo (Jackie Ansley) (see Marquise Jacqueline de Ravenel)
Silvana Mangano
Mrs. Frederick Melhado (Louise Liberman, previously Mrs. Richard Savitt) (see Mrs. Henry Grunwald)
Mrs. Paul Peralta-Ramos (Inga Rizell)
Mrs. Charles Percy (Loraine Guyer)
Mrs. Oscar Wyatt Jr. (Lynn Sakowitz)

## Fashion Professionals, Women
Mme. Bernard Camu (Ginette van der Straten Waillet)
Carrie Donovan
Sra. Gabriel Echevarría (Pilar Crespi) (see Pilar Crespi)
Loulou de la Falaise (see Mme. Thadée Klossowski [Loulou de la Falaise])
Donna Karan
Mary McFadden
Mme. Jacques Rouët (Louise Lindqvist)
Naomi Sims

## Men
The Marquess of Bath (Henry Thynne)
Alistair Cooke
President Valéry Giscard d'Estaing
Ahmet Ertegun
George Hamilton
The Hon. John V. Lindsay
Marcello Mastroianni
H.I.M. Mohammad Reza Shah Pahlavi of Iran
Joel Schumacher
O. J. Simpson
Dick Van Dyke
Michael York

## Fashion Professionals, Men
Giorgio Armani
James Galanos
Calvin Klein
Ralph Lauren
Jerry Magnin
Ottavio Missoni
Anthony Thomas "Tommy" Nutter
Carlo Palazzi
Daniel Zarem

## H.O.F., Women
Mme. Ahmed Benhima (Aïcha Laghzaoui)
Contessa Brando Brandolini d'Adda (Cristiana Agnelli)
Mrs. William F. Buckley Jr. (Pat Taylor)
Mrs. Kingman Douglass (see Adele Astaire)
Mrs. Prentis Cobb Hale (Denise Radosavljević, previously Denise Minnelli) (see Denise de Gigante)
Mrs. Paul Mellon (Bunny Lowe Lambert Lloyd)
Grace Mirabella
Mme. Pierre Schlumberger (São da Diniz Conceicao)

## H.O.F., Men
Gianni Bulgari
H.R.H. Prince Philip, the Duke of Edinburgh (first named to H.O.F. in 1969)
Robert Evans
Frank Gifford
Horace Kelland
Yves Saint Laurent
Robert Sakowitz

*12 named to Women's list; 8 named to Fashion Professionals, Women, list; 12 named to Men's list; 9 named to Fashion Professionals, Men, list; 8 named to Hall of Fame, Women; 7 named to Hall of Fame, Men*

# 1976
(FEBRUARY 15, 1977)

## Women
Lady Antonia Fraser
Pamela Harriman (see The Hon. Pamela Harriman)
Mrs. Reinaldo Herrera Jr. (Carolina Pacanins y Niño) (see Carolina Herrera)
Mrs. Irving Lazar (Mary Van Nuys)
H.S.H. Princess Edouard de Lobkowicz (Françoise de Bourbon-Parme)
Sra. Manuel Machado Macedo (Jackie Ansley) (see Marquise Jacqueline de Ravenel)
Mary Tyler Moore
Louise Nevelson
Empress Farah Pahlavi (Farah Diba)
Baroness Olimpia de Rothschild
Mrs. Thomas Watson Jr. (Olive Cawley)
Mrs. Oscar Wyatt Jr. (Lynn Sakowitz)

## Fashion Professionals, Women
Mrs. Herbert Marcus (Minnie Lichtenstein)
Mary McFadden
Contessa Donina Cicogna Mozzoni (Donina Toeplitz de Grand Ry)

## Men
Conte Brando Brandolini d'Adda
Jeffrey Butler
Angelo Donghia
Walt Frazier
Fred Hughes
Governor John Love
Marcello Mastroianni
Marques Anthony de Portago
Roberto Rossellini Jr.
Valerian Rybar
Joel Schumacher
The Marquess of Tavistock (Robin Russell)

## Fashion Professionals, Men
Giorgio Armani
James Galanos
Alexander Julian
Calvin Klein
Ralph Lauren
Jerry Magnin
Ottavio Missoni

## H.O.F., Women
Mrs. Rupert Hambro (Robin Boyer Butler, see Robin Butler)
Bianca Jagger
Mrs. Frederick Melhado (Louise Liberman, previously Mrs. Richard Savitt) (see Mrs. Henry Grunwald)

## H.O.F., Men
Billy Baldwin (first named to H.O.F. in 1974)
Frank Gifford (first named to H.O.F. in 1975)
Senator Barry Goldwater
George Hamilton
The Hon. John V. Lindsay

*12 named to Women's list; 3 named to Fashion Professionals, Women, list; 12 named to Men's list; 7 named to Fashion Professionals, Men, list; 3 named to Hall of Fame, Women; 5 named to Hall of Fame, Men*

# 1977
(JANUARY 13, 1978)

## Women
Mrs. Smith Bagley (Elizabeth Frawley)
Olive Behrendt

Comtesse Hubert d'Ornano (Isabelle Potocka)
Mrs. Gordon Getty (Ann Gilbert)
Mrs. Reinaldo Herrera Jr. (Carolina Pacanins y Niño) (see Carolina Herrera)
Diane Keaton
Mrs. Irving Lazar (Mary Van Nuys)
Sra. Manuel Machado Macedo (Jackie Ansley) (see Marquise Jacqueline de Ravenel)
Sra. Antonio Mayrink-Veiga (Carmen Solbiati)
Lacey Neuhaus
Mrs. T. Suffern Tailer (Maude Lorillard)
Baroness Thierry van Zuylen (Gaby Iglesias Velayos y Taliaferro)

## Fashion Professionals, Women
Grace Coddington
Carrie Donovan
Sra. Gabriel Echevarría (Pilar Crespi) (see Pilar Crespi)
Diane von Furstenberg
Muriel Grateau
Norma Kamali
Donna Karan
Elsa Klensch
Mme. Thadée Klossowski (Loulou de la Falaise)
Contessa Donina Cicogna Mozzoni (Donina Toeplitz de Grand Ry)
Mme. Jacques Rouët (Louise Lindqvist)
Mme. Elieth Roux

## Men
Mikhail Baryshnikov
Earl Blackwell
Jeffrey Butler
Kim d'Estainville
Arthur Levitt Jr.
Governor John Love
David Mahoney
Gerry Mulligan
President Anwar Sadat
O. J. Simpson
Thomas Tryon
Andrew Young

## Fashion Professionals, Men
Giorgio Armani
Ted Dawson
Tom Fallon
James Galanos
Alexander Julian
Calvin Klein
Rupert Lycett-Green
Jerry Magnin
Ottavio Missoni
Daniel Zarem

## H.O.F., Women
Mary Wells Lawrence
H.S.H. Princess Edouard de Lobkowicz (Françoise de Bourbon-Parme)
Mary McFadden
Empress Farah Pahlavi (Farah Diba)
Mrs. Oscar Wyatt Jr. (Lynn Sakowitz)

## H.O.F., Men
Angelo Donghia
Joel Schumacher
Yves Vidal
Michael York

*12 named to Women's list; 12 named to Fashion Professionals, Women, list; 12 named to Men's list; 10 named to Fashion Professionals, Men, list; 5 named to Hall of Fame, Women; 4 named to Hall of Fame, Men*

# 1978
(JANUARY 12, 1979)

## Women
Mme. Timothée N'Guetta Ahoua (Germaine)
Olive Behrendt
Candice Bergen

Mrs. Gordon Getty (Ann Gilbert)
Mrs. Reinaldo Herrera Jr. (Carolina Pacanins y Niño) (see Carolina Herrera)
The Countess of Iveagh, Miranda Guinness (Miranda Smiley)
Mrs. Irving Lazar (Mary Van Nuys)
Sra. Antonio Mayrink-Veiga (Carmen Solbiati)
H.M. Queen Noor of Jordan (Lisa Halaby)
Paloma Picasso
Diana Ross
Mrs. T. Suffern Tailer (Jean Sinclair Clark)

## Fashion Professionals, Women
Barbara Allen
Pat Cleveland
Grace Coddington
Muriel Grateau
Norma Kamali
Contessa Donina Cicogna Mozzoni (Donina Toeplitz de Grand Ry)
Jean Muir
Lacey Neuhaus
Anna Piaggi
Ellin Saltzman
Marina Schiano

## Men
Earl Blackwell
Governor Hugh Carey
H.R.H. Prince Charles, the Prince of Wales
Vitas Gerulaitis
Sir John Gielgud
Reinaldo Herrera Jr. (see Reinaldo Herrera)
Thadée Klossowski
David Mahoney
Dan Rather
President Anwar Sadat
Jay Spectre
John Travolta

## Fashion Professionals, Men
Giorgio Armani
Wilkes Bashford
Ted Dawson
Tom Fallon
Prince Egon von Fürstenberg
Charles Hix
Alexander Julian
Rupert Lycett-Green
Ottavio Missoni
Lee Wright

## H.O.F., Women
Mme. François Catroux (Betty Saint)
Sra. Gabriel Echevarría (Pilar Crespi) (see Pilar Crespi)
Sra. Manuel Machado Macedo (Jackie Ansley) (see Marquise Jacqueline de Ravenel)
Alexis Smith
Baroness Thierry van Zuylen (Gaby Iglesias Velayos y Taliaferro)

## H.O.F., Men
Jeffrey Butler
Kim d'Estainville
Daniel Zarem
(O. J. Simpson, later removed)

*12 named to Women's list; 11 named to Fashion Professionals, Women, list; 12 named to Men's list; 10 named to Fashion Professionals, Men, list; 5 named to Hall of Fame, Women; 4 named to Hall of Fame, Men*

# 1979
NO LIST

# The 1980s

## 1980
(JANUARY 14, 1981)

### Women
Mrs. Christian de Guigné III (Eleanor Christensen)
Mrs. Geoffrey Holder (Carmen de Lavallade)
Mrs. Francis Kellogg (Mercedes Tavacoli) (see Mrs. Sid Bass [Mercedes])
H.R.H. the Duchess of Kent (born Katharine Worsley)
Irith Landeau
Estée Lauder
Constance Mellon
Sra. Vittoria di Nora
Paloma Picasso
Diana Ross
Baroness Olimpia de Rothschild
Grace Ward, Countess Dudley (Grace Kolin Radziwill)

### Fashion Professionals, Women
Princess Anne Caracciolo
Mlle. Francine Crescent
Comtesse Hubert d'Ornano (Isabelle Potocka)
Norma Kamali
Contessa Donina Cicogna Mozzoni (Donina Toeplitz de Grand Ry)
Jean Muir
Ellin Saltzman
Marina Schiano

### Men
Thomas Ammann
Alistair Cooke
General Alexander Haig
David Hockney
James Hoge
Henry McIlhenny
Roger Penske
Senator Charles Percy
President José López Portillo
His Excellency Carlos Ortiz de Rozas
Earl E. T. Smith Jr.
Jerome Zipkin

### Fashion Professionals, Men
Giorgio Armani
Wilkes Bashford
Manolo Blahnik
Jean-Baptiste Caumont
Tom Fallon
Alexander Julian
Alexander Liberman
Rupert Lycett-Green
Count Angelo Zegna

### H.O.F., Women
Lily Auchincloss
Olive Behrendt
Mrs. Reinaldo Herrera Jr. (Carolina Pacanins y Niño)
Mrs. T. Suffern Tailer (Jean Sinclair Clark)

### H.O.F., Men
Earl Blackwell
Conte Brando Brandolini d'Adda
H.R.H. Prince Charles, the Prince of Wales

*12 named to Women's list; 8 named to Fashion Professionals, Women, list; 12 named to Men's list; 9 named to Fashion Professionals, Men, list; 4 named to Hall of Fame, Women; 3 named to Hall of Fame, Men*

## 1981
(JANUARY 15, 1982)

### Women
Mme. Nouha Alhegelan (Nouha Tarazi)
Jacqueline Bisset
Mrs. Gustavo Cisneros (Patricia Phelps)
H.R.H. Princess Diana, Princess of Wales (Diana Spencer)
Mrs. Gordon Getty (Ann Gilbert)
Lena Horne
Mrs. Francis Kellogg (Mercedes Tavacoli) (see Mrs. Sid Bass [Mercedes])
Mrs. Barry Kieselstein-Cord (CeCe Eddy) (see CeCe Cord)
Renate Linsenmeyer
Constance Mellon
Paloma Picasso
Baroness Edouard de Rothschild (Mathilde de la Ferté) (the former Lady Mathilde Abdy)

### Fashion Professionals, Women
Barbara Allen
Contessa Tiberto Brandolini (born Princess Georgina de Faucigny-Lucinge et Coligny)
Sra. Pilar Echevarría (Pilar Crespi) (named to H.O.F. in 1978)
Carolina Herrera (named to H.O.F. in 1980)
Norma Kamali
Contessa Donina Cicogna Mozzoni (Donina Toeplitz de Grand Ry)
Jean Muir
Mirella Pettini
Mme. Elieth Roux
(Sra. Pilar Echevarría [Pilar Crespi] and Carolina Herrera were erroneously named in 1981.)

### Men
The Duke of Bedford (Ian Russell)
John DeLorean
General Alexander Haig
Vernon Jordan
Sugar Ray Leonard
Jean-Pierre Marcie-Rivière
David Niven
Dan Rather
President Ronald Reagan
His Excellency Carlos Ortiz de Rozas
Valerian Rybar
Tom Wolfe

### Fashion Professionals, Men
Wilkes Bashford
Robert Beauchamp
Bijan (Pakzad)
Manolo Blahnik
James Galanos
John Fairchild
Alexander Julian
Calvin Klein
Philip Miller
André Leon Talley
Andy Warhol
Zoran (Ladicorbic)

### H.O.F., Women
Mrs. Christian de Guigné III (Eleanor Christensen)
Mme. Thadée Klossowski (Loulou de la Falaise)
Estée Lauder
Sra. Antonio Mayrink-Veiga (Carmen Solbiati)
Mme. Jacques Rouët (Louise Lindqvist)

### H.O.F., Men
Giorgio Armani
Tom Fallon
Alexander Liberman
Henry McIlhenny
Senator Charles Percy

*12 named to Women's list; 9 named to Fashion Professionals, Women, list; 12 named to Men's list; 12 named to Fashion Professionals, Men, list; 5 named to Hall of Fame, Women; 5 named to Hall of Fame, Men*

## 1982
(FEBRUARY 17, 1983)

### Women
Mrs. Gustavo Cisneros (Patricia Phelps)
H.R.H. Princess Diana, Princess of Wales (Diana Spencer)
Elizabeth Dole
The Duchess of Feria (Natividad Abascal Smith) (see Natividad Abascal)
Mrs. Oscar Hammerstein (Dorothy Blanchard Jacobson)
Mrs. Donald Harrington (Sybil Buckingham)
Mrs. Francis Kellogg (Mercedes Tavacoli) (see Mrs. Sid Bass [Mercedes])
Irith Landeau
Diana Ross
Mrs. Frank Sinatra (Barbara Blakeley Marx)
Raquel Welch
Mrs. R. Thornton Wilson Jr. (Josie Strother McCarthy)

### Fashion Professionals, Women
Marina Bulgari
Contessa Tiberto Brandolini (born Princess Georgina de Faucigny-Lucinge et Coligny)
Mrs. Johnny Carson (Joanna Ulrich Holland)
Tina Chow
Lauren Hutton
Iman
Norma Kamali
Mme. Catherine de Limur (Catherine Conrat)
Mariuccia Mandelli
Daniele Moreira
Anna Piaggi
Adrienne Vittadini

### Men
Prince Andrew of Great Britain and Northern Ireland
Peter Beard
Leo Castelli
Alistair Cooke
Christopher "Kip" Forbes
Prentis Cobb Hale
Julio Iglesias
Jeremy Irons
President François Mitterrand
Joseph Verner Reed
Roberto Rossellini Jr.
Rafaël López Sánchez

### Fashion Professionals, Men
Jeffrey Banks
Wilkes Bashford
Bijan (Pakzad)
Manolo Blahnik
Clifford Grodd
Didier Grumbach
Calvin Klein
Karl Lagerfeld
Issey Miyake
André Leon Talley

### H.O.F., Women
Mrs. Henry Kissinger (Nancy Maginnes)
Jean Muir
Loretta Young

### H.O.F., Men
James Galanos
Sir John Gielgud
Ottavio Missoni
David Niven

*12 named to Women's list; 12 named to Fashion Professionals, Women, list; 12 named to Men's list; 10 named to Fashion Professionals, Men, list; 5 named to Hall of Fame, Women; 4 named to Hall of Fame, Men*

## 1983
(FEBRUARY 24, 1984)

### Women
Sra. Umberto Agnelli (Allegra Caracciolo)
Mrs. Sid Bass (Anne Hendricks) (see Anne. H. Bass)
H.R.H. Princess Diana, Princess of Wales (Diana Spencer)
Linda Evans
The Duchess of Feria (Natividad Abascal Smith) (see Natividad Abascal)
H.R.H. Princess Firyal of Jordan (Firyal Irshaid)
Mme. Anténor Patiño (Beatriz de Rivera y Digeon, previously the Contessa di Rovasenda)
Mrs. Charles H. Price II (Carol Swanson)
Mrs. Abraham Ribicoff (Casey Mell)
Diane Sawyer
Mrs. Galen Weston (Hilary Frayne) (see The Hon. Hilary Weston)
Mrs. R. Thornton Wilson Jr. (Josie Strother McCarthy)

### Fashion Professionals, Women
Arlette Brisson
Mme. Claude Brouet
Joan Juliet Buck
Tina Chow
Comtesse Hubert d'Ornano (Isabelle Potocka)
Iman
Norma Kamali
Jun Kanai
Mrs. Barry Kieselstein-Cord (CeCe Eddy) (see CeCe Cord)
Dawn Mello
Contessa Donina Cicogna Mozzoni (Donina Toeplitz de Grand Ry)
Frances Patiky Stein

### Men
Arthur Ashe
Mark Birley
Alistair Cooke
Christopher "Kip" Forbes
John Forsythe
Mark Hampton
Jeremy Irons
Peter Jennings
Zubin Mehta
Senator Abraham Ribicoff
Baron David de Rothschild
Rafaël López Sánchez

### Fashion Professionals, Men
John Fairchild
Alan Flusser
Clifford Grodd
Alexander Julian
Karl Lagerfeld
Leo Lerman
Issey Miyake
Philip Miller
Monsieur Marc (de Coster)
Valentino
Gustav Zumsteg

### H.O.F., Women
Contessa Tiberto Brandolini (born Princess Georgina de Faucigny-Lucinge et Coligny)
The Duchess of Feria (Natividad Abascal Smith) (see Natividad Abascal)
Mme. Anténor Patiño (Beatriz de Rivera y Digeon, previously the Contessa di Rovasenda)

### H.O.F., Men
Arthur Ashe
Alistair Cooke

*12 named to Women's list; 12 named to Fashion Professionals, Women, list; 12 named to Men's list; 12 named to Fashion Professionals, Men, list; 3 named to Hall of Fame, Women; 4 named to Hall of Fame, Men*

## 1984
(FEBRUARY 13, 1985)

### Women
Mrs. Michael Caine (Shakira Baksh)
Tina Chow
Mrs. Gustavo Cisneros (Patricia Phelps)
Mrs. Gordon Getty (Ann Gilbert)
Mrs. Francis Kellogg (Mercedes Tavacoli) (see Mrs. Sid Bass [Mercedes])
Irith Landeau
Crown Princess Michiko of Japan (Michiko Shoda) (see H.I.M. Empress Michiko of Japan)
Mrs. Rupert Murdoch (Anna Torv)
H.M. Queen Noor of Jordan (Lisa Halaby)
Mrs. Ray Stark (Frances Brice)
Mme. Samir Traboulsi (Paula Mellin de Vasconcellos)
Mrs. R. Thornton Wilson Jr. (Josie Strother McCarthy)

### Fashion Professionals, Women
Laura Biagiotti
Arlette Brisson
Mme. Claude Brouet
Donatella Girombelli
Jerry Hall
Iman
Claude Lalanne
Dawn Mello
Nonnie Moore
Contessa Donina Cicogna Mozzoni (Donina Toeplitz de Grand Ry)
Jackie Rogers
Anna Wintour

### Men
The Duke of Beaufort (David Somerset)
Leo Castelli
Christopher "Kip" Forbes
Jeremy Irons
Peter Jennings
Sugar Ray Leonard
Charles Pfeiffer
Samuel P. Reed
Rafaël López Sánchez
Julio Mario Santo Domingo
Julian Schnabel
Tom Selleck

### Fashion Professionals, Men
Roger Baugh
Michel Bergerac
Manolo Blahnik
Mark Boxer
Clifford Grodd
Alexander Julian
Karl Lagerfeld
Leo Lerman
Philip Miller
Issey Miyake
Victor Skrebneski

### H.O.F., Women
Lily Auchincloss (first named to H.O.F. in 1980)
The Duchess of Feria (Natividad Abascal Smith) (see Natividad Abascal)
Mme. Anténor Patiño (Beatriz de Rivera y Digeon, previously the Contessa di Rovasenda)

### H.O.F., Men
Arthur Ashe
Alistair Cooke

*11 named to Fashion Professionals, Men, list; 3 named to Hall of Fame, Women; 4 named to Hall of Fame, Men*

His Excellency Carlos Ortiz de Rozas
Tom Wolfe

*12 named to Women's list; 12 named to Fashion Professionals, Women, list; 12 named to Men's list; 11 named to Fashion Professionals, Men, list; 3 named to Hall of Fame, Women; 4 named to Hall of Fame, Men*

## 1985
(FEBRUARY 27, 1986)

### Women
Mrs. Sid Bass (Anne Hendricks) (see Anne H. Bass)
Mrs. Dixon Boardman (Pauline Munn Baker) (see Pauline Pitt)
Helena Bonham Carter
Sra. Maria Pia Fanfani (Maria Pia Tavazzani)
Mrs. Donald Harrington (Sybil Buckingham)
Mrs. John R. Hearst (Kathleen Bickley) (later named to Fashion Professionals list)
Whitney Houston
Mrs. Francis Kellogg (Mercedes Tavacoli) (see Mrs. Sid Bass [Mercedes])
Mrs. Charles H. Price II (Carol Swanson)
Sra. Julio Mario Santo Domingo (Beatrice Dávila Rocha)
Maria Shriver
Baroness Sylvia de Waldner

### Fashion Professionals, Women
Anouk Aimée
Mme. Claude Brouet
Catherine de Castelbajac
Kitty D'Alessio
Donatella Girombelli
Jun Kanai
Mrs. Barry Kieselstein-Cord (CeCe Eddy) (see CeCe Cord)
Elsa Klensch
Mariuccia Mandelli
Nonnie Moore
Adrienne Vittadini
Anna Wintour

### Men
Thomas Ammann
The Duke of Beaufort (David Somerset)
Mark Birley
David Bowie
Christopher "Kip" Forbes
Mark Hampton
H.M. King Hassan II of Morocco
David Hockney
James Hoge
Kevin Kline
Charles Pfeiffer
Bobby Short

### Fashion Professionals, Men
Giorgio Armani (named to H.O.F. in 1981)
Roger Baugh
Bijan (Pakzad)
Manolo Blahnik
Jacques Dehornois
John Fairchild
Leonardo Ferragamo
Steven Kaufman
Philip Miller
Issey Miyake

### H.O.F., Women
Tina Chow
H.R.H. Princess Firyal of Jordan (Firyal Irshaid)
The Hon. Clare Boothe Luce
Paloma Picasso (first named to H.O.F. in 1983)
Mrs. R. Thornton Wilson Jr. (Josie Strother McCarthy)

## 1986
(FEBRUARY 16, 1987)

### Women

Mrs. Sid Bass (Anne Hendricks) (see Anne H. Bass)
Mrs. Michael Douglas (Diandra Luker)
Sra. Alfonso Fierro (Trinidad "Trini" Jimenez-Lopera y Alvarez)
Lady Charlotte Fraser (Charlotte Greville)
Mrs. Donald Harrington (Sybil Buckingham)
Anjelica Huston
H.H. the Rajmata of Jaipur (Princess Gayatri Devi, "Ayesha")
Mrs. Francis Kellogg (Mercedes Tavacoli) (see Mrs. Sid Bass [Mercedes])
Irith Landeau
Mrs. Rupert Murdoch (Anna Torv)
Barbara Walters
Mrs. Galen Weston (Hilary Frayne) (see The Hon. Hilary Weston)

### Fashion Professionals, Women

Laura Biagiotti
Evangelina Blahnik
Catherine de Castelbajac
Kitty D'Alessio
Donatella Girombelli
Mrs. John R. Hearst (Kathleen Bickley)
Joy Henderiks
Norma Kamali
Jun Kanai
Mrs. Barry Kieselstein-Cord (CeCe Eddy) (see CeCe Cord)
Mme. Bernard Lanvin (Maryll Orsini)
Anna Wintour

### Men

The Hon. Anthony Ackland
Mark Birley
H.R.H. Prince Dimitri of Yugoslavia
H.R.H. Prince Edward of Great Britain and Northern Ireland
Christopher "Kip" Forbes
Gregory Hines
James Hoge
Fred Hughes
H.M. King Juan Carlos of Spain
Rafael Lopez-Sanchez
Jean-Pierre Marcie-Rivière
Peter Sharp

### Fashion Professionals, Men

Bijan (Pakzad)
Manolo Blahnik
Nicholas Coleridge
Count Brando Crespi
Leonardo Ferragamo
Steven Kaufman
Bernard Lanvin (named to H.O.F. in 1970)
Philip Miller
André Leon Talley
Valentino
Paul Wilmot
Ermenegildo Zegna

### H.O.F., Women

Betty Furness
Mrs. Oscar Hammerstein (Dorothy Blanchard Jacobson)
Iman
Baroness Sylvia de Waldner

### H.O.F., Men

Ahmet Ertegun
David Hockney
President Ronald Reagan
Bobby Short

*12 named to Women's list; 12 named to Fashion Professionals, Women, list; 12 named to Men's list; 12 named to Fashion Professionals, Men, list; 4 named to Hall of Fame, Women; 4 named to Hall of Fame, Men*

## 1987
(FEBRUARY 15, 1988)

### Women

Mrs. John Gutfreund (Susan Kaposta Penn)
Mrs. Donald Harrington (Sybil Buckingham)
Anjelica Huston
Irith Landeau
Mrs. Rupert Murdoch (Anna Torv)
Mme. Philippe Niarchos (Victoria Guinness)
Marina Palma
Joan Rivers
Diane Sawyer
Mrs. Alfred Taubman (Judy Mazor Rounick)
Margaret Thatcher (see The Rt. Hon. Baroness Thatcher)
Alexandra Theodoracopulos

### Fashion Professionals, Women

Evangelina Blahnik
The Duchess of Cadaval, Claudine Álvares Pereira de Melo (Claudine Tritz)
Inès de la Fressange
Anouska Hempel
Joy Henderiks
Kelly Klein
Elsa Klensch
Joyce Ma
China Machado
Marian McEvoy
Dawn Mello
Lee Radziwill (Lee Bouvier, previously Princess Lee Radziwill) (see Mrs. Michael Canfield) (see Lee Radziwill Ross)

### Men

The Duke of Beaufort (David Somerset)
Corbin Bernsen
Mark Birley
The Hon. Richard Burt
Bryan Ferry
Christopher "Kip" Forbes
Prince Heinrich Fürstenberg
Count Sebastian de Ganay
Peter Jennings
James Niven
Julio Mario Santo Domingo
Julian Schnabel

### Fashion Professionals, Men

Richard Carroll
Count Brando Crespi
John Fairchild
Leonardo Ferragamo
Romeo Gigli
Clifford Grodd
Jean-Louis Dumas Hermès
Steven Kaufman
Beppe Modenese
Paul Smith
Paul Wilmot
Ermenegildo Zegna

### H.O.F., Women

Joan Juliet Buck
Mrs. Francis Kellogg (Mercedes Tavacoli) (see Mrs. Sid Bass [Mercedes])
Mrs. Charles H. Price II (Carol Swanson)
Sra. Julio Mario Santo Domingo (Beatrice Dávila Rocha)
Mrs. Galen Weston (Hilary Frayne) (see The Hon. Hilary Weston)

### H.O.F., Men

Manolo Blahnik
James Hoge
Fred Hughes
H.M. King Juan Carlos of Spain
Issey Miyake

*12 named to Women's list; 12 named to Fashion Professionals, Women, list; 12 named to Men's list; 12 named to Fashion Professionals, Men, list; 5 named to Hall of Fame, Women; 5 named to Hall of Fame, Men*

## 1988
(FEBRUARY 16, 1989)

### Women

Karole Armitage
Mrs. Vincent Astor (Brooke Russell Marshall)
Benazir Bhutto
Comtesse Frédéric Chandon de Briailles (Camilla Paravicini Mavroleon)
H.R.H. Princess Diana, Princess of Wales
Nina Griscom (Nina Renshaw) (see Nina Griscom Baker)
Carolina Herrera Jr. (see Carolina Adriana Herrera)
Irith Landeau
H.I.M. Empress Michiko of Japan (Michiko Shōda)
Marina Palma
Alexandra Theodoracopulos
Mrs. Robert Trump (Blaine Beard Retchin)

### Fashion Professionals, Women

Evangelina Blahnik
Mme. Claude Brouet
Mlle. Gwendoline Levié Ffoulke d'Urso (see Mme. Peter Bemberg [Gwendoline])
Donatella Girombelli
Anouska Hempel
Mrs. Barry Kieselstein-Cord (CeCe Eddy) (see CeCe Cord)
Carolyne Roehm Kravis (Carolyne Smith) (see Carolyne Roehm)
Mariuccia Mandelli
Marian McEvoy
Mme. Dreda Mele
Mrs. Julian Schnabel (Jacqueline Beaurang)

### Men

Eric Boman
The Hon. Richard Burt
Comte Frédéric Chandon de Briailles
President George Bush
Graydon Carter
Bryan Ferry
Christopher "Kip" Forbes
Comte Paul de Ganay
Mark Hampton
John F. Kennedy Jr.
Steve Martin
Sonny Mehta

### Fashion Professionals, Men

Bijan (Pakzad)
Gilles Dufour
Leonardo Ferragamo
Alan Flusser
Philip Miller
Beppe Modenese
Gene Pressman
André Leon Talley
Alexander Vreeland
Paul Wilmot

### H.O.F., Women

Kitty D'Alessio
Mrs. Donald Harrington (Sybil Buckingham)
Anjelica Huston
Mrs. Abraham Ribicoff (Casey Mell)
Mrs. Ray Stark (Frances Brice)

### H.O.F., Men

Thomas Ammann
The Duke of Beaufort (David Somerset)
Mark Birley
John Fairchild
Steven Kaufman
Peter Sharp

*12 named to Women's list; 11 named to Fashion Professionals, Women, list; 12 named to Men's list; 10 named to Fashion Professionals, Men, list; 5 named to Hall of Fame, Women; 6 named to Hall of Fame, Men*

## 1989
(MARCH 30, 1990)

### Women

Mme. Peter Bemberg (Gwendoline Levié Ffoulke, previously Mme. Luigi d'Urso)
Mrs. Guilford Dudley (Jane Anderson)
Inès de la Fressange
Nina Griscom (Nina Renshaw) (see Nina Griscom Baker)
Carolina Herrera Jr. (see Carolina Adriana Herrera)
Irith Landeau
Jenny Lumet
Anne McNally
Mme. Philippe Niarchos (Victoria Guinness)
Mrs. Spyros Niarchos (Daphne Guinness) (see Daphne Guinness)
Mrs. Howard Ruby (Yvette Mimieux Donen)
Alexandra Theodoracopulos
Mrs. Donald Trump (Ivana Zelníková Winklmayr)
Mrs. Robert Trump (Blaine Beard Retchin)

### Fashion Professionals, Women

Mrs. Michael Caine (Shakira Baksh)
Donatella Girombelli
Cathy Hardwick
Joy Henderiks
Mrs. Barry Kieselstein-Cord (CeCe Eddy) (see CeCe Cord)
Carolyne Roehm Kravis (Carolyne Smith) (see Carolyne Roehm)
Laura Montalban
Elizabeth Saltzman
Maria Snyder
Carla Sozzani
Frances Patiky Stein
Anna Wintour

### Men

Alec Baldwin
Comte Frédéric Chandon de Briailles
Daniel Day-Lewis
Christopher "Kip" Forbes
Arsenio Hall
Mark Hampton
Edward W. Hayes
John F. Kennedy Jr.
H.R.H. Prince Kyril of Bulgaria
Paul Newman
James Niven
Julio Mario Santo Domingo

### Fashion Professionals, Men

Count Brando Crespi
Gilles Dufour
Massimo Ferragamo
Philip Miller
Paul Smith
Alexander Vreeland
Paul Wilmot

### H.O.F., Women

Mrs. Vincent Astor (Brooke Russell Marshall)
Evangelina Blahnik
H.R.H. Princess Diana, Princess of Wales (Diana Spencer)
Sra. Alfonso Fierro (Trini)
Elsa Klensch
China Machado
Marina Palma

### H.O.F., Men

Bijan (Pakzad)
Peter Jennings
H.M. King Juan Carlos of Spain (first named to the H.O.F. in 1987)
Beppe Modenese
Charles Pfeiffer

*14 named to Women's list; 12 named to Fashion Professionals, Women, list; 12 named to Men's list; 7 named to Fashion Professionals, Men, list; 7 named to Hall of Fame, Women; 5 named to Hall of Fame, Men*

# The 1990s

## 1990
(FEBRUARY 22, 1991)

### Women

Lady Sarah Armstrong-Jones
Lady Annunziata Asquith
Nina Griscom Baker (Nina Renshaw) (see Nina Griscom)
Contessa Nally Bellati
Mrs. Michael Caine (Shakira Baksh)
Carolyne Roehm Kravis (Carolyne Smith) (see Carolyne Roehm)
Laura Montalban
Mrs. Colin Powell (Alma Johnson)
Julia Roberts
Princess Elisabeth von Sachsen-Weimar
Anna Wintour

### Men

Harry Connick Jr.
Matt Dillon
Comte Paul de Ganay
Mark Hampton
Earvin "Magic" Johnson
John F. Kennedy Jr.
Sonny Mehta
Paul Newman
James Niven
Robin Smith-Ryland
The Earl of Warwick, David Greville
Paul Wilmot

### H.O.F., Women

Irith Landeau
H.I.M. Empress Michiko of Japan (Michiko Shōda)
Baroness Sylvia de Waldner (first named to H.O.F. in 1986)
Contessa Donina Cicogna Mozzoni (Donina Toeplitz de Grand Ry)
The Rt. Hon. Margaret Thatcher (see The Rt. Hon. Baroness Thatcher [Margaret])
Mrs. Lawrence Copley Thaw (Lee Francis, previously Marchesa Lotteringhi della Stufa)
Alexandra Theodoracopulos

### H.O.F., Men

Bryan Ferry
Christopher "Kip" Forbes
Julio Mario Santo Domingo

*11 named to Women's list; no Fashion Professionals lists; 12 named to Men's list; 6 named to Hall of Fame, Women; 3 named to Hall of Fame, Men*

## 1991
(FEBRUARY 21, 1992)

### Women

Anne H. Bass
Candice Bergen
Comtesse Frédéric Chandon de Briailles (Camilla Paravicini Mavroleon)
Comtesse Florence de Dampierre
Lady Geraldine Hanson (Geraldine Kaelin)
Anne Jones
Mrs. Spyros Niarchos (Daphne Guinness) (see Daphne Guinness)
Jessye Norman
President Mary Robinson
Mme. François Rochas (Carole)
Mrs. Felix Rohatyn (Elizabeth Fly Vagliano)
Mrs. Edmond Safra (Lily Watkins Bendahan)

### Fashion Professionals, Women

Martha Baker
Isabel Canovas
Lucie de la Falaise
Inès de la Fressange
Joy Henderiks
Lauren Hutton
Jun Kanai
Kelly Klein
Dawn Mello
Nonnie Moore
Mrs. Kenneth Natori (Josefina "Josie" Almeda Cruz)
Adrienne Vittadini

### Men

Dixon Boardman
Ed Bradley
Prince Pierre d'Arenberg
The Hon. Tim Foley
Edward W. Hayes
Gene Hovis
Henry Kravis
H.R.H. Prince Kyril of Bulgaria
Peter Martins
Pat Riley
John Stefanidis
Galen Weston

### Fashion Professionals, Men

Joseph Abboud
Jeffrey Banks
Luciano Barbera
Hamish Bowles
Gimmo Etro
Massimo Ferragamo
Clifford Grodd
Jean-Louis Dumas Hermès
Christian Lacroix
Richard Lambertson
Philip Miller
Paul Wilmot

### H.O.F., Women
Nina Griscom Baker (Nina Renshaw) (see Nina Griscom)
Mrs. Michael Caine (Shakira Baksh)
Carolyne Roehm Kravis (Carolyne Smith) (see Carolyne Roehm)
Anne Slater

### H.O.F., Men
Comte Frédéric Chandon de Briailles
Comte Paul de Ganay
Mark Hampton
Paul Newman
Baron David de Rothschild
*12 named to Women's list; 12 named to Fashion Professionals, Women, list; 12 named to Men's list; 12 named to Fashion Professionals, Men, list; 4 named to Hall of Fame, Women; 5 named to Hall of Fame, Men*

## 1992
(FEBRUARY 19, 1993)

*Women's list divided into two categories:*

### Leading Fashion Dissidents
Isabella Blow
Naomi Campbell
Victoire de Castellane
Neneh Cherry
Carlyne Cerf de Dudzeele
Juliette Lewis
Courtney Love
Carrie Modine
Mrs. Julian Schnabel (Jacqueline Beaurang)

### Leading Fashion Classicists
Amanda Burden
Lucy Ferry
Pamela Harriman (see The Hon. Pamela Harriman)
Mrs. Randolph Hearst (Veronica de Gruyter Beracasa de Uribe)
Mrs. Barry Kieselstein-Cord (CeCe Eddy) (see CeCe Cord)
H.R.H. Princess Kyril of Bulgaria (Rosario Nadal y Fuster de Puigdórfila)
Joyce Ma
Comtesse Charles-Louis de Mortemart (Hélène Paultre de Lamotte)
Jessye Norman
President Mary Robinson

### Men
Hamish Bowles
Francesco Clemente
Prince Pierre d'Arenberg
Thierry Despont
Gregory Hines
John F. Kennedy Jr.
Christian Lacroix
Pat Riley
Khalil Rizk
Terence Stamp
André Leon Talley
Galen Weston
*9 named to Leading Fashion Dissidents; 10 named to Leading Fashion Classicists; no Fashion Professionals lists; 12 named to Men's list; no H.O.F. lists*

## 1993
(MARCH 25, 1994)

### Women
Anne H. Bass
Princess Caroline of Monaco (see H.R.H. Princess Caroline of Hanover)
Mrs. Randolph Hearst (Veronica de Gruyter Beracasa de Uribe)
Carolina Herrera Jr. (see Carolina Adriana Herrera)
Mrs. Ashley Hicks (Allegra Tondato)
Harumi Klossowska
H.R.H. Princess Kyril of Bulgaria (Rosario Nadal y Fuster de Puigdórfila)
Viscountess Linley, Serena Armstrong-Jones (Serena Stanhope)
Joan Rivers
Mrs. Edmond Safra (Lily Watkins Bendahan)
Mrs. Saul Steinberg (Gayfryd McNabb Johnson)
Sharon Stone

### Fashion Professionals, Women
Liza Bruce
Isabel Canovas
Carlyne Cerf de Dudzeele
Inès de la Fressange
Anouska Hempel
Joy Hendricks
Mrs. Barry Kieselstein-Cord (CeCe Eddy) (see CeCe Cord)
Kelly Klein
Joyce Ma
Carla Sozzani
Adrienne Vittadini
Anna Wintour

### Men
Martin Amis
Dr. Daniel Baker
Francesco Clemente
Prince Pierre d'Arenberg
Charles Gwathmey
Edward W. Hayes
Fernando de Cordoba Hohenlohe
Henry Kravis
H.R.H. Prince Kyril of Bulgaria
Andrew Lauren
Pat Riley
Denzel Washington

### Fashion Professionals, Men
Hamish Bowles
Massimo Ferragamo
Didier Grumbach
Christian Lacroix
Gerard Pipart

### H.O.F., Women
Comtesse Frédéric Chandon de Briailles (Camilla Paravicini Mavroleon)
Comtesse Hubert d'Ornano (Isabelle Potocka)
The Hon. Pamela Harriman
Mrs. Kenneth Natori (Josefina "Josie" Almeda Cruz)
Jessye Norman

### H.O.F., Men
David Brown
Gregory Hines
Sonny Mehta
Galen Weston
Paul Wilmot
*12 named to Women's list; 12 named to Fashion Professionals, Women, list; 12 named to Men's list; 5 named to Fashion Professionals, Men, list; 5 named to Hall of Fame, Women; 5 named to Hall of Fame, Men*

## 1994
(APRIL 21, 1995)

### Women
Sra. Paolo Asta (Donatella Kechler) (see Contessa Donatella Asta)
Lady Sarah Chatto (Sarah Armstrong-Jones)
Lady Charlotte Fraser (Charlotte Greville)
Pia Miller Getty
Mrs. Randolph Hearst (Veronica de Gruyter Beracasa de Uribe)
Carolina Herrera Jr. (see Carolina Adriana Herrera)
Jemima Khan
Mrs. Ashley Hicks (Allegra Tondato)
Mrs. Barry Kieselstein-Cord (CeCe Eddy) (see CeCe Cord)
Harumi Klossowska de Rola
H.R.H. Princess Kyril of Bulgaria (Rosario Nadal y Fuster de Puigdórfila)
Viscountess Linley, Serena Armstrong-Jones (Serena Stanhope)
Alexandra Miller
Marie-Chantal Miller (see H.R.H. Princess Pavlos of Greece [Marie-Chantal])
Danielle Steel Traina

### Fashion Professionals, Women
Sra. Nally Bellati
Isabel Canovas
Amy Fine Collins
Natasha Fraser
Inès de la Fressange
Marian McEvoy
Laura Montalban
Joan Rivers
Adrienne Vittadini

### Men
Francesco Clemente
Hugh Grant
Charles Gwathmey
Fernando e Cordoba Hohenlohe
John F. Kennedy Jr.
Henry Kravis
H.R.H. Prince Kyril of Bulgaria
Steve Martin
Brad Pitt
Tom Selleck
John Stefanidis
Sting

### Fashion Professionals, Men
Luciano Barbera
Hamish Bowles
Robert Bryan
Daniel de la Falaise
Jeffrey Miller
Philip Miller
Sergio Loro Piana

### H.O.F., Women
Anne H. Bass
Princess Caroline of Monaco (see H.R.H. Princess Caroline of Hanover)
Mrs. Angier Biddle Duke (Robin)
Lucy Ferry
Kitty Carlisle Hart
Mrs. Spyros Niarchos (Daphne) (see Daphne Guinness)
Mme. Georges Pompidou (Claude Cahour)

### H.O.F., Men
Dixon Boardman
H.R.H. Prince Dimitri of Yugoslavia
Jacques Grange
Edward W. Hayes
James Niven
Comte Jean-Charles de Ravenel
Pat Riley
André Leon Talley
*14 named to Women's list; 9 named to Fashion Professionals, Women, list; 12 named to Men's list; 7 named to Fashion Professionals, Men, list; 7 named to Hall of Fame, Women; 8 named to Hall of Fame, Men*

## 1995
(APRIL 5, 1996)

### Women
Countess Leopold von Bismarck (Debonnaire Patterson)
Mrs. Dixon Boardman (Pauline Munn Baker) (see Pauline Pitt)
Cosima von Bülow (see Cosima von Bülow Pavoncelli)
Amy Fine Collins
Lady Amanda Harlech
Carolina Herrera Jr. (see Carolina Adriana Herrera)
Jemima Khan
Viscountess Linley, Serena Armstrong-Jones (Serena Stanhope)
Joyce Ma
Sra. Angela Pintaldi
Lady Victoria de Rothschild
Marina Rust (see Marina Rust Connor)
Sharon Stone
Faye Wattleton
Anna Wintour

### Men
Mayor Willie Brown
Francesco Clemente
Luigi d'Urso
Tom Ford
Bryant Gumbel
Gene Hovis
John F. Kennedy Jr.
Imran Khan
Henry Kravis
H.R.H. Prince Kyril of Bulgaria
Christian Louboutin
Steve Martin
David Metcalfe
Fernando Sánchez
Denzel Washington

### H.O.F., Women
Contessa Donatella Asta (Donatella Kechler)
Candice Bergen
Mrs. Barry Kieselstein-Cord (CeCe Eddy) (see CeCe Cord)
Mrs. Henryk de Kwiatkowski (Barbara)
H.R.H. Princess Kyril of Bulgaria (Rosario)
Mrs. Mark Littman (Marguerite)
Mrs. Samuel Peabody (Judith)
Adrienne Vittadini
Baroness Geoffroy de Waldner (Louise "Lulu" Esmond) (see Baroness Louise de Waldner)

### H.O.F., Men
Comte Hubert d'Ornano
Ralph Lauren
Philip Miller
Gil Shiva
John Stefanidis
*15 named to Women's list; no Fashion Professionals lists; 15 named to Men's list; 9 named to Hall of Fame, Women; 5 named to Hall of Fame, Men*

## 1996
(APRIL 2, 1997)

### Women
H.R.H. Countess Arco (born Archduchess Maria-Beatrice of Austria-Este)
Carolyn Bessette-Kennedy
Carolina Herrera Jr. (see Carolina Adriana Herrera)
Nicole Kidman
Mrs. Henry Kravis (Marie-Josée Drouin)
Viscountess Linley, Serena Armstrong-Jones (Serena Stanhope)
Joyce Ma
H.R.H. Princess Pavlos of Greece (Marie-Chantal Miller)
Cosima von Bülow Pavoncelli
Lady Victoria de Rothschild (Victoria Schott)
Kristin Scott Thomas
Faye Wattleton

### Men
Dr. Daniel Baker
Hamish Bowles
Graydon Carter
The Hon. Harry Fane
Tom Ford
Charles Gwathmey
Jon Bon Jovi
Henry Kravis
Viscount Linley (David Armstrong-Jones)
Wynton Marsalis
Sir Evelyn de Rothschild
Denzel Washington

### H.O.F., Women
Mrs. Dixon Boardman (Pauline Munn Baker) (see Pauline Pitt)
Amanda Burden
Amy Fine Collins
Mrs. Rodman Arturo de Heeren (Aimée Lopes de Sotomaior)
Lee Radziwill Ross (Lee Bouvier, previously Princess Lee Radziwill) (see Mrs. Michael Canfield) (see Lee Radziwill)
Tina Turner
Grace Ward, Countess Dudley (Grace Kolin Radziwill)

### H.O.F., Men
Francesco Clemente
David Metcalfe
Fernando Sánchez
*12 named to Women's list; no Fashion Professionals lists; 12 named to Men's list; 7 named to Hall of Fame, Women; 3 named to Hall of Fame, Men*

## 1997
(APRIL 10, 1998)

### Women
Rosamond Bernier
China Chow
Carolina Herrera (H.O.F. 1980, returned to Women's list as an "elegant resister")
Nicole Kidman
Mrs. Henry Kravis (Marie-Josée Drouin)
Viscountess Linley, Serena Armstrong-Jones (Serena Stanhope)
Joyce Ma
Mary McFadden (H.O.F. 1977, returned to Women's list as an "elegant resister")
H.R.H. Princess Pavlos of Greece (Marie-Chantal Miller)
Eliza Reed (see Eliza Reed Bolen)
Mrs. Felix Rohatyn (Elizabeth Fly Vagliano)
Mrs. Charles Wrightsman (Jayne Larkin) (H.O.F. 1965, returned to Women's list as an "elegant resister")

### Men
Tony Blair
Ozwald Boateng
David Bowie
Graydon Carter
The Earl of Cawdor (Colin Campbell)
Madison Cox
Rupert Everett
Phillips "Pete" Hathaway
Matt Lauer
Maxwell
Sir Evelyn de Rothschild
H.R.H. Prince William

### H.O.F., Women
Lucie de la Falaise
Lady Amanda Harlech (Amanda Grieve)
Carolina Herrera Jr. (see Carolina Adriana Herrera)
Anna Wintour

### H.O.F., Men
Hamish Bowles
Ed Bradley
Luigi d'Urso
The Hon. Harry Fane
H.R.H. Prince Kyril of Bulgaria
*12 named to Women's list; no Fashion Professionals lists; 12 named to Men's list; 4 named to Hall of Fame, Women; 5 named to Hall of Fame, Men*

## 1998
(APRIL 30, 1999)

### Women
Victoire de Castellane
Cameron Diaz
Patricia Herrera (see Patricia Lansing)
Jade Jagger
Viscountess Linley, Serena Armstrong-Jones (Serena Stanhope)
Marian McEvoy
Mrs. Emilio de Ocampo (Brooke Douglass)
Gwyneth Paltrow
H.R.H. Princess Pavlos of Greece (Marie-Chantal Miller)
Eliza Reed (see Eliza Reed Bolen)
Uma Thurman
Aerin Lauder Zinterhofer

### Fashion Professionals, Women
Cecilia Dean
Rei Kawakubo
Dawn Mello
Vivienne Westwood

### Men
Kenneth Chenault
Prince Pierre d'Arenberg
Tony Duquette
Rupert Everett
Count Roffredo Gaetani
Phillips "Pete" Hathaway
Lord Hindlip (Charles)
Thomas Kempner
John F. Kennedy Jr.
Lenny Kravitz
Dylan McDermott
H.R.H. Prince Michael of Kent

### Fashion Professionals, Men
John Bartlett
Ozwald Boateng
Tom Ford
Patrick McCarthy

### H.O.F., Women
Rosamond Bernier
Inès de la Fressange
Sophia Loren
Joyce Ma
Queen Noor of Jordan (Lisa Halaby)
Faye Wattleton

### H.O.F., Men
David Bowie
Graydon Carter
Denzel Washington
*12 named to Women's list; 4 named to Fashion Professionals, Women, list; 12 named to Men's list; 4 named to Fashion Professionals, Men, list; 6 named to Hall of Fame, Women; 3 named to Hall of Fame, Men*

## 1999
(APRIL 21, 2000)

### Women
H.R.H. Countess Arco (born Archduchess Maria-Beatrice of Austria-Este)
Eliza Reed Bolen
Victoire de Castellane
Susan Fales-Hill
Nicole Kidman
Mrs. Henry Kravis (Marie-Josée Drouin)
Mrs. S. I. Newhouse (Victoria Carrington Benedict de Ramel)
Mrs. Emilio de Ocampo (Brooke Douglass)
Chloë Sevigny
Mrs. Martin Summers (Ann Tysen)
Mrs. Robert Trump (Blaine Beard Retchin)
Aerin Lauder Zinterhofer

### Men
Jonathan Becker
Michael Cannon
John Cahill
Madison Cox
Michael Douglas
Philip von Habsburg
Gene Hovis
H.S.H. Rupert von und zu Löwenstein
Patrick McCarthy
Dylan McDermott
Robert Rufino
Taki Theodoracopulos

### H.O.F., Women
Sra. Fernando Botero (Sophia Vari)
Lady Charlotte Fraser (Charlotte Greville)
Patricia Herrera (see Patricia Lansing)
H.R.H. Princess Pavlos of Greece (Marie-Chantal Miller)
Cosima von Bülow Pavoncelli

### H.O.F., Men
Lord Hindlip (Charles)
Wynton Marsalis
H.R.H. Prince Michael of Kent
Sir Evelyn de Rothschild
*12 named to Women's list; 12 named to Men's list; 5 named to Hall of Fame, Women; 4 named to Hall of Fame, Men*

# The 2000s

## 2000
(APRIL 13, 2001)

### Women
Victoire de Castellane
Susan Fales-Hill
Mrs. David Koch
(Julia Flesher)
Mrs. Henry Kravis
(Marie-Josée Drouin)
Cristina Macaya
Marian McEvoy
Anne McNally
Enid Nemy
Chloë Sevigny
Mrs. Sami Sindi (Rena Kirdar)
Sally Tadayon (see Sally,
Countess of Albemarle)
Uma Thurman

### Men
Fernando Botero
John Cahill
Michael Cannon
Tom Ford
Count Roffredo Gaetani
Geoffrey Holder
H.S.H. Prince Rupert
von und zu Löwenstein
Yo-Yo Ma
Patrick McCarthy
Sting
Taki Theodoracopulos
Chow Yun-Fat

### H.O.F., Women
H.R.H. Countess Arco
(born Archduchess Maria-
Beatrice of Austria-Este)
Lauren Bacall
Marisa Berenson
Mrs. Saul Steinberg
(Gayfryd McNabb Johnson)
Mrs. Martin Summers
(Ann Tysen)

### H.O.F., Men
Dr. Daniel Baker
Kenneth Chenault
Madison Cox
Phillips "Pete" Hathaway
Henry Kravis
*12 named to Women's list;
12 named to Men's list; 5 named
to Hall of Fame, Women; 5 named
to Hall of Fame, Men*

## 2001
(MARCH 29, 2002)

### Women
Halle Berry
Cecilia Dean
Anh Duong
Susan Fales-Hill
Nicole Kidman
Mrs. David Koch
(Julia Flesher)
Kate Moss
Enid Nemy
H.M. Queen Rania of Jordan
Carine Roitfeld
Marina Rust
(see Marina Rust Connor)
Mitsuko Uchida

### Men
Tiki Barber
Geoffrey Beene
Ozwald Boateng
Giuseppe Cipriani
Sean Combs
Anderson Cooper
Yo-Yo Ma
Lars Nilsson
Colin Powell
Robert Rufino
Mish Tworkowski
John Waters

### H.O.F., Women
Mrs. Henry Kravis
(Marie-Josée Drouin)
Marian McEvoy
Anne McNally

### H.O.F., Men
John Cahill
Michael Cannon
Prince Pierre d'Arenberg
Charles Gwathmey
H.S.H. Prince Rupert
von und zu Löwenstein
Patrick McCarthy
Sting
Taki Theodoracopulos
*12 named to Women's list;
12 named to Men's list; 3 named
to Hall of Fame, Women;
8 named to Hall of Fame, Men*

## 2002
NO LIST

## 2003
NO LIST

## 2004
(APRIL 2004, FIRST
APPEARANCE IN VANITY FAIR)

### Women
Sally, Countess of Albemarle
(Sally Tadayon)
Cate Blanchett
Marina Rust Connor
Sofia Coppola
Jemima Khan
Kate Moss
H.R.H. Princess Olga
of Greece
H.M. Queen Rania of Jordan
Oprah Winfrey
Aerin Lauder Zinterhofer

### Men
Jonathan Becker
David Beckham
George Clooney
Sean Combs
Anderson Cooper
Lapo Elkann
Jude Law
Bernard-Henri Lévy
H.R.H. Crown Prince
Pavlos of Greece
Brian Williams

### H.O.F., Women
Eliza Reed Bolen
Maxime de la Falaise
Susan Fales-Hill
Nicole Kidman

### H.O.F., Men
Tom Ford
*10 named to Women's list;
10 named to Men's list; 4 named
to Hall of Fame, Women;
1 named to Hall of Fame, Men*

## 2005
(APRIL 2005)

### Women
Alba Clemente
Sofia Coppola
Jemima Khan
Sienna Miller
Kate Moss
H.M. Queen Rania of Jordan
Carine Roitfeld
Vanessa & Victoria Traina
Connie Wald
Oprah Winfrey

### Men
Wes Anderson
Andre 3000 Benjamin
George Clooney
Anderson Cooper
Lapo Elkann
Charles Finch
Jude Law
Bernard-Henri Lévy
Ogden Phipps
Charlie Watts
*10 named to Women's list;
10 named to Men's list;
no Hall of Fame entries*

## 2006
(SEPTEMBER 2006)

### Women
Selma Blair
Charlotte Casiraghi
Alba Clemente
Sofia Coppola
Fran Lebowitz
Condoleezza Rice
Gwen Stefani
Blaine Trump
Oprah Winfrey
Renée Zellweger

### Men
David Beckham
George Clooney
Anderson Cooper
Lapo Elkann
H.R.H. Prince Ernst
August of Hanover
Count Manfredi
Della Gherardesca
Richard Johnson
Kanye West
H.R.H. Prince William
Brian Williams

### Couples
Sheherazade & Zac Goldsmith
Princess Marie-Chantal &
T.R.H. Crown Prince Pavlos
of Greece
Eugenia Silva & Alejandro
Santo Domingo
Isabel & Ruben Toledo

### Fashion Professionals
Ozwald Boateng
Alexandra Kotur
Hedi Slimane
Stella Tennant
Mario Testino

### Fashion Originals
Isabella Blow
Anna Piaggi

### Hall of Fame
Giancarlo Giammetti
Kate Moss
H.M. Queen Rania of Jordan
Connie Wald
Charlie Watts
*10 named to Women's list;
10 named to Men's list; 4 named to
Couples list; Fashion Professionals
category revived (combined men
and women), 5 named; 2 named
to Fashion Originals list; Hall of
Fame (combined men and women),
5 named*

## 2007
(SEPTEMBER 2007)

### Women
Charlotte Gainsbourg
Princess Alexandra of Greece
Marjorie Gubelmann
Princess Mafalda of Hesse
Fran Lebowitz
Michelle Obama
Bee Shaffer
Tilda Swinton
Ivanka Trump
Renée Zellweger

### Men
Tiki Barber
Jonathan Becker
Lapo Elkann
Count Manfredi
Della Gherardesca
Richard E. Grant
Lenny Kravitz
Luis & Rafael Medina
Hidetoshi Nakata
Nicolas Sarkozy
Gay Talese

### Couples
Serena & David
Armstrong-Jones, Viscountess
& Viscount Linley
Victoria & David Beckham
Lauren Bush & David Lauren
Angelina Jolie & Brad Pitt
Kelly Lynch & Mitch Glazer
Demi Moore & Ashton Kutcher
Rachel Roy & Damon Dash
Lady Isabella Stanhope
& Colin Campbell, Countess
& Earl of Cawdor
Isabel & Ruben Toledo
Shirin von Wulffen &
Frédéric Fekkai

### Fashion Professionals
Amy Astley
Tory Burch
Jefferson Hack
Liya Kebede
Alexandra Kotur
Margherita Missoni
Stefano Pilati
Michael Roberts
Katherine Ross
Hedi Slimane

### Fashion Originals
Peter Beard
Carlyne Cerf de Dudzeele
Lisa Eisner

### Hall of Fame
Alba Clemente
George Clooney
Marina Rust Connor
Anderson Cooper
Sofia Coppola
Jemima Khan
Anna Piaggi
*10 named to Women's list;
10 named to Men's list; 10 named
to Couples list; 10 named to Fashion
Professionals list; 3 named to
Fashion Originals list; 7 named to
Hall of Fame*

## 2008
(SEPTEMBER 2008)

### Women
Carla Bruni-Sarkozy
Julia Koch
Evelyn Lauder
H.R.H. Crown Princess
Mathilde of Belgium
Kate Middleton (see H.R.H.
the Duchess of Cambridge)
Michelle Obama
Sarah Jessica Parker
Tilda Swinton
Diana Taylor
Ivanka Trump

### Men
David Beckham
Daniel Craig
Lapo Elkann
H.S.H. Prince Heinrich
von und zu Fürstenberg
Count Manfredi
Della Gherardesca
Zac Goldsmith
Matt Lauer
Bryan Lourd
Morley Safer
Kanye West

### Siblings
Andrea & Pietro Clemente
Alexandra Kotur
& Fiona Kotur Marin
Luis & Rafael Medina

### Couples
Sydney & Charles Finch
Angelina Jolie & Brad Pitt
Kelly Lynch & Mitch Glazer

### Professionals
Stacey Bendet
Christy Turlington Burns
Carine Roitfeld
Katherine Ross

### Originals
Iris Apfel
Karl Lagerfeld
Julian Schnabel

### Hall of Fame
Jonathan Becker
Fran Lebowitz
H.R.H. Crown Prince
Pavlos of Greece
*10 named to Women's list; 10 named
to Men's list; 3 named to Siblings
list; 3 named to Couples list;
4 named to Professionals list;
3 named to Originals list;
3 named to Hall of Fame*

## 2009
(SEPTEMBER 2009)

### First Ladies
Carla Bruni-Sarkozy
Michelle Obama

### Women
Chiara Clemente
Penélope Cruz
Kathy Freston
Agnes Gund
Anne Hathaway
Alicia Keys
H.R.H. Princess Letizia
of Asturias
H.H. Sheikha Mozah of Qatar
Kelly Ripa
Lizzie Tisch

### Men
Tiki Barber
Arpad Busson
Daniel Craig
Matteo Marzotto
Barack Obama
Ogden Phipps II
Brad Pitt
Roo Rogers
Alejandro Santo Domingo
Cy Twombly

### Siblings
Jane & Aerin Lauder
Stavros & Eugenie Niarchos

### Couples
Paloma Cuevas
& Enrique Ponce
Diana Taylor
& Michael Bloomberg
Natalia Vodianova
& Justin Portman
Shelley Wanger
& David Mortimer

### Professionals
Stacey Bendet
Tory Burch

### H.O.F., Women
Mrs. Henry Kravis
(Marie-Josée Drouin)
Marian McEvoy
Anne McNally

### H.O.F., Men
John Cahill
Michael Cannon
Prince Pierre d'Arenberg
Charles Gwathmey
H.S.H. Prince Rupert
von und zu Löwenstein
Patrick McCarthy
Sting
Taki Theodoracopulos

### Men
Wes Anderson
Andre 3000 Benjamin
George Clooney
Anderson Cooper
Lapo Elkann
Charles Finch
Jude Law
Bernard-Henri Lévy
Ogden Phipps
Charlie Watts

### Men (2006)
Tiki Barber
Jonathan Becker
Lapo Elkann
Count Manfredi
Della Gherardesca
Richard E. Grant
Lenny Kravitz
Luis & Rafael Medina
Hidetoshi Nakata
Nicolas Sarkozy
Gay Talese

### Women (2010)
Georgina Chapman
Ali Hewson
David Lauren
Mathilde Meyer-Agostinelli
Candy Pratts Price
Rachel Roy
Franca Sozzani

### Originals
Duchess of Alba (Cayetana
Fitz-James Stuart)
Peter Beard
Nicky Haslam
Iké Udé
Bruce Weber

### Hall of Fame
Liliane Bettencourt
Catherine Deneuve
Lapo Elkann
Count Manfredi
della Gherardesca
Renée Zellweger
*2 named to First Ladies list;
10 named to Women's list;
10 named to Men's list; 2 named
to Siblings list; 4 named to Couples
list; 9 named to Professionals list;
5 named to Originals list;
5 named to Hall of Fame*

## 2010
(SEPTEMBER 2010)

### Women
Hope Atherton
Carla Bruni-Sarkozy
Samantha Cameron
Nora Ephron
Diane Kruger
H.R.H. Crown Princess
Mary of Denmark
Carey Mulligan
Wendi Murdoch
Michelle Obama
Tatiana Santo Domingo

### Men
Waris Ahluwalia
André Balazs
Alec Baldwin
Javier Bardem
Arki Busson
H.S.H. Prince Heinrich
von und zu Fürstenberg
Jay Penske
Martin Scorsese
Brian Williams
Pharrell Williams

### Siblings
Lou Doillon &
Charlotte Gainsbourg
Maggie & Jake Gyllenhaal
Andrew, David,
& Dylan Lauren
Julia & Vladimir
Restoin-Roitfeld

### Couples
Delfina Blaquier
& Nacho Figueras
Beatrice Borromeo
& Pierre Casiraghi
Lizzie & Jonathan Tisch
Christy Turlington & Ed Burns

### Professionals
Tory Burch
Georgina Chapman
Stacey Bendet Eisner
Alber Elbaz
Cindi Leive

### Originals
Duchess of Alba (Cayetana
Fitz-James Stuart)
Helena Bonham Carter
Lady Gaga
John Galliano
Lorry Newhouse
Bruce Weber

## Hall of Fame

David Beckham
Countess Marina Cicogna
Julia Koch
Alexandra Kotur
H.H. Princess Mafalda
   of Hesse

*10 named to Women's list;
10 named to Men's list; 4 named
to Siblings list; 4 named to Couples
list; 5 named to Professionals list;
6 named to Originals list;
5 named to Hall of Fame*

## 2011
(SEPTEMBER 2011)

### Women

Carla Bruni-Sarkozy
H.R.H. the Duchess of
   Cambridge (Catherine
   "Kate" Middleton)
H.S.H. Princess
   Charlene of Monaco
Andrea Dellal
Christine Lagarde
H.H. Sheikha Moza
   Bint Nasser of Qatar
Carey Mulligan
Tilda Swinton
Lizzie Tisch
Jane Lauder Warsh

### Men

Arpad Busson
Jenson Button
Mario d'Urso
Colin Firth
Nicholas Foulkes
Armie Hammer
Stavros Niarchos
Marcus Samuelsson
Alejandro Santo Domingo
Justin Timberlake

### Siblings

Claire, Jenna, Prisca
   & Virginie Courtin-Clarins
Cara, Chloe & Poppy
   Delevingne

### Couples

H.R.H. Princess Alexandra
   of Greece & Nicolas
   Mirzayantz
Lauren Bush & David Lauren
Emilia & Pepe Fanjul
T.S.H. Princess Matilde
   von Fürstenberg-Borromeo
   & Prince Antonius von
   Fürstenberg
Michelle & Barack Obama

### Professionals

Stella Tennant
Mario Testino
Christopher Bailey
Shala Monroque
Amanda Hearst

### Originals

The King of Bhutan
Lady Gaga
Janelle Monáe
Vanessa Paradis
   & Johnny Depp

### Hall of Fame

The Duchess of Alba
   (Cayetana
   Fitz-James Stuart)
Ogden Phipps II
Brian Williams

*10 named to Women's list;
10 named to Men's list; 2 named
to Siblings list; 5 named to Couples
list; 5 named to Professionals list;
4 named to Originals list;
3 named to Hall of Fame*

## 2012
(SEPTEMBER 2012)

### Women

Fan Bingbing
H.R.H. the Duchess
   of Cambridge (Catherine
   "Kate" Middleton)
Charlotte Casiraghi
Jessica Chastain

---

Alicia Keys
Diane Kruger
H.R.H. Crown Princess
   Mary of Denmark
H.H. Sheikha Moza
   Bint Nasser of Qatar
Léa Seydoux
Elettra Wiedemann

### Men

Tom Brady
Victor Cruz
Richard E. Grant
Prince Harry
Jay-Z
Matt Lauer
Eddie Redmayne
Morley Safer
Vito Schnabel
Iké Udé

### Couples

Ginevra Elkann & Giovanni
   Gaetani dell'Aquila
   d'Aragona
Livia Giuggioli & Colin Firth
Lauren & Andrés
   Santo Domingo

### Professionals

Erika Bearman
Stacey Bendet
Poppy Delevingne
Farida Khelfa
Matteo Marzotto
Stella McCartney
Robert Rabensteiner
Ulyana Sergeenko
Carlos Souza

### Originals

Bill Cunningham
Michelle Harper
Jean Pigozzi

### Hall of Fame

H.S.H. Princess Alexandra
   of Greece
Ozwald Boateng
Arki Busson
H.R.H. Prince Heinrich
   von und zu Fürstenberg
Lizzie Tisch

*10 named to Women's list;
10 named to Men's list; 3 named
to Couples list; 9 named
to Professionals list; 3 named
to Originals list; 5 named
to Hall of Fame*

## 2013
(SEPTEMBER 2013)

### Women

Beyoncé
H.R.H. the Duchess
   of Cambridge (Catherine
   "Kate" Middleton)
Jill Kargman
H.R.H. Princess
   Letizia of Asturias
Peng Liyuan
H.R.H. Princess Madeleine
   of Sweden
Brooke Shields
Charlize Theron
Kerry Washington
Dasha Zhukova

### Men

Francesco Carrozzini
Ronan Farrow
Isaac, Otis & Tara Ferry
Alexander Gilkes
Jack Huston
LeBron James
Henrik Lundqvist
Luca Cordero di Montezemolo
Charlie Siem
Justin Timberlake

### Couples

Gisele Bündchen & Tom Brady
Tabitha Simmons
   & Craig McDean
Lara Stone & David Walliams

### Professionals

Victoria Beckham
Tory Burch

---

Maureen Chiquet
Carmen Dell'Orefice
Dree Hemingway
Caroline Issa
Ricky Lauren
Jenna Lyons
Alice Temperley
Stella Tennant

### Originals

Thom Browne
Keith Richards
Dita Von Teese

### V.F. Challenge Winners

Darren Henault
Hallie Swanson

*10 named to Women's list;
10 named to Men's list; 3 named
to Couples list; 10 named to
Professionals list; 3 named to
Originals list; 2 named to V.F.
Challenge Winners list*

## 2014
(SEPTEMBER 2014)

### Women

Cate Blanchett
Beatrice Borromeo
Michelle Dockery
Audrey Gelman
Vanessa Getty
H.R.H. Crown Princess
   Mary of Denmark
H.M. Queen Máxima
   of the Netherlands
Lupita Nyong'o
Emmy Rossum
Emma Watson

### Men

Miguel Baez
Victor Cruz
Benedict Cumberbatch
Idris Elba
Neil Patrick Harris
Jeff Koons
Henrik Lundqvist
Eddie Redmayne
Vito Schnabel
Pharrell Williams

### Couples

Livia & Colin Firth
Lauren & Andres
   Santo Domingo
Shirin von Wulffen
   & Frédéric Fekkai

### Professionals

Sophia Amoruso
Rainer Andreesen
Amy Astley
Andrew Bolton
Bianca Brandolini D'Adda
Charlotte Olympia Dellal
Karlie Kloss
Natalie Massenet
Eugene Tsai Tong
Elie Top

### Originals

King of Bhutan
St. Vincent
Donna Tartt

### Hall of Fame

Stacey Bendet
H.R.H. Duchess of Cambridge
   (Catherine "Kate"
   Middleton)
Karl Lagerfeld

### V.F. Challenge Winners

Claudia Adaszewska
Kyle Hotchkiss Carone

*10 named to Women's list;
10 named to Men's list; 3 named
to Couples list; 10 named to
Professionals list; 3 named to
Originals list; 2 named to V.F.
Challenge Winners list*

## 2015
(SEPTEMBER 2015)

### Women

Francesca Amfitheatrof
Samantha Cameron
Charlotte Casiraghi
Amal Clooney
Misty Copeland
Mellody Hobson
H.M. Queen Letizia of Spain
Rihanna
Taylor Swift
H.R.H. the Countess of
   Wessex (Sophie
   Rhys-Jones)

### Men

H.R.H. Prince Carl Philip
   of Sweden
Robert Couturier
H.R.H. Prince Harry
Jonathan Ive
William Ivey Long
Stavros Niarchos
Bill Nighy
Jonathan Tisch
Iké Udé
Russell Wilson

### Couples

Matt Bomer & Simon Halls
Beatrice Borromeo
   & Pierre Casiraghi
Andrew Bolton
   & Thom Browne
Sophie Hunter
   & Benedict Cumberbatch
Jemma Kidd & Arthur
   Wellesley, Marchioness
   & Marquess of Douro

### Hollywood

Fan Bingbing
Michael Fassbender
Diane Kruger
Gugu Mbatha-Raw
Sienna Miller

### Professionals

Giovanna Battaglia
Victoria Beckham
Dao-Yi Chow
   & Maxwell Osborne
Pamela Golbin
Caroline Issa
Harold Koda
Peter Manning
Zac Posen
Lauren Santo Domingo
Nick Wooster

### Originals

Azzedine Alaïa
Jenna Lyons
FKA Twigs

### Hall of Fame

H.H. Sheikha Moza Bint
   Nasser Al-Missned of Qatar

*10 named to Women's list;
10 named to Men's list; 5 named
to Couples list; 5 named to
Hollywood list; 11 named to
Professionals list; 3 named to Originals
list; 1 named to Hall of Fame*

## 2016
(OCTOBER 2016)

### Women

Chimamanda Ngozi Adichie
Olivia Chantecaille
Anh Duong
Aurélie Dupont
Jane Lauder
H.M. Queen Máxima
   of the Netherlands
Eugenie Niarchos
Allison Sarofim
Olympia Scarry
Zadie Smith

### Men

Joe Biden
Victor Cruz
H.R.H. Crown Prince
   Frederik of Denmark
H.R.H. Prince Harry

---

Frédéric Malle
Leslie Odom Jr.
Vito Schnabel
Louis Spencer
Justin Trudeau
Russell Westbrook

### Couples

Lavinia & John Elkann
Juman Malouf
   & Wes Anderson
Michelle & Barack Obama
Charlotte & Alejandro
   Santo Domingo

### Hollywood

Fan Bingbing
Idris Elba
Lily James
Helen Mirren
Eddie Redmayne

### Professionals

Rainer Andreesen
Alex Badia
Anna Cleveland
Delfina Delettrez Fendi
Giorgio Guidotti
Aurora James
Rei Kawakubo
Gina Sanders

### Originals

Pat Cleveland
Andra Day
Daveed Diggs
Lady Gaga
Nicky Haslam

### Hall of Fame

Moses Berkson
H.R.H. Crown Princess
   Mary of Denmark
Tilda Swinton

### Special Citation for Steadfastness in Dress

H.M. Queen Elizabeth II
   of Great Britain and
   Northern Ireland

*10 named to Women's list;
10 named to Men's list; 4 named to
Couples list; 5 named to Hollywood
list; 8 named to Professionals list;
5 named to Originals list;
3 named to Hall of Fame;
1 named for Special Citation*

## 2017
(OCTOBER 2017)

### Women

Anh Duong
Charlotte Gainsbourg
Kirsten Green
Solange Knowles
H.M. Queen Letizia of Spain
Eugenie Niarchos
Rebecca de Ravenel
Rihanna
Lady Amelia Windsor
Dasha Zhukova

### Men

Roberto Bolle
Roger Federer
Donald Glover
LeBron James
Henry Koehler
Daniel Romualdez
Jack Schlossberg
Charlie Siem
Harry Styles
Justin Trudeau

### Couples

Brigitte & Emmanuel Macron
Queen Máxima & T.M. King
   Willem-Alexander of
   the Netherlands
Michelle & Barack Obama

### Hollywood

Cate Blanchett
Zoë Kravitz
Janelle Monáe
Ruth Negga
Dev Patel

---

### Professionals

Adwoa Aboah
Alexandre Arnault
Petra Collins
Inés Domecq
Mercedes Domecq
Nico Landrigan
Hervé Pierre
Miuccia Prada
Carlos Souza
Vanessa Traina

### Originals

Catherine Baba
Jaden Smith
Mademoiselle Yulia

### Hall of Fame

Lauren Hutton
Jeremy Irons
Lauren Santo Domingo

### Special Citation for Steadfastness in Dress

H.R.H. Prince Philip,
   the Duke of Edinburgh

*10 named to Women's list;
10 named to Men's list; 3 named
to Couples list; 5 named to
Hollywood list; 10 named to
Professionals list; 3 named to
Originals list; 3 named to Hall of
Fame; 1 named for Special Citation*

## 2018

### Women

Emily Blunt
Gemma Chan
Gal Gadot
Agnes Gund
Alicia Keys
H.M. Queen Letizia of Spain
Olivia Palermo
Tracee Ellis Ross
Zadie Smith
H.R.H. the Duchess of Sussex
   (Meghan Markle)

### Men

The Duke of Feria
   (Rafael de Medina)
Henry Golding
H.R.H. Prince Harry,
   the Duke of Sussex
Steve Harvey
Nicky Haslam
Joseph Kennedy III
Jean-Gabriel Mitterrand
Juan Santa Cruz
Darren Walker
Geoffrey Zakarian

### Professionals

Giovanna Battaglia Engelbert
Linda Fargo
Giorgio Guidotti
Gabriela Hearst
Rebecca de Ravenel

*10 named to Women's list;
10 named to Men's list;
5 named to Professionals list*

# Index

# Acknowledgments

First, I thank my parents, from whom I inherited an interest in clothes, and my sister,
who facilitated this preoccupation. I also thank Flora, for inspiring me always and for helping me
research and edit this book. I thank Brad for his patience and support.

My I.B.D.L. teammates, Aimée Bell, Graydon Carter, and Reinaldo Herrera, have been,
for longer than seems possible, dear presences in my life. This book grew organically
out of an assignment Aimée dreamed up for me some time ago. Chris Garrett and Kim Schefler
have helped make all things I.B.D.L. run smoothly. Andrew Wylie and Jessica Friedman wisely,
enthusiastically, and tactfully made sure this book became a reality. Charles Miers took
on the book, with sensitivity and a sense of adventure, and Anthony Petrillose kept the
whole enormous enterprise on track. Andrea Danese tirelessly and with a sense of humor poured
her heart, soul, and brains into this book. Pam Sommers, like Eleanor Lambert herself, is a
wizard of public relations. Carolina Herrera asked the right questions, gave the best answers,
and personifies so much of what this book is about.

I deeply thank my three angels of the "A" team for all their interminable hours of hard work
on a project that turned out to be far more complex and satisfying than any of us could have imagined.
The peerless Ann Schneider, a colleague for more than 20 years, brought us all to a state
of euphoria with each new photo she discovered. The ever upbeat, ever flexible, ever dedicated
Angela Panichi, as her name implies, is the art director from heaven. Our post-midnight
"quadruple A" sessions brought mischief and magic to this project night after night.

I thank Harold Koda for his acute interest in all the obscure minutiae of this undertaking
from the earliest stage of its development, and Hamish Bowles for his astonishing ability
to answer the most recherhé questions, from anywhere on the the planet. I thank
Gene Meyer and Frank de Biasi for their vast and deep knowledge of fashion and
decorating history, and of course for their decades of friendship. I thank Felipe Escalante
for looking, listening, and caring every step of the way. I thank Peter Devine for his
copyediting brilliance, invaluable for our many years together, and Isabel Ashton
for her longtime commitment to making every detail of the I.B.D. Lists as perfect as possible.
Sean Ferrer and Luca Dotti kindly and generously permitted their mother to grace our cover,
and Iké Udé magnanimously allowed his marvelous portrait to embellish the spine.
I thank Moses Berkson for sharing fond memories of his grandmother. Marc-Antoine Coulon
miraculously recreated, and courteously made available to us, his artwork for the Preface.
So many photographers and photographers' estates trusted us and gave their utmost to the book—
Mary Hilliard, Roxanne Lowit, Hannah Thomson, Billy Farrell, Patrick McMullan, and
the Richard Avedon estate among them. Marian McEvoy and Allegra Hicks enhanced the book
with photos from their personal collections. I thank Thom Browne for his friendship and for creating
fantastic designs that I am so happy to wear. A concluding word of gratitude goes to
Grace Pollak for bravely organizing unruly accounts and itineraries and to Cory de Guzman
for keeping my house, my wardrobe, and other elements of my life in near-impeccable order.

# Photo Credits

---

© AF Archive/Alamy: 71

© AGIP/Bridgeman Images: 154 (bottom)

© Rony Alwinm: 259

© Ulf Anderson/Gamma: 175

All from A. P. Images: 37; Ed Bailey, 167 (bottom right); Jorge Herrera, 203 (far right); Jim Pringle, 80;
Ugo Sarto, 102 (bottom left); Adam Scull, 167 (top right); David Smith, 85

© The Richard Avedon Foundation: 92, 100–101, 136

© Anthony Barboza: 129 (far right)

© The Cecil Beaton Studio Archive at Sotheby's: 17 (right), 30 (bottom right), 54, 54–55, 97

Roloff Beny: 59 (bottom left)

All from © BFA: Leandro Justen, page 233 (bottom right); Kelly Taub, 236; 243 (top)

© David Burnett/Contact Press Images: 182 (bottom left)

© Chouet Press/Best Image: 204 (bottom left)

© Howell Conant/Bob Adelman Books, Inc.: 59 (top left), 72, 73 (bottom)

Courtesy Condé Nast: 29 (top right), 116

© Marc-Antoine Coulon: 8

© Carolyn Cowan: 223 (bottom)

© Louise Dahl-Wolf/Center for Creative Photography, Arizona Board of Regents,
courtesy Millicent Rogers Museum, Taos, NM: 26

© David Downton: 7

© Everett Collection/Alamy: 83 (bottom left)

© Marina Garnier, 168 (top center): 229

All from Getty Images: Slim Aarons, 76, 112 (top); Dave Allocca, 253 (bottom); The Asahi Shimbun, 187 (far right); Jane Barlow, 246;
Cecil Beaton/Condé Nast, 46 (bottom), 62; Colin Bell, 210; Alain Benainous/Gamma-Rapho, 225; Dave Benett, 223 (far right);
Ullstein Bild, 60 (bottom left); Erwin Blumenfeld/Condé Nast, 42 (bottom); Vince Bucci/AFP, 203 (far right); Nathaniel S. Butler, 247;
R. J. Capak, 209; John Chillingworth/Picture Post, 75, 77 (bottom); Henry Clarke/Condé Nast, 107; Jerry Cooke, 56; John Cowan/Condé
Nast, 115; Kevin Cummings, 190; Alain Dejean/Sygma, 125 (top); Robert Doisneau/Gamma Rapho, 77 (top right);
Julio Donoso/Sygma, 204 (bottom center); Alfred Eisenstaedt/The Life Collection, 44–45, 124; Arthur Elgort/Condé Nast, 189, 245;
Thomas England/The Life Collection, 182 (top); Santo Forlano/Condé Nast, 113; Tony Frissell/The Life Collection, 77 (top left);
Ron Galella, 129 (top left), 135, 150, 154 (top), 156–157, 158, 167 (bottom center), 194, 198, 224; Gerard Gery/Paris Match,
111 (right); P. L. Gould, 197; Tim Graham, 176; Allan Grant/The Life Collection, 66, 73 (top left); Doug Griffin/Toronto Star, 155;
Dirck Halstead, 170; Evelyn Hofer, 132; Horst P. Horst/Condé Nast, 14, 18, 32, 43, 49 (bottom), 59 (top center), 105;
George Hoyningen-Huene, 25 (top); Anwar Hussein, 147; Frank Johnson/The Washington Post, 151 (bottom);
George Karger/Pix Inc./The Life Collection, 2; Keystone/Gamma-Rapho, 29 (far left), 89 (bottom center), 110; Mark Large, 230;
Gene Lester, 52; David Levenson, 168 (far left); Lipnitzki/Roger Viollet, 125 (bottom); The Estate of Jacques Lowe, 89 (top);
Leonard McCombe/The Life Collection, 119 (bottom); Terry McGinnis, 204 (top left); Jack Mitchell, 140 (bottom, far left);
Mondadori Portfolio, 60 (top left); Bert Morgan, 50 (bottom left), 74 (far left); Tim Mosenfelder, 203 (bottom left); Carl Mydans/The Life
Collection, 83 (bottom right); Norman Parkinson/Iconic, 60 (right); Pierre Perrin/Sygma, 181 (top);
Steve Pyke, 200; John Rawlings/Condé Nast, 30 (top right), 42 (top), 59 (far right); Patrick Siccoli/Gamma-Rapho, 168 (bottom right);
Barton Silverman, 119 (top right); Jim Smeal, 204 (far right); Edward Steichen/Condé Nast, 30 (top center); Bert Stern/Condé Nast,
90 (far left), 120; John Swope/The Life Collection, 90 (top center); Earl Theisen, 83 (top); Toronto Star, 29 (bottom center);
Venturelli, 262; Justin de Villeneuve, 98; Victor Virgile/Gamma-Rapho, 167 (far left); Dave Westing, 256 (top);
Graham Wiltshire, 139; Kevin Winter/DMI/The Life Collection, 180; Art Zelin, 130 (bottom center), 195; Vince Zuffante, 226 (top)

Additional Getty Images: 16 (far left, bottom center), 19 (bottom), 21, 29 (bottom right), 30 (far left), 38, 51, 82, 90 (top right),
103, 146, 160, 181 (bottom), 233 (top right), 234 (top right), 243 (bottom)

© Globe Photos/Zuma Press: 106

© Jean-Paul Goude: 254

Photographed by Milton H. Greene © 2019 Joshua Greene www.archiveimages.com: 89 (far left), 108 (bottom), 117

© Mary Hilliard: 10 (right), endpaper (back)

All from The Image Works: © The Mirisch Corporation/Ronald Grant/Alamy, 149; © Mirrorpix, 191 (top);
© Jack Nisberg/Roger-Viollet, 153; TopFoto, 40; © Madame Yevonde/ILN/Mary Evans, 41

© Constantin Joffé: 25 (bottom)

© Dafydd Jones: 12–13, 216–217, 218 (top), 228

© Douglas Kirkland: 114, 145 (top right)

ENDPAPER, FRONT, CLOCKWISE FROM TOP LEFT: telegram from Marella Agnelli sent to Eleanor at her office at 785 Fifth Avenue, date-and-time stamped December 31, 1959, 11:04 AM, in which she thanks Eleanor for her inaugural appearance on the List; thank-you note from Tina Chow to "Mrs. Lambert," written on a Mr. Chow notecard and dated March 29, 1985. Inducted into the Hall of Fame in 1985, Tina, a jewelry designer, muse, and collector of vintage couture, was married to the restaurateur Michael Chow; *The New York Times* article announcing the winners of the final Paris Dressmakers' Poll, the predecessor of Eleanor's List, January 29, 1940. Marina, Duchess of Kent, is visible beneath the headline; typed thank-you note from *Harper's Bazaar* editor-in-chief Carmel Snow to Eleanor, dated January 3, 1957. Carmel wrote, "Within the next few days I will try to get photographer to take a snap of me," in response to Eleanor's standard request for a photo from each winner; a portion of a full page in *Women's Wear Daily*, titled "The Best Dressed List Is Out" and dated Friday, January 14, 1966; *Vanity Fair*'s September 2006 issue, featuring that year's International Best-Dressed List and a cover photograph of Kate Moss, shot by Mert & Marcus. Moss rose to the Hall of Fame in 2006 after three appearances on the List; a ballot filled out and annotated by one of the nearly 2,000 voters canvassed by Eleanor for the 1954 List; typed note from Nancy Reagan, then the wife of Governor Ronald Reagan, on her Sacramento, California, Executive Residence notepaper, thanking Eleanor for elevating her to the Hall of Fame, dated February 20, 1974; a thank-you note from Inès de la Fressange to Eleanor, typed on Chanel notepaper and mentioning an enclosure of a favorite photo of her, taken by Karl Lagerfeld.
PHOTOS, BOTTOM: portrait of Eleanor Lambert taken by Oscar White on December 18, 1946; CENTER LEFT: Eleanor, right, with Jacqueline de Ribes in Paris, visiting the International Ballet of the Marquis de Cuevas, which the vicomtesse successfully managed for three years, early 1960s. On the right, a sliver of writer Anita Loos's face is visible; TOP RIGHT: Eleanor seated for dinner with designers John Weitz and Bill Blass and *New York Herald-Tribune* columnist Eugenia Sheppard, at a fashion party in 1963. Photo by Fernand Fonssagrives.

ENDPAPER, BACK, CLOCKWISE FROM TOP LEFT: telegram, dated January 3, 1958, from Audrey Hepburn, then married to Mel Ferrer, informing Eleanor how "excited and happy" she was to learn that she would be on the 1957 List, her second appearance; page 38 from the January 11, 1963, issue of *Life* magazine, featuring a story about the List and depicting winners, including Jacqueline Kennedy, Evangeline Bruce, Lee Radziwill, Gloria Vanderbilt, Gloria Guinness, and Marella Agnelli; the Duchess of Windsor's thank-you telegram to Eleanor ("Mrs. Seymour Berkson"), dated December 31, 1957, in which she and the Duke of Windsor send their best wishes for the new year. The Duchess signed the telegram "Wallis"; opening page of the annual I.B.D.L. announcement and portfolio, from *Vanity Fair*'s September 2008 issue; Eleanor's draft of a note to Aimée Bell, deputy editor of *Vanity Fair* and a member of Eleanor's I.B.D.L. committee, requesting her help with finding "new young people to include," circa 2000. Aimée was one of four people to whom Eleanor would bequeath the List in 2002; note to Eleanor from the office of H.R.H. the Prince of Wales, St. James's Palace, thanking her for her letter "advising Prince William that he has been named one of the twelve best-dressed men in the world," signed by palace assistant Claire Southwell and dated April 28, 1998; "Suzy" column, written by Aileen Mehle for the New York *Daily News*, February 15, 1977, with the headline "We've Got A Little List." Aileen was often given first exclusive of the yearly announcement.
PHOTOS, BOTTOM: Eleanor with Christopher Eddy, arriving in the snow for one of the first Council of Fashion Designers of America galas, held at the Metropolitan Museum of Art, New York, 1970s. Photo by Bill Cunningham; CENTER: celebration for Eleanor's 90th birthday, Venice, Italy, 1993. Lynn Wyatt, at right, applauds. Photo by Mary Hilliard; TOP: Eleanor with her grandson, the photographer and filmmaker Moses Berkson, who wears a hand-me-down suit from Kenneth Jay Lane, December 7, 1998. They are attending the 50th Anniversary Party of the Year for the Costume Institute, at the Metropolitan Museum of Art. The Party of the Year, or Met gala, first held at the Rainbow Room, was an idea conceived in 1948 by Eleanor to raise money for the Institute. Photo by Mary Hilliard.

287

First published in the United States of America in 2019 by
Rizzoli International Publications, Inc.
300 Park Avenue South
New York, NY 10010
www.rizzoliusa.com

Introduction © 2019 by Graydon Carter
Foreword © 2019 by Carolina Herrera
For photography credits, see page 285

PUBLISHER Charles Miers
ASSOCIATE PUBLISHER Anthony Petrillose
EDITOR Andrea Danese
DESIGN Angela Panichi
PHOTOGRAPHY EDITOR Ann Schneider
COPYEDITOR Peter Devine
PRODUCTION MANAGER Barbara Sadick
MANAGING EDITOR Lynn Scrabis

Printed in China

2019 2020 2021 2022 / 10 9 8 7 6 5 4 3 2 1
ISBN: 978-0-8478-6413-3
Library of Congress Control Number: 2019943568

Visit us online:
FACEBOOK.COM/RIZZOLINEWYORK
TWITTER: @RIZZOLI_BOOKS
INSTAGRAM.COM/RIZZOLIBOOKS
PINTEREST.COM/RIZZOLIBOOKS
YOUTUBE.COM/USER/RIZZOLINY
ISSUU.COM/RIZZOLI

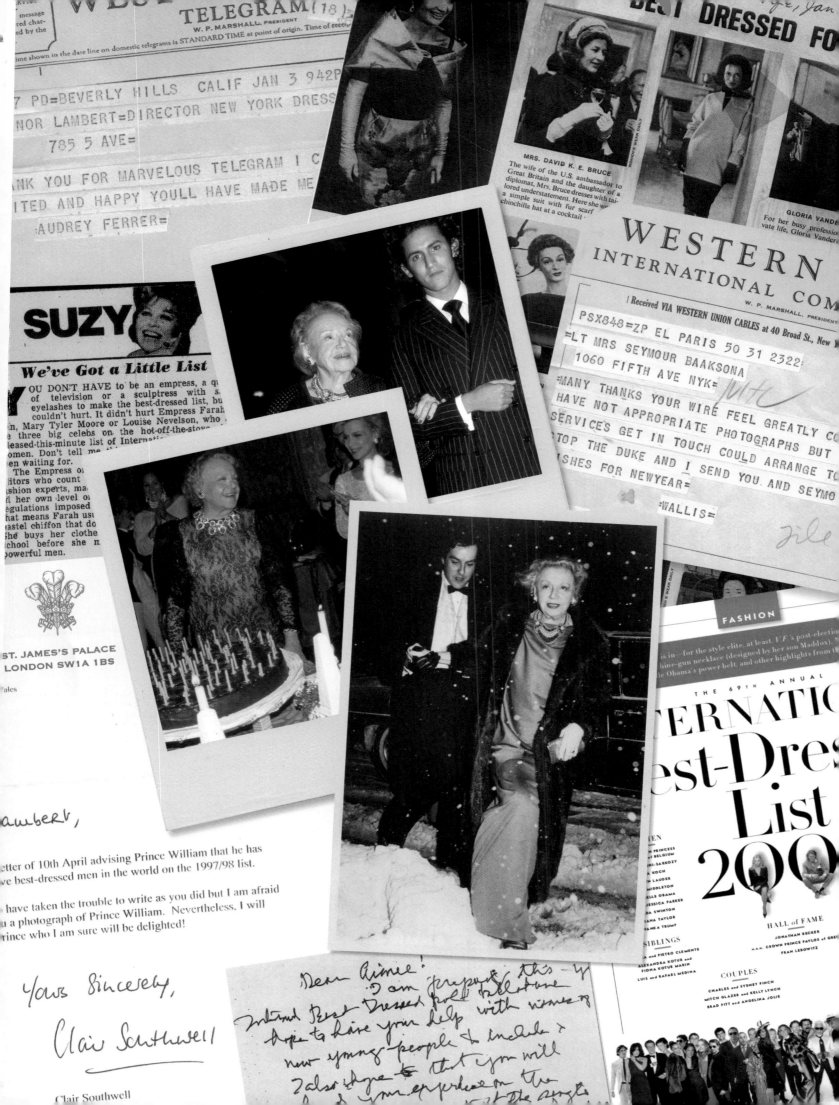

e shown in the dare line on domestic telegrams is STANDARD TIME at point of origin. Time of recei

7 PD=BEVERLY HILLS CALIF JAN 3 942P

NOR LAMBERT=DIRECTOR NEW YORK DRESS

785 5 AVE=

ANK YOU FOR MARVELOUS TELEGRAM I C

ITED AND HAPPY YOULL HAVE MADE ME

AUDREY FERRER=

**BEST DRESSED FO**

**MRS. DAVID K. E. BRUCE**
The wife of the U.S. ambassador to
Great Britain and the daughter of a
diplomat, Mrs. Bruce dresses with tai-
lored understatement. Here she w
a simple suit with fur scarf
chinchilla hat at a cocktail

GLORIA VANDE
For her busy professio
vate life, Gloria Vanders

## SUZY

### We've Got a Little List

YOU DON'T HAVE to be an empress, a qu
of television or a sculptress with s
eyelashes to make the best-dressed list, bu
couldn't hurt. It didn't hurt Empress Farah
n, Mary Tyler Moore or Louise Nevelson, who
leased-this-minute list of Internati
men. Don't tell me
en waiting for.
The Empress o
itors who count
fashion experts, ma
l her own level o
egulations imposed
at means Farah us
pastel chiffon that do
She buys her clothe
chool before she m
powerful men.

Received VIA WESTERN UNION CABLES at 40 Broad St., New

PSX848=ZP EL PARIS 50 31 2322:

=LT MRS SEYMOUR BAAKSONA

1060 FIFTH AVE NYK

=MANY THANKS YOUR WIRE FEEL GREATLY C
HAVE NOT APPROPRIATE PHOTOGRAPHS BUT
SERVICES GET IN TOUCH COULD ARRANGE TO
TOP THE DUKE AND I SEND YOU AND SEYMO
SHES FOR NEWYEAR=

=WALLIS=

**ST. JAMES'S PALACE
LONDON SW1A 1BS**

ales

ambert,

etter of 10th April advising Prince William that he has
ve best-dressed men in the world on the 1997/98 list.

have taken the trouble to write as you did but I am afraid
u a photograph of Prince William. Nevertheless, I will
rince who I am sure will be delighted!

Yours Sincerely,

Clair Southwell

Clair Southwell

**FASHION**

is in — for the style elite, at least. F.F.'s post-electi
hine-gun necklace (designed by her son Maddox),
le Obama's power belt, and other highlights from

THE 69TH ANNUAL

**INTERNATIO
Best-Dress
List
200**

HALL of FAME

JONATHAN BECKER

H.R.H. CROWN PRINCE PAVLOS of GRE

FEAM LEBOWITZ

**COUPLES**

CHARLES and SYDNEY FINCH

MITCH GLAZER and KELLY LYNCH

BRAD PITT and ANGELINA JOLIE

Dear Aimee!
I am preparing this
Internal Best Dressed poll
hope to have your help with names
new young people to include
I also hope that you will